A Keener I

Introduction

Alan C. Braddock and Christoph Irmscher

In April 2007, after meeting in Brussels, the United Nations Intergovernmental Panel on Climate Change (IPCC) issued its *Fourth Assessment Report* on global warming. Reflecting a consensus among the world's leading climate change scientists, the report painted a disturbing picture. It began dramatically by highlighting some of the changes already wrought by "anthropogenic" greenhouse gases in the earth's atmosphere. These include "increasing ground instability in permafrost regions," "earlier timing of spring events, such as leaf-unfolding, bird migration, and egg-laying," "poleward and upward shifts in ranges in plant and animal species," "heat-related mortality in Europe," "longer dry seasons and more uncertain rainfall" in southern Africa, "sea-level rise," and other unusual phenomena.[1]

The report also contained a number of troubling forecasts. For example, according to the IPCC scientists, "The resilience of many ecosystems is likely to be exceeded this century by an unprecedented combination of climate change, associated disturbances (e.g. flooding, drought, wildfire, insects, ocean acidification), and other global change drivers (e.g. land use change, pollution, over-exploitation of resources)." The report predicted that, thanks to rising sea levels by the 2080s, many millions more people may be flooded. Climate change could also adversely affect "the health of millions of people" through higher incidence of heat waves, droughts, fires, storms, and associated problems with agricultural production, malnutrition, and disease.[2]

Hardly immune from threats posed by global warming, many of the world's nonhuman species face a similar emergency. According to the report, "For increases in global temperature exceeding 1.5–2.5°C and in concomitant atmospheric carbon dioxide concentrations, there are projected to be major changes in ecosystem structure and function, species' ecological

interactions, and species' geographic ranges, with predominantly negative consequences for biodiversity." The numbers produced by the IPCC scientists make that scenario seem even starker: "Approximately 20–30% of plant and animal species assessed so far are likely to be at increased risk of extinction if increases in global average temperature exceed 1.5–2.5°C."[3]

In a more detailed region-by-region survey of current and likely future impacts, the report then explained that the worst devastations already affect and will likely increase in poorer, developing countries. Without bothering to note cruel ironies, the authors described how the United States—the world's largest producer of greenhouse gases—can expect to face the least-dramatic consequences of a development it has done more to create and exacerbate than any other single nation.[4]

But all is not lost, yet. Offering a summary of possible steps for limiting the effects of global warming, the report maintained that, at least for the time being, "a wide array of adaptation options" remains available. In addition, the scientists said, "Many impacts can be avoided, reduced or delayed by mitigation" and "sustainable development." But they also cautioned that the time for complacency has passed, for "more extensive adaptation than is currently occurring is required to reduce vulnerability to future climate change." Although researchers in America and elsewhere have been raising concern about global warming for decades, the IPCC report put world policymakers on notice by effectively offering an ultimatum: human culture must now change dramatically and rapidly in order for life on earth as we know it to survive in some acceptable, sustainable form. The planet, as other climate scientists have recently suggested, is approaching a "tipping point," after which global warming and associated environmental changes could become self-generating forces accelerating beyond our control.[5]

～

If art historians and other scholars in the humanities care about such things—and presumably they do—how can they respond? What options do they have for confronting this global environmental crisis? As non-scientists, are they restricted to undertaking the sorts of everyday political actions (voting, donating, organizing, demonstrating, etc.) and lifestyle changes (recycling, being more energy efficient, buying local products, etc.) increasingly embraced by other lay citizens in communities around the world? Or may they also choose to reassess and redirect scholarly inquiry itself on some level, in the hope that this move would foster solutions through a transformation of environmental perception and historical understanding?

As editors of the present volume, we emphatically say yes to the latter question and offer the following collection of essays as one possible response. Obviously, the scholarship contained herein will not in itself achieve the necessary effects of "mitigation" called for by the IPCC, but we nevertheless believe that our work can contribute to a broader re-imagination of environmental relations, responsibilities, and possibilities facing our planet today. By critically illuminating the environmental contexts of past cultural artifacts, scholarship in our view has the power to change the way we think about history while also contributing actively to current cultural conversations.

To some readers, such a proposal will seem utopian, evoking idealistic reform movements or avant-garde manifestos of old, while to others our commitment to the "greening" of art history will look as if it ignores more urgent contemporary concerns. To us, however, it offers a welcome path to intellectual renewal and "sustainability" in multiple senses. The present volume does not attempt to impose a strict template or to offer a totalizing prescription for all scholarship in all historical fields. At the same time, we are convinced that simply disavowing any scholarly responsibility, whether for ideological or aesthetic reasons or both, amounts to a cynical retreat into intellectual hermeticism—a rarified form of fiddling while Rome, or in this case the entire planet, burns. Ultimately, we advocate an "environmental turn" in cultural interpretation, as much for its potential to enrich scholarship as for its contribution to the larger movement of environmentalism.

~

Accordingly, *A Keener Perception* highlights recent and emerging research in American art history marked by a "green" or "ecocritical" perspective. Briefly defined, ecocriticism emphasizes issues of environmental interconnectedness, sustainability, and justice in cultural interpretation. When it is historically oriented, ecocritical scholarship may bring attention to neglected evidence of past ecological and quasi-ecological sensibility or it may cast canonical works and figures in a new light by revealing their previously unnoticed complexity, ambivalence, or even antipathy regarding environmental concerns. Ecocriticism does not radically revolutionize cultural studies by abandoning existing methods in favor of an entirely new theory or unified model of interpretation cut from whole cloth. In that sense, it differs somewhat from psychoanalytic criticism, deconstruction, and other approaches that have departed more dramatically from prior scholarship to establish their own vocabularies, tropes, and epistemologies.

Rather, ecocriticism borrows liberally from those and other interpretive

modes to produce a polymorphous set of possible strategies, strategies that are not united by a single method but which orbit around issues of cultural-environmental concern. It may adapt aspects of phenomenology or postcolonial theory, for example, but give them a new focus. What distinguishes ecocriticism, then, is an effort to reorient and expand cultural studies by emphasizing the particular ways in which human creativity—regardless of form (visual, verbal, aural) or time period (ancient, modern, postmodern)—unfolds within a specific environment or set of environments, whether urban, rural, or suburban.[6]

Outside the discipline of art history, where it remains largely unknown, ecocriticism has sparked a flurry of activities since the early 1990s, including new academic programs, professional organizations, journals, and monographic series published by university presses. In 1992, for example, a handful of literary scholars founded the Association for the Study of Literature and Environment (ASLE). Having since blossomed into a large organization with international affiliate chapters, ASLE now sponsors a wide-ranging program of conferences, events, discussion lists, and publications, including the journal *Interdisciplinary Studies in Literature and Environment,* or *ISLE.* Writing about these and other developments in 1999, Lawrence Buell, the Powell M. Cabot Professor of American Literature at Harvard University and a contributor to the present volume, described such activity as an "ecocritical insurgency."[7]

Despite its overall rebellious nature, ecocritical interpretation does to some extent respect disciplinary boundaries. Where art history is concerned, it entails a more probing and pointedly ethical integration of visual analysis, cultural interpretation, and environmental history than has so far existed in the field. As the following essays demonstrate, ecocritical work does not exclude the use of tried-and-true art historical approaches. In general, though, it pays sharper attention to the environmental embeddedness of art within a world that is both stubbornly real and infinitely vulnerable. Perhaps most importantly, ecocritical art history recognizes that this world is not exclusively the province of human beings.

Ecocritical art history therefore challenges what might be called the entrenched speciesism, or fundamental anthropocentrism, that has long governed this and other humanistic disciplines. The same impulse to displace anthropocentrism informs ecocritical work in literary studies and other fields. In lieu of a narrowly humanistic hermeneutics, ecocriticism brings a wider web of interpretive factors into play, fostering greater historical awareness of

environmental relationships, the predicament of the nonhuman, and the limits of human dominion over the world. Scholarly inquiry, by its very nature, retains an irreducible human dimension, but we believe that the essays collected in *A Keener Perception* exemplify a more self-critical and, at the same time, more generous approach to artistic creativity and the environments in which it has unfolded than traditional art history has provided.

~

To highlight the scope, challenges, and potential value of ecocritical studies in American art history, we have chosen to call this volume *A Keener Perception,* a phrase taken from Thomas Cole's "Essay on American Scenery" of 1835. For Cole, the celebrated founder of the Hudson River school of painting, "nature" was an "exhaustless mine from which the poet and the painter have brought such wondrous treasures—an unfailing fountain of intellectual enjoyment, where all may drink, and be awakened to a deeper feeling of the works of genius, and a keener perception of the beauty of our existence." Such perception, Cole thought, eluded "those whose days are all consumed in the low pursuits of avarice, or the gaudy frivolities of fashion, unobservant of nature's loveliness, . . . unconscious of the harmony of creation."[8]

Cole obviously viewed some of his contemporaries with condescension, but his "keener perception" cannot be reduced to mere snobbish social differentiation. More importantly for him, it entailed a metaphorical coupling of artistic imagination and environmental preservation, creating a bulwark against the destructive economic forces of his time:

> In this age, when a meagre utilitarianism seems ready to absorb every feeling and sentiment, and what is sometimes called improvement in its march makes us fear that the bright and tender flowers of the Imagination shall all be crushed beneath its iron tramp, it would be well to cultivate the oasis that yet remains to us, and thus preserve the germs of a future and a purer system. And now, when the sway of fashion is extending widely over society—poisoning the healthful streams of true refinement, and turning men from the love of simplicity and beauty to a senseless idolatry of their own follies—to lead them gently into the pleasant paths of Taste would be an object worthy of the highest efforts of genius and benevolence.[9]

As a native of Lancashire, England, who immigrated to America in his late teens, Cole had firsthand knowledge of modern industrialism and its propen-

sity for "poisoning the healthful streams" of both human imagination and the wider world. Thus he recognized a mutual relationship, even a formative interplay, between aesthetics and the environment without viewing them entirely as human fabrications or—to use more recent vocabulary—"texts," "simulacra," or cultural "constructions."[10]

Cole's reverence for the "harmony of creation" hearkened back to ancient notions of the pastoral, non-urban life. At the same time, he filtered such notions through other lenses: the Christian dissenting tradition of his British upbringing; his American Whig Party political and patronage affiliations; and eighteenth-century European concepts of the Beautiful, the Picturesque, and the Sublime—aesthetic categories that differentiated landscape according to degrees of compositional order and disorder, harmony and chaos. Working from within these inherited frameworks, Cole used his art to confront the challenges posed by modernization and technological change during the early nineteenth century. His call for "a keener perception of the beauty of our existence" indicates that he understood "nature" as not only a divine object to be contemplated by those with rarified taste but also something fragile, subject to transformation, and threatened by human action.[11]

But Cole was not an ecologist in the modern scientific sense of that term. For one thing, the term "ecology"—derived from the Greek words *oikos* (house, dwelling) and *logos* (knowledge or science)—was not even coined until 1866 by the German naturalist Ernst Haeckel. Unlike Haeckel, Cole (who died in 1848) did not rigorously study the complex, site-specific interrelationships among multitudes of species in organic life cycles. Cole was not a scientist. Recognizing this fact underscores the important historical distance between his romantic "keener perception" and either the modern environmental sciences or the ecological-political activism of our time.[12]

Haeckel's coinage of "ecology" hardly developed out of thin air in 1866, though. It built upon scientific research and cultural discourse long predating the 1860s. In 1749, for example, the world-renowned Swedish botanist Linnaeus (author of the widely influential *Systema Naturae*, 1735) published an essay titled "The Oeconomy of Nature," addressing interrelationships of life-forms and their active roles in maintaining what he perceived to be orderly, systematic cycles of growth and decay in particular geographic locales.[13]

Other important precursors for Haeckel were the early-nineteenth-century European biochemists Justus von Liebig (German) and Jean-Baptiste Dumas (French), who published scientific treatises that examined environmental interrelationships in detail for purposes of improving agriculture and food

supplies. Their work revealed startling connections between human and non-human life processes. The findings of Liebig and Dumas, together with research on physical geography and populations by contemporaries such as Alexander von Humboldt, Charles Lyell, and Thomas Malthus, illustrate the wide currency of interest in understanding human life within broader environmental contexts and forces during the period. Such research also informed the later writings of Charles Darwin, who in *Origin of Species* (1859) envisioned nature as a "tangled bank" of interdependent organisms, co-constituents of a "web of life." Darwin's assessment tapped a vein of inquiry going back decades and laid the groundwork for the twentieth-century concept of an "ecosystem."[14]

Cole's environmental sensibility evolved parallel to, but outside, the scientific tradition we have just described. From our twenty-first-century perspective, his outlook therefore may appear scientifically naive, quaintly earnest, idealistic, and even elitist. Moreover, his references to nature as an "exhaustless mine" full of "wondrous treasures" ironically (and unwittingly) seem entangled in the very forces of utilitarian development and environmental transformation that he wanted to critique. And yet, despite Cole's obvious historical distance from our twenty-first-century social views and global environmental problems, we find his predicament strangely resonant with our own. Some version of Cole's situation still vexes us today.

As Angela L. Miller argues in an essay for this volume, Cole's pictures embody the complex perspective articulated in his words. For example, *The Course of Empire* (1833–36) chafed against the dominant ideologies of American exceptionalism and utilitarianism during the expansionist presidency of Andrew Jackson. Widely considered Cole's masterpiece, it consists of a five-part painted allegory on the rise and fall of a hypothetical civilization. Beginning with the primordial *Savage State* and passing through phases of *The Arcadian or Pastoral State, Consummation, Destruction,* and *Desolation,* the series unfolds in a single fictive location, giving us an overview of dramatic transformations in human society and the environment over time. A tremendous mountain overlooks the scene from a distance, mirroring our position of detached observation and functioning as a talisman of environmental change. After its domestication with roadways and other human structures in the middle phase of *Consummation* (fig. 1), the mountain "witnesses" human civilization's undoing in *Destruction* and its ultimate reclamation by the environment in *Desolation.*

Cole's private letters indicate that he viewed *The Course of Empire* as an al-

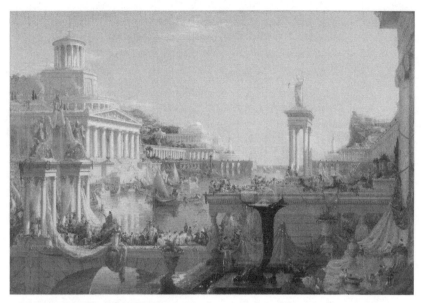

1. Thomas Cole, *The Course of Empire: The Consummation of Empire,* 1835–36. Oil on canvas. Collection of New-York Historical Society, negative number 1858.3.

legorical warning against the destructive social and environmental impacts of Jacksonian expansionism, which the artist associated with deforestation and "dollar-godded utilitarians." But the generic classical trappings of Cole's series only reminded contemporary observers of ancient Rome, not the United States. Moreover, some of the artist's prominent patrons—including Luman Reed, who commissioned *The Course of Empire*—were businessmen whose fortunes benefited in various ways from Jackson's policies, a fact that accentuates the contradictions of Cole's situation.

As a way of resituating Cole and his Hudson River school followers, Miller juxtaposes their work with the ideas of George Perkins Marsh, often regarded as America's first modern ecologist, who, in *Man and Nature* (1864), expressed his concerns about deforestation and other forms of environmental depredation without allegorical obliqueness. As a result of Miller's comparison, new parallels between art history and environmental history begin to emerge, along with thought-provoking questions such as: What *is* the relationship between art and the world? And, what limitations does aesthetics impose on environmental and political expression? Or, conversely, do the

aesthetic refractions of art also give us the freedom to imagine sustainable new worlds and futures?[15]

Understanding the struggles of artists such as Cole in all their contradictory richness instructs us to be savvier in our present cultural-environmental engagements. Cultivating such savviness is a crucial aim of ecocritical art history as we see it. By looking beyond binary abstractions such as nature/culture or pristine wilderness/concrete jungle, ecocritical art history warily avoids romantic pitfalls while registering a new sense of environmental breadth and ethics in interpretation. The point is not simply to explore complexity or contradiction for its own sake; rather, ecocritical art history attempts to sort through a given problem in order to articulate a more environmentally aware and responsive interpretation of the work of art, one thoroughly grounded in visual analysis and historical evidence while also capable of defamiliarizing the artist's product, enabling the viewer to adopt a fresh perspective.[16]

When he coined the term "defamiliarization" (*ostranenie* in Russian) in 1917, the Russian formalist literary critic Viktor Shklovsky defined it thus: "The purpose of art is to impart the sensation of things as they are perceived and not as they are known. The technique of art is to make objects 'unfamiliar,' to make forms difficult, to increase the difficulty and length of perception because the process of perception is an aesthetic end in itself and must be prolonged. Art is a way of experiencing the artfulness of an object; the object is not important." Modulating Shklovsky's formalist ideas somewhat, we would say that ecocriticism defamiliarizes both art and critique by making us see things anew—and perchance more ethically—in their relation to their environment.[17]

Ecocritical art history necessarily pays attention not only to overtly engaged or sympathetic forms of environmentalist expression but also to works apparently indifferent, or even hostile, to such concerns. We believe that every work of art has environmental significance and is therefore open to ecocritical inquiry, regardless of its specific ideological claims or orientation. As Lawrence Buell has observed in the context of literary studies, "Any serious reader knows that the kind of art, the kind of criticism, which takes the form of a waywardly insinuating thought experiment can be more instructive than the overtly polemical kind which 'has a palpable design on us,' as John Keats dismissively put it." And yet, Buell also points out that "the two modes also need each other, even as they pull against each other."[18] The essays in *A Keener Perception,* the rest of which we will now summarize briefly, gener-

ally embrace such a view and variously translate it into visual terms as a principle for interpretation in art history.

~

In the contribution that opens this volume, Timothy Sweet examines the Roanoke corpus, a body of English colonial images—watercolor drawings by John White and published reproductive engravings of same by Theodor de Bry—representing Virginia at the time of Sir Walter Ralegh's expedition to North America in 1585. Recent scholarship has tended to focus on how the corpus constructed Algonquian life and manners. But Sweet reminds us that the original purpose governing such representations was to provide "a compendium of political, economic, and environmental information." Despite the anthropocentric colonial aims of the Roanoke corpus, the ultimate value of these engravings for contemporary European viewers lay in picturing an environmental horizon that went far beyond the human figures. Combining economic considerations with aesthetic concerns, the Roanoke corpus leveraged the power of art to imagine the opportunities as well as the limits of economic growth. As Sweet sees it, despite important historical differences this remains a defining challenge and opportunity for our time, too.

Thomas Hallock's essay is similarly concerned with the visionary power art acquires when it seeks to understand unfamiliar environments. Hallock meditates on what he calls the process of "vivification" in drawings made by Philadelphia naturalist William Bartram during his travels through the Southeast in the 1770s. He notes Bartram's propensity for identifying morphological parallels between flora and fauna, as if this Enlightenment empiricist sought to reveal an underlying, unifying vitality in nature that not only encompassed him but demanded his emotive response through art. By using such an approach to capture a rich variety of local details in his drawings, Bartram did more than simply record an exact likeness of his specimen-objects. Rather, as Hallock observes, the artist-naturalist manifested an irrepressible "curiosity" about organisms and their environments, imbuing his drawings with a unique sense of life and place. This sense of vitality—merging aesthetic and environmental perception—gives Bartram's work a living quality of its own and has inspired many viewers over time to revisit the sites of his travels.

Christoph Irmscher discovers a similar dialectic of observation and invention in the work of Antoine Sonrel, a French-born scientific illustrator and photographer in the employ of the eminent Harvard naturalist Louis Agassiz. As Irmscher shows, the lithographs of "medusa" jellyfish that Sonrel pro-

duced for Agassiz's *Contributions to the Natural History of the United States of America* (1855–62) provocatively featured a world alien to the human observer, one that jeopardized human ordering systems, both scientific and artistic. Since medusae immediately lose their shape when out of the water, no observer could see the organism as it appeared in Sonrel's representation of the largest American specimen, the *Cyanea arctica*. By letting its lacy tentacles undulate beyond the inked border of the lithograph, Sonrel emphasized the medusa's status as a real creature, not just an illustrator's crazy dream. In Irmscher's ecocritical analysis, environmental fragility thus functions as a figure of epistemological challenge. Art historians have been reluctant to accept scientific illustrations as belonging to an artistic genre in its own right, but Sonrel's example demonstrates their profound implications as images inhabiting the boundaries of imagination and knowledge, art and science.

Elizabeth Hutchinson's essay begins where Sonrel's work ends, with the medium of photography, discussed here in relation to an important forest environment of the American West. Specifically, the author considers technical variations and the changing public reception of nineteenth-century photographs by Carleton Watkins that depicted California's "Mammoth Trees," the giant sequoias of Calaveras County. Focusing on Watkins's images of the oldest known sequoia, the "Grizzly Giant," and its devoted caretaker, Galen Clark, Hutchinson traces the transformation of that great tree from quasi-religious public icon to commodified tourist attraction over the period of a few decades. With close attention to the interplay of thematic content and photographic technique, Hutchinson reveals the power of art literally to frame environmental perception for the public in multiple ways, depending on variations of form and distribution. Her study also demonstrates the vagaries of public perception to be contingent upon larger historical factors, in this case tourism and advertising, that dramatically transformed the West as both image and environment after the Civil War.

In his essay, Alan C. Braddock investigates a neglected urban environmental reality—Philadelphia's late-nineteenth-century water pollution crisis—in order to offer a new reading of the celebrated outdoor pictures by Thomas Eakins, one of America's foremost realist painters. Previous scholarship on Eakins, including recent revisionist accounts, has consistently concentrated on human-centered themes: psychosexual conflict, public scandal, social constructions of masculinity, American nationalism, and so forth. Instead, Braddock holds the artist's iconic scenes of rowing, hunting, and swimming up to

the kind of scrutiny that only ecocriticism can provide. In doing so he considers the obvious but unexamined fact that Eakins—an artist widely regarded as an "empirical" realist—never chose to depict Philadelphia's rapidly growing industrial sector or associated pollution, even when these realities touched him personally. Reinterpreting Eakins's celebrated realism in the light of considerations about environmental justice, Braddock shows that the artist's white middle-class assumptions about racial difference and ecological conditions led him to offer subtly differentiated views of the city's outdoor spaces.

Shifting our attention to a different urban context and the twentieth century, Jeffrey Myers discusses the Harlem Renaissance mural paintings by Aaron Douglas of *Aspects of Negro Life*. According to Myers, these extraordinary works challenge the traditional view of African-American history, which has regarded rural and urban environments as mutually exclusive in an evolutionary tale of progress from plantation slavery to urban freedom. As Myers suggests, the stylistic and metaphorical interplay of realism and abstraction, trees and skyscrapers, in Douglas's murals implicitly criticize mainstream environmentalism's valorization of rural and "wilderness" space over urban space. In place of an abstract opposition between nature and culture, argues Myers, the artist told a subtler visual story of continuity and change in which African-American people have adapted to various—rather than antithetical—environments over time.

Mark Andrew White brings needed ecocritical attention to Alexandre Hogue, a neglected Texas regionalist painter whose works of the 1930s adapted Christian themes of sacrifice in raising national awareness about the Dust Bowl, an environmental and socioeconomic disaster aggravated by modern industrial agribusiness. White explains how Hogue cast the drought-stricken plains as a human body lacerated by tractors, monocropping, and erosion in a pictorial parallel of the literary, journalistic, and scientific critiques of land abuse written during the same period by contemporaries such as John Steinbeck, Archibald MacLeish, and Aldo Leopold. White does not overlook the catastrophic social and economic dimensions of the Dust Bowl crisis, but he shows that Hogue himself regarded them as embedded within a larger environmental horizon. The subsequent rise of modernist abstraction in America sent Hogue's reputation into art historical oblivion, but White's ecocritical interpretation gives us reason to reconsider both the painter and the orthodox modernist canons that banished him.

Jonathan Massey assesses the work of visionary modernist R. Buckminster

Fuller as an important twentieth-century precursor to today's rapidly grow-ing movement of sustainable design. Best known for inventing the geodesic dome, Fuller viewed buildings as "environmental valves" that should effi-ciently regulate the transmission of life-sustaining resources between human occupants and their environments, with far-reaching implications for both in-dividuals and the planet as a whole. Noting the eighteenth- and nineteenth-century intellectual roots of Fuller's ideas and designs, Massey interprets his career as a complex and deeply problematic exercise in "sumptuary ecology," whereby proper design was imagined as an efficient, equitable, and sustain-able distribution of resources through the elimination of waste and the eradi-cation of obsolete social hierarchies.

Rebecca Solnit's subtle reading of works by Eliot Porter challenges pre-vailing assumptions about "nature photography" as a merely reproductive genre of limited aesthetic or critical interest. Tracing Porter's career as a pho-tographer and environmental activist with the Sierra Club from the 1940s through the 1980s, she demonstrates how his various series featuring threat-ened and "wild" ecosystems dissolved boundaries between fine art and mass communication, realism and abstraction, politics and aesthetics. Although Porter clearly retained a romantic investment in notions of pristine wilder-ness, Solnit highlights his savvy environmental pragmatism, evident espe-cially in his deliberate selection of particular sites to depict and in his mar-keting of images through lavishly illustrated Sierra Club publications. Solnit usefully distinguishes Porter's innovative dye transfer color process and eco-logical attention to organic relationships from the earlier, more spectacular black-and-white works by Sierra Club conservationist and modernist hero Ansel Adams, and she productively compares Porter's rich colors and satu-rated pictorial compositions to the "all-over" drip paintings by Jackson Pol-lock, a contemporary abstract expressionist. Solnit thus does for Porter the artist something analogous to what Porter the environmentalist did for the ecosystems he photographed: she situates him within a web of interrelated historical events and actions.

Janet Catherine Berlo turns our attention to Native American art and is-sues of environmental justice in her poignant account of weavings by Alberta Thomas, a Navajo woman whose tribal community was devastated by can-cer related to industrial uranium mining on reservation lands. Berlo focuses upon one work by Thomas, *The Four Mountains of the Shootingway Chant* (1981), the composition and theme of which she relates to ancient Navajo sandpainting ceremonials dedicated to healing through a cosmic realignment

of human-environmental relations, or *hózhó*. While being careful not to over-read Thomas's work as an undisguised artistic expression of environmental outrage against corporate greed and negligence, Berlo nonetheless makes a convincing case for understanding the weaving as an unusually apt and timely embodiment of resilient Navajo traditions in their multiple intersections with, and productive responses to, the modern world. Such a reading acquires special relevance in view of the fact that Alberta's husband, Carl, at the time was one of the many Navajo uranium miners already afflicted with cancer.

In the final essay of this volume, Finis Dunaway offers a fresh perspective on the photographs taken by Subhankar Banerjee at the Arctic National Wildlife Refuge in Alaska. As Dunaway notes, viewers have typically regarded the Banerjee photographs as documents of a pristine wilderness inhabited solely by polar bears, caribou, and Native people—a distinctly American "last frontier" as yet unspoiled by modern economic development. In an interesting echo of nineteenth-century congressional uses of landscape art for promoting conservation (as in the case of Thomas Moran's *Grand Canyon of the Yellowstone* [1872], discussed in Angela Miller's essay), U.S. senator Barbara Boxer in 2003 referred to Banerjee's photograph and to a current exhibition of his work at the Smithsonian Institution as evidence of the need for continued environmental protection of the refuge. Dunaway makes a strong case for viewing the refuge as a global village of sorts, deserving protection not for its indigenous isolation but rather for its worldly diversity. How fitting, then, that the photographer responsible for capturing that diversity—Subhankar Banerjee, a Calcutta-born American immigrant—in his very person exemplifies global circulation and migration as well. The complexities of Banerjee's work point to the power of ecocritical art history to augment established forms of postcolonial critique by adding to them an important environmental dimension.

In the current age of globalization, an "ecocritical insurgency" in art history need not be limited to North American topics. For a couple of reasons, though, *A Keener Perception* takes U.S. culture as its focus. A practical one is that our project grew out of an American Studies Association (ASA) conference session on "The Environmental Imagination: Toward a Green History of American Art," organized by Alan C. Braddock in 2005. Another reason has to do with our desire to focus ecocritical attention on the United States as a nation traditionally wedded to the twin ideologies of exceptionalism and naturalism—the belief in America as "nature's nation" (as the intellectual

historian Perry Miller described it in 1967). Previous scholarship in art history has examined this historical configuration and related discourses, but almost exclusively from political and aesthetic perspectives that have tended to treat environmental questions as relatively minor concerns.[19]

Even with the American national focus, though, we hope that *A Keener Perception* will contribute to a more global rethinking of art history's horizon. We can easily imagine a host of future publications, conference sessions, doctoral dissertations, college courses, and even high school curricula dealing with all manner of global topics pertinent to a richly multivalent ecocritical art history. As it is, *A Keener Perception* already speaks to global concerns through essays on more local, specific subjects such as Elizabethan colonial prints by the Flemish engraver Theodor de Bry; scientific illustrations created by the French-American or French-born artist Sonrel for the Swiss-American naturalist Agassiz; Douglas's Harlem Renaissance murals evoking environments from West Africa to the American plantation south to New York City; and photographs of transcontinental migratory birds at the Arctic National Wildlife Refuge in Alaska, taken by Banerjee, an Indian American. Despite its overt focus on North America, such artistic and environmental diversity aptly captures the worldly scope of ecocritical art history. The interdisciplinary, intergenerational character of our roster of contributors also embodies ecocriticism's global propensity for crossing boundaries and forging new kinds of knowledge and community.

Even as a representation of American art history, our anthology necessarily leaves out much that seems important. But we hope that the following essays will inspire our readers in multiple disciplines to pursue future ecocritical work in a visual vein. To that end, we would like to suggest a few potential topics for research, chosen randomly from a host of possibilities: popular images of yellow fever epidemics and medical heroism from late-eighteenth-century Philadelphia to Cuba circa 1900; works and criticism of the "Ash Can School" or 1950s urban "junk" art, read closely in the light of twentieth-century discourse on pollution, cleanliness, and social disorder; the rise and environmental/health impacts of industrial chemicals in art supplies used by modern artists from the late nineteenth century to the present, highlighting notable artist deaths (including that of Beat sculptor Jay DeFeo, for example) as well as scientific toxicity research and efforts by art schools to control or eliminate such materials; the earthworks and land art of Robert Smithson, Michael Heizer, Richard Serra, and other artists for whom "environment" has signified material, perceptual, or historical space largely de-

void of ecological concerns; and the relative marginalization of environmental activist artists such as Alan Sonfist, Mel Chin, Mierle Laderman Ukeles, and Newton and Helen Mayer Harrison. A few studies have been done along these lines, but they remain isolated and sporadic, probably because art historians have until now generally perceived environmental issues to be less familiar or less conducive of grant support than research in the firmly established fields of identity politics and social history. In our view, endless opportunities for new ecocritical work beckon for scholars inclined to pursue them.

~

As a way of concluding this introduction, we would like to single out a pertinent nineteenth-century example—a foil to Thomas Cole—that underscores the potential of future ecocritical research in art history: John James Audubon, often (and misleadingly) hailed as the great inspiration behind one of the most successful environmental protection movements in American history, the Audubon Society. Though Audubon was perhaps not, as Robert Penn Warren has suggested, the "greatest slayer of birds who ever lived," he killed hundreds of birds, sometimes even in a single day. Yet modern biographers and art historians have reinvented him as a patron saint of conservation, constantly recycling a few excerpts from his writings in which he imagines an end to nature as we know it.[20]

A particular favorite of Audubon scholars is an entry from a diary Audubon kept during his 1826 stay in England, where he imagined himself talking to Walter Scott and inviting him to come to the United States in order to preserve, with his pen, American nature before it was too late and "Nature will have been robbed of her brilliant charms." Other familiar selections include a passage from Audubon's Labrador journal in which he feared that "Nature herself seems perishing" and a prose sketch titled "The Eggers of Labrador." The latter is especially revealing, since here Audubon's sympathy for the birds slain by poachers vied with a much more serious concern for himself as a bird collector: "Scarcely, in fact, could I procure a young Guillemot before the eggers left the coast."[21]

While we understand the desire to "modernize" Audubon, we also believe that history is more interesting when it is not told as a thinly veiled version of ourselves. Warren got it right: Audubon was first and foremost an artist (and a terrific writer), and a greedy one, too. For him America was still the land of plenty, a paradise from which humans were not likely to be expelled. Audubon knew very well that hunters destroyed millions of bobolinks each year;

not to worry, he told his reader, millions yet remained. Consider the following from a letter Audubon wrote on November 12, 1843, shortly after he had come back from his western journey, his last great expedition: "I have no less than 14 New Species of Birds . . . first rate skins in pickle of the Buffalo Bull, Cow, and Calves—Elks, Big horns Antelopes . . . a fine Grisley Bear."[22]

From our perspective, those who passed the first game laws in various states during the 1830s and 1840s showed more ecological awareness than Audubon ever did. Nevertheless, modern historians have tended to exaggerate his temporary flashes of insight because he was, well, Audubon. America—still in search of the laughter that the Puritans forgot, as Oliver Wendell Holmes once said—loves a good conversion story. Yet as much as we would like to believe that Audubon had seen the light, that he transformed himself from a methodical mass killer of birds to a nineteenth-century version of Saint Francis, communing harmoniously with the bird world, the historical evidence will not allow us to come to that conclusion. Nor was he an exemplary American in any narrow, nationalistic sense. Rather, this Haitian-born nomadic son of a French merchant was a multilingual, multinational multitalent. Just as an artist need not have been a flag-waving patriot to teach us about the complexities of life in nineteenth-century America, he or she does not have to be treated anachronistically as a dyed-in-the-wool environmentalist to merit inquiry from an ecocritical perspective.[23]

It is in Audubon's art, a place where humans rarely appear, that American birds emerge in their full otherness, taunting the human observer's limited understanding and commenting, if only obliquely, on the quixotic attempt to re-create them "as if full of Life."[24] Because full of life they are *not,* and, as if to drive home this point, Audubon, a kind of lethal father figure to the birds he can "conserve" only in his art, features many of them involved in complex reenactments of scenes of slaughter, as victims as well as perpetrators, an indirect reflection of the very drama that has brought them to the gigantic, "double-elephant"-sized sheet of paper (27.5 inches wide and 39.5 inches tall) that is now before us. Any Audubon composition can teach us more than a Peterson field guide about the problems that derive from attempting to see nature "humanly," as it were.

In his well-known watercolor of the bald eagle (plate 31 from his magnum opus, *The Birds of America*) (fig. 2), painted in 1828 in England, Audubon uses a simple trick to provide the viewer with a representation of the birds that is much more dynamic than previous images by his predecessors such as Mark Catesby (1683–1749) or Alexander Wilson (1766–1813).

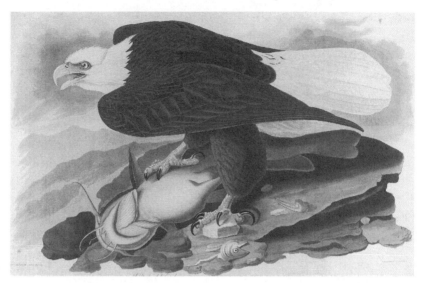

2. John James Audubon, *White-headed Eagle,* 1828. Hand-colored lithograph published in Audubon, *The Birds of America* (London, 1827–38), plate 31. Courtesy, The Lilly Library, Indiana University, Bloomington.

Whereas in Wilson's representation of the bird in *American Ornithology* (1808–14), the dominant horizontal formed by the eagle's strong body is replicated in the horizontal body of the dead fish the eagle has caught, Audubon tilts and turns the body of the eagle's prey, a catfish, presenting to the viewer the fish with its white, pristine belly up, head curved downward. There is no blood, at least not yet, although the exposure of the fish's belly, its most vulnerable side, along with the eagle's ferocious talons and open beak, makes us, the viewers, anticipate the violation that seems imminent. The catfish's body is slack, limp, soft, while the eagle's is muscular, hard, concentrated, every feather expressing its fierce determination. High in the mountains, where there is neither water nor any other trace of life, the catfish is out of its element, to be sure. The fact that it is still so intact makes Audubon's image seem even odder. This is a scene from a different world made newly accessible through art, a world "other" than that known and experienced by the human viewer.

Just a few weeks prior to our writing this introduction, the bald eagle was taken off the list of endangered species in the United States, which was good news not so much for the conservationists (who fear that this will mean open

season for the destruction of the eagle's habitats) but for property developers. "Bald Eagles don't pay taxes; I pay taxes," declared Edmund Contoski of Lake Sullivan, Minnesota, who had successfully sued the U.S. Department of Fisheries and Wildlife in order to get the bird "delisted." Contoski will now be able to build cabins on his lakeside property, which happens to be close to the nest of a pair of bald eagles. It is anyone's guess who will move first—Contoski's tourists or the birds. Audubon's painting, read from an ecocritical perspective, uncovers the fallacy behind Contoski's argument, which assumes that the same criteria can and should be applied to humans and animals, with the assumption that humans will always prevail. The Department of Fisheries and Wildlife defines sustainability by numbers; from their perspective, 1,312 breeding pairs of eagles in Minnesota are enough to stop worrying about their habitats, regardless of the environmental costs. According to their neo-Darwinist free market ideology, human beings will rightfully prevail as the fitter species, come what may to the rest of the planet's inhabitants.[25]

An ecocritical perspective, whether applied to nineteenth-century paintings by Audubon or current environmental policies, relentlessly exposes such false assumptions for what they are while pointing the way to a more sustainable future. In our opinion, the "ecocritical" Audubon—or de Bry, or Bartram, or Cole, or Sonrel, or Watkins, or Eakins, or Hogue, or Douglas, or Fuller, or Porter, or Thomas, or Banerjee—reminds us of the limitations of the human point of view and the dangers of entrenched anthropocentrism. More than simply a negative discourse of limitations, however, ecocriticism presents unexpected opportunities to us as scholars and citizens of the world. With all of this in mind, *A Keener Perception* seeks to promote a new environmental discourse at the disciplinary intersection of art history and a growing body of ecocritical scholarship already in progress elsewhere.

Notes

1. Intergovernmental Panel on Climate Change (IPCC), *Climate Change 2007: Impacts, Adaptation and Vulnerability. Working Group II Contribution to the Intergovernmental Panel on Climate Change Fourth Assessment Report, Summary for Policymakers* (http://www.ipcc.ch/SPM13apr07.pdf) (Geneva: IPCC Secretariat, 2007), 1–3. For an example of news coverage about the *Fourth Assessment Report* see James Kanter and Andrew C. Revkin, "Scientists Detail Climate Changes, Poles to Tropics," *New York Times,* April 7, 2007, A1.

2. IPCC, *Fourth Assessment Report,* 5, 7.

3. Ibid., 6.

4. Ibid., 8–22.

5. Ibid., 17, 19. On the "tipping point" hypothesis, see, for example, Jeffrey Kluger, "Global Warming Heats Up," *Time,* March 26, 2006; Julie Eilperin, "Debate on Climate Shifts to Issue of Irreparable Change: Some Experts on Global Warming Foresee 'Tipping Point' When It Is Too Late to Act," *Washington Post,* January 29, 2006, A1. For historical background on American scientific awareness of global warming and efforts to alert policymakers see James Gustave Speth, *Red Sky at Morning: America and the Crisis of the Global Environment* (New Haven: Yale University Press, 2004), 1–9.

6. For an excellent introduction to ecocriticism in literary studies see Lawrence Buell, *The Future of Environmental Criticism: Environmental Crisis and Literary Imagination* (Malden, Mass.: Blackwell, 2005). Buell acknowledges that ecocriticism has "been influenced by French phenomenologists Gaston Bachelard and especially Maurice Merleau-Ponty" (as well as by Martin Heidegger and Arne Naess) but points out that they all "focus on life as experienced by prototypical humans rather than on environmental history of natural processes or social struggle" (101–2). On a newer strain of "ecophenomenology" in philosophy see the articles by Edward S. Casey, David Wood, and others in a special volume of the journal *Research in Phenomenology* 31 (2001). In subtitling the present book we chose the term "ecocritical" instead of "environmental" to avoid confusion with phenomenological interpretations of Earthworks and other so-called environmental art since the 1960s. Such interpretations remain largely anthropocentric in the sense noted by Buell and have yet to engage the sort of ethical or historical considerations we have in mind.

7. For ASLE and *ISLE* see, respectively, http://www.asle.umn.edu and http://www.unr.edu/cla/engl/isle. Lawrence Buell, "The Ecocritical Insurgency," *New Literary History* 30, no. 3 (1999): 699–712. For an example of an ecocritical book series see Under the Sign of Nature: Explorations in Ecocriticism, published by the University Press of Virginia (http://www.upress.virginia.edu/browse/series/ecocrit.html). The only major example of ecocritical art history to date is Greg Thomas, *Art and Ecology in Nineteenth-Century France: The Landscapes of Théodore Rousseau* (Princeton: Princeton University Press, 2000), which focuses on one French artist of the Barbizon school. A special issue on "Art and Ecology," *Art Journal* 51, no. 2 (1992), is devoted exclusively to contemporary art.

8. Thomas Cole, "Essay on American Scenery" (1835), reprinted in *American Art, 1700–1960: Sources and Documents,* ed. John W. McCoubrey (Englewood Cliffs, N.J.: Prentice-Hall, 1965), 99.

9. Ibid., 100–101.

10. In a well-known statement that became emblematic of postmodern theory generally, the French philosopher of deconstruction Jacques Derrida once declared, "Il n'y a pas de hors-texte" (There is nothing outside [or no outside] of the text); *Of Grammatology*, trans. Gayatri Chakravorty Spivak (Baltimore: Johns Hopkins University Press, 1976), 158.

11. On Cole's background, the pastoral, and eighteenth-century aesthetics see Andrew Wilton and Tim Barringer, *American Sublime: Landscape Painting in the United States 1820–1880* (Princeton: Princeton University Press, 2002), 10–65; William H. Truettner and Alan Wallach, eds., *Thomas Cole: Landscape into History* (New Haven: Yale University Press; Washington, D.C.: National Museum of American Art, 1994), 1–31, 70–95.

12. Haeckel's first reference to "ecology" occurs in his *Generelle Morphologie der Organismen* (Berlin: G. Reimer, 1866); see Robert C. Stauffer, "Haeckel, Darwin, and Ecology," *Quarterly Review of Biology* 32, no. 2 (1957): 138–44.

13. On Linnaeus and the roots of "ecology," see Donald Worster, *Nature's Economy: A History of Ecological Ideas,* 2nd ed. (Cambridge: Cambridge University Press, 1994), esp. 31–38, 138–43, 192.

14. On Liebig, Dumas, and the emergence of "ecology" and "ecosystem" as environmental terms see Thomas, *Art and Ecology in Nineteenth-Century France,* 5–8. Regarding Darwin's "web of life," see Robert C. Stauffer, "Ecology in the Long Manuscript Version of Darwin's *Origin of Species* and Linnaeus' 'Oeconomy of Nature,'" *Proceedings of the American Philosophical Society* 104, no. 2 (1960): 235–41.

15. George Perkins Marsh, *Man and Nature; or, Physical Geography as Modified by Human Action* (New York: Scribner, 1864), ed. David Lowenthal, with a foreword by William Cronon (Seattle: University of Washington Press, 2004). See also David Lowenthal, *George Perkins Marsh: Prophet of Conservation* (Seattle: University of Washington Press, 2000).

16. For an important critique of "wilderness" as pristine, uninhabited blankness see William Cronon, "The Trouble with Wilderness; or, Getting Back to the Wrong Nature," in *Uncommon Ground: Toward Reinventing Nature,* ed. Cronon (New York: Norton, 1995), 69–90.

17. Victor Shklovsky, "Art as Technique" (1917), republished in *Russian Formalist Criticism: Four Essays,* ed. Lee T. Lemon and Marion J. Reis (Lincoln: University of Nebraska Press, 1965), 12.

18. Buell, *The Future of Environmental Criticism,* vii.

19. Perry Miller, *Nature's Nation* (Cambridge, Mass.: Belknap Press, 1967). Passages of environmentally sensitive analysis do appear in studies by historians of American art such as Elizabeth Johns, Nancy Anderson, Alan Wallach, Joni Kinsey, and a few others. See Alan Wallach, "Thomas Cole's *River in the Catskills* as

Antipastoral," *Art Bulletin* 84, no. 2 (2002): 334–50; Nancy Anderson, Thomas P. Bruhn, and Joni Kinsey, *Thomas Moran* (Washington, D.C.: National Gallery of Art; New Haven: Yale University Press, 1997); Elizabeth Johns, "Settlement and Development: Claiming the West," and Nancy K. Anderson, " 'The Kiss of Enterprise': The Western Landscape as Symbol and Resource," in *The West as America: Reinterpreting Images of the Frontier, 1820–1920,* ed. William H. Truettner (Washington, D.C.: Published for the National Museum of American Art by the Smithsonian Institution Press, 1991), 191–235, 237–83.

20. Floyd Watkins and others, eds., *Talking with Robert Penn Warren* (Athens: University of Georgia Press, 1990), 244. Recent examples in the hagiographic mode include Richard Rhodes, *John James Audubon: The Making of an American* (New York: Random, 2004), and the 2007 installment of the annual exhibit "Audubon's Aviary" (devoted to "Natural Selection") at the New-York Historical Society, which included an entire wall panel on the "Ecological Audubon."

21. John James Audubon, *Writings and Drawings,* ed. Christoph Irmscher (New York: Library of America, 1999), 186–87; *Audubon and His Journals,* ed. Maria R. Audubon, 2 vols. (1897; reprint, New York: Dover, 1986), 1:407, 2:406–11.

22. John James Audubon, *The Birds of America, from Drawings Made in the United States and Their Territories,* 7 vols. (New York: J. J. Audubon, 1840–44), 4:13; Audubon, *Writings and Drawings,* 857.

23. Peter Matthiessen, *Wildlife in America* (New York: Penguin, 1987), 157–58; Oliver Wendell Holmes, "At the Saturday Club," *The Poetical Works of Oliver Wendell Holmes,* 2 vols. (Cambridge, Mass.: Houghton, Mifflin, 1892), 2:267.

24. Audubon, "My Style of Drawing Birds," *Writings and Drawings,* 761.

25. Peggy Mihelich, "Bald Eagle Soaring 'Success,' But at What Cost?" Cnn .com, June 9, 2007, http://www.cnn.com/2007/TECH/science/06/07/bald.eagle .delisting/index.html.

I

Filling the Field

The Roanoke Images of John White and Theodor de Bry

Timothy Sweet

John White's watercolor drawings from the 1585 Roanoke voyage and the engravings made from them to illustrate Theodor de Bry's edition of Thomas Hariot's *A briefe and true report of the new found land of Virginia,* generally referred to as de Bry's *America,* volume 1 (1590), have been widely praised for their "outstanding documentary quality." The Roanoke corpus consists of several genres: map, natural history illustration, genre scene, landscape, town view, and portraiture. Most critical attention to date has focused on the portraits of the Carolina Algonquians. In the original context of production and reception, however, the human figures in themselves were not necessarily the most important features of the Roanoke corpus; rather, they were one aspect of a compendium of political, economic, and environmental information. An ecocritical reading, particularly one inflected with economic concerns, can recover this original context by asking questions about land use, resources, and environmental carrying capacities. In such questions—which urgently preoccupy us today—historicist and ecocritical approaches converge.[1]

The Roanoke corpus projected onto the New World a tension between a fantasy of harmony with nature and an imperative to transform or "improve" nature. The encounter of this tension, central to the Tudor cultural imaginary, with the material reality of Roanoke brought forth new combinations of artistic practices in the composite art of the survey, which rendered the space of representation, like the land itself, as a field to be filled. In filling the field, the art of the survey engaged the problem of "adequation." The latter term, which Lawrence Buell has adapted from the writings of Francis Ponge, identifies the dual accountability of any environmental representation to both mental-cultural schemata invented by human beings (for example, artistic

genre conventions) and the external object-world. In the Roanoke corpus and similar promotional works, that meant that survey artists had to deliver accurate descriptions of nonhuman nature and indigenous human culture in the New World. Not knowing in advance what parts of that environment might be turned to productive use, such artists approached their task in a relatively descriptive, or realistic, manner. At the same time, they needed to render that environment comprehensible to their English audience by using familiar representational conventions that were rhetorically effective in persuading prospective investors and colonists.[2]

Among the various cultural schemata involved in the interplay of adequation, two are of particular interest here. One is the cartographic convention of "garnishing" maps, or representing by means of icons the location of something such as a town, a wood, a range of hills, a species of plant or animal. The other is the convention of doubling in figure drawing, a formal resolution of the tension between the desire for a complete view of the whole figure and the assumption that the view is taken from one position at one moment in time. In the context of colonialism, garnishing and doubling acquired new empirical authority as forms of naturalistic representation. That is, in the absence of other imagery depicting the same subject, they functioned as unassailably accurate visual records of the Virginia environment. As a result, their visual operations of filling the field both affirmed the New World's supposed natural productivity and followed improvement's imperative of intensification, whereby labor transformed void or vacant space into culturally productive space, providing a political rationale for this transformation. Conceptualizing the visual domain as a field to be filled with information in turn invited and directed the material analogue of this visual operation: the filling of actual fields in the New World through the material practices of colonization.

∽

The ecology of the Roanoke corpus—the images' representation of the place of human life within the surrounding environment—exhibits a tension that has long been central to Euro-American culture: a tension between, on the one hand, an imagined harmony with nature and, on the other, a recognition of the need to transform nature in order to produce culture. In Tudor England, the transformation of nature was articulated specifically in terms of new practices of economic intensification or "improvement." To put it in terms most familiar to sixteenth-century colonialists, this tension encapsulated the difference between the states of humankind before and after the biblical Fall of Adam and Eve in Eden. Indeed, the de Bry edition of Hariot's

Report opened with that very narrative episode. In the frontispiece engraving, which clearly does not derive from any of White's drawings, Eve plucks the apple and Adam's agonized expression indicates that he foresees the consequences of eating. Meanwhile, background vignettes depict some of those consequences: a mother and child indicating the curse of pain in childbirth, a man tilling a field enacting the curse of labor. The scene's historicizing reminder still resonates today, for even if we no longer unanimously embrace the story of the Fall, we often experience a version of its emotional and environmental import in the form of alienation from nature.[3]

The fantasy of prelapsarian harmony was culturally powerful, coloring Arthur Barlowe's report on the first reconnoitering voyage to Virginia made for Sir Walter Ralegh in 1584, for example. Barlowe claimed that the indigenous peoples were "such as lived after the manner of the golden age. The earth bringeth foorth all things in aboundance, as in the first creation, without toile or labour." Other early reports echoed this optimism. Hariot, whose account of Carolina Algonquian culture was drawn from a year's residence at Roanoke, claimed that they were "free from all care of heapynge opp Riches for their posterite, content with their state, and liuinge frendlye together of those thinges which god in his bountye hath giuen vnto them." Hariot imagined that the environment's natural "bountye" enabled and supported—possibly even produced—the Algonquians' apparent cultural predisposition against the accumulation of property: they could afford to be careless of the future. To some extent, fantasies of this sort may have expressed English ruling-class worries about the laboring classes' supposed propensity to idleness. Colonial promoters such as the younger Richard Hakluyt, who was instrumental in the conception of the de Bry volume, thus proposed a regime of improvement, theorizing that the New World would provide a field for labor that could be directed to the production of import commodities to enrich England's economy while providing a market for England's manufactures, especially wool cloth. Developing a systematic theory of the relation of economy to environment, the promoters argued that the New World could function as a source of input and output capacities that could reverse England's economic entropy.[4]

Tensions between the fantasy of natural abundance and the imperative of improvement thus shaped the politics of colonization. English theories of colonization as early as Thomas More's *Utopia* (1516) had held that any "waste"—void or vacant land—could legitimately be appropriated for production. Promoters had an interest in representing the New World as un-

cultivated or undercultivated, but also as potentially productive. Although they saw that the Native Americans farmed the land, visions of natural abundance sometimes blinded them to the extent of indigenous labor and land-management techniques. The English, therefore, could attribute sufficiency to the spontaneous bounty of the natural environment itself rather than to productive labor. This understanding of the land shaped the entire Roanoke corpus, especially the portraits with background landscapes showing an abundance of fish or game.[5]

On the other hand, promoters had to persuade investors and colonists that such "wastes" could be productive—that is, could be "improved"—so they had to adduce evidence of productivity and of a capacity to support intensified economic engagements beyond mere sufficiency. In such cases, promoters did recognize indigenous labor and environmental management. De Bry, for example, provided evidence of industry and agriculture in a georgic sequence of plates depicting several modes of labor, including the manufacture of a dugout canoe, the use of the canoe in fishing, the broiling of fish, the boiling of corn, and finally "Their sitting at meate" enjoying the fruits of their labors. The promoters needed to show the New World environment as both empty and full: empty of prior economic engagements that would question the legitimacy of colonial appropriation, yet bearing evidence that the land could be ordered and made productive over and above what the English regarded as subsistence. They needed to derive both points from their understanding of the relation of Carolina Algonquian culture to the environment.[6]

In a short promotional tract written for Ralegh's Virginia project in 1584, Richard Hakluyt the elder advised that "a skillful painter is to be carried with you which the Spaniards used commonly in all their discoveries to bring the descriptions of all beasts, birds, fishes, trees, townes, etc." Such a painter was found in John White. Unfortunately, no more detailed instructions for White have survived among the Roanoke documents. However, White's instructions would likely have been similar to those written for a voyage planned by Sir Humphrey Gilbert for 1582. Although this expedition never sailed, the instructions to its artist, surveyor, and cartographer, Thomas Bavin, have survived. These instructions suggest how the cartographic convention of garnishing may have shaped the Roanoke voyagers' understanding of the Virginia environment. Among other points regarding the production of maps, natural history illustrations, and so on, Bavin was directed to:

drawe to lief one of each kinde of thing that is strange to us in England by the which he may alweis *garnishe his plott* as he shall so course upon his returne. As by the portraiture of one Cedar Tree he may drawe all the woodes of that sorte and as in this so may he doe the like in all things ells. . . . And lett Bavin in his plottes use severall marckes for severall thinges to be sett downe without alteration, as one for Woodes, another for hills, Another for Rockes, another for shelfes, another for the Cannell of a Ryver not altering his marckes untill he shall perfectly fynishe his whole discovery. . . . Also sett downe in your plottes the dyvers sorts of Trees in eache of their particuler places be yt in woodes or otherwise dispersed naming the woodes by those kinde of Trees that shall most growe there.[7]

The instructions for Bavin were exhaustive and even redundant, indicating that the expedition's managers and investors wanted to know everything. They directed the artist to record "any thing worth the noting either like our thinges in Europe or differing from them in any manner of way." Counter to this totalizing directive, however, was a reductive impulse to sort the array according to some criteria of importance, things "worth the noting," as indicated in the "garnishing" of the plots with icons. Context thus called forth varying levels of specificity in the practice of garnishing. For purposes of orientation and navigation, all woods, no matter what their composition, could be noted by one kind of mark—a generalized tree—repeated consistently from plot to plot, indicating the species that "most growe there." Other contexts, such as the projection of timber production, might require distinguishing particular species (cedar, for example), although the scale of the plot could still dictate visual conflation of mixed woods through a single icon.[8]

This practice of garnishing the plot in accordance with scale and purpose constituted a fundamental representational strategy in the Roanoke corpus. Such conceptualization of the visual field brings to mind characteristics of seventeenth-century Dutch art, as discussed by the art historian Svetlana Alpers. According to Alpers, cartographic description was closely related to other forms of artistic representation in Holland and northern Europe during the period. Although the traditions of mapping and picturing would eventually diverge in the general cultural separation of science from art, in the late sixteenth century they were still conjoined components of a comprehensive approach to the visual field. The point here is not to explore specific

Dutch influences upon White and de Bry (though there were connections) but rather to identify the broad visual orientation of their colonial images. Not unlike contemporary maps, White's drawings and de Bry's engravings served as powerful tools of colonization. As tools, they needed to suit the particular mode of colonization in question. The English mode (as distinct from the Spanish or Portuguese) envisioned the full appropriation of productive resources. It also presumed the use of English rather than indigenous labor to improve those resources.[9]

Pictorial garnishing thus modeled the interplay of representational conventions, colonial imperatives, and environmental realities in a manner that demonstrates the problem of adequation. In the Roanoke corpus, such interplay appears clearly in a specific series of images that offer progressively closer views, zooming in, as it were, from aerial map to landscape. The series in question begins with an overview of coastal Carolina and culminates in relatively detailed renderings of two towns, Pomeiooc and Secoton. This trajectory displays steps in the transformation from iconic to naturalistic representation driven by the overall demand to fill the visual field. The long view evident in the initial map images indicates that the New World contained plenty of wasteland. As we focus telescopically from map to landscape and then town view, the field increasingly fills with evidence of human management. The land's capacity for improvement—its amenability to transformation through the use of familiar English production techniques—thus accorded with the pictorial field's susceptibility to familiar iconic representation. In other words, pictorial representation and colonial development followed one another hand-in-hand, rendering the land's independent qualities of fertility and "aboundance" increasingly familiar, along with the artistic devices for depicting such qualities.[10]

Presumably with Hariot's aid, White drew a coastal map showing some navigational data marking shallows in sounds and inlets as well as locations of several Algonquian towns. It also features additional garnishes, consisting of icons for ships and canoes. The latter provide less information than we might expect, given the contemporary instructions for Bavin. Other copies of the map, since lost, perhaps included greater detail, of the sort that appears in the first de Bry plate, depicting "The carte of all the coast of Virginia." Where White had indicated the Algonquian towns with red or brown dots, the de Bry engraving used a ring of short, vertical lines to indicate a palisade. This icon marks all towns as impaled, though some in fact were open; neither had White's notation marked the difference between impaled and

open towns. The de Bry map is garnished with icons of trees at fairly regular intervals where White's map remains blank. These icons are all of similar shape and size, evidently indicating a large deciduous species, except at the southern and western margins, where they are replaced by icons of a different shape, possibly indicating conifers.[11]

The extension of the de Bry map inland beyond the margin of White's map, moreover, invites a fairly thick representation of topography—the piedmont is suggested by icons of wooded hills ascending from the coastal plain—though on this scale the vegetation remains relatively undifferentiated. During this era, cartographic practice was beginning to remove human figures from the land and relegate them to the margins of maps, abstracting people from their environmental context to subject them to grids of political, economic, and ethnographic classification. In contrast to this practice, the de Bry map iconographically places the Algonquians on the land itself (though not necessarily always to scale): the figures of Algonquians garnish all the landscapes. Classificatory work is, of course, done by White's portraits. Yet, the maps and landscapes, by means of these icons, recognize the grounding of indigenous culture in the environment and thus imply that colonization would amount to English substitution for the Algonquians.[12]

In the next plate of de Bry's volume, "The arriual of the Englishemen in Virginia," an enlargement of about four times (compared to the previous map) allows for greater detail and a quasi-naturalistic view begins to emerge (fig. 3). Notable here are icons of cornfields outside the towns, a feature absent from the larger map. Each town has three neat, identical fields ranged at regular intervals around one side of its palings, as if such an arrangement were typical of all towns. The crop could easily be taken for wheat. This rendering of indigenous agriculture in terms of a familiar English pattern persists through the series. The scale here invites differentiation of the tree icons (there are at least five distinct shapes of tree) and the addition of other vegetation icons, such as a pair of grapevines as large as the largest tree. The disproportional size of the vines arguably projects a particular mode of development: promoters hoped to establish both wine and raisin production to replace imports from Spain, Portugal, and France. Yet, other garnished features—palisades, canoes bearing pairs of Algonquians, even a fish weir, as well as English ships—are out of scale with the land and with each other.

The background of a later plate, "An ageed manne in his Winter garment" (fig. 4), gives an even closer view: the icons are now enlarged and scaled naturalistically relative to each other and to the land, while still retaining their fa-

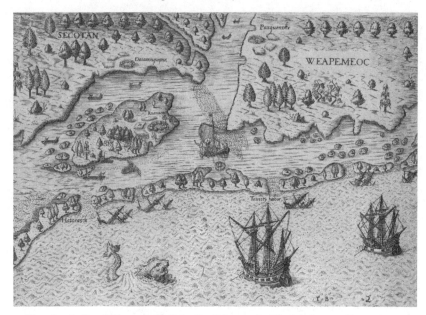

3. Theodor de Bry, "The arriual of the Englishemen in Virginia," 1590. Engraving published in Thomas Hariot, *A briefe and true report of the new found land of Virginia* (Frankfurt, 1590), vol. 1, plate 2. By permission of Houghton Library, Harvard University, Cambridge, Massachusetts.

miliar iconic shapes. The margins of the crop fields still follow the circular shape of the palisade, although the disposition of the several fields differs: here there are two rather than three equal-sized plots, now ranged on opposite sides of the town. Individual trees, scaled proportionally to the height of the crop, are ordered so as to define a woods; however, they are still iconic in their very regular spacing. Buildings, absent from within the palisades on the maps and mere marks on the previous image, are here rendered in enough detail to discern the bark facing. As we will see momentarily, the two town views of Pomeiooc and Secoton continue this general pattern, adding detail as the scale demands.

The Roanoke images thus hold in tension the colonial imperatives of land-as-waste-and-abundance (woods, deer, fish) and land-as-capacity-for-improvement (towns, grain, grapes). At any point on the continuum from map to landscape, the convention of garnishing prescribes filling the visual field according to the demands of scale. The comparative absence of detail in White's map of coastal Carolina and drawing of Pomeiooc derives from the

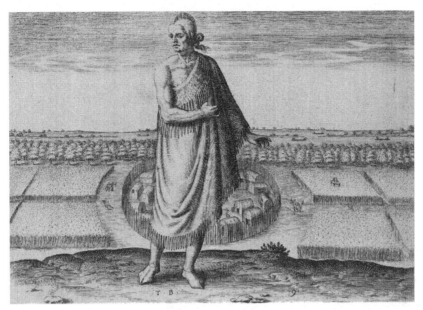

4. Theodor de Bry, "An aged manne in his Winter garment," 1590. Engraving after original watercolor by John White, published in Thomas Hariot, *A briefe and true report of the new found land of Virginia* (Frankfurt, 1590), vol. 1, plate 9. By permission of Houghton Library, Harvard University, Cambridge, Massachusetts.

watercolors' status as sketches: they are elements from which composite views could be built up, as was done by de Bry. In this sense, all of White's sketches are like his natural history illustrations: like a pineapple, tern, or grouper rendered in itself, extracted from environmental context. The ethnographic portraits follow the same logic. Thus de Bry put White's "aged manne in his Winter garment," a figure against a blank ground, into a quasi-naturalistic landscape view.[13]

The relation of figure to ground in the de Bry portraits further reveals a concern for the structure of labor by means of which the environment would be transformed to produce culture. The subjects of the portraits (nine of the twenty-three plates in the volume) are identified according to European notions of political hierarchy, from "A werowan or great Lorde of Virginia" through lesser nobles and "Religious men" to commoners such as "An aged manne in his winter garment" (see fig. 4) and the ambiguous "Coniuerer," or conjurer. Whereas White's portraits contained no backgrounds, de Bry's portraits always posed their figures against detailed landscapes, which provided

basic information about the nature of the environment and the Algonquians' engagement with it. Subordination of ground to figure in early modern English portraiture allegorized the feudal relationship between country estate and aristocratic owner. The same compositional convention governed the portrait of the "werowan," for example. Not unlike his English counterpart, this Algonquian "Lorde of Virginia" suggested landed privilege, as indicated by his bow and the background hunting scenes. Even as it honored the Native aristocracy, such an allegory implicitly defined the political project of colonization as the replacement of Algonquian with English "Lordes."[14]

And yet, the relation of figure to ground in Virginia was more complicated than this. For example, since the conjurer's magic assisted with hunting, he too was posed against a background of hunting scenes, despite his otherwise humble, non-aristocratic bearing. Thus the logic of replacement implicitly extended from lords on down the social hierarchy of labor. The figure of "An ageed manne," presumably perceived by the English as a commoner, similarly stands against an agrarian landscape that he was imagined to have worked throughout his life (see fig. 4). Colonization would supplant his relation to the ground as well—the relation of labor. Underlying any allegory of figure to ground, in other words, was a more basic assumption evident in the compositional form of the de Bry plates. Regardless of local political relations, the plates illustrated an artistic imperative to fill the (visual) field with descriptive information about the environment that supported Carolina Algonquian culture. Mirroring that artistic imperative was an economic one central to the English project of colonization: the need to fill the (material) field.[15]

Such an imperative found its fullest realization in images that integrated figures into elaborate naturalistic scenes, as in the de Bry engraving of "Their manner of fyshynge in Virginia" (fig. 5). The fishing scene is formally interesting because it is the only extant image in White's hand in which a figure is doubled. In the manner of garnishing, the convention of doubling operates on a continuum from notational to naturalistic representation. More than does garnishing, however, doubling intensifies an object's presence. In the fishing scene, everything contributes to a sense of abundance. Fish are rendered iconically, seemingly above the surface of the water, two or more icons standing for each of at least five species (not to mention other marine fauna in the foreground). The weir in the middle ground is full, and the foreground canoe is filled with fish nearly to the gunwales. Note that this abundance of fish supports the labor of a large number of men, who are shown in four

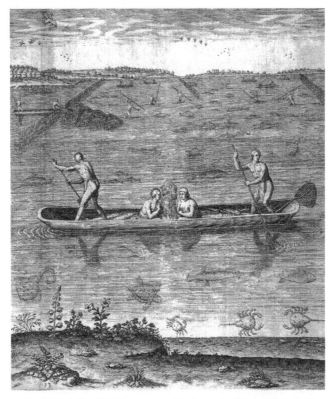

5. Theodor de Bry, "Their manner of fishynge in Virginia," 1590. Engraving after original watercolor by John White, published in Thomas Hariot, *A briefe and true report of the new found land of Virginia* (Frankfurt, 1590), vol. 1, plate 13. By permission of Houghton Library, Harvard University, Cambridge, Massachusetts.

doubled pairs. Those standing in the foreground canoe and those wading in the middle distance are particularly rendered as doubles in the classic sense, giving front and back views of the same pose. The figures are especially interesting since White would not have been trained in the art of nude figure drawing. There is no particular virtuosity here: the scene is not a vehicle for White to display his talents in figure study. By contrast, most of the de Bry portraits do show doubled human figures so as to display the engraver's technical skill, while also conveying maximum ethnographic information about costumes and the like.[16]

In the fishing scene, however, it is not ethnographic description as such

but rather the larger economic context that draws forth these sets of doubles: the demonstration of both abundance and labor prescribes the inclusion of so many icons of fish and human figures. For, in the context of understanding the prospects for environmentally oriented labor, ethnography (the representation of the Algonquians' difference from the English) is largely irrelevant. The point is that natural resources can support the labor of a given number of persons. From the promoters' perspective, the indigenous labor depicted here could be supplemented or replaced by that of the idle English poor. Thus the representation of the fish is governed by the logic of doubling as well: White needed to show fish in many species and abundant numbers. Although mostly drawn to scale, the fish are icons, clearly visible above the surface of the water. Here, purely naturalistic representation did not suffice (even supposing White could have met the technical challenge of showing fish beneath the surface). For, in reality, such a collection of diverse species would not present itself in one moment. Moreover, the compositional problem of showing the waters filled with fish all the way out to the horizon would have been daunting, if they had naturally presented themselves so. And yet, because the fish are drawn more or less to scale, in the water and in the canoe, iconic representation becomes naturalized: their scaled presence within a persuasive scene conveys the dual economic message of natural abundance and potential for improvement through labor. As in the examples of garnishing we have noted above, the de Bry engraving of the fishing scene extends the logic of White's watercolor, filling the field with more fish of more species, more weirs, more canoes and fishermen.

This logic of doubling in the extended sense structures White's most naturalistically rendered scene, the view of Secoton, de Bry's source for "The Tovvne of Secota" (fig. 6). White was probably familiar with the conventions of town views from the widely disseminated *Civitates Orbis Terrarum* or similar prints. Although convention allowed for a continuum of formats in the orientation of the visual plane, from vertical (scenographic prospect or landscape) to horizontal (ichnographic prospect or plan), most favored was the semi-oblique view, which included as much of a town's streets and waterways as possible while still permitting its distinctive architecture to be rendered in elevation. Usually, the semi-oblique view gestured toward perspective, though lines and vanishing points were not strictly observed. A compendium of information on trade, productions of the surrounding countryside, social structure, costumes and customs, and so on was given in an accompanying text, and often by means of iconography within the view itself as well.[17]

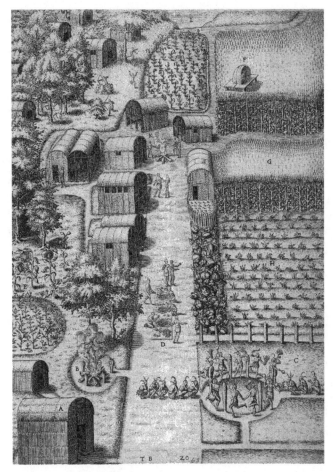

6. Theodor de Bry, "The Tovvne of Secota," 1590. Engraving after original watercolor by John White, published in Thomas Hariot, *A briefe and true report of the new found land of Virginia* (Frankfurt, 1590), vol. 1, plate 20. By permission of Houghton Library, Harvard University, Cambridge, Massachusetts.

White's view of Secoton, rendered in semi-oblique format, follows all these conventions, including textual inscriptions concerning economy and ethnography. As the play of adequation structured European town views, such that key features were rendered clearly yet regularized for communicability and aesthetic effect, so too should we recognize White's neatly balanced and divided image as an aesthetically pleasing composition. Moreover, as in the case of European town views, this is a composite view, its environmental and so-

cial representations inflected by the logic of doubling and garnishing. As one of the most distinctive customs, the ceremonial dance around a circle of totems takes prominent place in the lower-right quadrant. White made a separate drawing of such a ceremony, and the proximity of the circle to the rest of the town in the view of Secoton does not seem to answer to Hariot's observation that "the place where they meet is a broade playne." White, in fact, shows two fires in Secoton, one labeled "The place of solemne prayer" and another in the middle distance, unlabeled. Other activities include someone in a hut guarding the corn from birds and animals (upper right) and a middle-ground vignette of "Their sitting at meat," the subject of a separate ethnographic portrait—the vignette in the composite referring iconically to this separate drawing.[18]

Like doubling in the case of figure study, the depiction of these various activities and objects in a single, naturalistically rendered scene is a technical solution to the problem presented by the assumption that the view is taken in a single time-space. Whereas the convention of the *Civitates* town view abstracted human figures to the margin (usually the foreground), here White and de Bry place all human figures fully within the space of the view itself. This placement demonstrates their interest in understanding Algonquian culture as grounded in its environment. The only limit to the number of figures and activities that can be represented becomes the aesthetics of the view itself, the form of the composition.

The de Bry engraving intensifies this filling of the field—though not beyond an aesthetically defined limit. The result is a pleasing composite: full and vital, but not overwhelming (as in, say, one of the elder Bruegel's teeming scenes). For example, the engraving adds some deer hunts within the village itself, where White had only shown a couple of bowmen in the upper-left quadrant. Since Hariot's *Report* remarks nothing of the kind (nor does any other contemporary account), we must assume that the deer hunts are meant as yet one more demonstration of abundance and of a general sense of harmony between nature and culture—perhaps specifically a means of managing the deer population to protect the crops. For as Hariot describes the purpose of the elevated hut in the upper-right quadrant, "wherin they place one to watche for there are suche number of fowles, and beasts, that vnless they keepe the better watche, they would soone deuoure all their corne." In any case, the depiction of deer hunting would have rendered the scene familiar to the English gentry, since deer hunting was associated with aristocratic privilege. Yet, within the Tudor culture of improvement, it may also have tapped

an emerging characterization of deer parks as wasteland ready to be transformed into agriculturally productive space.[19]

Although White's depiction of Algonquian agriculture has generally been taken as naturalistic, it follows the demand to fill the field that, as we have seen, governs the entire Roanoke corpus. Like every other informational aspect of the scene, it too is a composite. In White's drawing, above the ceremonial circle are three plots of maize, labeled, respectively, "Corne newly spronge," "Their greene corne," and "Their rype corne," though there is very little visual differentiation between the "greene" and "rype" stages. Paul Hulton, presumably following Barlowe's often exaggerated account from the first Roanoke voyage, finds that White depicts the crops of three sowings, planted in May, June, and July, in their different stages. Barlowe sees maize iconically even at this scale, evidently referring only to a single variety of maize with one maturation period, plantings maturing May to July, June to August, and July to September, respectively. Hulton thus concludes that the drawing was made in mid-July.[20]

Hariot had discerned, on a closer view, that the Algonquians grew at least "three sortes" of maize, with different maturation periods (from eleven to fourteen weeks) and heights as well as "diuers colours." These numerous varieties and sub-varieties were (though even Hariot does not pursue the matter in sufficient detail) differently suited to uses as flour, hominy, and dried, parched, and fresh whole kernels. Any combination of varieties could have been growing on any date when White made sketches, so long as different varieties planted in close proximity did not flower at the same time, to prevent crossing, if any of a particular crop was to be saved for seed. Yet, in order to do its representational work, the image need not be thought of as being taken from a single moment in time-space: rather, it brings together the logics of garnishing and doubling.[21]

The important point was to render an understanding of a crop wholly unfamiliar to the English. Hariot thus emphasized "how specially that countrey corn is there to be preferred before ours: Besides the manifold waies in applying it to victuall, the increase is so much that small labour and paines is needful in respect that must be vsed for ours." Among the greatest differences between maize and English small grains is that maize has a usable green stage (fresh corn eaten as kernels or "on the cob"). Thus it was especially important to show the crop in three stages. The depiction of the "newly spronge" plot shows planting information (note how far apart, as compared with English small grains), while the plots of fresh-kernel and dry corn show

the two distinct stages at which a crop could be harvested. The de Bry engraving makes this distinction clear where White's drawing fails for lack of fine detail: in the engraving, we see that the ears in the fresh stage retain their husk, whereas the ears of the "rype" stage have been husked, evidently to facilitate drying prior to harvest. Hariot's caption similarly refers to the corn in the middle section, the fresh-kernel section, as having "come vnto his rypeurs [ripeness]."[22]

White's and de Bry's handling of the informational composite alters the Algonquian's typical disposition of other crops as well. Hariot had observed the indigenous system of intercropping: "they make a hole, wherein they put foure graines [of maize]. . . . By this meanes there is a yarde spare ground betwene euery hole: where according to discretion here and there, they set as many Beanes and Peaze: in diuers places also among the seedes of *Macócqwer, Melden,* and *Planta Solis.*" White and de Bry, by contrast, show each crop planted in a separate field, in accordance with English rather than indigenous practice; in the depiction of the fresh-kernel and dry stages of maize, the plants are spaced too closely to accommodate any such interplanting. Curiously, "Beanes and Peaze" are not shown at all. The fields thus look neat and orderly, giving evidence of (what the English would consider to be) good management, unlike the unkempt appearance (from the English perspective) that would have resulted from any attempt to render the fields naturalistically according to Hariot's observations—bean vines twining around cornstalks, with interplantings of sunflowers, weedy-looking *Melden,* or ungainly pumpkin vines. This pattern of regularization extends to the organization of the entire composition: the several fields, religious and ceremonial grounds, and dwelling places are even surrounded by lawns, after the manner of the nicest English estates (though the pasturage is for deer rather than cattle or sheep) and segregated into discrete, purposeful spaces by carefully manicured paths. The composite form—taking apart elements of Algonquian culture's relation to the environment and reassembling these discrete elements iconically—thus depicts New World nature as benefiting from careful management after the English manner.[23]

Rendering in a single visual field a compendium of information not available to an observer constrained by a discrete point in time and space, the composite view of Secoton thus brings together the logics of garnishing and doubling that govern environmental representation in the entire Roanoke corpus. Naturalized through the form of the composition (here, the town-view landscape), the informational composite addresses the tension in the Tudor

economic-environmental discourse between a persistent Edenic fantasy of harmony and an emergent imperative of economic intensification. The Algonquians are shown to benefit from both nature's "aboundance" and their own careful management of the environment. By analogy, the English might strike the same balance.

~

The Roanoke corpus does not look especially "green" on first view, for it neither celebrates the grandeur of the American environment nor criticizes its despoliation. In classical anthropocentric fashion, human beings figure centrally in each of the images discussed here, reminding us that pre-conquest America was not a pristine Edenic wilderness but rather a well-populated and well-managed environment. What insight, then, can the Roanoke corpus provide for contemporary environmentalism?[24]

In its emphasis on the orderly arrangement of resources and production, the corpus tells us that economic and aesthetic concerns mutually informed European perceptions of America from the beginning, augmented by "golden age" fantasies and biblical ideas about the Promised Land. Thomas Hariot recognized the importance of economic principles when, after his return from Virginia, he set about calculating the theoretical upper limit of the earth's population. In these calculations, Hariot in effect formalized the concept of carrying capacity, asking what the natural environment could support. It seems likely, then, that the Roanoke corpus contributed to the burgeoning interest in population theory evident, for example, in the English translation of Giovanni Botero's *Greatness of Cities* (1606) and in Ralegh's *Historie of the World* (1614). Colonization provided an occasion to consider carrying capacity in an explicitly managerial context. As the elder Hakluyt instructed the Roanoke voyagers, "The soil and climate first is to be considered, and you are with Argus eies to see what commoditie by industrie of man you are able to make it to yeeld." Viewing the American environment with an economic eye, ever vigilant, like Argus—observing a Carolina Algonquian culture firmly grounded in the land and extrapolating the possibilities for so grounding English culture—White, Hariot, the Hakluyts, and de Bry defined the terms of the dialectic of "commoditie": nature/culture, abundance/improvement.[25]

Current environmental discourse, hoping to synthesize these binaries, might learn from the visual structure of the Roanoke corpus. For if the colonial promoters imagined that America's abundance could support a great deal of intensification or improvement, nevertheless the conceptualization of

the visual domain as a field to be filled also suggests a limit to intensification: this limit is defined by aesthetics. If, in our era, when economic growth is viewed as an unquestioned good, the idea of environmental limits has become invisible, then a reflection on the dictates of form and scale, inspired by productions such as the Roanoke corpus, can recall it to our sight. In the aesthetics of the composite view, the field can be filled only so far while remaining legible and pleasing. Intensification beyond this limit—filling the field beyond what the scale can support—would spoil the (new) world's environmental promise.

Notes

1. Bernadette Bucher, *Icon and Conquest: A Structural Analysis of the Illustrations of de Bry's Great Voyages,* trans. Basia Miller Gulati (Chicago: University of Chicago Press, 1981), 13. See also David Beers Quinn, *Set Fair for Roanoke: Voyages and Colonies, 1584–1606* (Chapel Hill: University of North Carolina Press, 1985), 188, 196. The de Bry engravings were not made from the same set of drawings that survives in White's hand, but rather from other copies that have not survived; see Paul Hulton, *America 1585: The Complete Drawings of John White* (Chapel Hill: University of North Carolina Press, 1984), 20.

2. Lawrence Buell, *The Environmental Imagination: Thoreau, Nature Writing, and the Formation of American Culture* (Cambridge, Mass.: Belknap Press, 1995), 91–103.

3. On the Tudor culture of improvement see Andrew McRae, *God Speed the Plough: The Representation of Agrarian England* (Cambridge: Cambridge University Press, 1996), 133–228.

4. Barlowe quoted in *The Roanoke Voyages, 1584–1590,* ed. David Beers Quinn, 2 vols. (London: Hakluyt Society, 1955), 1:108. Thomas Hariot, *A briefe and true report of the new found land of Virginia of the commodities and of the nature and manners of the naturall inhabitants,* trans. Richard Haklyut (1590; reprint New York: J. Sabin & Sons, 1871), caption to plate 13, p. 51. At the request of de Bry, Hariot supplied captions for the plates. Hariot's Latin was translated into English by Richard Hakluyt the younger. On Hariot's involvement in the de Bry project see John W. Shirley, *Thomas Harriot: A Biography* (Oxford: Clarendon Press, 1983), 144–45. On idleness and labor in promotional literature see Shannon Miller, *Invested with Meaning: The Raleigh Circle in the New World* (Philadelphia: University of Pennsylvania Press, 1998), 26–49; Mary C. Fuller, *Voyages in Print: English Travel to America, 1576–1624* (Cambridge: Cambridge University Press, 1995), 27–30. On the relation

of economy to environment see Timothy Sweet, *American Georgics* (Philadelphia: University of Pennsylvania Press, 2002), 12–28.

5. This justification was peculiarly English; see Patricia Seed, *American Pentimento: The Invention of Indians and the Pursuit of Riches* (Minneapolis: University of Minnesota Press, 2001), 29–44.

6. Hariot, *A briefe and true report,* plates 12–16.

7. "Instructions for a Voyage of Reconnaissance to North America in 1582 or 1583," in *New American World: A Documentary History of North America to 1612,* ed. David B. Quinn, 5 vols. (New York: Arno Press, 1979), 3:243–44, emphasis added; Richard Hakluyt the elder, "Inducements to the Liking of the Voyage intended towards Virginia in 40. and 42. degrees," ibid., 69. On White's training and influences see Paul H. Hulton and David Beers Quinn, *The American Drawings of John White, 1577–1590, with Drawings of European and Oriental Subjects,* 2 vols. (Chapel Hill: University of North Carolina Press, 1964), 1:6–24; Hulton, *America 1585,* 7–12; and Michael G. Moran, "John White: Renaissance England's First Important Ethnographic Illustrator," *Journal of Technical Writing and Communication* 20 (1990): 343–56.

8. "Instructions for a Voyage," 243.

9. Svetlana Alpers, *The Art of Describing: Dutch Art in the Seventeenth Century* (Chicago: University of Chicago Press, 1983), 119–68. See also J. B. Harley, *The New Nature of Maps: Essays in the History of Cartography,* ed. Paul Laxton (Baltimore: Johns Hopkins University Press, 2001), 52–81. For discussion of artists from the Low Countries working on map production in England beginning in the 1570s see John Goss, *The Mapmaker's Art: An Illustrated History of Cartography* (New York: Rand McNally, 1993), 106. On differences between northern and southern European colonial modes see Seed, *American Pentimento.*

10. Hulton, *America 1585,* plates 60, 32, 36.

11. This icon was familiar, albeit used here for a different purpose. In English maps of the period, for example, *Christopher Saxton's Atlas of the Counties of England and Wales* (1574–79), a ring of palings indicates a park.

12. On the removal of the human figure to the margins see Valerie Traub, "Mapping the Global Body," in *Early Modern Visual Culture: Representation, Race, and Empire in Renaissance England,* ed. Peter Erickson and Clark Hulse (Philadelphia: University of Pennsylvania Press, 2000), 44–97.

13. For examples of the natural history illustrations see Hulton, *America 1585,* plates 5–31, 50–58.

14. Hariot, *A briefe and true report,* plates 3, 5, 9, 11. On the political allegory of portrait composition see Miller, *Invested with Meaning,* 126, as well as Richard Hal-

pern, *The Poetics of Primitive Accumulation: English Renaissance Culture and the Genealogy of Capital* (Ithaca: Cornell University Press, 1991), 178.

15. On the hunting cult see Karen Ordahl Kupperman, *Roanoke: The Abandoned Colony* (Totowa, N.J.: Rowman & Allanheld, 1984), 56; Hulton, *America 1585,* plate 43.

16. Hulton, *America 1585,* plate 43, 35–36.

17. Georg Braun and Franz Hogenberg, *Civitates Orbis Terrarum,* 6 vols. (Cologne, 1572–1618); see the reprint, intro. R. A. Skelton, 3 vols. (Cleveland: World Publishing, 1966). On the conventions of town views see Skelton's introduction, ibid., vii–xiii; Goss, *Mapmaker's Art,* 256–64; and P. D. A. Harvey, *Maps in Tudor England* (Chicago: University of Chicago Press, 1993), 66–77.

18. Hariot, *A briefe and true report,* caption to plate 18, p. 58. For White's drawings see Hulton, *America 1585,* plates 39 and 41; compare to de Bry plate 16. For a comparative view of Bristol (a city familiar to White from his 1577 work with the Frobisher expedition) in the *Civitates* see *The Atlas of Historic Towns,* ed. M. D. Lobel (Baltimore: Johns Hopkins University Press, 1969–75), vol. 2. In the *Civitates* view, the artist regularized the representations of rivers and streets to form a pattern of concentric circles transected by a cross.

19. Hariot, *A briefe and true report,* caption to plate 20, p. 61. On the perception of deer parks as wasteland see McRae, *God Speed the Plough,* 260–61.

20. Hulton, *America 1585,* 179. For Barlowe's account see *Roanoke Voyages,* 1:105.

21. Hariot, *A briefe and true report,* plate 13.

22. Ibid., caption to plate 20, p. 61. Since de Bry's typesetters probably were not fluent in English, the orthography of the captions is often highly irregular (even for Hakluyt). The "u" in "rypeurs" is presumably an inverted "n."

23. Ibid., 14–15, emphasis in original. *Macócqwer,* says Hariot, are "called by vs Pompions, Mellions, and Gourdes"; *Melden* is a leafy green used "for pot hearbes." "Planta solis" is the sunflower.

24. See Buell, *The Environmental Imagination,* 143–79, on the challenge of decentering human subjectivity.

25. The relevant manuscript is discussed in Barnett J. Sokol, "Thomas Harriot—Sir Walter Ralegh's Tutor—on Population," *Annals of Science* 31 (1974): 205–12. On Hariot's continued interest in American colonization see David B. Quinn, "Thomas Harriot and the Virginia Voyages of 1602," *William and Mary Quarterly* 27 (1970): 268–81. On English interest in population theory in the context of colonization see Joyce Chaplin, *Subject Matter: Technology, the Body, and Science on the Anglo-American Frontier, 1500–1676* (Cambridge, Mass.: Harvard University Press, 2001), 120–30. Hakluyt, "Inducements," in *New American World,* 3:66.

2

Vivification and the Early Art of William Bartram

Thomas Hallock

I hope you will make Bartram live again.
—William H. Mills to Francis Harper, 1939

In the library of a Quaker Meeting I used to attend, I came across a snapshot of Bartram's ixia, a rare flower technically known as the *Calydorea cuelestina* (fig. 7). Someone had tucked this yellowed photograph, along with some newspaper clippings, into a reprint of William Bartram's famous book of natural history, *Travels through North & South Carolina, Georgia, East & West Florida, the Cherokee Country, the Extensive Territories of the Muscogulges, or Creek Confederacy, and the Country of the Chactaws* (1791). I lack training in the history of photography, did not recognize the name on the bookplate, and could not date the print. Still, I know enough about *Travels* and its author to explain why this image moved me. Bartram first described the ixia that now bears his name in a 1767 letter to Benjamin Rush; the letter remained unpublished in his lifetime, and the flower played hide-and-seek with scientists for another century, escaping formal classification until 1936. To see a *Calydorea caelestina* in the wild is an impressive achievement. The plant has an extremely limited range (a few counties in northeastern Florida) and blooms at difficult-to-find times (just before dawn and when the soil has been compacted, traditionally by fire but also from tires). The Friends who took this photograph, in short, knew they had something special. On the back of the print, a shaky script identifies "Hand of Grace Allen." She clutches the flower by the stalk; the blossoms ruffle easily. A watchband pinches the skin around her wrist. The person holding the white paper remains unknown. The rest of the caption reads: "Bartram's Ixia with Shadow on Paper Background at Sunrise. Ixia wilts on exposure to Sunlight."[1]

The snapshot conveys to me not so much the pleasure of a well-wrought work of art as a pastoral in its classic use. The old photograph, almost buried in a seldom-used library, freezes nature in time. The *Calydorea caelestina*

7. Unidentified photographer, "Hand of Grace Allen. Bartram's Ixia with Shadow on Paper Background at Sunrise. Ixia wilts on exposure to Sunlight," n.d. Courtesy, St. Petersburg Religious Society of Friends, St. Petersburg, Florida.

physically connects Grace Allen and her companions to the history of a place. What I find more moving still is that there are other Grace Allens out there. In the modern-day South (and with regard to the environment especially), William Bartram commonly serves as a benchmark, a measure for gauging the present landscape against the past. A Philadelphia native, Bartram lived in and traveled through the South in the 1760s; an extensive tour of the region from 1773 to 1777 led to the book by which he is principally known. Today, scholars and enthusiasts from the eight states he entered (North and South Carolina, Georgia, Florida, Alabama, Mississippi, and Louisiana) have made something of a cottage industry out of his trail—documenting, debating, and pondering the meaning of things he saw two hundred years ago. I first became aware of this phenomenon—some say a cult—when I agreed to edit the newsletter of the Bartram Trail Conference (BTC), a lively group founded in 1976 that is dedicated to advancing Bartram's legacy. There are now a BTC Web site, biannual meetings and occasional symposia, two published guides, hiking maps, a recently dedicated canoe trail, scholarly monographs that sell surprisingly well to the general public, literary memoirs, novels in which Bartram or his book makes a cameo, and reenactors from

Florida and Alabama. Each issue of the BTC newsletter (now in another's capable hands) offers variations of the "Billy and Me" story, where the naturalist's Quakerly perspective is applied to the continuities and changes in the southern landscape.[2]

Something about this figure invites personal introspection. Something about him raises a vague, persistent longing for connection. The Orlando-area writer Bill Belleville frames Bartram's lyrical fascination with the Floridan aquifer against the post-Disney sprawl that devoured his community and home. "If I traced and retraced the original writings of Billy Bartram," Belleville wonders, would a spring's "untold secrets be somehow articulated to me?" What Belleville wants is recharge; that is, a deep spiritual cleansing from the same aquifer rendered in *Travels*. Others set the book against individual loss. In the acknowledgments of his father-son biography, *The Natures of John and William Bartram,* Thomas P. Slaughter notes that the writing of his book accompanied the births of two children and the passing of a parent, two grandparents, and his dog Willy. (Slaughter's book is one of two on the subject that eulogizes a dog in the preface.) At once compelling and idiosyncratic, *The Natures of John and William Bartram* engages subjects that are beyond academic, moving freely from gaps in the evidentiary record to speculation on another's life. The concern here is not whether Slaughter's open style yields insight (it does), or whether his interpretations hold up to close scrutiny (sometimes yes, sometimes no), or whether the more literal-minded scholars accept his speculations (usually not); my point is merely that Bartram's aesthetic encourages us to think from the gut.[3]

Young "Billy" Bartram's artistic career began in the 1750s, when his botanist-father John began shipping watercolors to the London drapier, gardener, and scientific middleman Peter Collinson. Billy's work evolved over the next decade as his drafting skills improved and he explored more overtly the problem of dislocation that came with rendering objects for an audience elsewhere. Illustrations commissioned by the London physician John Fothergill, completed during the 1773–77 tour and now in the British Museum, most provocatively occupy this tension between the subjective and the mimetic. As his career continued into the 1790s and the early nineteenth century, Bartram explored questions of how one comes to know the natural world and whether animals have souls, and he pondered the permeability between the human, plant, and animal realms. The result is an expressive quality even in illustrations done for technical works, such as the plates completed for Benjamin Smith Barton's *Elements of Botany* (1803). All told, Bar-

tram enjoyed a long career—one that is underappreciated still, and that awaits further study. What holds his impressive and varied body of work together, however, is the location of pathos within botanic or zoological subjects. Bartram's two-hundred-year-old Nature appears vivified, brought to life, while his attention to physical details evokes emotional responses. We feel closer not only to him but to his Nature as a result.[4]

Consider one of his major illustrations from a peak period, *The Great Alachua Savana* (fig. 8). This large pen-and-ink drawing, undated, depicts the wet prairie south of present-day Gainesville. Bartram first visited the Alachua savannah in 1774, and he left several accounts which, taken together, amount to a scientific-personal record of the place. Here is where the Seminole chief Cowkeeper gave the naturalist his name "Puc Puggy" (flower gatherer); a 1790 prospectus for *Travels* also included a description of this spot. Clearly, the place mattered to Bartram, and the illustration maps both a physical and emotive landscape. A stippled palm to the left vies with the flattened prairie to orient the image, offering vertical and horizontal perspectives that somehow compete without contradicting. As the classical palm formally composes the scene, distancing the viewer, the flat prairie seems to fold inward. A visual origami results, one that enfolds interiority into the conventional stuff of science. One could actually lay this image over a modern map and establish reasonable coordinates. Sharply rendered details such as the veiny roots and serrated leaves add to the immediacy. Yet, the exaggeration of certain plants, animals, and landmarks also makes this landscape Bartram's own. An American lotus, which he also drew, looms over the lake; deer, described memorably in *Travels,* bound across the savanna; a Seminole chickee hut awaits the visitor; the "musical savanna cranes" fly into the upper-right corner's suggestion of infinite space. The drawing hooks the viewer through sharply rendered details while leading us inward, toward a more meditative or reflective state. One who has visited this prairie cannot help but think, *I have seen that bird* or *I know that plant* or *I hate how that platform on the south rim shakes in the wind.* My eye always returns to the sandhill cranes in the upper right.[5]

Ten years ago I completed a dissertation on early national nature writing at an urban university in the Northeast. Buffeted by a tight job market, my wife, Julie, and I took teaching jobs at a regional campus in southern Georgia. The positions carried heavy teaching and service expectations. The job overwhelmed us (we left after Julie's load reached five classes per semester). So too did the small-town South and the monotonous pine planta-

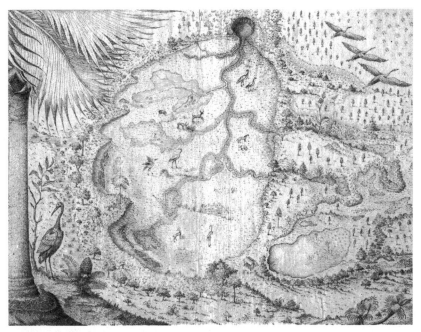

8. William Bartram, *The Great Alachua Savana*, 1765. Ink on paper. Courtesy, American Philosophical Society, Philadelphia.

tions that threaten to swallow native forests whole. Seeking respite, Julie and I tossed a copy of *Travels* into the trunk of our Honda Civic and sought out Bartram landscapes. We have followed his trail since then, through ten years of happy marriage, two homes (including one major renovation), the complications that face a dual-career couple, a miscarriage and difficulty conceiving. At an early stage of our southern journeys with Bartram, we hiked near the lake depicted in the lower right of *The Great Alachua Savana*. It was early January. We sat down in a meadow near sunset, hoping to see wild turkeys, when a flock of sandhills flew above us. The wingspan of sandhill cranes can reach seven feet. They fly in formation and travel up to thirty-five miles per hour, filling the sky with their throaty, deep, pterodactyl-like clucks that can tear at the tissues of time. Our hearts stood still.[6]

The literary critic N. Bryllion Fagin had it right back in the 1930s when he called Bartram an "interpreter of the American landscape."[7] Bartram's words and images help us see the world through another's peaceful, more appreciative eyes. Yet, the popular appeal (including my own subjective response) has not really been explained historically. The quality of vivification,

the sense of taxonomy sprung to life, evolved from the predicament of having to present American subjects for institutional bodies in Europe. The experiences of a naturalist in the field, in turn, fueled a number of philosophical questions—the permeability between the human and nonhuman, matters of knowing—that compelled Bartram to give his plants and animals human qualities. All this from an illustrator who, by training, focused upon distinguishing "characters," or details. Bartram's art understandably then invites a connection not just with the landscape, flora, and fauna of the present-day South but with the person as well. People today wake before sunrise to see a *Calydorea caelestina* in the wild. Bill Belleville misses his house and Thomas Slaughter eulogizes his dog. Bartram's Nature reaches across the centuries. But to ask the question one more time: why?

The contemporary responses seem less puzzling when we recall that Bartram's art was originally meant to travel great distances. Natural history in the eighteenth century laid emphasis upon classification. Details mattered. One plant's similarities to and differences from another plant allowed it to be classified; the importance of distinguishing "characters," in turn, fed a culture of accumulation. If botanists were to "number the streaks of the tulip" (as Samuel Johnson's Imlac quipped), they needed more than one tulip for the "streak" to bear relevance. As comparison generated meaning, then, the compass of Enlightenment practice expanded. Natural history abetted what the literary theorist Mary Louise Pratt called "planetary consciousness," as devotees blanketed the globe in search of new specimens. And it was this construction of a comparative tableau that provided colonial Americans with a niche. They sent "nondescripts" (undescribed curiosities) to Europe. Bartram sharpened his eye upon these terms, having trained himself to please his tulip-streak-numbering patrons on the other side of the Atlantic.[8]

Space, in this way, helped create an icon of regionalist place. To understand the dynamics of colony and metropole in Bartram's time, one need look no further than to his primary influence, Mark Catesby. Catesby's *The Natural History of Carolina, Florida, and the Bahama Islands* (1731), itself a key work in the history of American ornithological art, opens with a caveat that situates peripheries against the center. "The early inclination I had to search after plants, and other productions in nature," Catesby writes, was "suppressed by my residing too far from London, the center of all science." He continues: "I was deprived of all opportunities and examples to excite me to a strong pursuit after those things to which I was naturally bent. Yet my curiosity was such, that not being content with contemplating the products

of our own country, I soon imbibed a passionate desire of viewing as well the animal as vegetable productions in their native countries; which were strangers to England. Virginia was the place."[9] Catesby understood that in order to make his mark, he would have to travel; indeed, the success of his prints (which fetch prices in the thousands today) lies in their vivid rendering of what was then unfamiliar.

Bartram faced a similar, although not identical, situation. He, like Catesby, lived far from "the center of all science," yet distance presented him with an opportunity. He grew up on a farm and botanic garden that fronted Philadelphia's Schuylkill River. Migratory birds flocked to the spot, and while still in his early teens, young Billy took to hunting and drawing the new birds for naturalists in Europe. Many of his early watercolors were done in a generic "Magpie on a Stump" style; what mattered to Peter Collinson was not formal aesthetics, however, but the potential contributions to ornithology. Collinson delighted in the "nondescripts." Writing along the top of a sketch of the "Fringilla" tree, which features a pine warbler, he notes: "I take this to be the Pine-creeper of Catesby." On the "Parus Gutture Nigro": "Not in Catesby." And so on.[10]

Bartram's earliest work was framed against Catesby's *The Natural History of Carolina, Florida, and the Bahama Islands*—against an artist whose points of reference were the metropole and *not London*. Billy's task was to render as *natural* what lived outside Europe. Indeed, the watercolors sent to Collinson usually involved a backstory about the procurement (or failure to do so) of the object depicted. Since the 1730s, for example, Collinson had asked John Bartram to ship turtles from America. It was a frustrating venture. Eggs disappeared in the passage or perished from exposure at sea. After repeated requests, Collinson finally received a healthy snapping turtle. An August 1755 letter recounts how this "formidable animal" nabbed at a stick and then settled into the muck of his garden pond, where (since it was a snapping turtle) Collinson rarely saw it again. To mitigate the loss, he asked William for an illustration. The younger Bartram complied, which leads to another story (the naturalist George Edwards was so impressed that he asked William to draw American birds, which were used for the former's *Gleanings of Natural History*), but what the anecdote reveals are the defining terms for a colonial artist. The illustration served as a substitute for the stick-nabbing "formidable tortoise" that had disappeared into the bottom of a patron's pond.[11]

Bartram's aesthetic evolved upon this problem: his drawings were to serve

as a substitute for the thing itself. And, as his skills improved, his works grew in thematic complexity, and his knowledge of American flora and fauna deepened. From the 1760s until the Revolution, he lived and traveled through much of the modern-day South. The frustrated botanist and artist failed in attempts to establish himself as a trader on the Cape Fear River, then as a planter on the St. Johns. (Slim evidence suggests that he worked on a surveying expedition led by cartographer William de Brahm around 1767; if so, he probably received tutoring there.) After his first return from Florida, he completed a series of pen-and-ink drawings for Collinson that marked a new stage in his career. One of the more arresting of these, the so-called *Colocasia* (actually an American lotus), explores the paradox between taxonomy and Nature, vivifying the scientific specimen while circumscribing his own liminal position as a colonial naturalist (fig. 9).[12]

Here the artist began to inhabit his own studies, yet here also (and this paradox is key) the story would begin in a London garden. The ever despairing Collinson could not grow a lotus. He complained in one of a series of letters to John Bartram: "My Colocasia nuts don't appear—I despair of them—If any Fresh nuts offer again put them instantly in a Bottle [and] send them over tho Billys lively drawing gives a Clear idea of it yett to be sure, the real thing is to be preferred to the most perfect Work of Art."[13] The snapping turtle in his pond, Collinson speculates elsewhere, probably made a meal of the lotus' shoots or seeds. If so, the irony was perfect because the reasons for requesting the "great mud tortoise" and *Colocasia* were identical: to provide the likeness of an evasive American specimen. Therein lay the rub. The drawing could *not* replace the physical object. After receiving this illustration, Collinson continued to plead for seeds or "nuts." Just as the "real thing [was] preferred" over an illustration, so too did collectors value lifelike qualities. Even the "most perfect Work" did not equal the flower in bloom.

The *Colocasia* gathers particular interest when we view it from within this colonial space that Collinson defined. On one hand, Bartram anticipates the protocol of Enlightenment botany. The upper two-thirds of the image have an abstracted background, upon which the object is rendered for the sake of identification. Referring specifically to this section, Collinson praised "the Skill of the Artist" here in showing "Nature in her progressive operations"; in other words, he liked seeing the flower at different angles and stages of blossom. Yet the image refused to cede entirely to the static realm of European taxonomy, giving this image a thematic richness. A horizon line splits the *Colocasia* in two, opening a visual depth that, as art historian Michael

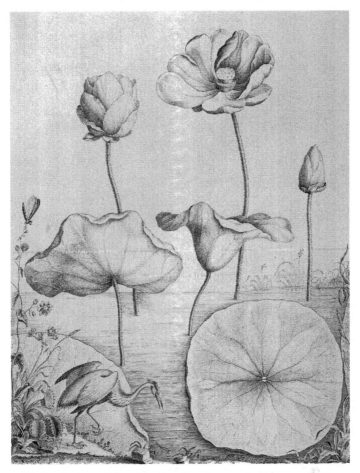

9. William Bartram, *Colocasia, or American Lotus,* 1767. Ink on paper. Courtesy, Natural History Museum, London.

Gaudio argues, contrasts to the flat field of taxonomy. In the quarter leaf of the lower left, Bartram screens his North Carolina years. The Venus fly-trap, or *Dionaea muscipula,* grows there alone. (Besides K-Mart, the flower can be found only in the Wilmington, North Carolina, area.) The interests of the artist and his patron parted over this telling detail. Writing from England, Collinson criticized the sketch's use of "imaginary plants." What he did not realize was that the *Dionaea* is real—*rare* but not imaginary, native to one small corner of the colony, notoriously difficult to ship. The correspondence from Europe, however, reveals the role of distance in shaping an aes-

thetic. In an earlier letter from the same year, he remarked to the artist's father: "William & Moses [William's brother, also living in North Carolina] has obliged Mee in his Curious observations."[14]

The word "curiosity" has a complex history, one that scholars have only recently begun to understand spatially. Susan Scott Parrish notes that it suggested a certain fluidity between the "observer and the observed." The term conventionally signaled a new object of study, something new to natural history, and for logical reasons, the word was often attached to American specimens. "Curiosities" dwelled between categories of knowledge, and this refusal to adhere to any one system excited wonder about all creation. As a carnivorous plant (neither flora nor fauna), the *Dionaea* epitomized the American "curiosity." Bartram knew that. Well versed in the nuances of scientific rhetoric, he exercised a carnivorous plant's full range of associations by setting it alongside the heron who stalks a minnow. The juxtaposition punned upon the spatialized idea of "curiosity," as the image itself interleaved conventional scientific practice (the flower depicted from different views) within a physical setting that could only have been North Carolina. And that raises a rich question for our understanding of the *Colocasia* and early botanic art in general. If America served as a subject of "curiosity" in itself and not simply the source of *curiosities* for London collectors, what space would the "curious" colonial artist need to define?[15]

Bartram's aesthetic snaps into focus when set against a dilemma of dislocation—when we situate his role within a culture whose center resided elsewhere. Nearly every critic of *Travels,* the work for which he is best known, notes that his Nature rejected clear boundaries. An aesthetic of blurred taxonomies (epitomized by the *Colocasia*) unfolded from the paradox that had been defined for a "curious" colonial botanist. The introduction to *Travels* used the *Sarracenia* and *Dionaea* to establish an important suggestion, one that runs through the remainder of the book—that all forms of life possess common traits. In a mini-essay, Bartram careens from a "large fat bomble bee" who draws nectar from a plant to a spider who eats the bee; this bee, in turn, possesses the "circumspection and perseverance of a Siminole" hunter; the spider (who ate the bee who sucked the nectar) later becomes "the delicious evening repast of a bird or lizard." For Bartram, Nature is united because each creature serves as another's snack. A similar understanding leads him to anthropomorphize native flora. His pitcher plants possess "nerves" in their leaves; they "imbibe rain" through "minute pores" and perspire. In unpublished manuscripts Bartram takes the thinking still further, expressing belief in a "Divine Intelligence" that "penetrates and animates the Universe."

A belief in the connecting tissue found in all "Living moving beings" drives the visual explorations of human qualities in a plant or animal.[16]

When I recently assigned *Travels* for an undergraduate seminar at the University of Mississippi, my student Amanda Proctor hit the nail on the head: "It's like his plants have personalities." Even the most technical illustrations suggest a botanic language of the heart. Shuttling between the systems of classification that were available at the time, Bartram negotiated what the art historian calls "surface and depth," or what the scientist may regard as subjective and objective knowledge, or what the trendy literary critic calls epistemic rupture—all to suggest (and here is where the colonial naturalist translated his "curiosity" into an aesthetic) that the botanist must see a flower in order to understand it. This emphasis upon locale partially explains the ongoing cult of Bartram and the market for "Billy and Me" narratives in the present-day South. Yet it was distance—as much as the familiarity with physical *place*—that gave need for the details that make his work seem so close. The colonial exchange taught Bartram to portray objects for collectors who lived elsewhere; in the passage of two hundred years, the vector of time merely supplanted that of space. A mourning, a consciousness of the life and death at the heart of any pastoral, results. For while Bartram's art depicted specific landscapes, flora, and fauna, the poignancy in his art is driven by the ineluctable otherness of the past. His illustrations feel alive because we momentarily close the gap of centuries that used to be an ocean.[17]

The *Calydorea caelestina,* or rather its history, holds out this possibility for transcendence in a flower. Precisely when William saw the ixia that now bears his name remains a mystery. Francis Harper incorrectly speculated that John and William Bartram marked it during their 1765–66 tour; John did not describe it in his diary, however, and the dates of their journey fail to coincide with the blooming cycle (a rare factual slip by Harper). William's 1791 *Travels* includes a plate of the ixia, but the written description runs less than a sentence. A more complete account was probably the casualty of the book's sloppy, even haphazard production. Earlier descriptions and illustrations, to a similar end, vanished into the obscurity of the archive. In late 1767, William completed a spare and elegant watercolor that he sent to Peter Collinson (fig. 10). Collinson did not recognize the plant's rarity, however, and praised the illustration only in passing as "fine . . . beyond my description." A surviving 1767 letter to the Philadelphian Benjamin Rush provides the most complete account. Bartram probably penned the letter with an eye for publication, but it too disappeared into the archive.[18]

The loss is ours, for sure, because the Rush letter contains some of Bar-

10. William Bartram, *Ixia Caelestina*, 1767. Watercolor on paper. License granted courtesy of The Rt. Hon. The Earl of Derby 2008, Knowsley Hall, Prescot, Merseyside, United Kingdom.

tram's most lyrical prose. A particularly delightful passage recounts a meadow full of *Calydorea caelestina* blossoming at dawn:

The flowers open in the Morning soon after the day breaketh, whose Petals appear as a transparent Film framed with singular beauty consisting of a number of longitudinal Fibres, which take their rise from the bottom departing from each other gradually to near the middle, then they divide, thus again to the end, and are so very minute pre-

venting altogether an appearence of the finest webby membrane, of so tender and delicate an excellence, they are bruised and ruffled, by the gentlest breathe of wind, and no sooner then the slightest glance of the Sunbeams pass over them then they disappear, the Acres of ground were partly cover'd in such manner as to cast a glowing purple around soon after the sun is above the horison, it would be almost imposeble to find a flower; and one would be apt to conjecture all the beauty seen this moment to be mere delution.

The usual "characters" are noted. Bartram reviews the "small and nearly round Bulb," the leaves "like a blade of common Grass," and the distinguishing parts of the flower—the stamen, "anthera," "Germen," "Stile," and pericarpum (or seed box). As with the *Colocasia,* however, the stuff of taxonomy competes with physical place. Writing to Rush, then in Edinburgh, provides the occasion to dramatize the difficulty of "shipping" knowledge overseas. Bartram describes how he tried to crop a single flower ("admirable beyond anything Vigitation presents"), only to be "baffled in the attempts." He presses the petals into his copy of Linnaeus, but the pages blot out their color and the "purple tinct" stains through several pages. "I have Gena: Plantm: [Linnaeus's *Genera plantarum*] by me," Bartram writes, yet the flower has "struck thro . . . five leaves," leaving "a fixt and most perfect purple colour."

Scholars of eighteenth-century nature writing have emphasized the influence of Carl von Linné, or Linnaeus, in environmental thought—sometimes equating his method with an entire culture. (Similar blanket statements about taxonomic grids have also been used to abet flat claims about the hubris of pre-romantic writing.) Yet not every individual who owned a volume of Linnaeus subscribed to his method, and while Bartram did bring *Genera plantarum* to Florida, he remained skeptical about the sexual system throughout his life. Both father and son were field botanists who knew firsthand how new discoveries could slip past existing taxonomies. The plate illustrating the ixia in *Travels* cites Joseph Pitton de Tournefort's *Herbal*—an older, if still viable, source that was stronger on the Iridaceae (iris) family, of which the ixia is a member (and that retained a charm that *Genera plantarum* lacks). Elsewhere, William Bartram criticized Linnaeus more pointedly, particular in regard to the synonymae (multiple names) that appeared in later editions of *Genera plantarum*. Notwithstanding the "excellent System" by the Swedish naturalist, Bartram explained to his botanic peer Henry Muhlenberg: "there still remains much confusion & error, particularly in regard to the

Vegetables of America, arising from a disagreement betwixt European &
American Botanests which is in a great degree owing to the ignorance &
carelessness of the compilers of the numerous Nomenclators without suffi-
cient descriptions. And with the utmost difficulty & regret I must observe,
that In my opinion that most valuable part of Linnaeus's botanical work,
namely the Synonymae of the Spec. plantarum is the cause of not a little
confusion."[19] His conclusion about the "disagreements" followed six decades
of the family's shipping *stuff* across the Atlantic. William Bartram appre-
ciated the need for precision, yet for the same reason he understood that
the verbal thickets created by each different system led to "confusion and
error."

This ixia needs to be seen in the field, a point that the plant's later his-
tory actually confirms. Botanists use the term "type specimen" to mark the
plant or animal specimen upon which a first identification is based. Almost
to script, the flower pressed into the *Genera plantarum* has disappeared. I
know for certain that the *Calydorea caelestina* was still in the book where
Bartram left it until the mid-twentieth century. A manuscript note by the
scholar Francis Harper says it was on page 32 of a copy at the Historical So-
ciety of Pennsylvania. But this preserved flower, the *type specimen,* has since
turned up missing. I asked James N. Green of the Library Company (who
now holds the society's books). Green checked a second edition, well traveled
and inscribed to "J Bartram," but he saw only the trace of a stain on page 36.
There was, however, a "quite intense dark brown stain that migrates through
several leaves on p. 242."[20]

What has happened to the flower described in the letter to Rush? If the
volume is the same one that the Bartrams brought to Florida, and we suspect
it was, then that "perfect purple colour" has faded to brown—leaving only
the intense trace of the prior beauty. Books and names must remain ancil-
lary to the thing itself. Knowledge comes from the field. Any study of nature
should move beyond flat taxonomy. The *Calydorea caelestina* that evaded sci-
entists until 1936 did not fit the prevailing system in 1767. William Bartram's
artful prose and illustrations, as the product of a dislocating culture, aspired
to an exact likeness of the thing itself. His aesthetic evolved as he learned to
encircle the peripheries, working tensions between the translation of knowl-
edge and "being there." How perfect then that his most impressive discovery
played hide-and-seek with biologists and archivists for two hundred years.
How perfect that the type specimen has disappeared. Those who wish to
see the ixia that bears his name must journey back to the place of its discov-

ery. The elderly Friends who photographed the *Calydorea caelestina* understood this connection. They captured the perfect pastoral, the "sylvan historian" who, Keats writes, never bids "the Spring adieu." When I see the hand of Grace Allen clutching the flower by its stalk, time stops for me. William Bartram lives again.

Notes

1. Unsigned photograph, library of the St. Petersburg Monthly Meeting of the Religious Society of Friends (Quakers); note on Baldwin/Muhlenberg and the ixia.

2. The BTC's excellent Web site, constructed by Brad Sanders, is www .bartramtrail.org. Guidebooks and literary retracings of the trail include Jim Kautz, *Footprints across the South: Bartram's Trail Revisited* (Kennesaw, Ga.: Kennesaw State University Press, 2006); Brad Sanders, *Guide to William Bartram's Travels: Following the Trail of America's First Great Naturalist* (Athens, Ga.: Fevertree, 2000); Charles D. Spornick, Alan R. Cattier, and Robert J. Greene, *An Outdoor Guide to Bartram's Travels* (Athens: University of Georgia Press, 2003). A copy of *Travels* is carried by the protagonist of Charles Frazier's novel *Cold Mountain* (New York: Vintage, 1998) and in the movie of the same title. Nature writers who have used Bartram as a touchstone include Christopher Camuto, *Another Country: Journeying toward the Cherokee Mountains* (Athens: University of Georgia Press, 2000); Bill Belleville, *River of Lakes: A Journey on Florida's St. Johns River* (Athens: University of Georgia Press, 2001) and *Losing It All to Sprawl: How Progress Ate My Cracker Landscape* (Gainesville: University Press of Florida, 2006).

3. On botanic writing as an emotive "short-cut," see Christoph Irmscher, *The Poetics of Natural History: From John Bartram to William James* (New Brunswick: Rutgers University Press, 1999), 19. Slaughter meditates on birth and loss in *The Natures of John and William Bartram* (New York: Vintage, 1996), xix; Belleville in *Losing It All to Sprawl,* 174. Brad Sanders mourns the passing of Darcie (*Guide to William Bartram's Travels,* vi); Belleville's aging shelty, Shep, also plays a role in the mourning process in *Sprawl;* and J. D. Sutton, who portrays Bartram in Florida, notes his nine "furry children," seven cats and two dogs (all rescued), in his author biography; see the Florida Humanities Council Web site (http://www.flahum.org/ images/sections/road_scholars/press_materials_F06S07/BIO_JD_Sutton.doc).

4. Bartram's career falls roughly into four periods: (1) juvenilia, or a "Stump and Magpie" phase; (2) pen-and-ink drawings in the 1760s that garnered commissions in Europe; (3) mature work, mostly from his travels, for Fothergill; (4) and journeyman work from the 1790s until 1803, which most prominently included the illustrations for Barton's *Elements of Botany.* One of the few studies of Bartram's art is

Charlotte M. Porter, "The Drawings of William Bartram (1739–1823), American Naturalist," *Archives of Natural History* 16, no. 3 (1989): 289–303. A fine selection of his early watercolors is kept at Knowsley Hall (outside Liverpool) in the collection of the Earl of Derby. Drawings from the 1760s and 1770s done for John Fothergill are at the Natural History Museum, London. Most of these are included in Ewan, *William Bartram: Botanical and Zoological Drawings;* Alecto Historical Editions has recently printed a fine (and expensive) edition of the Fothergill album. Much of the journeyman work survives in print, only the cataloging remains to be done, and images completed for *Elements of Botany* (plus other drawings) are at the American Philosophical Society. Lastly, Bartram's influence was extended through the tutoring of Alexander Wilson and the early volumes of *American Ornithology* (1808–14), the first illustrated ornithology published in the United States, which owes its existence to training at the Bartram family's garden.

5. The most detailed description of the lotus appears in the published *Travels* (353–71). A second illustration is reprinted in *William Bartram: Botanical and Zoological Drawings, 1756–1788,* ed. Joseph Ewan (Philadelphia: American Philosophical Society, 1968), plate 57. *Proposals for Printing by Subscription . . . Travels . . . By William Bartram* (Philadelphia, 1790) is viewable in the online Jefferson Papers, Library of Congress (http://memory.loc.gov/cgi-bin/query/P?mtj:1:./temp/~ammem_RXbn::).

6. Bartram describes the "musical" cranes in *Travels* (114). The International Crane Foundation's Web site has samplings of sandhill crane calls (http://www.savingcranes.org/species/sandhill.cfm).

7. N. Bryllion Fagin, *William Bartram: Interpreter of the American Landscape* (Baltimore: Johns Hopkins University Press, 1933).

8. *Samuel Johnson: The Oxford Authors,* ed. Donald Greene (New York: Oxford University Press, 1984), 352; Mary Louise Pratt, *Imperial Eyes: Travel Writing and Transculturation* (New York: Routledge, 1992), 15; on "transplantation" in the Bartram-Collinson correspondence see Irmscher, *The Poetics of Natural History,* 25.

9. *Catesby's Birds of Colonial America,* ed. Alan Feduccia (Chapel Hill: University of North Carolina Press, 1985), 137.

10. "Parus" and "Parus Gutture Nigro" (Knowsley Hall, W291.50). Of the drawings that survive from Collinson's collection, there are about thirty birds, several species of turtles, maples, oaks, and other trees. In the base of the "Parus Gutture Nigro," Bartram carves his own initials into the stump, in effect signing this ornithological postcard from Pennsylvania. The insertion of his presence into an object in nature, I suggest, anticipates the process of vivification seen in the later work.

11. Bartram's "great Mud Tortoise" (Knowsley Hall, W291.119) is reprinted in *William Bartram: Travels and Other Writings,* ed. Thomas P. Slaughter (New York:

Library of America, 1996), plate 22. After seeing this work and presumably other illustrations, George Edwards asked Bartram to sketch Pennsylvania birds; see Edwards to Bartram, November 15, 1761, reprinted in *Memorials of John Bartram and Humphry Marshall,* ed. William Darlington (New York: Hafner, 1967), 419–20.

12. To see how closeness to the object shaped the illustration, compare Bartram's drawings of the *Franklinia alatamaha, Evening primrose, Oak-leaved hydrangea,* and *Pinckneya bracteata,* completed for Robert Barclay in 1788, and drawn, respectively, from a live sample in the garden, from memory of a specimen that was dead but that also grew in his garden, from sketches completed during his travels, and from a dried specimen (all four are viewable on the Web site of the Natural History Museum, London: http://piclib.nhm.ac.uk/piclib/www/). Although other factors intervened, the illustrations that were completed closest to a live specimen possess the most vitality.

13. Collinson to John Bartram, May 17, 1768, Bartram Papers, 3:76, Historical Society of Pennsylvania, Philadelphia.

14. Collinson to John Bartram, February 16, 1768, Bartram Papers, 3:75; Collinson to William Bartram, July 18, 1768, Bartram Papers, 3:78; Collinson to John Bartram, February 17, 1768, Bartram Papers, 3:79. Art historian Michael Gaudio finds in Bartram's art a tension between "surface and depth"—between the flat, "transparent" truths of Linnaean taxonomy and the "subjective, opaque" and more "suspicious meanings" that point to, but never fully disclose, biography: see "Surface and Depth: The Art of Early American Natural History," in *Stuffing Birds, Pressing Plants, Shaping Knowledge: Natural History in North America, 1730–1860,* ed. Sue Ann Prince (Philadelphia: American Philosophical Society, 2003), 39.

15. Susan Scott Parrish provides an excellent gloss of the term in *American Curiosity: Cultures of Natural History in the Colonial British Atlantic World* (Chapel Hill: University of North Carolina Press, 2006), 57–59.

16. *Travels* lviii–lvix, liii–liv; Benjamin Smith Barton to William Bartram [with draft essay by Bartram on reverse], September 14, 1795, Bartram Papers, 1:9.

17. Conversation with Amanda Proctor, University of Mississippi, April 21, 2006.

18. Harper speculates that John and William saw the ixia during their winter 1765–66 tour in *The Travels of William Bartram: Naturalist Edition,* ed. Francis Harper (New Haven: Yale University Press, 1958), 360n; the *Calydorea caelestina* blooms April–June according to Walter Kingsley Taylor's *Florida Wildflowers in their Natural Communities* (Gainesville: University Press of Florida, 1986), 86; the description appears in the 1791 *Travels* (98), with engraving on the facing page; see the digitalized edition at http://docsouth.unc.edu/nc/bartram/menu.html. The ixia drawing was auctioned off following Peter Collinson's death, was later purchased by the Thirteenth Earl of Derby, and is now in the family's collection at Knowsley

Hall. Collinson responded to William Bartram on February 16, 1768, Bartram Papers, 3:73. The letter to Rush, December 5, 1767, is in the collection of the Library Company of Philadelphia, now held by the Historical Society of Pennsylvania (Rush Mss. 3). Edmund and Dorothy Smith Berkeley included William's description in *The Correspondence of John Bartram, 1773–1777* (Gainesville: University Press of Florida, 1992), 691–93; Nancy E. Hoffmann provides a more accurate transcription in "The Construction of William Bartram's Narrative Natural History: A Genetic Text of the Draft Manuscript for *Travels through North and South Carolina, Georgia, East & West Florida*" (Ph.D. diss., University of Pennsylvania, 1996), 300–302.

19. Bartram to Muhlenberg, September 8, 1792, Muhlenberg Corr. 21, Historical Society of Pennsylvania. Michel Foucault's seminal discussion of the tableau in *The Order of Things* (New York: Vintage, 1973) influenced Pamela Regis, *Describing Early America: Bartram, Jefferson, Crèvecoeur, and the Rhetoric of Natural History* (DeKalb: Northern Illinois University Press, 1992), 19–25; Donald Worster sets up a flattened dichotomy in the eighteenth-century mind between "Arcadian" nature (represented by Gilbert White) and the "imperial" embodied by Linnaeus; see *Nature's Economy: A History of Ecological Ideas* (New York: Cambridge University Press, 1994), 5–53.

20. James N. Green to the author, June 26, 2006.

3
Wonderful Entanglements

Louis Agassiz, Antoine Sonrel, and
the Challenge of the Medusa

Christoph Irmscher

"I have never felt more deeply the imperfection of our knowledge than in attempting to describe this beautiful representative of the genus Cyanea," declared Louis Agassiz in 1862. He was an acknowledged expert on marine invertebrates and therefore someone who should know what he was talking about:

> I can truly say that I have fully shared the surprise of casual observers, in noticing this gigantic Radiate stranded upon our beaches, and wondered what may be the meaning of all the different parts hanging from the lower surface of the large gelatinous disk. It is true that naturalists have long ago given particular names to all of them,—they have distinguished a mouth, a stomach, ovaries, tentacles, and even applied the name of eyes to some prominent specks on the margin. . . . [But] is that which is called a mouth, in Jellyfishes, truly a mouth? is the so-called stomach truly a stomach? are the so-called ovaries really ovaries? . . . have the parts designated as arms any resemblance to the upper limbs of the Vertebrates?[1]

This remarkable passage appears in the fourth volume of Agassiz's monumental monograph *Contributions to the Natural History of the United States of America* (1855–62), one of the most impressive accomplishments in nineteenth-century science writing. Or was it one of the most impressive failures? Intended to be a complete account, in ten oversized volumes, of the "mode of life of all our animals" and supported by payments from some twenty-five hundred subscribers, Agassiz's great work was never finished. Two out of the four lavishly illustrated volumes that he managed to publish were devoted to

creatures Agassiz himself admitted seemed the lowest of the low: the jelly-fish or medusae.

In the passage I have just quoted, Agassiz was writing about a particular jellyfish, the largest ever found, called the *Cyanea arctica,* now considered a subspecies of the *Cyanea capillata,* better known as "lion's mane." In the next paragraph, Agassiz gives us an extended description of the *Cyanea* that again flirts with images taken from the world of human experience. The medusa's long, toxic tentacles are like "floating tresses of hair," while the thicker lobes behind them seem like "rich curtains, loosely waving to and fro." Linnaeus, the father of modern biological taxonomy, was the first to note a resemblance between the stinging tentacles of jellyfish and the snaky locks of the Medusa, and it seems clear that Agassiz is alluding to this mythological image. But he realizes pretty quickly that standard comparisons won't do here. "The most active imagination," Agassiz admits, "is truly at a loss to discover, in such a creature, any thing that recalls the animals with which we ourselves are most closely allied. There is no head, no body, there are no limbs" (*Contributions* 4:89).

Words fail us when we try to describe this animal. All the questions we ask of nature have to be formulated in language, as do the answers we find. But language inevitably returns us to a world shaped by our own notions and expectations, and that is, Agassiz realizes, *not* the world of the medusa. Evidently, the term "medusa" itself isn't appropriate. And if the jellyfish is not really a medusa, it's not really a fish either. Nor is it really made of jelly. Agassiz's prose brilliantly confronts this problem, dancing around its own insufficiency.

Consider now the illustration of the *Cyanea* that Agassiz included in *Contributions* (fig. 11). It was produced by Antoine Sonrel (d. 1879), Agassiz's favorite illustrator. Spilling down the page, the *Cyanea* seems otherworldly, a spectacle of fragile and mysterious beauty, a phantasma more than a natural history specimen. Sonrel seems to revel in the contrast he has developed between the medusa's thin, wispy appendages occupying the lower two-thirds of the page and the bulging shapes that loom behind them in the upper third. More persistent viewers who still want to think of this creature in terms of the human face and of human hair will be sobered by the explanation, offered in Agassiz's text, that the "mouth" we're looking at is actually the creature's digestive cavity and that the two sacs we see precisely where the "eyes" would be are, in fact, the genital pouches. But we don't really need Agassiz's commentary to understand the picture. Sonrel's illus-

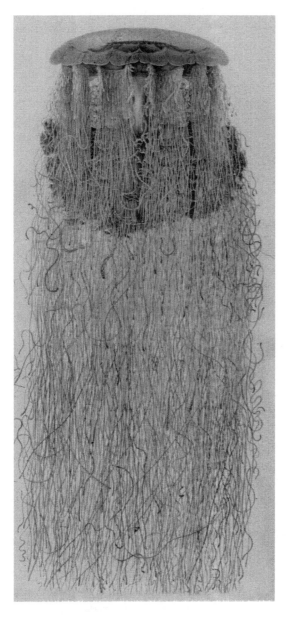

11. Antoine Sonrel, *Cyanea arctica,* ca. 1860. Lithograph published in Louis Agassiz, *Contributions to the Natural History of the United States of America* (1855–62), vol. 3, plate 4.

tration radically confronts us with, and in fact revels in, the reality of a life utterly different from ours, infinitely more complex than can be captured in language limited by the narrow horizon of human self-experience.

This essay addresses Agassiz's lifelong obsession with visual representation as manifested in his collaboration with Sonrel, one of the most extraordinary natural history illustrators I've encountered. I am interested especially in the extent to which their work on marine invertebrates amounts to a critique of what Edward O. Wilson has called "self-indulgent anthropocentrism."[2] Anthropomorphic thinking, often taken to be a direct expression and consequence of the unexamined notion that humans are primary among the diversity of beings, had come under fire at just about the same time that Agassiz got involved in his research on medusae. In his *Sea-side Studies* (1860), George Eliot's husband, the critic and philosopher George Henry Lewes, cautioned against attributing "irritation" or "alarm" to sea anemones, an approach that he felt was detrimental to "scientific seriousness." To claim that mollusks "see," he said, does justice to neither the mollusk nor its human observer: "Molluscan vision is not human vision; nor in accurate language is it vision at all."[3] Now anthropomorphism isn't necessarily an indication of bad science. Some (like Immanuel Kant, who makes a careful distinction between "dogmatic" and "symbolic" anthropomorphism)[4] consider it a useful tool; some even think it might very well be unavoidable. But anthropomorphic thinking becomes problematic when it stunts our appreciation of the full complexity of nature and, to paraphrase Tom Tyler, when it restricts the fullness of what we can think both about ourselves and other animals.[5]

~

Born in 1807 in Motier, Switzerland, Louis Agassiz was one of the world's most revered scientists when he arrived in Boston in 1846, ostensibly to give a few lectures and to see for himself the fauna of the New World. He stayed for almost three decades, during which he revolutionized the way natural history was taught in American schools and colleges. He also became one of Darwin's fiercest opponents, risking his reputation to delay the acceptance of evolution in the United States. At the time of his premature death, in December 1873, from a combination of overwork and ill health, he had just put the finishing touches on yet another refutation of his archenemy. As far as Louis Agassiz was concerned, the promise of the first paragraph of Darwin's book—that some light might be thrown on "that mystery of mysteries, the origin of species"—was still unfulfilled. Darwin had offered "only a conjecture," and not even the best one.[6]

Unsurprisingly, Agassiz has few serious admirers today. Historians of science shun him for his stubborn resistance to Darwinism, and the discovery of his degrading photographs of southern slaves and Brazilian natives hasn't helped him find favor with cultural historians either.[7] But, in his own time, the European-born Agassiz, whom Emerson considered one of "My Men," was second to none in terms of his influence on American science, culture, even literature.[8] He was the Stephen Jay Gould of his time, worth a second look today if only because he so fervently believed that science should be part of the fabric of society, a communal effort, not the pursuit of the experts: "The results of science," Agassiz argued in *Methods of Study in Natural History,* his most popular book, "should not be kept, like the learning of the Egyptians, for an exclusive priesthood who may expound the oracle according to their own theories, but should make a part of all our intellectual culture."[9]

Even before he came to the United States in 1846, Agassiz was known for his limitless ambition, as someone who cheerfully ignored whatever restrictions had been imposed on him by chance or circumstance. He became a naturalist even though his family wanted him to be a doctor. He grew up in a vicarage in a remote Swiss village and became the protégé of the likes of Georges Cuvier and Alexander von Humboldt. And he became a marine biologist before he had ever seen an ocean. The sea and the creatures inhabiting it held powerful sway over his imagination, as they did over those of many of his Victorian contemporaries. "With Earth's surface mostly mapped and the readily visible life forms largely described and catalogued," naturalists turned to the depths of the sea and began to educate larger audiences about what they found there.[10] Fueled by accessibly written handbooks such as British naturalist Philip Henry Gosse's *The Aquarium* (1854), Charles Kingsley's *Glaucus* (1855), or Lewes's *Sea-side Studies,* the aquarium craze quickly swept to the other side of the Atlantic. Having underwater creatures in the house was not only instructive and fun, it was also inexpensive. A parlor aquarium could be endlessly and easily restocked as a result of the rock-pooling excursions that Gosse, Kingsley, and other naturalists also helped to make popular. As Lewes quipped, sea anemones were less troublesome to keep around the house than a hippopotamus.[11] For those who shied away from the effort, public museums soon included lavish displays of live marine animals. In 1858, the Boston Aquarial Gardens opened their doors.

When Agassiz first arrived in Boston, coming from landlocked Switzerland, he was barely able to contain his excitement over being able to see, for

the first time and in the flesh, the creatures he had, for so long, studied only in a fossilized state or preserved in the glass cases of natural history museums. Interestingly enough, his attention soon turned to jellyfish, extremely fragile marine organisms that, since they had the reputation of being poisonous, did not usually make it into the Victorian parlor aquarium. In 1850 Agassiz published a long article in *Memoirs of the American Academy of Arts and Sciences* about the new genus of naked-eye medusae that he had established.[12] Asserting, on the very first page, that there was "a deep scientific interest connected with the subject," Agassiz professes to be still overwhelmed by all the new things he has seen since he first came to the United States; his eyes, he declares, have "hardly yet fully opened." Powerful emotions seep into his scientific prose. Amid a profusion of detail, talk of a medusa's epithelium, chymiferous tubes, pennate muscular bundles, and nervous plexuscs, Agassiz himself, the questioning, puzzled, and infinitely excited investigator, remains always present, admitting, for example, that he is a newcomer to the field or that the evidence he has gathered is not always conclusive: "I must confess that I never met with more perplexing difficulties than those I experienced in satisfying myself of the real nature of what so clearly seemed a structure, which always vanished under certain influences of light, while it was so plain under others" (*Memoirs* 282). The proper way of seeing animals like the small *Sarsia* that refuse to be observed under other than special circumstances—at night, with a small candle placed behind a glass jar— becomes the hidden theme of his article:

> It is indeed a wonderful sight, to see a little animal not larger than a hazel-nut, as soft as jelly, as perishable as an air-bubble, run actively through as dense a medium as water, pause at times and stretch its tentacles, and now dart suddenly into one direction or another, turn round upon itself, and move suddenly in the opposite direction, describe spirals like a bird of prey rising in the air, or shoot in a straight line like an arrow, and perform all these movements with as much grace and precision, and elongate and contract its tentacles, throw them at its prey, and secure, in that way, its food, with as much certainty, as could a larger animal provided with flesh and bones, teeth and claws, and all the different soft and hard parts which we consider generally as indispensable requisites for energetic action; though these little creatures are, strictly speaking, nothing more than a little mass of cellular gelatinous tissue.
> (*Memoirs* 230)

Agassiz's long sentence is clearly constructed for rhetorical effect. He begins with the attributes of the jellyfish (softness, smallness, perishableness, transparency) and ends with those of the kind of animal a jellyfish is *not*. But the clear implication is, at least for now, that a mass of gelatin, a heap of cells (as Agassiz says elsewhere), can, if in different ways, do all that we take for granted in a much larger, firm-bodied animal. So much energy, so much activity, so much evidence of volition, such powerful movements, such a voracious appetite—wouldn't that lead us to expect a far more complicated structure than the "primitive simplicity" that characterizes the jellyfish? Or is it not so primitive, after all? Note that, in the passage above, all the comparisons Agassiz offers (jellyfish are like a hazelnut, an air bubble, a bird of prey, an arrow and, finally, a "large animal," which, significantly, remains unnamed) follow from the simple attempt to take a closer look at this little animal and to understand it on its own terms.

~

Jellyfish, then, posed particular problems to one of the most sophisticated human observers of the nineteenth century; indeed, they offered a perceptual as well as an epistemological challenge. At the beginning of the third volume of his *Contributions,* Agassiz picks up where he left off in 1850 and re-creates an encounter any one of his readers might have had walking on the beach and finding one of these strange, watery creatures washed ashore by the now receding tide. We pick it up, we look at it, we touch and destroy it, yet we still haven't learned a thing. As the jellyfish "melts away" on our naked, clumsily interfering hand, so does our knowledge of its "slight" existence, unless we take our looking seriously: "When we first observe a jelly-fish, it appears like a moving fleshy mass, seemingly destitute of organization; next we may observe its motions, contracting and expanding, while it floats near the surface of the water. Upon touching it, we may feel the burning sensation it produces upon the naked hand, and perhaps perceive also that it has a central opening, a sort of mouth, through which it introduces its food into the interior. Again, we cannot but be struck with their slight consistency, and the rapidity with which they melt away when taken out of the water" (*Contributions* 3:4). As we move from our first impressions to a more informed sense of how each perceived detail will assume its place within a larger context, the microscopic becomes the macroscopic. Where there was a jellyfish we see the world:

But it is not until our methods of investigation have improved; and when, after repeated failures, we have learned how to handle and treat

them, that we begin to perceive how remarkable and complicated their internal structure is;—it is not until we have become acquainted with a large number of their different kinds that we perceive how greatly diversified they are;—it is not until we have had an opportunity of tracing their development, that we perceive how wide the range of their class really is;—it is not until we have extended our comparisons to almost every type of the animal kingdom, that we can be prepared to determine their general affinity, the natural limits of the type to which they belong, the distinct characteristics of their class, the gradation of their orders, and the peculiarities that may distinguish their families, their genera, and their species. (*Contributions* 3:4)

This extraordinarily well-crafted passage accomplishes several purposes. First, though it is part of a learned work of natural history, it suggests that the scientist's perspective is not much different from that of an ordinary observer. Seeing an animal for the first time, "we" all begin in a state of comparative ignorance. The sting of the jellyfish comes as a surprise to us, and we do not yet know what to make of the "central opening" in the middle of its bell-shaped body. All we see is a shapeless gelatinous mass. Descartes famously argued against relying too much on our senses in our dealings with nature: a sensation of tickling caused by a feather does not resemble anything *in* the feather.[13] But far from excluding such evidence, Agassiz's approach to nature, in fact, depends on it—on what the naked, incautious hand, burning from the unexpected encounter, feels, or what the eye, straining to give shape and meaning to what seems to have no definite outline, has perceived. Slowly, step by step, our familiarity with this creature increases. *Really* understanding it, however, involves much more than repeated observations. It means looking at what's inside that transparent mass, looking at other animals unlike it, and watching its development from the egg to adulthood. The repetition of "how" ("how remarkable and complicated"; "how wide"; "how greatly diversified") indicates the vastness of conclusions that can be drawn from our experience of this one blubbery mass, so soft that it quickly dissolves when taken out of its element. It is no coincidence that Agassiz's passage ends with "species," a word that had become a cornerstone of his attacks on Darwin, who regarded species as the subjective constructions of the taxonomist.

In a sense, Agassiz's riff about touching a jellyfish (deliberately left unnamed here) also re-creates, in a nutshell, the history of the study of "acalephs" (the class to which Agassiz believed the medusae belong) as Agassiz

describes it in the first chapter of the third volume of *Contributions:* from Aristotle's sketchy account ("They have the mouth in the middle, and live from the rocks as from a shell") to Michael Sars's papers on the developmental stages of medusae, published in Norway in the 1830s and 1840s, to the present moment, distinguished by Agassiz's own efforts. What Agassiz's summary conveys is the extraordinary complexity of the subject—weighty tomes have been devoted to animals that dissolve into nothing as we try to hold them in our hands. Ironically, though the entire passage about the jellyfish is cast in terms of a religious revelation (first we see through a glass darkly, but then we shall see all), the process itself (our looking, touching, feeling) seems much more important than the result. For Agassiz, the "primary consideration in education" was, as he explained in one of his annual reports to the members of the Massachusetts legislature, to teach his students "how to observe." From the beginning, he placed specimens rather than books in their hands, watching them constantly as they were dealing with them, until he had ascertained "what are their ability of seeing for themselves, and their aptitude for this kind of studies."[14] Seeing, not reading, was Agassiz's educational mantra (the only textbook he accepted was the Book of Nature itself).[15] And, as Agassiz never tired of pointing out, nature observation was serious business. In *Methods of Study in Natural History* he recommended that under certain circumstances the student pursuing microscopic research adhere to "a special diet before undertaking his investigation, in order that even the beating of his arteries may not disturb the steadiness of his glance."[16] The inconvenient fact that jellyfish are notoriously hard to watch, far from being a deterrent, is actually further grist for Agassiz's mill, yet more proof that natural history is hard, to be pursued only by those who don't give up easily and who learn to see properly.

~

For all his obvious love of words, his fond indulgence for rhetorical flourishes, then, Agassiz was entranced with nonverbal, visual ways of understanding and representing nature. His lovely claim that the draftsman's pencil was "one of the best eyes" comes to mind,[17] as do the blackboard sketches that the ambidextrous Agassiz himself produced, to the delight of his popular audiences. "He would lead his listeners along the successive phases of insect development," writes his wife, Elizabeth, and first biographer, "talking as he drew and drawing as he talked, till suddenly the winged creature stood declared upon the blackboard, almost as if it had burst then and there from the chrysalis, and the growing interest of his hearers culminated in a

burst of delighted applause."[18] Agassiz's chalk outlines "were what few artists could make," wrote Theodore Lyman, his longtime assistant, in a tribute published shortly after the master's death.[19] And Ernest Longfellow, the poet's son and a professional (though not lavishly talented) painter himself, recalled what a "treat" it was to "see a perfect fish or skeleton" develop under Agassiz's hand "with extraordinary sureness and perfect knowledge, without any hesitation or correcting, like a Japanese drawing in its truth to nature, and it seemed a shame that such beautiful drawings were only in chalk and had to be rubbed out again."[20] Newspaper transcripts of Agassiz's public lectures were sprinkled with phrases such as "Illustrates from board" or (in a more extreme case) "Illustrates from diagrams which cover the whole wall of the hall." In one of these accounts, the faithful transcriber, after several such asides, released a cry of frustration: "It is difficult to convey a correct idea without these illustrations; hence the pre-eminent value of Prof. Agassiz's lectures above any idea of them conveyed on paper."[21]

In print, Agassiz relied on the skills of his illustrators. When he was Professor of Natural History in Neuchâtel, Agassiz founded his own lithographic establishment, employing several illustrators who worked exclusively for him, a practice he continued in the United States. According to Lyman, Agassiz was a "pitiless critic of a zoological drawing" and was rarely satisfied even with the "finest work." However, "the man who never failed to please him was Sonrel."[22] We know very little about Sonrel's life, except that he was born in Nancy and that he died in 1879 in Woburn, Massachusetts (where a street is named after him). Even his first name is uncertain: in French documents he shows up as "Auguste," but his death notice lists him as "Antoine."[23] In 1848 he left Europe to join Agassiz in Boston and found employment as a lithographer with the firm of Tappan and Bradford. But he had brought his own lithographic equipment and presses with him, and in 1850 he was able to open his own shop in Boston, establishing a reputation as one of the finest scientific illustrators of his time. When Agassiz published his essay on the naked-eye medusae in 1850, the illustrations were Sonrel's. Without Sonrel's help, Agassiz declared, without his "quickness in seizing the characteristic features of organized beings, and in reproducing them with a delicate touch," he would not have been able to conjure up anything for his audience (*Memoirs* 222).

For the paleontologist Agassiz, who had spent years studying the marks and scratches left by glaciers on the rocks and mountains of the world, "stone-drawing" (to use the literal translation of "lithography") seemed an

eminently suitable medium for natural history illustration. Agassiz would never forget a moment in his life decades before when, during a visit to a museum in Germany, he saw a perfect impression of a fossilized medusa on two slabs of slate, the pliable, watery creature immortalized in the rock: "The impression made upon my mind, by the preservation, through countless ages, of an animal so soft as a jelly-fish, was so vivid, that, although I have never seen those fossils since, I well remember their general appearance" (*Contributions* 3:125). What else did nature itself do but draw in stone?

Along came Sonrel, who had made a career out of doing deliberately and with great perfection what nature did so casually, so effortlessly. Jellyfish consist of 98 percent water and lose their shape immediately when taken out of their element, which is why Sonrel would draw their likenesses directly on the stone, using specimens he had freshly netted or watched swimming in the water off the coast of Massachusetts. But no human observer, Sonrel included, would have come across a medusa just as it appears in his representation of the *Cyanea* (see fig. 11), drifting lazily against a calm white paper background. In order to behold the medusa in its full glory, Agassiz's reader had to fold out the plate, only to be told in the notes accompanying it that the actual specimen depicted, "an adult of ordinary size," had in fact been four times larger ("Explanation of the Plates," *Contributions* 3:[7]).

In Sonrel's drawing, the lower ends of the tentacles are rather unceremoniously cut off—a reminder that this image is not the real thing, but just that: an image, a representation. "When perfectly undisturbed," writes Agassiz, "the tentacles may be extended to an extraordinary length" ("Explanation," *Contributions* 3:[7]). But now look at the right and left margins of the picture: by refusing to cut the tentacles off there, by letting them undulate beyond the lithograph's inked border, Sonrel seems to be telling us the opposite. Somewhere out there was, indeed, a real animal, disturbed by the artist's hand so that he could make its portrait. The medusa as we see it in Sonrel's drawing is at the same time found and constructed, its representation an act of both discovery and invention, to modify terms I have taken from Lawrence Buell's *Writing for an Endangered World*.[24]

Agassiz knew how much he owed to Sonrel's skill. Normally, he regarded research that had been performed for him, either at his museum in Cambridge or his lab in Nahant, as his property: its authors had to be acknowledged, but only as part of the institutional framework within which they had produced their results.[25] In 1863, for example, he severed his relationship with his assistant and most promising student, Henry James Clark (an ex-

cellent microscopist, who had executed many of the original drawings for the lithographs in *Contributions*), when the latter complained that his share hadn't been announced more prominently.[26] But these rules didn't apply to Sonrel's work. His artistic vision put him in a class of his own; he was no mere laborer in Agassiz's scientific vineyard. In the course of a long passage comparing the *Cyanea* with another species of medusa, the *Aurelia,* Agassiz's praise for Sonrel's extraordinary skill quickly turns into praise for the complexity of the living, moving thing that his artist has captured so well in a medium so little suited for the representation of life:

> I cannot suppress my admiration for the skill with which Mr. Sonrel has reproduced all these tentacles in their wonderful entanglement, and yet with such distinctness, that every one may be traced in unbroken continuity, from its point of attachment to the furthest distance to which it stretches. He has succeeded in giving them all the variety of aspect which they present in active motion, when in the same bunch some of the tentacles may be entirely drawn in to within a fraction of an inch of their point of attachment, and others stretched to their utmost length, while others, again, wave from one bunch across the other bunches, or flow in undulating lines, or bend upon themselves, or are twisted in a spiral, and still others appear like heavy leads sinking among the rest. (*Contributions* 4:101–2)

Agassiz deliberately emphasizes the difference between visual and verbal representation, making his words strain to capture, for the reader's ear, the very same impression Sonrel's drawing produces instantaneously for the viewer—that of a multifaceted organism in constant flux. Note how syntax ("when . . . and others . . . while others, again . . . or . . . or . . . or . . . and still others") and sound ("*ten*tacles . . . en*t*anglement"; "*within* a *f*raction *of* an *i*nch"; "undu-*l*ating *l*ines") work together to "entangle" the reader in an experience that, as Agassiz realizes, defies conventional methods of representation.

Another lithograph Agassiz includes in the same volume gives us a view of the surface of the *Cyanea*'s disk (fig. 12). Agassiz's accompanying text reveals that here Sonrel's skill was put to the test even more than before: "it must be borne in mind . . . that what might be taken for lines upon the surface of the disk, are, in reality, the optical effect of parts occupying the thickness of the disk, and its lower surface." Agassiz reaches for a metaphor to describe what words cannot convey, namely, the unequal transparency of the

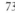

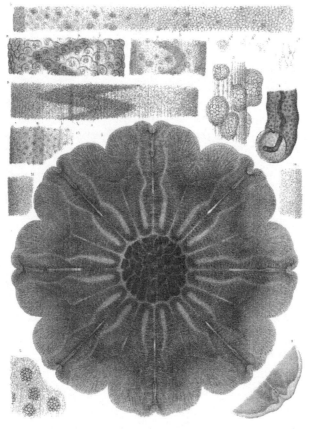

12. Antoine Sonrel, *Cyanea arctica*, ca. 1860. Published in Louis Agassiz, *Contributions to the Natural History of the United States of America* (1855–62), vol. 3, plate 5.

disk, thick in some places, thinner in others—an impression Sonrel's image captures effortlessly: "It is as if a mass of transparent jelly of a flat, hemispheric form, was resting upon a surface adorned with various structural details, which could all readily be seen through the jelly" (*Contributions* 4:92).

Unlike Sonrel's lithograph seen in figure 11, this illustration is more of a diagram, complete with letters and numbers keyed to the explanations Agassiz provides elsewhere in this section. Sonrel gives us a plethora of structural details here; the *Cyanea* appears not as an organic whole but as the sum of its many parts. The straight edges of the segments of lobes, appendages, tentacles show the effects of the naturalist's relentless knife. Surrounded by sev-

ered limbs and magnified cells, the tessellated disk of the *Cyanea,* spared by the naturalist, has remained intact. Intricately patterned and luminous, it sends the viewer, once again, groping for analogies.

~

An interesting difference emerges between Agassiz and Sonrel's treatment of the *Cyanea* and the representation of jellyfish in the works of Agassiz's hotheaded contemporary, Ernst Haeckel. If Huxley was "Darwin's bulldog" in England, Haeckel was his "German shepherd" on the Continent, a prolific and aggressive polemicist but also a consummate artist.[27] Entranced, like Agassiz, with the sinuous curves of marine animals, Haeckel attacked Darwin's American opponent wherever and whenever he could, finding fault with his theories, classifications, and morphological descriptions. When we turn to Haeckel's own prose, however, in *Das System der Medusen* (1880) as well as in the later *Kunstformen der Natur* (1899–1904), we discover, to our surprise, that here the proud harbinger of scientific progress still thinks about jellyfish in unabashedly anthropomorphic terms, to the extent that he names two of them, the small *Mitrocoma Annae* and the large *Desmonema Annasethe,* after his deceased first wife, Anna Sethe, of whose beauty and blond hair he had been powerfully reminded when contemplating these elusive creatures.[28] Haeckel's decorous language prettifies even the medusa's sexual organs, such as the "enticingly ruffled" gonad, which hangs suspended from a "delicate light yellow apron" or "Geschlechtsgardine" (literally translated, a "genital drape").[29]

Haeckel's own drawings regularly "improve on" the specimens he is depicting, creating swirling tableaux of flowing lines and perfect symmetry that seem to have more in common with the conventions of art nouveau than the organisms he had observed.[30] In plate 8 of his *Kunstformen,* for example, Haeckel arranges three specimens—all of them known as Discomedusae—as if they were performing a kind of ballet (fig. 13). Here the main purpose seems to be to create the impression of weightlessness. The two smaller medusae in, respectively, the lower-right and the upper-left corners of the composition mark an invisible diagonal that intersects with the visible and much stronger diagonal connecting the upper right with the lower left, embodied by Haeckel's favorite medusa with its sinuous tentacles, the *Desmonema Annasethe.* So strong is that diagonal, striving against the gravitational pull, that it overrules the more conventional, diagram-like view of the medusa's disk seen from below that Haeckel gives us in the center of the lower third of the picture. Scientific seeing is pushed aside by the artist's view of nature. By con-

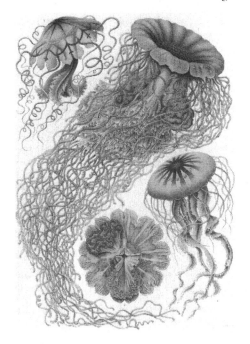

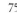

13. Ernst Haeckel, *Discomedusae,* published in *Kunstformen der Natur* (Leipzig, 1899–1904), plate 8. Courtesy, The Lilly Library, Indiana University, Bloomington.

trast, Sonrel's vertical *Cyanea* occupies its own separate space, keeping its distance from the viewer. Haeckel's superficially more dynamic composition invites the creature to come closer and to try out different angles of vision. At the same time, his diagonals have a stability of their own: what could be a field of force is in fact a pattern.[31] Haeckel's "jellyfish love" manifested itself also in his home in Jena, the "Villa Medusa," where the sinuous forms of the medusae ornamented his ceilings, his furniture, his porcelain, and his velvet cushions.[32]

That Sonrel's love of visual detail had served as an inspiration for *Kunstformen* is evident. While Haeckel has nothing good to say about Agassiz himself, calling him the "most ingenious and busiest swindler in the entire field of natural history," he praises Sonrel's "prachtvolle Figuren" (splendid illustrations) to the skies.[33] It is interesting to see how, in the case of Agassiz versus Haeckel, the more progressive thinker of the two—Haeckel being the creator, in fact, of the modern concept of *Ökologie,* "ecology"—turns out to be more traditional when it comes to the proper representation of nature, a reminder that in the history of nineteenth-century culture the battle lines may not always be so clearly drawn. Haeckel didn't distort his images out of

necessity, but purposefully, out of a strong conviction that the human self has a right to change what it sees, while Sonrel, whose plates of the *Cyanea* point to a reality the illustrator's pen cannot capture, didn't take the dominance of the human point of view for granted.[34]

Featuring a world alien to the human observer, the plates Sonrel produced for Agassiz's book aren't just visual aids. Instead, they offer an illuminating and often provocative commentary on the kind of science Agassiz advocated. In numerous public lectures and essays, he had repeated his firm opposition to Darwin, arguing that the many forms of life on earth were merely God's "different modes of treating the same material."[35] It was the scientist's task, as the humble "translator of the thoughts of God," to retrace the outlines of the preconceived divine plan, which had been executed "with the definite object of introducing man upon the earth."[36] But the plates Agassiz commissioned for his great work (as well as Agassiz's own prose) implicitly question that simple anthropocentric argument. Sonrel's illustrations identify and, in eco-critical fashion, *reinforce* a central contradiction in Agassiz's work: the objects he depicts—an army of young turtles glaring at the viewer, a partially dissected cannonball jellyfish drifting silently on a white page—always exceed the static framework of the human ordering system the scientist wanted to impose on it. Sonrel's plates gesture beyond their frames, at a world no human imagination can, at least currently, fully grasp. A medusa is an infinitely complex living being; it is not, to use the anti-evolutionist Michael Behe's now infamous image, a mousetrap. In the final analysis, Agassiz and Sonrel would prove to be unlikely patron saints for the Discovery Institute and the Intelligent Design enthusiasts that have rallied around it.[37]

~

Ernest Longfellow, though he admired Agassiz's fugitive blackboard drawings, had only disdain for the hope the "poor dear man" harbored that science and art could be made one: "A slavish copying of nature is not art, and art does not concern itself with fauna and geological periods, but with the impression a particular scene or effect has on the spectator and can be made to have on the imagination of others."[38] Longfellow's characterization of Agassiz's alleged category mistake (confusing illustration, as a slavish copying of nature, and true art liberated from such constraints) is typical even of modern approaches to the genre of scientific illustration, which has been largely shunned by art historians.[39] Lithographs especially seem to question traditional conceptions of art: living on in multiple reproductions, they deprive the original image of its uniqueness and authenticity.[40] But lithographs

also challenge—since they are, after all, based on hand-drawn designs—the traditional expectations of the scientist, for whom images are "pictorial devices" rather than the result of choices made by an individual artist and for whom the primary mode of scientific representation is linguistic.[41] In Agassiz's *Contributions,* Sonrel's intense drawings straddle that murky, worrisome, but also, I happen to believe, exciting zone between art and science: they are contrived enough to be more than a mere record of a sighting and precise enough to serve the purposes of accurate scientific information (a key to marine invertebrates published by the Marine Biological Laboratory in Woods Hole still uses, without attribution to Sonrel, a modified version of the lithograph from Agassiz's *Contributions*).[42] They inhabit what Vladimir Nabokov—a novelist as well as an accomplished entomologist—once called "the high ridge where the mountainside of 'scientific' knowledge joins the opposite 'slope' of artistic imagination."[43]

Like Agassiz's science, lithography, too, eventually became obsolete. Far swifter than the hand that draws, to paraphrase Walter Benjamin, is the eye looking through a lens. Remarkably, Sonrel easily transitioned to the new medium of photography. In an article published in 1871, Agassiz's son and successor, Alexander, predicted that photographic illustrations would yield "figures with an amount of detail which the great expense of engraving or lithographing would usually make impossible."[44] As a test case, he included a photograph from his work in progress, *Revision of the Echini,* provided by none other than Sonrel himself.[45] The illustration, which shows an organism called *Arbacia punctulata,* better known as the purple sea urchin, had been produced, to startling effect, with the help of the Albert technique, a process that requires the treatment of a glass plate with bichromated gelatin (fig. 14).

With its bristling spines extended, Alexander Agassiz's sea urchin, seen from the top, looks stranger and more threatening than its harmless nickname, "porcupine of the sea," would lead us to expect. The photograph is clearer, less overtly fantastic than Sonrel's earlier lithograph of the medusa, but somehow it doesn't show us a world that seems more comprehensible in human terms either. Because the intervening hand of the artist is less visible, the photographed object would seem more immediate, more ready to engage us than the lithographed *Cyanea.* And yet it doesn't. Seen against its white background, Alexander Agassiz's purple sea urchin looks more like the spiked ball used in medieval weaponry than something cute and collectible

14. Antoine Sonrel, *Arbacia* (or *Echinodaris*) *punctulata,* published in Alexander Agassiz, "Application of Photography to Illustrations of Natural History," *Bulletin of the Museum of Comparative Zoology* 3, no. 2 (1871): 47–48. From the Archives of the Ernst Mayr Library of the Museum of Comparative Zoology, Harvard University, Cambridge, Massachusetts.

one would find on the beach. But does it? Once again, our quest to find familiarity where there is none is frustrated.

Sonrel was able to turn the same defamiliarizing gaze that distinguishes his natural history pictures on the humans around him. A strange photographic montage from the later part of his career shows none other than Louis Agassiz himself facing, well, Louis Agassiz (fig. 15). On the right, Agassiz no. 1 seems to be engaged in writing, his head bent in concentration over a small notebook. His doppelgänger on the left, however, Agassiz no. 2, is apparently finished with his task. Before him the little notebook is still open; the pen remains poised in the left hand. Agassiz's right hand is resting comfortably on his thigh. Is he waiting for the ink to dry? Or is he about to *begin?*

Stereoscopic views, popular at the time, duplicated the same object, taken from slightly different angles, to create the illusion of depth when the photographs were viewed through a special instrument that allowed the two im-

15. Antoine Sonrel, "Louis Ag
assiz (speaking with himself),"
ca. 1871. Albumen print, carte
de visite. From the Archives
of the Ernst Mayr Library of
the Museum of Comparative
Zoology, Harvard University,
Cambridge, Massachusetts.

ages to be seen as one. Sonrel alludes to this technique, but by providing dif-
ferent views of the same person in *one* portrait, he intentionally confuses the
beholder, substituting two images where we would expect to see only one.
Late-nineteenth-century photographers developed such double portraits in
part because they were a neat trick (after the first exposure, the subject of the
photograph quickly had to move into a different position so that the second
half of the picture could be made).[46] But Sonrel's double portrait of Agassiz
isn't mere gimmickry. To be sure, duplication has a comical effect, as Henri
Bergson has taught us. But it is unsettling, too, threatening to take away what
seems to make humans human.[47] Duplicated by the lens of Sonrel's camera,
Agassiz the scientist seems poised to become like one of his specimens.

But maybe that's not such a bad thing, after all. Whether he was drawing
a medusa off the coast of Massachusetts, photographing a sea urchin, or por-
traying the scientist in his parlor, Sonrel, working at Agassiz's behest, drew
our attention not only to what we see but to *how* we see. He challenged the

unified point of view through which the human observer of nature seeks to establish himself, mistakenly, as the lord of all he surveys. The *Cyanea arctica,* incidentally, has eight eyes, hooded by folds rising from the margins of the disk. Here's looking at you.

Notes

My research for this project was supported by a grant from the National Endowment for the Humanities. Thanks are due also to Dana Fisher of the Ernst Mayr Library, Museum of Comparative Zoology, Harvard University.

1. Louis Agassiz, *Contributions to the Natural History of the United States of America,* 4 vols. (Boston: Little, Brown, 1857–62), 4:87. Cited hereafter in the text as *Contributions.*

2. Edward O. Wilson, *On Human Nature* (Cambridge, Mass.: Harvard University Press, 1978), 17.

3. George Henry Lewes, *Sea-side Studies at Ilfracombe, Tenby, the Scilly Isles, & Jersey* (Edinburgh: Blackwood, 1858), 255, 341–42.

4. Immanuel Kant, *Prolegomena zu einer jeden künftigen Metaphysik,* ed. Karl Vorländer (1783; 6th ed. Hamburg: Felix Meiner, 1920), sec. 57, 129. See Sandra D. Mitchell, "Anthropomorphism: Cross-Species Modeling," in *Thinking with Animals: New Perspectives on Anthropomorphism,* ed. Lorraine Daston and Gregg Mitman (New York: Columbia University Press, 2005), 100–117.

5. Tom Tyler, "If Horses Had Hands . . ." *Society & Animals* 11, no. 3 (2003): 267–81.

6. Charles Darwin, *The Origin of Species,* ed. Gillian Beer (1859; Oxford: Oxford University Press, 1996), 3; Louis Agassiz, "Evolution and Permanence of Type" (1874), in *The Intelligence of Louis Agassiz: A Specimen Book of Scientific Writings,* ed. Guy Davenport (Boston: Beacon, 1963), 232.

7. See Brian Wallis, "Black Bodies, White Science: Louis Agassiz's Slave Daguerreotypes," *American Art* 9, no. 2 (1995): 39–61; Christoph Irmscher, "Agassiz Agonistes," in his *The Poetics of Natural History: From John Bartram to William James* (New Brunswick, N.J.: Rutgers University Press, 1999), 236–81.

8. Ralph Waldo Emerson, journal entry, June 1871, in *The Heart of Emerson's Journals,* ed. Bliss Perry (1926; New York: Dover, 1995), 331.

9. Louis Agassiz, *Methods of Study in Natural History* (Boston: Ticknor and Fields, 1863), 43.

10. Manfred Laubichler, "Nature's Beauty and Haeckel's Talents," *Science,* June 17, 2005, 1746.

11. See Lewes, *Sea-side Studies,* 115–16; Lynn Barber, *The Heyday of Natural History, 1820–1870* (London: Cape, 1980), 121.

12. Louis Agassiz, "Contributions to the Natural History of the Acalephae of North America. Part I: On the Naked-Eyed Medusae of the Shores of Massachusetts," *Memoirs of the American Academy of Arts and Sciences,* n.s., 4 (1850): 221–316. Cited hereafter in the text as *Memoirs.*

13. For Descartes, visualization was a source of error in the sciences; he argued that our perceptions have merely mental status and that sensation is an unreliable source of knowledge. See Brian Baigrie, "Descartes's Scientific Illustrations and 'la grande mécanique de la nature,'" in *Picturing Knowledge: Historical and Philosophical Problems Concerning the Use of Art in Science,* ed. Baigrie (Toronto: University of Toronto Press, 1996), 86–134; see also 129 n. 3.

14. "Fifth Annual Report of the Director of the Museum of Comparative Zoology, by Louis Agassiz," *Annual Report of the Trustees of the Museum of Comparative Zoology, Together with the Report of the Director, 1863* (Boston: Wright & Potter, 1864), 7.

15. Though he owned a large library, Agassiz apparently didn't treat his books very well. In manuscript notes, his shocked sister-in-law, Emma Forbes Cary, mentions the "valuable books in shabby bindings" that Agassiz kept in "common wooden book-cases." See Lucy Allen Paton, *Elizabeth Agassiz: A Biography* (Boston: Houghton Mifflin, 1919), 45. Unlike the sacrosanct specimens in his museum, books, for Agassiz, were *tools,* to be used and, frequently, argued with—viz. his own profusely (and passionately) annotated copies of Darwin's *Origin of Species* and Haeckel's *Natürliche Schöpfungsgeschichte* are now kept in the Special Collections of the Ernst Mayr Library at the Museum of Comparative Zoology, Harvard University.

16. Agassiz, *Methods,* 297.

17. Samuel H. Scudder, "In the Laboratory with Agassiz," *Every Saturday,* April 4, 1874, 369–70.

18. Elizabeth Cary Agassiz, *Louis Agassiz: His Life and Correspondence,* 2 vols. (Boston: Houghton Mifflin, 1886), 2:406.

19. Theodore Lyman, "Recollections of Agassiz," *Atlantic Monthly,* February 1874, 225.

20. Ernest Longfellow, *Random Memories* (Boston: Houghton Mifflin, 1922), 28.

21. "Lectures on Natural History: Professor Agassiz' Third Lecture," *Supplement to the Connecticut Courant,* January 8, 1848, 6–7.

22. Lyman, "Recollections," 225.

23. While Agassiz continued to be his chief employer, Sonrel also worked for

Spencer Fullerton Baird of the Smithsonian Institution. Indications of his versatility are the steel plates he contributed to the revised edition of Thaddeus William Harris's *Treatise on Some Insects Injurious to Vegetation* (Boston: Crosby and Nichols, 1862). For more on Sonrel see Ann Blum and Sarah Landry, "In Loving Detail," *Harvard Magazine* 79 (May–June 1977): 38–51; Bettina A. Norton, "Tappan and Bradford: Boston Lithographers with Essex County Association," *Essex Institute Historical Collections* 114 (July 1978): 149–60; Sally Pierce and Catharina Slautterback, *Boston Lithography, 1825–1880: The Boston Athenaeum Collection* (Boston: The Boston Athenaeum, 1991), 180–81; Ann Shelby Blum, *Picturing Nature: American Nineteenth-Century Zoological Illustration* (Princeton: Princeton University Press, 1993), 369 n. 34.

24. Lawrence Buell, *Writing for an Endangered World: Literature, Culture, and Environment in the U.S. and Beyond* (Cambridge, Mass.: Harvard University Press, 2001).

25. The "Regulations for the Museum of Comparative Zoology," passed by the faculty of Harvard College on November 5, 1863, stated that "whatever is done by any one connected with the Museum . . . is considered as the property of the Museum"; *Annual Report of the Trustees of the Museum of Comparative Zoology* (Boston: Wright and Potter, 1965), 48–49. In a letter to F. W. Putnam, March 24, 1864, Agassiz insists on the difference between authorship and ownership, the latter of which seems the more important of the two: "I would remind you of the relations of an author to a publisher furnishing the means and materials for a book to be brought out by him. The one has the rights of authorship, the other of ownership." Putnam, one of Agassiz's assistants, had taken some papers with him when he quit his service. Agassiz Letter Books, vol. 2, Museum of Comparative Zoology, Houghton Deposit MCZ F 890, Harvard University.

26. See Henry James Clark, *A Claim for Scientific Property,* Broadside, Cambridge 1863 (Harvard University Archives HUG 300), and Clark, *Mind in Nature; or The Origin of Life, and the Mode of Development of Animals* (New York: Appleton, 1865), 37.

27. Laubichler, "Nature's Beauty."

28. Ernst Haeckel, *Das System der Medusen: Erster Theil einer Monographie der Medusen,* 3 vols. (Jena: Gustav Fischer, 1880), 1:189, 527.

29. Ernst Haeckel, *Kunstformen der Natur* (1904; Wiesbaden: Marix, 2004), 22.

30. See plate 8 in *Kunstformen der Natur* (fig. 13) as well as plate 30 ("Desmonema") in vol. 3 ("Atlas") of *System der Medusen.* On Haeckel's falsifications see the chapter "Le Darwinisme: Classification de Haeckel," which Agassiz added to the French translation of his *Essay on Classification* (*De l'espèce et de la classification*

en Zoologie, trans. Félix Vogeli [Paris: Baillière, 1869], 375–91), as well as, more recently, Stephen Jay Gould, "Haeckel's 'Artforms of Nature': Either or Neither? Fused or Misused?" in Gould, *The Hedgehog, the Fox, and the Magister: Mending the Gap between Science and the Humanities* (New York: Three Rivers, 2003), 157–63, and Gould, *I Have Landed: The End of a Beginning in Natural History* (New York: Harmony, 2002), 305–20.

31. See Rudolph Arnheim, *The Power of the Center: A Study of Composition in the Visual Arts,* rev. ed. (Berkeley: University of California Press, 1982), 106–12.

32. See Michael Huey, "Medusa Man," *World of Interiors,* August 1999, 54–63.

33. Ernst Haeckel, *Ziele und Wege der heutigen Entwicklungsgeschichte* (Jena: Dufft, 1875), 80; Haeckel, *System der Medusen,* 519.

34. Donald Worster, *Nature's Economy: A History of Ecological Ideas,* 2nd ed. (Cambridge: Cambridge University Press, 1994), 192. See also Stephen Jay Gould's critique of the "Whiggish" view of history in "Agassiz's Later Private Thoughts on Evolution: His Marginalia in Haeckel's *Natürliche Schöpfungsgeschichte,*" in *Two Hundred Years of Geology in America,* ed. Cecil J. Schneer (Hanover, N.H.: University Press of New England, 1979), 277–82. Lorraine Daston and Peter Galison, in *Objectivity* (New York: Zone, 2007), contrast Haeckel's "truth-to-nature" with the newly emerging regimen of "mechanical objectivity," as represented by Haeckel's opponent, the embryologist Wilhelm His, who employed a drawing prism and stereoscope to project and then trace meticulously "objective" representations of his specimens (193–95). Sonrel's version of "objectivity" was more comprehensive—but, in a sense, no less accurate and "unprejudiced"—than the "unthinking, blind sight" (16) Daston and Galison regard as the hallmark of objectivity. As I argue here, Sonrel had found a different way of eliminating "the knower" from his images.

35. Agassiz, *Methods,* 129.

36. Louis Agassiz, *An Essay on Classification* (London: Longman, Brown, Green, Longmans, & Roberts, 1859), 9; Louis Agassiz, *The Structure of Animal Life: Six Lectures* (New York: Scribner, Armstrong, 1874), 3.

37. See Michael Behe, *Darwin's Black Box: The Biochemical Challenge to Evolution* (New York: Free Press, 1996), 42. For a trenchant critique of Behe's mousetrap model see Michael Ruse, *Darwin and Design: Does Evolution Have a Purpose?* (Cambridge, Mass.: Harvard University Press, 2003), 313–36.

38. Longfellow, *Random Memories,* 28.

39. The two standard surveys of Anglo-American natural history illustration were written by, respectively, an antiquarian bookseller with scientific interests and the archivist of a natural history museum. See S. Peter Dance, *The Art of Natural History* (1978; New York: Arch Cape, 1990), and Blum, *Picturing Nature.* The most

comprehensive collection of essays addressing the use of pictorial devices in scientific discourse is Baigrie's *Picturing Knowledge* (see note 13). Only one of the ten contributors is an art historian. For a refreshingly different approach to scientific illustration see Daston and Galison, *Objectivity.*

40. Walter Benjamin, "The Work of Art in the Age of Mechanical Reproduction" (1936), trans. Harry Zohn, in *The Norton Anthology of Theory and Criticism,* gen. ed. Vincent B. Leitch (New York: Norton, 2001), 1166–86; see esp. 1168.

41. This view of the scientist's work has been thoroughly challenged in recent years; see the essays in Baigrie, *Picturing Knowledge,* and Martin Kemp, *Visualizations: The Nature Book of Arts and Science* (Oxford: Oxford University Press, 2000).

42. See http://www.mbl.edu/BiologicalBulletin/KEYS/INVERTS/3/visual_key.htm.

43. Vladimir Nabokov, "Audubon's *Butterflies, Moths, and Other Studies*" (1952), in Nabokov, *Strong Opinions* (New York: McGraw Hill, 1973), 330.

44. Alexander Agassiz, "Application of Photography to Illustrations of Natural History. With Two Figures Printed by the Albert and Woodbury Processes," *Bulletin of the Museum of Comparative Zoology* 3, no. 2 (1871): 47–48. See also Alexander Agassiz to Elizabeth Agassiz, June 6, 1870, and to Charles Darwin, December 9, 1872, in *Letters and Recollections of Alexander Agassiz, with a Sketch of His Life and Work,* ed. G. R. Agassiz (Boston: Houghton Mifflin, 1913), 104–105 and 120–21.

45. See plate II, 4 in Alexander Agassiz, *Illustrated Catalogue of the Museum of Comparative Zoology, at Harvard College. No. VII: Revision of the Echini.* Part III and IV (Cambridge, Mass.: Harvard University Press, 1873).

46. The devices used to expose half of the negative at a time included special plate holders and rotating partial lens caps. For other examples of the genre see the online exhibition of the American Museum of Photography, *Seeing Double: Creating Clones with a Camera* (http://www.photography-museum.com/seeingdouble.html).

47. Henri Bergson, "Laughter," in *Comedy,* ed. Wylie Sypher (New York: Doubleday Anchor, 1956), 81.

4

The Fate of Wilderness in American Landscape Art

The Dilemmas of "Nature's Nation"

Angela L. Miller

In the 2004 film *The Day After Tomorrow,* the Northern Hemisphere is engulfed by a new "Ice Age," a catastrophic climate change, resulting from global warming, that transforms the conditions of life on the planet. The administration in Washington, struggling to understand the scale of the crisis, meets in a rotunda somewhere in the White House hung with four paintings by leading artists of the nineteenth-century American landscape tradition, including Thomas Cole and Frederic Church.

No such space exists in the White House, but the selection of landscape art as a backdrop to an unprecedented environmental crisis is entirely appropriate for evoking the central dilemma the film confronts: the dependence of advanced post-industrial society on a natural world that has been consistently violated. The film's creators evidently banked on the symbolic resonance that grand images of wilderness continue to carry for American audiences, as symbols of a time when the nation was carpeted with forests and not traversed by highways, when earth's atmosphere was replenished by healthy infusions of carbon dioxide, preserving an equilibrium crucial to climatic and social stability.

The contemporary symbolism contained in these well-known works of landscape art is a muted echo of the even fuller public response they once provoked. Between the 1820s and the 1870s the American landscape drew the fascinated attention of the nation's most accomplished painters and their audiences. Landscape painting as an expression of national identity emerged in New York City. Promoted by wealthy urban patrons and the leading cultural institutions of the nation's "empire" city, including the Century Club, the Union League, and the National Academy of Design, landscape painting

spoke not only to the nation's cultural progress in the arts but to its deepest ambitions as a republic.

By its peak of popularity in the 1850s and 1860s, leading landscape painters were celebrated figures, building lavish villas along the Hudson River, which wound its way down to New York. They would come to be known as the Hudson River school, even though their subject matter would eventually encompass a far larger area. What is most significant in the present context—the history of American art and the environment—is that these ideas were conveyed to a broad audience through representations of nature more powerfully than by the "real" thing itself. And by midcentury, the representation of nature had become codified in a set of mythic narratives, spatial conventions, and communal symbols. Landscape viewing evolved into a specific kind of cultural practice: an act of public spectatorship in which crowds of people stood poised before large-scale works that demanded to be read part by part, like an unfolding story. Yet, a closer look at key examples of landscape art reveals not one national story but several, each assuming center stage at a different historical moment.

The image of the American landscape extended far beyond the fine arts medium of painting on canvas. Popularized in such large-scale publications as William Cullen Bryant's two-volume collection *Picturesque America* (1872–74), celebrated in verse and in travel literature, and central to an emerging tourist itinerary directing domestic and foreign travel for pleasure, images of the American landscape were among the first popular native expressions of cultural nationalism in the early decades of the nineteenth century, focusing an emerging pride of place in the peculiar natural features of the new nation. Anglo-Protestant traditions of belief shaped the new republic's emergent sense of exceptionalism—the idea that America was a place apart, a previously unpeopled wilderness where history, born in nature rather than in corrupt institutions, could begin again. For a culture steeped in the Bible, "sublime" wilderness was a place where moral and spiritual virtue would be renewed, where God spoke to his new chosen people. The nation's prophetic destiny as the first Christian republic in modern history was directly linked to its natural heritage.

Such beliefs, however, left considerable space for cultural debate over the particular relationship of wilderness to national culture. The decades that saw the emergence of landscape art also witnessed a massive movement to colonize and develop the land, to serve the needs of the new extractive and industrial economy that would propel the United States away from its agrarian

origins. In what follows I will look more closely at three distinct aesthetic responses to the dilemma of "nature's nation"—the problem of reconciling wilderness as America's birthright and unique heritage with economic and social development as national imperatives of the United States. These three case studies—critical romanticism, or the wilderness ideal; the middle landscape, or the ideal of aesthetic and social harmony between nature and culture; and preservationism, or the ideal of federal protection for undeveloped nature apart from development—follow a rough historical progression from the early to the later nineteenth century.

Critical Romanticism and the American Landscape

In the early decades of the nineteenth century, the emerging nation-states in Europe and North America (and slightly later in South America) turned to images of the undeveloped landscape as a means of grounding the abstractions of nationhood in the emotionally satisfying experience of nature. A cultural, artistic, and philosophical movement of international reach, romanticism developed out of a growing awareness of the ways in which the Industrial Revolution and the emergence of an extractive form of market capitalism had disrupted the intimate exchange between the human and the natural that had characterized most of human history. The paradox of landscape art was that it arose at a time when western nations were busily occupied in converting nature into commodities through industry and market capitalism.

Anglo-American romanticism looked to the subjective, private experience of nature as a source of personal renewal and a pointed alternative to the disenchantments of a modernity defined by weights and measures, by the logic of profit and loss. Its vision of a world in which natural and human rhythms were in harmony looked to the landscape for expression of interior moods and feelings—what Carolyn Merchant, drawing on Martin Buber, describes as an "I-Thou" relationship that saw a common spirit pervading all things human and natural.[1] This generation of English and American romantics challenged the extractive vision of nature as the source of raw materials—a spur to capitalist development—with an aesthetic, philosophical, and spiritual commitment to wilderness. Writers, poets, and painters from William Wordsworth to Ralph Waldo Emerson and Henry David Thoreau—witnessing the rise of industry and the enormous material ambitions of the new middling class of industrial producers—attacked the utili-

tarian mentality behind capitalism. These obsessions, they felt, left society blind to the broader dimensions of a universe animated by natural energies—manifestations of a spiritual order far greater than the human.

Wilderness, traditionally construed by westerners as a space outside of history and human cultivation, in fact is a concept whose very existence bears the historical mark of human intervention. Coined during the late medieval period (the 1200s) as a term with decidedly negative connotations, "wilderness" by the late eighteenth century could also express longing for an alternative to an entirely human-centered world.[2] Such a vision also inchoately questioned the consequences of imperious human attitudes toward the conquest of nature. With the beginnings of a self-conscious environmental, or conservation, movement in the late nineteenth century, "wilderness" increasingly encompassed a critique of those attitudes as detrimental to the future health of society.

One artist in particular grasped the implications of the philosophical shift initiated amid the culture of romanticism. Thomas Cole had emigrated from England with his family in 1818 as a seventeen-year-old. He brought to the United States an English romantic sensibility and a deeply religious response to his adopted country's embattled wilderness. Cole saw the nation's expansion across the continent as a tumultuous, destructive process that posed difficult, sometimes irresolvable dilemmas and choices for the new republic.

It may seem strange that a romantic vision of the American wilderness as a powerful spiritual and national resource was first realized in paint by an Englishman. Cole's family had come from Lancashire, a region of England that had early on felt the full force of the Industrial Revolution—William Blake's "Satanic mills" threatening to transform the rural districts into blighted regions resembling hell. Cole brought with him to America this intensified awareness of natural fragility and of the destructive powers of industry, enhanced by his familiarity with romantic literature. Largely self-taught in painting, Cole more than any other artist in America at the time instinctively grasped the dramatic potential of the Catskill Mountain region in the hinterlands of New York City. In no sense a wilderness, the Catskills harbored a corrosive tanning industry that also contributed to deforestation. It was also a popular destination for aesthetic tourists in search of the picturesque. Cole's paintings of the Catskills and the White Mountain region in New Hampshire, however, read natural features as prophetic signs of a land fresh from the hand of Providence. Dramatized by the cycles of the seasons and the rhythms of natural processes of decay and rebirth, his

paintings spoke eloquently to a metropolitan audience. While members of that audience were confident in their position at the helm of a growing commercial and trade empire—a position solidified by the opening of the Erie Canal in 1825—they were often only one generation removed from a rural existence. Steeped in the prophetic language of "nature's nation," they received a "shock of recognition" on seeing Cole's earliest landscapes, exhibited in a New York shop window in 1825. Earlier landscape art had been topographical, depicting specific views with banal accuracy and bland pictorial harmony. By contrast, Cole's dramatic compositions struck a more emotional chord, quickly winning major patronage and critical acclaim when the artist was only in his late twenties.

Variant definitions of national identity could often be served by the same symbol or visual image. Audiences of Cole's Catskill paintings could see his romantic wilderness as the treasured symbol of America's exceptionalism. Yet these same audiences were the entrepreneurs and businessmen deeply implicated in the market revolution that was rapidly transforming the metropolitan hinterlands. For them landscape art would become a therapeutic retreat from the forces of market development in which they themselves were involved, forces that were, furthermore, endangering the very wilderness to which they turned for refuge. Cole saw this dilemma more clearly than most; the wilderness that guaranteed America's privileged conversation with God, and which was central to America's emerging identity as a republic, was under attack by Americans themselves.

Cole's *View from Mount Holyoke, Northampton, Massachusetts, after a Thunderstorm—The Oxbow* (fig. 16) wove romantic artist, nature, and nation into a dynamic image of environmental change fraught with troubling implications for the future of the republic. The artist completed the picture during the same year, 1836, in which he finished his ambitious and much-celebrated five-part series *The Course of Empire* (fig. 17). Cole even reused a discarded canvas from that series for *The Oxbow,* suggesting an interesting relationship between the works. Understanding the environmental and national concerns explored by Cole in *The Oxbow* thus requires some knowledge of *The Course of Empire.* It was in that series, after all, that Cole most fully investigated the link between the fate of nature and the future of the republic. He did so, however, in an allegorical format that left unnamed the subject of his moral tale. *The Course of Empire* depicts a generic, or hypothetical, civilization whose classical architecture and other accoutrements evoke the ancient Greco-Roman world. *The Oxbow,* on the other hand, represents a specific

16. Thomas Cole, *View from Mount Holyoke, Northampton, Massachusetts, after a Thunderstorm—The Oxbow,* 1836. Oil on canvas. The Metropolitan Museum of Art, New York, Gift of Mrs. Russell Sage, 1908 (08.228).

location—the Connecticut River near Northampton, Massachusetts. Closer inspection reveals, however, that the artist composed the scene with deliberate ambiguity. Deeply committed to his adopted nation, Cole preached to his public in the language of Old World histories and through the lessons of the Old Testament, projected onto the landscape of the recently settled Northeast.

The first three canvases of *The Course of Empire* told a story familiar to Americans in the 1830s—the rise of a great empire from origins in primitive wilderness. In the first canvas, *The Savage State,* hunters wearing animal skins roam through a feral landscape of forest and mountains, as mists rise from the sea, suggesting the infancy of culture. The second in the series, *The Arcadian or Pastoral State,* shows a domesticated nature harmoniously integrating wilderness and civilization, a momentary balance upset in the third and central canvas of the series, *Consummation,* a glittering (and, for Cole's audiences, profane) image of maritime empire. Political corruption is suggested in this phase by the central image of an emperor borne aloft by his followers. The arts, whose modest beginnings emerged in the previous canvas,

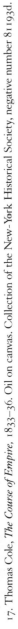

17. Thomas Cole, *The Course of Empire*, 1833–36. Oil on canvas. Collection of the New-York Historical Society, negative number 811193d.

here have developed to excess. A place-defining mountain peak seen in the first two canvases has virtually disappeared behind elaborate classical architecture (see fig. 1 in the introduction). *Consummation* sets the stage for the final two canvases, which play out the implications of imperial arrogance. In *Destruction,* the empire is overwhelmed by an invading army, recalling the sack of Rome. The violence of the invaders, however, merely acts out the underlying ruthlessness of the empire itself, in its exploitation of nature. Cole concluded the series with *Desolation,* a haunting moonlit image of the former civilization in ruins, returning to its beginnings in nature.

Cole's *The Course of Empire* brought to light, in striking fashion, an anxiety shared by many of his contemporaries. Literary historian Perry Miller describes that anxiety as the "secret, hidden horror that its gigantic exertion [of empire building] would end only in some nightmare of debauchery called civilization."[3] Such a vision of historical defeat, Miller suggests, might seem incongruous for a nation confident of its Christian civilizing mission and its future greatness. Most early viewers of *The Course of Empire* overlooked or resisted its implications for the American republic of the 1830s, but Cole's letters and papers suggest that he was thinking deeply about his adopted country at the time. For Cole the series was an allegorical object lesson that graphically revealed the catastrophic results of falling away from nature. Republics, as any student of antiquity would know, stood or fell on the virtue of their citizens, and what guaranteed that virtue in the United States was proximity to nature (a primary tenet of cultural nationalism in these decades). America's ideology of exceptionalism—its optimism about escaping the laws of cyclical rise and decline that defined Old World empires—pointed to an unavoidable conclusion in Cole's view: as the nation's forests and unsettled regions receded before the onslaught of civilization, so did the source of its cultural virtue, leaving the fledgling republic vulnerable to the very debauching artificiality so vividly imagined in the central canvas of Cole's series.

In the decades before the Civil War, two contrasting currents of cultural belief were on a collision course: the idea of America as a new Eden whose undefiled wilderness guaranteed its survival as a republic, and the commitment to an often ruthless transformation of raw nature into civilization. The shrine of nature was under attack, according to Cole, by the "dollar-godded utilitarians," and yet both parties—romantics and profit-minded capitalists alike—considered themselves servants of their nation's prophetic mission.[4] In 1836, Cole wrote revealingly in his journal, "If men were not blind and insensible to the beauty of nature the great works necessary for the purpose

of commerce might be carried on without destroying it, and at times might even contribute to her charms by rendering her more accessible—but it is not so they desecrate whatever they touch. They cut down the forests with a wantonness for which there is no excuse . . . and leave the herbless rocks to glimmer in the burning sun."[5] In short, the "dilemma" of American nationalism which Miller identified was that it was grounded in "an irreconcilable opposition between Nature and civilization."[6]

Intentionally or not, Cole's *The Oxbow* could be read as an either/or scenario dramatizing these two very different visions of the nation's future. Painted on an unusually large canvas (51½ x 76 inches), it offered a panoramic view of the Connecticut River Valley in western Massachusetts, where the river turned back upon itself, creating an unusual natural feature that attracted picturesque tourists. The rugged forested terrain of the mountain where Cole sat observing the scene was a favorite place from which to view the Oxbow. From this vantage point, the valley below provided a positive vision of agrarian peace and plenty in contrast to the wilderness on the left side of the canvas. Such a reading would be consistent with the optimistic vision of those promoting the colonization of nature in the 1830s. This call for a domesticated nature reflected the ideal of the middle landscape, a set of aesthetic conventions traceable to the European pastoral landscape tradition but directed at resolving—in aesthetic terms at least—a specifically American historical tension. For the aesthetic of the middle landscape realized a balance between the extremes of wilderness and its complete overthrow at the hands of an imperious nation. The middle landscape, in short, suspended the motions of history. Cole's *Course of Empire,* however, confronted the impossibility of realizing the middle landscape in real historical time. In different ways—as a five-part serial composition, for example, and as a panoramic view that implied extension beyond its frame—Cole insistently located the "moment" of wilderness within a broader trajectory of change and development.

In a letter to his patron Luman Reed, Cole wrote that in his painting of the Oxbow he wished "to tell a tale."[7] Though he did not reveal the tale that is told, its narrative power is evident. Indeed, the panoramic breadth of the image links it to the popular genre of the 360-degree stationary panorama, the diorama, and the moving panorama, painted on long strips of canvas and then unrolled across a stage, providing an explicitly narrative dimension as the view passed before the audience.[8] This narrative dimension operates in Cole's painting. The impulse to read *The Oxbow* panoramically is encour-

aged by the storm front that engulfs the left or wilderness side of the land-scape. In narrative terms, *The Oxbow* collapsed two of the first three stages of empire: wilderness and pastoral nature. Yet, reading the canvas laterally, the implication is that the process of development will carry us from agrarian pastoralism toward increasing settlement and urbanization.

Cole left little doubt that he intended his "tale" to transpose the allegory of ancient empire, dramatically told in his just-completed series, onto the young republic of the 1830s. On the distant hillside that breaks the horizon, its mount just brushed by the advancing storm front (or is it retreating?), are a series of markings that have been read by scholars as Hebrew letters for the "Almighty."[9] Like his contemporaries, Cole was convinced that his adopted nation had a providentially appointed mission of redemption to fulfill—America, as he wrote elsewhere, was a new Eden. But in Cole's view the nation's privileged position in history was threatened by the ignorance and greed of its citizens, who embraced a developmental ethos that threat-ened a rupture between themselves and the source of their virtue. The divine inscription significantly shapes our understanding of the painting, pointing toward an open-ended future in which confidence about the direction of the nation gives way to a prospect as unstable as the weather itself. Nature here seems to act out the ambivalence felt by many of the artist's contemporaries.

The conflict between Cole's romantic devotion to wilderness and the im-perial conquest of nature was intensified by the agrarian character of the republic before the Civil War. While manufacturing and industry certainly played a role in transforming the countryside, it was farming that wrought far greater damage upon the forests of North America. Numerous European visitors to the New World cited practices such as slash-and-burn agricul-ture and tree girdling as assaults against aesthetic values. Those values were rooted in eighteenth-century categories of the beautiful and the picturesque, which privileged the harmony between part and whole, smooth spatial tran-sitions, and a modulation of open fields and forests. Basil Hall, an English-man who had come to the United States in the late 1820s to secure sketches of the scenery for publication at home, wrote of newly cleared lands as having "a bleak, hopeless aspect . . . cold and raw," and lacking the settled aestheti-cally pleasing appearance of European nature. Such scenes, he concluded, had no parallel in the Old World.[10] Slashing, burning, and girdling practices served a rapidly expanding nation of farmers who pitted themselves against a "wilderness" that required taming in order to yield economic profit or even subsistence. With few exceptions, American artists avoided such scenes of

aesthetic and environmental devastation, preferring the comforting fiction of the middle landscape to the realities of a transitional landscape marked by the unsettling of nature.

Cole was acutely aware of the devastating impact of agriculture. Verbal images of natural desolation, of "prostrate trees—black stumps—burnt and deformed," recur throughout his journals. English romantic that he was, Cole experienced such injuries to nature on a deeply personal level, associating them symbolically with what he called the "wasted places" of the American spirit.[11] The barrenness of nature held for him the threat of artistic impotence; he saw colonization as a process by which nature's energies, tied to his own creative power, were drained away. The artist, bereft of the spiritual and aesthetic resources of wilderness, would have nowhere to turn for spiritual and creative renewal. Environmental destruction, motivated by the quest for gain, threatened to produce cultural sterility.

Cole's concerns proved prophetic, for by midcentury many shared his alarm over the impact of "Yankee enterprise" and the "axe of civilization."[12] Indeed, the complaint that America's wilderness—along with its human counterpart, the Native American—was passing into the mists of history had lost force through overstatement. But few of his contemporaries matched the moral conviction of Cole's attack on American utilitarianism. And his broader vision of the dire impact of American settlement on nature would not be equaled until after the Civil War, with the publication of George Perkins Marsh's *Man and Nature* in 1864.

Marsh was a scholar and diplomat of wide-ranging and speculative interests. Synthesizing the evidence of environmental destruction in Europe, the Middle East, and the United States over several millennia, Marsh produced the single most influential work of environmental history in the nineteenth century. Cole's dramatic visualization of the ravages of American farming anticipated Marsh's unblinking analysis of human impact on nature. Marsh's observations about the results of deforestation in North America on drainage patterns and soil erosion formed only a small part of his global picture. Nonetheless, placing the environmental forces acting on nature in the United States within a vastly extended perspective of time and space, Marsh leveled a direct attack on the myth of American exceptionalism, casting further doubt on the idea of "nature's nation" as the basis of collective identity for the republic. From his perch in Italy, where he wrote *Man and Nature* while serving as minister to the newly unified nation, Marsh was able to see his own country within a broader history of environmental forces acting impartially

across a range of geographical and natural conditions. Nature in America was distinct only in the relatively recent appearance of the Euro-American colonizer. Marsh singled out agriculture, particularly the cultivation of tobacco and cotton for export along with domestic cattle, as most injurious to the American forest.[13]

Despite similarities in their vision of environmental change, Marsh was far more explicit than Cole in his call for Americans to intervene actively in the management of nature. He envisioned what twentieth-century environmentalists would later call "sustainability," and though he did not use that term he expressed the concept behind it with remarkable clarity. In a show of goodwill toward future generations, he summoned his contemporaries to "a self-forgetting care for the moral and material interests of our own posterity." His analysis was also prescient in its proto-ecological understanding of the interconnectedness of species and environments, noting, for instance, how deforestation contributed to the rapid growth of certain insect populations, formerly kept in check by birds whose habitats had been destroyed by forest removal. Marsh called for the restabilization of nature, or the restoration of "the relative positions of land and water . . . the atmospheric precipitation and evaporation . . . [and] the distribution of vegetable and animal life," following the fury of change wrought by Euro-American expansion across the continent. Such a process would, in turn, prepare the land for "permanent civilized occupation," taking care not "to derange and destroy what, in too many cases, it is beyond the power of man to rectify or restore."[14]

Cole, working two generations before Marsh, had no such developed program for reversing the environmental destruction of American "progress." There is, however, one moment in Cole's painting that points toward more active agency and direct choice by Americans in the matter of their natural heritage. In a compositional gesture unusual for the 1830s, *The Oxbow* implied that Americans could be more than passive witnesses to the historical processes transforming their landscape. Instead, as the painting suggests through an important detail, they could be decisive actors within history. In the foreground, Cole himself appears in the landscape as the artist wearing a hat and sitting before an easel. Nearby rests a pack and folded umbrella, alluding to the recent storm. The figure of Cole turns and looks directly out of the picture, making the beholder complicit with his act of representation and, by extension, another moral witness to the changes in the land. To be a moral witness rather than merely a passive spectator is, however, to acknowledge one's role in history, with its burden of responsibility and choice.

Thirty years before Marsh, then, and many decades before the emergence of the modern environmental concept of sustainability, Cole turned away from the rhetorical bluster of the new nation-state heedless of nature's fragility and finiteness. Instead, he dramatically brought to life the precarious nature of American history and identity. The momentum of change sweeping across the republic like a storm front rendered the vision of a stable middle landscape a transitory moment in an unfolding panorama of historical development. Cole understood, as few of his contemporaries did, that the historical process was neither necessarily benign nor inevitable, but a product of social and moral decisions.

In the concept of wilderness, Cole enshrined all that differentiated the sensitive artist-poet and his aristocratic patrons from the unsavory new democratic energies driving the economic exploitation of nature in the new republic. What was true for Cole was also true for Francis Parkman and other social and political conservatives. Fresh out of Harvard, Parkman was from an old New England family that could afford to hold itself aloof from the self-making energies of those struggling for a stake in the material and social progress of the new nation. Traveling to the West in 1846 with his French guides, enjoying the manly solitude of the frontier while "reveling" in Byron, Parkman expressed contempt for the awkward, hungry-eyed emigrants he encountered on the trail, driven by "the restless energy of [the] Anglo-American." His elitist disdain for those unable to rise above material or economic motives played out in his preference for "unaided nature" and for the natural grace of his guide, Henry Chatillon.[15] Parkman's *The Oregon Trail* (1849), an account of his journey to the West, plainly reveals the class-based nature of his preference for unsettled lands, free of the motley mix of humanity on the frontier, and only dimly touched by the presence of Native Americans.[16]

By the 1850s, however, the ravaging energies of the pioneer—those locusts of the prairie that brought havoc in their wake—would be recuperated as part of an emerging mythology of the frontier. Western wilderness tested the self-reliance of a new democratic culture of self-made men, epitomized by the figure of the pioneer. Out of raw, unsettled nature they would build a future, or so the myth would have it. The pioneer appeared frequently in the art of the 1850s. In works by Asher B. Durand, Jasper Cropsey, George Caleb Bingham, and others, wilderness is the stage on which Americans enacted their historic destiny in subduing the continent, valued not for itself but as a measure of the resourceful independence and fortitude of the American pio-

neer as a type of the new nation. The shift in the image of the pioneer, evident even in Cole's late work of the 1840s, was prophetic of a broader mid-century move away from the romantic veneration of unsettled wilderness.[17]

The Middle Landscape: Stopping History

For the generation after Cole, the challenge was to devise pictorial formulas that symbolically resolved the dilemma of "nature's nation." One solution that circulated widely in the polite literature and art of the urbanized middle class was the pictorial formula of the middle landscape. Already well tested in the 1830s and 1840s (as we have seen), the middle landscape emerged as the predominant aesthetic approach to American nature in the decade prior to the Civil War.[18]

Though slightly older than Cole, Asher B. Durand represents this very different generational attitude toward wilderness and the dilemmas of "nature's nation." He developed late as an artist, producing his mature work in the 1850s, the decade after Cole's death in 1848. In the 1840s, Cole moved away from his critical romanticism, painting fewer wilderness landscapes in favor of a domesticated nature that accommodated modest development. Durand's work extends this tendency, with grand, large-scale landscape "compositions" of which the most impressive is *Progress (The Advance of Civilization)* (fig. 18). In its panoramic breadth and symbolic ambitions, *Progress* recapitulated the historical themes Cole had explored in his work of the 1830s, but in 1853 the context had changed, as had prevailing artistic attitudes toward development. *Progress* juxtaposes wilderness with the settled landscape, weaving together passages of closely observed nature into a grand narrative that, like Cole's *The Oxbow,* tells a tale. But Durand's tale now has replaced ambivalence and national reckoning with a child's fable of disarming simplicity. The composition moves smoothly through the stages in the transportation revolution, from wagon to canal to steamboat to train, the trestles of the railroad blending seamlessly into the contours of the landscape and its smoke dissolving without a trace into the atmospheric haze that blunts the raw edges of the developed landscape. Durand pushed the urbanized future—with its troubling implications for a culture long suspicious of industry and its effect on republican virtue—into the light-infused distance, where industrial fumes blend into morning mists. *Progress* illustrates the ideological function of the middle landscape, in which the pastoral aesthetic mythically reconciles conflicting versions of the nation within one seamless unity. Yet, like most tales

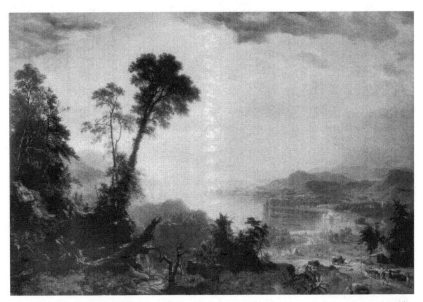

18. Asher B. Durand, *Progress (The Advance of Civilization)*, 1853. Oil on canvas. Property of the Westervelt Company and displayed in the Westervelt-Warner Museum of American Art in Tuscaloosa, Alabama.

for children, this one contains hidden complexities. Witnessing the changes in the landscape are two Native Americans nestled in a lushly wooded foreground. Regret for the past (the unsettled wild landscape but also the intimate relationship to nature signaled by the Native American) mingles with celebration of the future: the Indian becomes the vanishing Indian. But even as Durand celebrated the republic's dominion over nature, he qualified the meaning of progress by conveying a sense of longing for the ostensibly timeless and unchanging existence of nature's indigenous inhabitants.

Unlike Cole's *The Oxbow,* which also reads laterally, Durand's pictorial narrative unfolds mainly from foreground to background, inviting our eye to move into the deep space of the landscape. Whereas Cole's scene asks a question—the Connecticut River, turning back on itself in the oxbow shape, even forms a giant question mark emblematizing the historical dilemma facing Americans—Durand's painting, full of visual blandishments (the buttery, polished surface, for example), offers certainty and resolution in place of moral ambiguity.

What had changed? Public awareness of the destructiveness of settle-

ment had actually intensified since Cole's early embittered outbursts against those who cut down his beloved forests. Why then was Durand so quick to substitute a vision of smooth progress, tinged only by momentary regret for the threat posed to Native people? By the 1850s the taste for wilderness had largely given way to a preference for the pastoral landscape. Sublime wilderness, with its unstable energies and personally engaging qualities, appealed less to metropolitan audiences than the shared pleasures of a nature increasingly enjoyed for its domesticated, park-like qualities. The new, middle landscape mode thus responded to middle-class discomfort at the intense, spiritually demanding wilderness of the romantics. Eastern nature was now more clearly demarcated into areas of wilderness, settlement, and urban metropolis. Those three geographies were, furthermore, seamlessly linked within an emergent network of markets extending outward from metropolis to hinterland. As a result, the contested status of nature between wilderness and settlement had been, for the moment at least, safely adjudicated by the establishment of a metropolitan market culture that wove these distinct arenas into a smooth fabric serving the increasingly confident nation-state at midcentury.[19] The problems of the wilderness were thereby displaced to the western frontier. As we will see, landscape paintings of the West employed many of the same strategies and aesthetic solutions after the Civil War to negotiate the stress of conflicting ideals: wilderness and habitat preservation versus a powerful extractive ethos that viewed nature as raw material for a postwar society increasingly defined by industry, transportation, and national wealth.

Yet, neither the middle landscape nor the wilderness ideal seriously acknowledged Native Americans' claims to the land. Like the forests of North America, the Native Americans lay directly in the way of the republic's imperial ambitions. The notion of wilderness untouched by human habitation hardly represented the historical reality of a land that had been inhabited, transformed, and adapted to human needs for millennia. Environmentalists and environmental historians today understand the concept of "wilderness" quite differently; they now recognize the extent to which it served to erase the long-standing history of Native cultures, including the ways in which these cultures actively remade nature and created new ecological regimes. As literate, eastern, middle-class Americans of the nineteenth century thought about their nation's future, neither the romantic wilderness nor the midcentury pastoral aesthetic prepared them to meet the challenges of an advanced urban-industrial society. Nor did those antebellum pictorial modes

begin to address the predicament of indigenous people whose lands and ways of life were directly challenged by social and economic expansion.[20]

Wilderness Preservation and Native Dispossession

By the late 1850s, Frederic Church—Cole's only student—had emerged as the leading landscape artist of his generation. Church expanded the symbolic charge and moral weight of American landscape painting by merging aspects of his teacher's style with a new emphasis on natural history and astounding technical power. His greatest works looked beyond the continental United States to Labrador, the Arctic, and South America. Church thereby relocated the Edenic potential of the New World landscape to extreme zones of the Western Hemisphere that—in the eyes of his audiences at least—remained largely untouched by Euro-Americans until after the Civil War. Influenced by the comprehensive vision of Alexander von Humboldt, a German scientist who had spent decades studying the interrelated life systems of South American nature, Church painted works such as *Heart of the Andes* (1859) and *Rainy Season in the Tropics* (1866). Though grounded in meticulous, Humboldtian studies of botany, geology, and meteorology, Church's work in many ways remained indebted to the symbolic values of earlier landscape painting. *Rainy Season in the Tropics* shows a paradisiacal tropical wilderness refulgent with sunlight. Dividing the composition is a deep chasm in the earth, recalling the fissure in the nation itself between North and South. Arcing across it like a natural suture is a rainbow—sign of the renewed covenant between God and his chosen people.

The motif of the chasm reappeared six years later in Thomas Moran's colossal painting *Grand Canyon of the Yellowstone* (fig. 19). Once again a geological feature acquires deep symbolic import for a generation struggling to redefine the meaning of wilderness in the wake of the Civil War. Moran here wove together the precise geological details of the site into a grand synthesis that revealed to the curious gaze of easterners the mysteries that lay at the heart of the continent. The occasion for his painting was the expedition of Ferdinand Hayden in 1871, one of a series of federal surveys of the continental interior during the late nineteenth century. Launched by the newly formed United States Geological Survey, these mapping and mineralogical expeditions helped prepare the way for railroads, settlers, and extractive industries in the West.

The national park system was created in the midst of this massive fed-

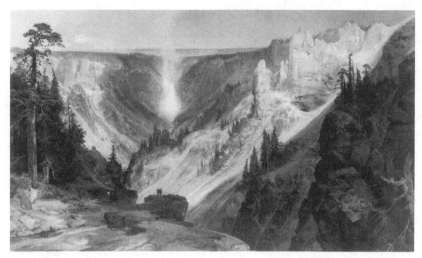

19. Thomas Moran, *Grand Canyon of the Yellowstone,* 1872. Oil on canvas. Smithsonian American Art Museum, Washington, D.C. Lent by the Department of the Interior Museum.

eral investment in information gathering about the region, indicating that in the decades following the Civil War, the nation's relationship to wilderness had changed once again. Establishment of Yellowstone as the first national park in 1872, the year Moran completed his picture, constituted an official acknowledgment that wilderness required federal protection.[21] The wilderness preservation movement and the national park system offered a new resolution of sorts to the prewar dilemma of "nature's nation" by setting aside areas as natural shrines protected from development. But the creation of wilderness preserves after the war once again failed to accommodate the Native Americans who had long occupied these lands. Indeed, the institution of a national park system revealed the underlying problem at the heart of the wilderness ideal itself: its refusal or inability to accommodate the human presence, even when this presence had been an integral part of the very "wilderness" being protected from it.[22]

Prior to completing his enormous *Grand Canyon,* Moran had circulated watercolors of the region to members of Congress as a form of visual lobbying, which played an instrumental role in the move to preserve Yellowstone as a "wilderness." Like Cole, Moran was an Englishman from Lancashire who understood what would capture the attention of his audiences—in his case an even grander and more minutely detailed spectacle of nature. When Congress purchased *Grand Canyon of the Yellowstone,* it launched Moran's

career as an artist dedicated to painting sublime western landscapes that omitted railroads, mining, settlement, and other signs of modernity. Despite (or thanks to) such omissions, Moran's pictures struck viewers as compellingly realistic—an effect enhanced by the artist's technique of composing his finished works from the most striking details in field sketches and watercolors, which he had executed at various locations in the West.

Moran's magisterial *Grand Canyon* shows the Yellowstone Falls exhaling a great column of spume into the sky above, while the aquamarine of the river below traces its course through a graceful V-shaped valley. Standing on a rocky promontory surveying the scene in the middle foreground are two tiny figures. One man, possibly the Yellowstone expedition leader Ferdinand Hayden, gestures toward the scene before him. A second man is dressed in the ceremonial fashion of a Native American chieftain. Around his neck he appears to wear a medal of the sort given by the federal government to tribal representatives in acknowledgment of treaty agreements over land transfers. The two men stand around the common axis formed by a spearlike pole, the Native figure facing us with his back turned to the landscape while the surveyor directs his attention toward the great valley, back turned to us. Together they metaphorically embody past and future at a moment of symbolic transfer, when the visual grandeur and natural resources of the West pass from Native hands to the federal government.[23] Countering earlier perceptions of Yellowstone as an infernal region of dangerous telluric energies, a place resistant to the human presence, Moran organized the scene to conform to aesthetic ideals. His balanced composition alternates foreground shadows with light-filled middleground and a darkened distance, culminating in the point of visual emphasis and highest value—the falls themselves. An impressively orchestrated scene combining breadth of vision with depth of geological detail, *Grand Canyon of the Yellowstone* serves the broader objective of scientific understanding and, ultimately, social control of the West.

Completed just after Congress passed legislation establishing Yellowstone as a national park, Moran's painting grandly synthesized a vision of the western wilderness as national shrine protected from the very forces of development to which the artist himself was indirectly allied as a member of the Hayden expedition.[24] Vastly enlarging the panoramic formats used by Cole and Durand (*Grand Canyon* measures seven by twelve feet), Moran represents a third and final heroic phase in American landscape painting, marked by the forceful expression of national identity.

By the 1870s, however, the symbolic uses of wilderness had changed once

again. The spiritual and natural potency of wilderness now became totemic property of the nation that had adopted it for symbolic purposes.[25] The national park system created places of refuge for tourists, but it did not address the underlying problem of how to reconcile human needs with ecology in the developing West. Moreover, hallowed natural sanctuaries such as Yellowstone presupposed the fiction that they were static, pristine wilderness terrains, outside and above the complex interplay of human and nonhuman nature.

In other words, Yellowstone's image as a wilderness was achieved through a willed act of historical erasure when, in fact, Shoshones, Bannocks, and Crows had crisscrossed the area for centuries and the Sheep Eaters actually lived there. Blackfeet, Coeur d'Alenes, and Nez Perces also passed through Yellowstone in their annual migrations. The designated parkland bore extensive evidence of sustained human habitation in the fragile harmony that existed between Native hunters and the buffalo, elk, deer, and mountain sheep inhabiting the region. Native peoples practiced yearly burning in order to clear paths, control underbrush, and maintain plant species. They also quarried obsidian from rich deposits in the area and traded it over vast distances as part of an extended cultural network. Moran's painting at least acknowledges this prior presence. Yet, in the same stroke, its masterly presentation of an aesthetically reordered landscape effects a symbolic dispossession through the implied narrative enacted by the two foreground figures.[26]

The image of land transfer proved prophetic. Demoralized by depletion of game through commercial hunting, the near extinction of buffalo, and the destruction by miners of their traditional grasses and other foodstuffs, the Crows ceded a good part of their lands within the park to the federal government in 1880. The process of dispossession did not occur without Native resistance, however. Three years earlier, in 1877, the United States Army had pursued a small band of Nez Perces across Yellowstone, which was now off-limits to them. The first federal headquarters in Yellowstone Park was a fort, complete with gun turret. By the late 1880s the park management had become adamant about excluding Native hunters from the park, as recreational hunters complained of diminishing stocks and "wanton" destruction of game.[27] Throughout much of the nineteenth century, of course, eastern Americans, who were far removed from the territorial tug-of-war in the West, had sentimentalized the plight of the "vanishing Indian" as an exemplum of the endangered wilderness.[28] In an ironic reversal of such sympathies, the park's white constituents—hunters, tourists, and managers—blamed Native people for supposedly ruining the wilderness at Yellowstone.

Moran's painting resolved these painful historical realities in a wishful image of the peaceful transfer of ownership and sovereignty from the Native American to the white colonizer.[29]

How does the historian explain this redefinition of Native people as incompatible with the concept of wilderness preservation? Romanticism had traditionally represented the "noble savage" as a figure stereotypically living in harmony with nature but also radically other, occupying wilderness and a different order of being from that of Europeans, closer to the world of animals. The wilderness concept, in short, worked against what William Cronon identifies as the space "where we actually live" and which surrounds us "if only we had eyes to see it."[30] The late-nineteenth-century version of wilderness, with its insistence on expunging any human history or presence, merely pursued the romantic wilderness concept—grounded in the radical segregation of human and natural histories—to its logical extreme. Alston Chase, a critic of the National Park Service, summed up the ironies of Native dispossession in Yellowstone in the following terms: "Created for the benefit and enjoyment of the people," the park had "destroyed a people. Dedicated to preservation, it evicted those who had preserved it. Touted as pristine, [and] . . . denied its Indian past, it deprived us of the knowledge to keep it pristine."[31] As a Native American rights activist later observed, "There was no wilderness until the Whites arrived."[32]

From its origins in a form of adversarial romanticism to its institutionalization in the philosophy of the National Park Service, the wilderness concept reveals very different histories in its movement across the nineteenth-century cultural landscape of the nation. Critical to any assessment of the concept's impact, however, is the degree to which its various apologists have acknowledged that wilderness is a part of human history, not separate from it; that "humans" include the people indigenous to these regions; and that as such, wilderness becomes a reality that is pliable and open to human intervention, rather than a static ideal impervious to time, history, and human desire for an intimate and productive commerce with the natural world. In looking at the specific histories of artistic representation, I have charted three distinct episodes, ranging from the personal investment of the English-American romantic Thomas Cole—rife with natural drama that visualized his own struggles and his moral argument with the emerging nation-state—to the carefully constructed fictions of a stable middle ground, formalized in much midcentury landscape art, as epitomized by Durand's *Progress*. Moran's *Grand Canyon of the Yellowstone* offers a summa of the western paradise

as a glorious void entirely receptive to the penetrating gaze and scientific expertise of the newly empowered postbellum nation-state. In the latter two works, the presence of the Native American introduces a more pointed— if unacknowledged—focus to the historical dilemmas that accompanied Americans' establishment of a continental empire.

One might well ask why American artists—with the possible exception of Cole—have been so quick, in general, to accommodate the moral evasions of a nation that seemed, in the words of Herman Melville, "not so much bound to any haven ahead as rushing from all havens astern."[33] But, to ask such a question is to hold them to a higher standard of accountability than that to which we hold ourselves, by assuming that it is possible to think beyond one's own historical horizon. And we cannot, in any case, look to representation for anything more than a temporary, and ineffectual, resolution of entrenched historical dilemmas. Landscape painting offered aesthetic solutions to problems whose origins were social—an imaginary stage on which to explore the role of nature in the nation's evolving identity. As symbolic constructs they acted out a range of different cultural scenarios. Yet, the problems they engaged were ones that could only be fully addressed in the arena of democratic deliberation, debate, and choice.

Notes

1. Carolyn Merchant, *The Columbia Guide to American Environmental History* (New York: Columbia University Press, 2002), 71. Other recent interpretations of romanticism, however, have considerably complicated this reading, arguing for the complicity between romanticism and capitalist consumerism. See, for instance, Colin Campbell, *The Romantic Ethic and the Spirit of Modern Consumerism* (Oxford, U.K.: Blackwell, 1987); also Kenneth Myers, "On the Cultural Construction of Landscape Experience, Contact to 1830," in *American Iconology,* ed. David Miller (New Haven: Yale University Press, 1993), 58–79.

2. Carolyn Merchant, "Shades of Darkness: Race and Environmental History," *Environmental History* 8, no. 3 (2003): 381; Raymond Williams, "Ideas of Nature," in *Problems in Materialism and Culture: Selected Essays* (London: Verso, 1980), 70–71.

3. Perry Miller, "The Romantic Dilemma in American Nationalism and the Concept of Nature," in *Nature's Nation* (Cambridge, Mass.: Belknap Press, 1967), 198.

4. Cole to Luman Reed, March 6, 1836, Cole Papers, New York State Library, Albany.

5. Cole's journal, August 6, 1836, quoted in Angela Miller, "The Imperial Republic: Narratives of National Expansion in American Art, 1820–1860" (Ph.D. diss., Yale University, 1985), 117–18.

6. P. Miller, "Romantic Dilemma," 199.

7. Dated March 1836, reproduced in full in John K. Howat, ed., *American Paradise: The World of the Hudson River School* (New York: Metropolitan Museum of Art, 1987), 126.

8. The moving panorama was popularized in the 1840s, the decade after Cole's painting. See John Francis McDermott, *The Lost Panoramas of the Mississippi* (Chicago: University of Chicago Press, 1958).

9. This reading is found in Matthew Baigell and Allen Kaufman, "Thomas Cole's *The Oxbow:* A Critique of American Civilization," *Arts Magazine* 55 (January 1981): 136–39.

10. Basil Hall, *Forty Etchings, from Sketches Made with the Camera Lucida, in North America in 1827 and 1828* (Edinburgh: Cadell, 1829).

11. These phrases are taken from Cole's letters from the mid-1830s; cited in Angela Miller, *Empire of the Eye: Landscape Representation and American Cultural Politics* (Ithaca: Cornell University Press, 1993), 60–61.

12. Such phrases were common by midcentury, especially in critical reviews of landscape art.

13. George Perkins Marsh, *Man and Nature,* ed. David Lowenthal (Cambridge, Mass.: Belknap Press, 1965); see also David Lowenthal, *George Perkins Marsh: Prophet of Conservation* (Seattle: University of Washington Press, 2000). Marsh's insights have been substantiated and expanded on by recent environmental history; see, for example, Andrew C. Isenberg, *The Destruction of the Bison: An Environmental History, 1750–1920* (New York: Cambridge University Press, 2000), on the role of the transportation revolution, steamboats in particular, in deforestation.

14. Marsh, *Man and Nature,* 35, 279.

15. Theodore Parkman, *The Oregon Trail: Sketches of Prairie and Rocky Mountain Life* (New York: Hart, 1977), 230; see also 98.

16. See Roderick Nash, *Wilderness and the American Mind* (New Haven: Yale University Press, 1981), 52–53, 60, 75–77, on James Fenimore Cooper's character Leatherstocking, whose attitudes toward nature and the pioneer mirror those of Parkman. Cooper, like Parkman, was no democrat.

17. This midcentury myth of the pioneer anticipates the full enunciation of the frontier myth with Frederick Jackson Turner's famous lecture at the Chicago World's Fair, "Significance of the Frontier in American History," delivered in 1893. The representation of the pioneer in the 1850s reveals that the ground for Turner's frontier thesis was already being prepared culturally by midcentury. Examples in-

clude Thomas Cole's *Home in the Woods* and *Hunter's Return,* Jasper Cropsey's *Retired Life* and *The Backwoods of America,* Asher B. Durand's *First Harvest in the Wilderness,* George Caleb Bingham's *Emigration of Boone across the Cumberland Gap,* and William Tyler Ranney's *Advice on the Prairie,* all dating from the late 1840s and 1850s. For reproductions of most of these works see William H. Truettner, ed., *The West as America: Reinterpreting Images of the Frontier, 1820–1920* (Washington, D.C.: Smithsonian Institution Press, 1991), 31, 113–14. Cropsey's *Backwoods* is an American frontier version of Cole's *Savage State* from *The Course of Empire.*

18. The term "middle landscape" can be traced to Leo Marx, *The Machine in the Garden: Technology and the Pastoral Ideal in America* (New York: Oxford University Press, 1970), esp. 121, 150, 226.

19. On the role of metropolitan culture in producing landscape meaning see Andrew Hemingway, *Landscape Imagery and Urban Culture in Early Nineteenth-Century Britain* (New York: Cambridge University Press, 1992); on the linkages between city and country see William Cronon, *Nature's Metropolis: Chicago and the Great West* (New York: Norton, 1991).

20. The literature on Native interaction with the environment of North America has become vast in recent years; see the bibliography on the subject in Merchant, *Columbia Guide to American Environmental History,* 335–46.

21. Already by 1864, however, Yosemite had been ceded to the state of California as a protected site by an act of Congress. See Truettner, *The West as America,* 272.

22. The literature on the linkages between national parks and Native American dispossession includes Robert H. Keller and Michael F. Turek, *American Indians and National Parks* (Tucson: University of Arizona Press, 1998); Mark David Spence, *Dispossessing the Wilderness: Indian Removal and the Making of the National Parks* (New York: Oxford University Press, 1999); and Philip Burnham, *Indian Country, God's Country: Native Americans and the National Parks* (Washington, D.C.: Island Press, 2000). Rebecca Solnit, *Savage Dreams: A Journey into the Landscape Wars of the American West* (Berkeley: University of California Press, 1999), dwells on the many historical ironies of a sublime wilderness aesthetic built upon the often violent erasure of Native histories.

23. Joni Louise Kinsey, *Thomas Moran and the Surveying of the American West* (Washington, D.C.: Smithsonian Institution Press, 1992), 44, makes a similar suggestion.

24. Landscape artists frequently benefited from commercial and industrial development. Frederic Church accompanied lumbermen to paint the wilderness of Maine, ironically while the railroad was celebrated as a means through which Americans could have greater contact with nature. A. Miller, *Empire of the Eye,* 203.

25. See Myra Jehlen, "The American Landscape as Totem," *Prospects* 6 (1981): 17–36.

26. On Moran's reorganization of the actual landscape of the Yellowstone Valley see Kinsey, *Thomas Moran,* 54–58. Kinsey also associates this aesthetic "management" of the site with the concurrent scientific survey of the region.

27. Spence, *Dispossessing the Wilderness,* 62. The foregoing account also draws on Keller and Turek, *American Indians and National Parks,* 17–42.

28. Up to the late nineteenth century, Native Americans had been considered part of the wilderness. For early colonial attitudes see Jill Lepore, *The Name of War: King Philip's War and the Origins of American Identity* (New York: Vintage, 1999), esp. 83, 85.

29. Alan Trachtenberg, *The Incorporation of America: Culture and Society in the Gilded Age* (New York: Hill and Wang, 1982), 11–37; Joel Snyder, "Territorial Photography," in *Landscape and Power*, ed. W. J. T. Mitchell (Chicago: University of Chicago Press, 1994), 175–201; and Michael Bryson, *Visions of the Land: Science, Literature, and the American Environment from the Era of Exploration to the Age of Ecology* (Charlottesville: University Press of Virginia, 2002), 80–104.

30. William Cronon, "The Trouble with Wilderness; or, Getting Back to the Wrong Nature," in *Uncommon Ground: Rethinking the Human Place in Nature,* ed. Cronon (New York: Norton, 1996), 86.

31. Quoted in Keller and Turek, *American Indians and National Parks,* 24. See also Merchant, "Shades of Darkness," 385–87, on the disconnect between wilderness preservation and social justice.

32. Quoted in John Cawelti, "The Frontier and the Native American," in *America as Art,* ed. Joshua Taylor (New York: Harper and Row, 1976), 137.

33. Herman Melville, "The Try-Works," in *Moby-Dick or The Whale* (1851; New York: Modern Library, 1992), 611.

5
They Might Be Giants

Galen Clark, Carleton Watkins, and the Big Tree

Elizabeth Hutchinson

To mid-nineteenth-century Americans, California was well known as the origin of many a "tall tale." "The Celebrated Jumping Frog of Calaveras County," Mark Twain's classic 1865 fable about a grizzled old-timer whose acrobatic amphibian—"Dan'l Webster"—did not measure up in the final competition, captures the larger-than-life spirit that surrounded the men and women living in the foothills of the Sierra Nevada.[1] Calaveras County was already known as the home of California's most legendary heroes: the giant sequoia trees. After their "discovery" by European Americans in 1855, the mammoth trees became the immediate subject of national attention. The gigantic scale of these trees, and the implication of age that went with their height, captured the country's imagination.

The summer that Twain published his Californian myth, Carleton Watkins ventured into the area for the third time to make photographs of these giants that would convey their almost unreal greatness. He made several photographs of the "Grizzly Giant," then the largest and oldest known tree in the United States. Watkins split his portrait into two views: a full-scale image that shows the height of the tree, and a section that emphasizes its girth. The latter is the focus of this investigation. An extraordinarily large photograph for the time, the eighteen-by-twenty-two-inch *Section of the Grizzly Giant—33 Feet Diameter* tries to approximate the scale of its subject (fig. 20). The negative was created with a "mammoth" camera specifically constructed to capture the scale and grandeur of California's overgrown landmarks: waterfalls several times higher than Niagara, rock formations bigger than cathedrals, and trees on an unheard-of scale. The Grizzly Giant seems almost too big to fit into this frame. It stretches nearly to the sides of the

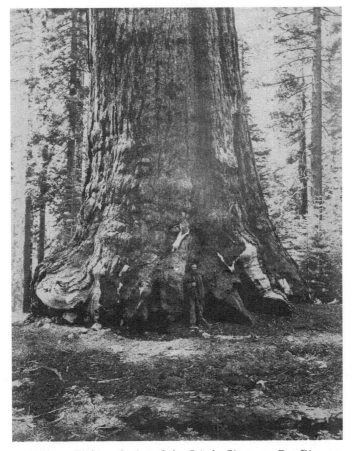

20. Carleton Watkins, *Section of the Grizzly Giant—33 Feet Diameter*, 1865–66. Albumen print. The J. Paul Getty Museum, Los Angeles.

print, the trunk shooting out of the top without beginning to narrow, as if it could go on forever.

If this were not enough to cast the viewer into a state of awe, the vast girth of the tree is underscored by positioning a figure at its base. This man is, physically and symbolically, no slouch himself; he is the six-foot, two-inch Galen Clark, the caretaker of the copse of giant sequoias in which the Grizzly Giant stands. Clark's knowledge and skill as a naturalist and guide were made famous in countless articles and books about the region. The photograph's significance is further underscored by the stature of its photographer.

When he exposed the image, Carleton Watkins was already the best-known California landscape photographer of his day.[2]

Susan Stewart has written provocatively about the subject of giants in Western culture. The gigantic, she claims, provides a metaphorical screen through which an individual can work out his or her relationship to the exterior world: "We find the gigantic at the origin of public and natural history. The gigantic becomes an explanation for the environment, a figure of the interface between the natural and the human."[3] Produced the year after the Yosemite Valley and nearby Mariposa Grove of Big Trees were set aside as national monuments, the photograph juxtaposes three "giants"—the tree, its caretaker, and its photographer—as a testament to the possibilities of giants, natural and human, in structuring an American relationship to the western landscape.

The choice to use a work by Watkins to investigate changing attitudes toward the American wilderness is an obvious one. Long praised for the beauty of his quasi-modernist formal compositions, he has recently been described as a propagandist for the exploitation of California's natural resources, creating aesthetic images that legitimized the region's commercial development. The debate over how much attention to pay to his unique vision continues today.[4] However, my focus is not primarily on the artist but on his audience. By closely examining the prints themselves, the physical contexts in which they were viewed, and the period visual culture they invoke, I would like to speculate on the meanings the photographs might have communicated to their viewers. I will begin by examining two prints of this image, one produced shortly after the negative was exposed, and the other made sometime after 1875.

By grounding this analysis in two products of a single negative, I hope to avoid a common pitfall in writing about photographs, which is to reduce them to unproblematic, virtual illustrations of social forces instead of active players in the field of visual culture. For at least two decades, scholars have called for a turn away from formalist readings of nineteenth-century photographs toward an understanding of the historical changes that were supported by the books, periodicals, and archives in which they appeared.[5] Interestingly, this process of rehistoricizing can take us away from the materiality of the objects being discussed. While many scholars describe the content and even the style of photographs at length, they often look past the details of individual prints, by which I mean the exposing, developing, and

printing that are necessary to creating the final illusionistic image, as well as the signs of wear and use that show the unique histories of each object. In other words, historians of photography tend to write about pictures and *not* prints. We discuss what a photograph depicts as if our access to it is not influenced by such extraneous visual information, yet such signs of construction and use directly affect *how* we see *what* we see in a photograph that is the subject of historical investigation. My interest comes from a desire to investigate how close looking allows us to see more clearly how visual culture is the bearer of meaning in specific historical contexts for specific audiences, for it is only by confronting the materiality of historical objects that we can fully animate historical relationships to the material world.

I will argue that one print of Watkins's "Grizzly Giant"—in its internal form and in the contexts in which it was viewed—encourages an attitude of grandeur and reverence toward nature, while the other, made two decades later and viewed in different contexts, encourages the dispassionate, even commodified attitude of the tourist. I use the term *tourism* not only in its literal sense of referring to commercial activities set up for actual travelers, but also in terms of what Dean MacCannell explores as the "ideological framing of history, nature, and tradition . . . that has the power to reshape culture and nature to its own needs.[6] At the same time, these two prints expose the conflicts embedded in literal tourism in mid-nineteenth-century America, conflicts generated by the tensions between the antimodern ideology with which romantic travelers pursued "scenery" and the commercial processes used to produce this intangible product.[7] This conflict became exacerbated in the period between the two prints because of things that affected people's relationship to both Watkins's photograph and its natural subject matter.

1865

The Grizzly Giant is the acknowledged patriarch of the Mariposa Grove of Sequoias. It is not so tall and graceful in general outline, nor is its cubical contents as great as some other trees in the Grove. It is located on more comparatively open and dry ground and has a unique individuality of majestic grandeur all its own, different from any other known Sequoia. It has been very badly injured by fires during unknown past centuries, leaving only four narrow strips of sapwood connecting with its roots. Many of its top branches have been broken down by the weight of

heavy winter snows and fierce gales of wind. . . . Dying for centuries, yet still standing at bay, it is probably not only the oldest living tree, but also the oldest living thing on earth.

—Galen Clark, *The Big Trees of California,*
Their History and Characteristics

It is useful to remember *where* and *how* early prints of *Section of the Grizzly Giant* were encountered. Carol Armstrong has demonstrated the importance of understanding nineteenth-century photographs in the context of the albums and books in which they were generally found.[8] This is certainly where the mammoth plate *Section* belongs, historically speaking. Although Watkins's stereo views began to be marketed nationally in 1865, the primary means of encountering his larger pictures that year was in the bound albums he had been publishing since 1863, updating the plates after subsequent trips.[9] To reconstruct the early viewer's experience of this photograph we might first look at how the image falls within a narrative created by the album of which it was a part. For unlike the personal photograph albums with which we are most familiar, which bring together images garnered from all over and are arranged according to the owner's personal whim, the extant Watkins albums offer to diverse audiences a similar set of images arranged in a similar order.

No one to date has commented on the order of images in Watkins's albums, but the progression they follow is a logical one, repeating the experiences of visitors to the area from beginning to end, first using horizontal photographs and then vertical ones (so that the viewer did not have to constantly turn the heavy album).[10] The initial picture in most of them is *The First View of the Valley from the Mariposa Trail,* reproducing a panoramic scene taken from a promontory not far from the Mariposa Trail, which led into Yosemite Valley from the south. The second image, *Best General View of the Yosemite Valley from Mariposa Trail,* marks another view available along this trail. After that, the viewer metaphorically enters the valley, looking first to the left at *El Capitan* and then to right to *The Bridal Veil Fall.* Subsequent pictures take the viewer up the valley toward Cathedral Spires and the Three Brothers, then into the Little Yosemite Valley to view the Vernal and Nevada Falls, and out of the region via the easily climbed Sentinel Dome for some final panoramic views. The final images are of the Mariposa Grove, located over twenty miles southwest of the valley that was, in 1865, usually visited on both the way in and the way out of Yosemite itself. Subsequent tourist

guides reinscribe this itinerary as the standard. In 1868, state geologist Josiah Whitney published *The Yosemite Book*, designed as a guide to visitors to the area and, according to John Sears, the model for all subsequent nineteenth-century guides to the region.[11] The book not only recommends this same route but even previews those experiences in twenty-eight photographs made for the publication by Watkins.

Viewing images bound into an album structures not only *what* to look at, but also *how* to view it. While small stereocards might seem like expendable parlor toys, the very act of looking at the weighty tome would encourage a reverential feeling. Guests would have to bend over tables to gaze into the heavy books, a position that would direct their attention away from their pedestrian surroundings "into" the view in a quiet setting that would emphasize a sense of personal contact with the awesome natural monuments of the West. The idea of contemplation is particularly strongly invoked in the *Grizzly Giant* photographs, which are positioned at the end of the album, with the *Section* following the full view, offering a virtual experience of stepping in for a closer examination.

This sequence seems to have been important to the artist. Watkins photographed the base of the Grizzly Giant on each of his trips to the Mariposa Grove. His early pictures of the section are horizontal and thus appear at the end of the first suite of images in the 1863 albums. In 1865 he switched to a vertical composition. This may have been influenced by the fact that he was photographing illustrations for Whitney's *Yosemite Book* at the same time; *The Yosemite Book* photographs are all verticals. In both Whitney's book and albums containing prints from the 1865 negative, Watkins placed the *Section* after a photograph of the entire Grizzly Giant. Moreover, the inclusion of a human figure in the *Section* for the first time (the other photographs are pure landscapes) encourages the viewer to consider the relationship of people to the American landscape.

Modern scholars have located only a handful of the albums, suggesting that circulation of the expensive, heavy objects was limited. Several have been traced back to earlier owners, such as the influential minister and California booster Thomas Starr King, the Central Pacific Railroad financier Collis P. Huntington, and the Harvard botanist Asa Gray. Viewers also certainly included Watkins's patrons Josiah Whitney, John and Jessie Frémont, and, we can assume, other Yosemite promoters such as editor Horace Greeley and House Speaker Schuyler Colfax, both of whom visited the region in the early 1860s. The elite group who saw a mammoth plate image of the *Section* early

on thus included many who were directly concerned with the natural, scientific, and economic potential of the region.

These viewers would have interpreted the image in the light of their own aestheticized experiences of the Big Trees. In the mid-nineteenth century the Mariposa Grove was as important as any other feature of the area; contemporary accounts by scientists and travelers devote at least as much time to describing the first encounter with the giant sequoias as to rhapsodizing about the domes and waterfalls of the valley. As Whitney claimed, "No other plant ever attracted so much attention or attained such a celebrity within so short a period."[12] The age of the trees impressed visitors as much as their size. As Greeley over-optimistically noted upon his visit: "That they were of very substantial size when David danced before the ark, when Solomon laid the foundations of the Temple, when Theseus ruled in Athens, when Aeneas fled from the burning wreck of vanquished Troy, when Sesostris led his victorious Egyptians into the heart of Asia, I have no manner of doubt."[13] The antiquity of the trees seemed to offer reassurance. Visitors to the grove even hugged the trees. Trees were frequently personified as models of human greatness in midcentury culture, and descriptions of the giant sequoias frequently treat them as animate beings. Greeley called them "patriarchs"; another visitor described them as "hoary old survivors."[14] The *Section* invites similar associations. As the viewer gazes at the bark of the Grizzly Giant, the tree seems to take on human qualities. Knots and bumps begin to coalesce into faces, especially on the left side.

In *Section* the figure of Galen Clark provides a model of the viewer's communion with the vastness of nature. Clark's tiny body is almost absorbed by the tree. The monochromatic photograph adapts the guide's colors to those of the Grizzly Giant, but the affinity between these two runs deeper, so that the wisps of Clark's beard start to look like the leafy fronds of the young trees in the front of the composition. Covered in slouchy layers—checked shirt, cardigan, jacket, with long pants that bunch around his boots—Clark's wrinkled silhouette echoes that of the tree behind him. The caretaker and his charge even share the same posture, seeming to lean back to the left and turn slightly to the right. The resemblance between man and tree is such that we need to labor to pick out the details of Clark's features. In fact, one of Watkins's viewers wrote that his eye was wearied by the work involved in taking in this view.[15]

The wealth of detail has a moral. It forces the viewer to achieve an understanding of the landscape through great effort, causing him or her to medi-

tate on the complexity of God's creation. Contemporary aesthetic theory encouraged Americans to look for signs of divine and national destiny in representations of nature.[16] Asher Durand's well-known 1848 painting *Kindred Spirits,* which depicts friends Thomas Cole and William Cullen Bryant "reading" a landscape, demonstrates this tradition (fig. 21). The figures are overwhelmed, absorbed, by the view, and in their concentration and gestures demand the viewer's serious visual investigation and interpretation. The almost photographic precision with which Durand renders the rocks and leaves arrests the viewer in studious stillness as his or her eyes bore deeper into the details.

While there is no evidence that Watkins read Durand's "Letters on Landscape Painting" (1855) or other documents of the American romantic tradition, his photographs conform to the compositional conventions of this school. His understanding of a correct depiction of landscape could have come through his exposure to photographs by Francis Frith and Frederick Langenheim, whose work drew on the conventions of painting, during his early career in the studio of Bay Area photographer R. H. Vance. Moreover, by 1865 Watkins had long been associating socially and professionally with highly educated men and women like the Frémonts, which would have offered opportunities to discuss how to interpret nature.

Aesthetic discussions in nineteenth-century America frequently took on a nationalist tone. Durand and Cole routinely celebrated the nation's wilderness as a sign of the country's unique destiny. A desire to endow the Mariposa Grove (until June 30, 1864, a Mexican territory) with a national identity can be seen in the fact that visitors named the trees after cultural heroes, including "George Washington," "General Jackson," and, with an inadvertent tip of the hat to Mark Twain, "Daniel Webster."[17] The naming of the species itself became an opportunity to demonstrate nationalist pride, with British scientists immediately suggesting the name *Wellingtonia gigantea,* and Americans clamoring for *Washingtonia gigantea.* The final name decided upon was *Sequoia gigantea,* because of the similarity between the new trees and California's other redwoods, the *Sequoia sempervirens.* Clark's pose reinforces an association with American heroes. With his woodsman's garb and gun at the ready he invokes countless nineteenth-century representations of another American cultural hero: Daniel Boone.

Clark himself came to play the role of the heroic American "natural man." Until his friend John Muir began crusading for conservation at the turn of the century, Clark was the man most associated with the Yosemite

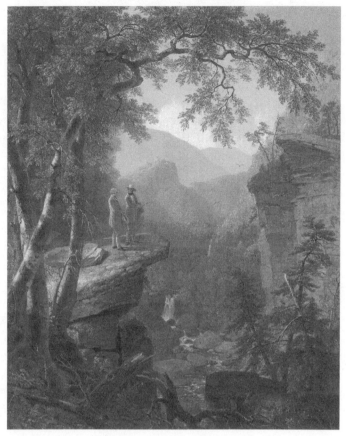

21. Asher B. Durand, *Kindred Spirits,* 1849. Oil on canvas. Courtesy, Crystal Bridges Museum of American Art, Bentonville, Arkansas.

region. A surveyor and guide who served on the Yosemite Commission and was the official caretaker of the Mariposa Grove, Clark had been personally involved with nearly every group of visitors to the Yosemite area. Most stayed overnight at the ranch he erected in 1857. In subsequent years he expanded his ranch into a hotel (now called the Wawona) and with his friend Milton Mann developed trails and roads to make traveling easier. Clark used his authority to promote a reverent relationship to nature similar to the one encouraged by the narrative of the album. His books repeatedly describe the Mariposa Grove as an example of "the mighty grandeur and magnificence of the works of God."[18]

If the giants *in* the picture helped structure the viewer's response, the gi-

ant outside the picture—Watkins himself—did, too. For viewers of the album were not just looking at pictures of nature's self-evident grandeur, but at *Watkins's* views. The name was embossed on the cover and printed on the title page, and often even signed on the plates themselves. Although Watkins wasn't the first photographer to venture into Yosemite and the Mariposa Grove, or even the first to take photographs from many of the points of view included in the album, his is the name that is associated with a definitive understanding of the area. Watkins's photographs even set up expectations for travelers before they came. As Fitz Hugh Ludlow put it in a letter published in the *Atlantic Monthly* while en route to the region, "We were going into the vale whose giant domes and battlements had months before thrown their photographic shadow through Watkins's camera across the mysterious wide continent."[19]

The respect the image confers on these giants would have been particularly appealing for the albums' viewers, as they, too, were interested in the development of the American landscape. Some benefited from the scientific exploitation of the region, contributing to the establishment of an American geology and botany with institutional support. Others gained economically from the idealized perception of the landscape that the three giants created. As George Dimock has pointed out, Yosemite's celebration as an exceptionally important national natural treasure and the area's preservation for public use facilitated public comfort with the private development of adjacent lands for the mining and lumber companies of Frémont, Collis Huntington, and others.[20] Finally, setting up Yosemite as America's first western tourist destination spawned a different kind of lucrative landscape development, including the railroad, hotels, and other kinds of concessions. In her analysis of painter Albert Bierstadt and others, Nancy Anderson has argued that western landscapes frequently negotiated the new realm of economic development by appealing to older ideas about the elevated value of nature: "Skillfully crafted and consciously composed for a market interested in the West (often as an investment), most western landscapes carried a conciliatory message implying that the natural and technological sublime were compatible, that the wilderness landscape Americans had used to define themselves and their nation since the seventeenth century could endure as a cultural icon while being converted to economic use."[21] The album's viewers didn't see these projects as crass commercialism. They linked their personal view of the West with national necessities. Album owner Thomas Starr King, whose book on the White Mountains of New Hampshire helped spread American

landscape tourism, first saw the Big Trees on a trip designed to rally California behind the Union cause. Speaker Colfax saw the grove after it had been set aside as the nation's first natural area to be protected from private development. The fact that the Senate took time out from war administration in 1864 to create the beginnings of what would later become the national park system is not a coincidence. Angela Miller has suggested that representations of the West made around the years of the Civil War attempted to establish a harmonious image of a future, reunified America, providing a temporary escape from the painful rifts and losses in the East.[22] Oliver Wendell Holmes's articles on photography in the *Atlantic Monthly* during the Civil War praise Watkins's "calm," "clear," and "distanced" views. Holmes was particularly intrigued by the ability of photography to transport the viewer to a different time and place: one article, printed in the same month as the South's first major victory at Manassas, invites the reader to join him on a "stereographic trip" to the American landmarks of romantic travel: New York's Niagara Falls, New Hampshire's White Mountains, and Virginia's Natural Bridge.[23]

For its early viewers, then, the *Section,* in its visual details and in the contexts in which it was viewed, seemed to endorse a destiny that benefited the nation and themselves. Names like the "Grizzly Giant" and the "Father" and "Mother of the Forest" invite the viewer to think of these trees as superhuman creatures who assure us of the greater plan (and paternal care) of God. Romantic viewers found the Mariposa Grove a sign that this continent was as old as other aspects of God's creation, and that the young republic had something ancient and noble with which to counter Europe's monuments of civilization. In a more presentist light, hopeful Union supporters named other trees after human "giants" such as Ulysses S. Grant and Abraham Lincoln. For viewers from this narrow group, the problems embedded in this endorsement—the self-contradictory idea of developing public access to a natural preserve, the tenuous proposal that romantic ideas could hold off crass tourism, the questionable belief that nature can solve cultural problems—were hard to see. But as the nation was unable to simply return to a path of progress, so Watkins's photograph ultimately fails in its attempts to perpetuate a vision of America unified through shared values. Visual culture frequently incorporates aspects of the very discourses it would most want to suppress, and hints of the instability of these values can now be found in the same image that proposes them.

Its title referring to the divisive war in a way that "base" or "trunk" never

would, the *Section* implicitly offers as much of an appeal for moral leadership as a demonstration of moral authority. The *Section* thus seems unable to sustain its conciliatory message about the ability of art to control interpretations of humans' relationship to larger forces. Clark appears to search for solace, modeling the viewer's turn to the landscape for explanations of the chaotic human world. The pale fissures in the tree's bark even evoke this chaos, as several of the shapes resemble topsy-turvy human bodies. The end of the album ultimately provides as many questions as answers about the viewer's appropriate relationship to the American land.

1881

As a result of the great injuries it has sustained from the destructive elements and lack of moisture in the ground during the past few centuries, the wood growth has been very slow, the annual ring increase being as thin as wrapping paper, too fine to be counted with the unaided eye. The inside growth of bark has been equally slow, and has not been equal to the wear and disintegration on the outside by the elements. The bark is now worn down smooth and very thin, and probably the tree does not now measure as much in circumference as it did several centuries ago.

—Clark, *The Big Trees of California*

According to his 1907 book, Clark knew that the stature of the Grizzly Giant was diminishing over time due to natural forces. What he did not realize was the way in which his and Watkins's efforts to preserve the tree contributed to this process. Each facilitated the transmission of information about the Mariposa Grove to a broadening audience that was bound to see the American landscape differently. A later Watkins photograph of families relaxing on the porch of Clark's expanded hotel captures this audience. Showing women in hoopskirts with a delicate baby carriage, it suggests that visitors came for a less rigorous experience of nature than their forebears did. The lodge has changed, too. Its original log walls have been replaced by clapboard, and the woods surrounding the building have been cleared to create a lawn enclosed by a picket fence. All of this suggests that tourists of the Gilded Age brought with them a desire for the comforts of home. Tourism in Yosemite was becoming increasingly tied to a spreading middle-class leisure industry.

Susan Stewart has observed that the late nineteenth century witnessed a transformation of the gigantic from a mode associated with individual heroes

and community values to the anonymous sphere of commercial advertising.[24] In the case of the Grizzly Giant, it is interesting to note the speed with which something revered as a sign of divine and human greatness was reduced to a gimmick to attract the fractured attention of the modern consumer. In particular, the consumers enticed by advertising images of the Grizzly Giant were tourists. Watkins's photographs cannot be divorced from this transformation. As "markers" of a tourist attraction, they participated in a system that was inherently unstable. MacCannell has argued that within tourism such markers frequently replace, and sometimes even obliterate, the attraction itself, as when a high-rise tourist accommodation destroys the "natural" character of the setting, which attracted the tourists who stayed there.[25]

These changes can be seen in a print made from Watkins's negative of the *Section of the Grizzly Giant* sometime after 1875 (fig. 22). It suggests the loss of the authority of the Grizzly Giant as a site demanding reverence *and* of Clark and Watkins as interpreters of that experience. While Watkins, Clark, and the Grizzly Giant seem like three giants whose fates are inextricably linked, the men's names do not actually appear anywhere in later prints made from the negative. This omission coincides with a decline in status for both men. Watkins lost the rights to his early negatives to his competitors John Jay Cook and Isaiah West Taber during the financial crises of 1875 and 1876. By the 1880s, Taber was distributing Watkins's Yosemite photographs under his own name within an ever-increasing tourist market. Travelers who were not interested in or who could not afford an entire album of Watkins's views could purchase an unmounted mammoth print for five dollars—less than an expensive chromolithograph.[26] Rolled up, such an image could easily be carried home and stored with other souvenirs. As a souvenir, it was incorporated into travelers' own narratives of the trip rather than being integrated into the controlled narrative of Watkins's album.

The challenge of the Taber print of the *Section* was to retain a sense of this giant tree's grandeur in an image that seems to disappear into the gigantic inventory of tourist photographs of the American landscape. Clark's pose echoes countless tourists posing in front of a landmark. The very caption printed on the bottom of the image, "113. Section of the 'Grizzly Giant,' 33 feet diameter, Mariposa Grove, Cal.," with its seemingly random number, implies the existence of countless other photographs in this inventory alone. Without a familiarity with the prints' author or subjects, does the photograph demand the viewer's attention at all?

Taber's perfunctory caption aptly registers an important transfer of au-

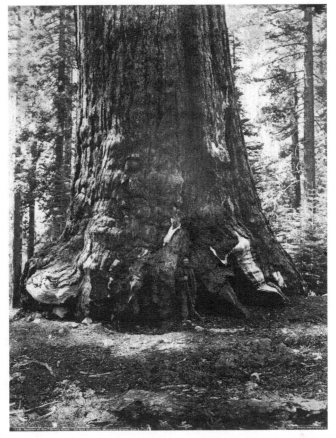

22. Carleton Watkins, *Section of the Grizzly Giant,* printed by Isaiah West Taber, after 1875. Albumen silver print from glass negative. The Metropolitan Museum of Art, New York, The Elisha Whittelsey Collection, The Elisha Whittelsey Fund, 1972 (1972.643.3). Image © The Metropolitan Museum of Art.

thority over the interpretation of the photograph from a socially connected photographic master to an anonymous consumer. Introducing a different kind of representational system into the supposedly indexical transcription of nature, the caption's crisp line of type interrupts the viewer's involvement with the scene depicted. The gray strip behind the words defies the illusion of space created by the image. The viewer is transported, not into the scene, but into an imaginary space where the tree is not a physical object but merely a spectacle.

Ironically, the Mariposa Grove was designated a protected area explicitly to save it from such a fate. By 1864 the Calaveras Grove had already been developed into a crass commercial wonderland where visitors could dance on a tree stump, ride horses through another fallen giant, and climb the scaffolding that entrepreneurs had erected in order to flay the bark of the "Mother of the Forest" for display in the East. But while the Grizzly Giant was protected from such vulgar treatment, it was subjected to photography—another form of "skinning."

Later viewers of the *Section* were likely to respond to Galen Clark differently, too. Without recognition by a viewer who had personally toured the grove with Clark, the stalwart guide's tiny scale and sideways glance make him almost insignificant. He is so overwhelmed by the tree that he looks freakish, Lilliputian. As in photographs of post–Civil War freak show "professional giants" posed with dwarves, the man's diminution and the tree's overgrown appearance suggest that scale signifies nothing outside its own entertainment value.[27]

Clark's archaic miner's garb makes him a sign of local color, like the picturesque "mule-men" and Native Americans described in Yosemite guidebooks. This loss of identity was, in many ways, literal for Clark, who suffered a decline in reputation and power in 1880. Losing a political struggle in that year to those who wanted the park to accommodate more visitors, Clark was removed from the Yosemite Commission and reduced to making a living by offering buggy tours to the growing number of tourists speeding through the region. In posing for such pictures, he encouraged the commodification of Yosemite even as he worked to slow that process.

The imposition of an increasingly market-driven authority over the park is echoed in the Taber print of the *Section*. Although Taber prints are generally of no lower quality than those published by Watkins's studio, late prints of the *Section* suffer from apparent damage to the negative. In this example, an out-of-focus oval "bruise" appears in the area of the tree trunk above Clark's head. Elsewhere, dark flecks and glitches litter the background scenery. Fingerprints in the upper-left corner of the image further signal the printer's carelessness, their greasy-looking marks revealing the process of photographic reproduction here to be a form of industrial production. These breaks in the illusionism of the photograph add another screen between the viewer and the scene represented. Calling attention to the surface of the print, they remind the viewer that photographs are objects, even commodities, whose materiality resists representation. Printed on paper made from

wood pulp, a technology introduced to the United States in 1866, the photograph even evokes the sacrifice of California's forests to the lumber industry, and perhaps to the environmental devastation that followed. Wood pulp paper was much cheaper and easier to produce than the rag paper that preceded it, but it was also less durable. The edges of the photograph show it to be razor thin, absurdly fragile for the support of so substantial a subject, and rather like wrapping paper, the disposable industrial product to which Clark compares the mighty tree's waning rings.

In the development of Yosemite, the symbolic authority of the California landscape as a sign of America's destiny was also shown to be vulnerable. Travelers working through prefabricated itineraries often found themselves unable to re-create the appropriate response to the wonders of nature, as one of the Mariposa Grove's visitors described: "Alas! There was the first big tree, sunlight sparkling all over its great cinnamon-colored trunk, and I was ready to shout, and, spurring my prosaic beast, to rush with the rest in a graceless scramble to be first to reach his majesty's foot. The charm was broken. I was willing, anxious to be deeply moved, but no answering emotion came—such moods do not come at the bidding. . . . I had built an ideal grove, and at first sight it was demolished."[28]

The best visual comparison to bring out the disenchanted meanings of the later print of the *Section* might be a popular illustration of P. T. Barnum's star performer Jumbo the Elephant (with his trainer, Matthew Scott) made about the same time (fig. 23). Posters the size of Watkins's prints began to appear on the walls of buildings in cities in the 1870s and 1880s, marking the triumph of commercialism over the landscape. Incorporated into the anonymous tourist experience of a commodified Yosemite, Watkins's once-sublime Giant has lost its punch. Posed against his own charge's trunk, Clark has also become ineffectual. Very early in his career, Clark had prevented local shopkeepers from putting up advertisements on the mammoth trees. The commissioners passed a law prohibiting signs in the Yosemite land grant, but such precautions did not keep the trees' meaning frozen in time.[29] The significance of the Grizzly Giant, like the stature of Clark the wilderness guide and the fame of Watkins the photographer, competes with new kinds of greatness produced in a commodity economy where the heroic stature of an elephant surpasses that of a president.

These days, prints from Watkins's negative are more likely to be found framed on museum walls than in studies or parlors. Album leaves have become separated from one another, and Taber prints have been mounted and

23. Unidentified artist, *Jumbo on His Travels,* ca. 1860s–70s. Printed broadside. Courtesy, Elizabeth Seeley Collection, Bridgeport Public Library, Bridgeport, Connecticut.

interfiled with earlier prints. In this context, the story they tell is one about art rather than one about attitudes toward the wilderness. The art-world context has preserved Watkins's gigantic stature even as the passage of time has further erased Clark's and the Grizzly Giant's, creating ever more distance between these pictures and the environmental history of which they are a part. As I have argued, however, a return to the pictures themselves can recuperate a history of looking at and interpreting the American wilderness.

Notes

Earlier versions of this essay were presented at Arizona State University and Columbia University. Grants from the Research Allocations Fund of the University of New Mexico and the Gilder Fund of Barnard College supported my research. Geoff Batchen, Alexander Nemerov, Bill Truettner, and Gray Sweeney offered helpful comments on earlier drafts.

1. Twain's story was first published as "Jim Smily and His Jumping Frog" in the *New York Saturday Press,* November 18, 1865, 248–49.

2. For a comprehensive bibliography of works on Carleton Watkins see Amy Rule, ed., *Carleton Watkins: Selected Texts and Bibliography* (Boston: G. K. Hall, 1993).

3. Susan Stewart, *On Longing: Narratives of the Miniature, the Gigantic, the Souvenir, the Collection* (Durham, N.C.: Duke University Press, 1993), 71.

4. Evidenced by Douglas R. Nickel et al., *Carleton Watkins: The Art of Perception* (San Francisco: San Francisco Museum of Modern Art, 1999).

5. See, for example, Douglas Crimp, "The Museum's Old/The Library's New Subject," *Parachute* 22 (Spring 1981): 32–37.

6. Dean MacCannell, *Empty Meeting Grounds: The Tourist Papers* (New York: Routledge, 1992), 1. For more on tourism and modernity see MacCannell's *The Tourist: A New Theory of the Leisure Class* (New York: Schocken Books, 1989).

7. On the "production" of scenery see Dona Brown, *Inventing New England: Regional Tourism in the Nineteenth Century* (Washington, D.C.: Smithsonian Institution Press, 1995).

8. Carol Armstrong, *Scenes in a Library: Reading the Photograph in the Book, 1843–1875* (Cambridge, Mass.: MIT Press, 1998), 15–17.

9. Nanette Margaret Sexton, "Carleton E. Watkins, Pioneer California Photographer (1829–1926): A Study in the Evolution of Photographic Style, during the First Decade of Wet Plate Photography" (Ph.D. diss., Harvard University, 1982), 231.

10. This itinerary roughly conforms to that described by visitors from the 1850s to the 1870s. See, for example, Fitz Hugh Ludlow, "Seven Weeks in the Great Yosemite," *Atlantic Monthly,* June 1864, 739–54. My information is based on five albums from the 1860s. In albums that contained views from more than one series, the *Grizzly Giant* portraits come at the end of the Yosemite and Mariposa photographs.

11. Josiah D. Whitney, *The Yosemite Book: A Description of the Yosemite Valley and the Adjacent Region of the Sierra Nevada, and of the Big Trees of California* (New York: Julius Bien, 1868); John F. Sears, *Sacred Places: American Tourist Attractions in the Nineteenth Century* (New York: Oxford University Press, 1989), 137.

12. Whitney, *The Yosemite Book,* 103.

13. Horace Greeley, *An Overland Journey from New York to San Francisco in the Summer of 1859* (New York: Knopf, 1964), 264.

14. Ibid., 267; Isaac H. Bromley, "The Big Trees and the Yosemite," *Scribner's Monthly,* January 1872, 266.

15. Rev. H. J. Morton, "Yosemite Valley," *Philadelphia Photographer* 11 (1866): 377.

16. See Asher B. Durand, "Letters on Landscape Painting: Letter Two," *The Crayon* 1 (1855): 34; J. Gray Sweeney, "The Nude of Landscape Painting: Emblematic Personification in the Art of the Hudson River School," *Smithsonian Studies in American Art* 3, no. 4 (1989): 43–65.

17. Whitney, *Yosemite Book,* 103; Greeley, *Overland Journey,* 264. The debate over naming is recounted in N. P. Willis, "The Mammoth Trees of California," *Hutchings California Magazine,* March 1857, 390.

18. Quoted in Shirley Sargent, *Galen Clark, Yosemite Guardian* (San Francisco: Sierra Club, 1964), 129.

19. Ludlow, "Seven Weeks in the Great Yo-Semite," 740.

20. George Dimock, *Exploiting the View: Photographs of Yosemite and Mariposa by Carleton Watkins* (North Bennington, Vt.: Park-McCullough House, 1984).

21. Nancy K. Anderson, "'The Kiss of Enterprise': The Western Landscape as Symbol and Resource," in *The West as America: Reinterpreting Images of the American Frontier, 1820–1920,* ed. William Truettner (Washington, D.C.: Smithsonian Institution Press, 1991), 241.

22. Angela Miller, *Empire of the Eye: Landscape Representation and American Cultural Politics* (Ithaca: Cornell University Press, 1993), 205.

23. Oliver Wendell Holmes, "Doings of the Sunbeam," *Atlantic Monthly,* July 1863, 8; Holmes, "Sun-Painting and Sun-Sculpture," *Atlantic Monthly,* July 1861, 16–17.

24. Stewart, *On Longing,* 85.

25. On "markers," see MacCannell, *The Tourist,* 109–17.

26. For example, Louis Prang's print of Albert Bierstadt's *Sunset: California Scenery* was listed in the 1869 catalog for ten dollars; Ron Tyler, *Prints of the West* (Golden, Colo.: Fulcrum, 1994), 139.

27. On "professional giants" see Robert Bogdan, *Freak Show: Presenting Human Oddities for Amusement and Profit* (Chicago: University of Chicago Press, 1988), 113.

28. "The Yosemite," in *Picturesque America; or, The Land We Live In,* ed. William Cullen Bryant (New York: Appleton, 1874), 471.

29. Sargent, *Galen Clark,* 76.

6

Bodies of Water

Thomas Eakins, Racial Ecology, and the Limits of Civic Realism

Alan C. Braddock

In 1877, the Philadelphia realist painter Thomas Eakins (1844–1916) completed *William Rush Carving His Allegorical Figure of the Schuylkill River* (fig. 24), a historical picture commemorating an important local ship carver, sculptor, and civic leader of the early American national period. Now widely regarded as a signature piece by Eakins, the picture represents Rush at work on an artistic project related to Philadelphia's nineteenth-century public water supply, the Schuylkill River. Art historians have offered various interpretations of the painting, mainly having to do with aesthetic issues concerning naturalism and the academic agenda that Eakins was promoting in Philadelphia at the time. This essay casts a wider interpretive net in order to bring the painting into a conversation about the Schuylkill River itself and the politics of environmental history in Philadelphia.[1]

As I will argue, the *William Rush* and other works by Eakins provide an interesting case study in "racial ecology," a term that began to acquire currency in the aftermath of the Hurricane Katrina disaster of 2005. I use it here for art historical purposes to describe the artist's subtle pictorial mapping of Philadelphia's regional environment into various aquatic zones, which he distinguished by the presence of racial difference or its absence. Following an unspoken aesthetic decorum that embodied prevailing social and environmental assumptions, Eakins pictured racial difference in certain marginal, polluted spaces like the marshes and fisheries south of the city while excluding it from other, more manicured areas such as the Schuylkill River at Fairmount Park and the Main Line suburbs. In doing so, he affirmed the expectations of his elite art patrons and members of the white middle class, whose positive civic vision of Philadelphia he largely shared, at least during the early part of his career. The pictures Eakins painted of the Philadelphia

24. Thomas Eakins, *William Rush Carving His Allegorical Figure of the Schuylkill River,* 1876–77. Oil on canvas on masonite. Philadelphia Museum of Art: Gift of Mrs. Thomas Eakins and Miss Mary Adeline Williams, 1929.

environment were unusually realistic for their time, but their realism was selective and reassuring about the city's public image. The *William Rush,* with its white female personification of the river, serves as an epitome or meta-representation of his racial ecology in art. Its studio setting and historical subject aptly encode Eakins's creative detachment from troubling social and environmental realities that were beyond the pale of representation, even for his realism.[2]

Eakins never formalized these ideas as an aesthetic theory or strategy, at least not exactly as I have described it, but he was keenly interested in constructing persuasively realistic pictures of different kinds of people, their occupations, the spaces they inhabited, and related environmental conditions. As he once said in a letter describing a hypothetical great painting, "in a big picture you can see what o'clock it is afternoon or morning if its hot or cold winter or summer & what kind of people are there & what they are doing & why they are doing it." Such a philosophy led him to produce works that not

only reported but also helped construct and naturalize specific social and environmental relations in Philadelphia, aspects of which have persisted into our time.[3]

Let us begin with some background about the *William Rush,* a picture reconstructing one vignette from Philadelphia's past: an early national artisan sculptor at work, carving his wooden statue personifying the Schuylkill River. Such a statue once existed, in fact, but it had largely disintegrated by the 1870s (when a bronze replica was produced to preserve its likeness). Sometimes called *Water Nymph with Bittern,* the statue represented a female figure holding a local river bird (the bittern) on her shoulder, signifying the Schuylkill's role as a natural resource sustaining all forms of life in the Philadelphia region. Rush carved the work in 1809 as part of a decorative fountain constructed for the city's Centre Square pumping station, the heart of a new steam-powered waterworks system designed by architect Benjamin Latrobe. At the time, Rush was serving as an official member of the Philadelphia Water Committee, which supervised the new system. Eakins never saw Rush's statue in this original location, but he had studied earlier paintings and prints that depicted it in situ.[4]

At once a source of water and civic pride, the waterworks symbolized modern progress for many Philadelphians during the nineteenth century, including Eakins, because it used innovative hydraulic technology to bring clean water from the Schuylkill River downtown to urban residents. Among other benefits, the new water system helped to counteract terrible yellow fever epidemics that had plagued the city during the 1790s. When urban population growth and mechanical problems outmoded Latrobe's system, the city built a new dam and public waterworks along the Schuylkill River northwest of downtown Philadelphia at Fairmount in the 1820s. At that time, Rush's *Water Nymph and Bittern* was moved to an elaborate Greek Revival–style plaza at this Fairmount Dam complex, which served the city as both water supply and tourist attraction for decades. No doubt Eakins had observed the statue here, as he lived in Philadelphia's Fairmount neighborhood, only a short walk away. Today the Fairmount Water Works complex functions as a historical museum and interpretive center.[5]

In the picture by Eakins, we see William Rush busily carving in his shop on Front Street in Old Philadelphia. The sculptor is just barely visible in the background shadows at far left, leaning over with mallet and chisel in his hands as he carves the Schuylkill River allegory. Around him are various figures and artistic accoutrements indicative of his profession. The illumi-

nated figure of a nude female model stands on a wooden pedestal in the foreground, her back turned to us as she faces Rush, steadying a large book on her shoulder to simulate the anatomical effects of holding a heavy American bittern. Her elderly chaperone sits to the right, quietly knitting. Assorted wooden fragments are strewn about on the floor, while written inscriptions and preparatory drawings for maritime scrollwork cover the wall at right. Deep in the background darkness we see additional statues of *George Washington* and *The Allegory of the Waterworks,* two later sculptures by Rush that give the painting a sense of transhistorical significance as a summa of the elder artist's career. In vivid contrast to those shadowy background forms, Rush's living model captures our attention in the foreground. Her brightly lit clothing, discarded casually over a Chippendale chair, cascades toward us in a way that metaphorically evokes foamy water from the personified river.

By representing Rush at work, Eakins tapped an older European tradition of studio pictures going back to Gustave Courbet and Diego Velázquez.[6] But he also viewed the Philadelphia sculptor as an appropriate American prototype for his own contemporary artistic purposes. Besides being a crafty local artist and public servant, Rush had played a role in founding the Pennsylvania Academy of the Fine Arts, an important Philadelphia institution where Eakins studied and taught. In an era of American Centennial historicism, nationalism, and modernization circa 1876, Rush thus provided Eakins with a usable past icon, a local hero whose efforts in behalf of both the waterworks and academic art symbolized Philadelphia's rich legacy of progress. To produce this civic commemoration, Eakins marshaled all the resources at his disposal. In addition to making numerous preparatory drawings and sculptural models, he conducted extensive local history research on his subject, studying early national period clothing, visiting Rush's neighborhood in Old Philadelphia, and interviewing elder city residents who remembered the sculptor.

As a way of demonstrating his knowledge and research, Eakins took the unusual step of writing a long, descriptive exhibition label for the painting. In one passage, explaining the iconography of Rush's Schuylkill allegory, he wrote, "The woman holds aloft a bittern, a bird loving and much frequenting the quiet dark wooded river of those days." As a native Philadelphian who had spent a lot of time swimming, rowing, and hunting along the Schuylkill, Eakins knew the river's wildfowl and other species well. His written statement discloses a striking environmental observation about local *natural* history on the Schuylkill River watershed: the bittern, Rush's emblematic bird,

apparently no longer was "loving and much frequenting" the river by the 1870s. As Eakins's words suggest, the bittern's presence there was part of the past as well. Moreover, he tacitly acknowledged that the Schuylkill had lost its "quiet dark wooded" aspect of old.[7]

Eakins neither explained nor expressed any clear value judgment on such matters, but his research for the *William Rush* evidently gave him an inkling of environmental change in the Philadelphia region over time as a fact of modernity. His painting even seems to broach such change spatially by locating Rush and the carved bittern in the background shadows, creating a complex visual metaphor for the word "Schuylkill," meaning "hidden river" in Dutch. Occupying a "quiet dark wooded" place at the rear of the studio, they effectively recede into Philadelphia history. What had produced the environmental change noticed by Eakins and subtly articulated by his picture? And what, if anything, do other paintings by Eakins tell us about it?

One way to begin answering those questions is to look more closely at Philadelphia's environmental history during the late nineteenth century. In the 1860s, 1870s, and 1880s, Philadelphia newspapers, magazines, and public health reports increasingly rang alarm bells about the effects of rapid population growth on water purity and sanitary conditions, specifically concerning the Schuylkill River. Despite the city's historic reputation for good government, scientific progress, and clean water, by the time Eakins painted *William Rush,* Philadelphia had become infamous for its pervasive pollution and political corruption. Already in the antebellum period, in fact, the city was colloquially nicknamed "Filthy Dirty." By the 1870s, the Schuylkill River was so badly polluted from untreated industrial sewage and domestic cesspool waste that disease in the city reached scandalous proportions, with hundreds of residents dying every year from waterborne diseases, including recurring epidemics of typhoid. According to official annual reports by the city's Board of Health, the human death toll from typhoid during the 1860s was 4,357. That figure rose to 4,417 for the 1870s and a whopping 6,394 for the 1880s. Bureaucratic inaction by the city's Republican Party machine only compounded the problem, further mortgaging Philadelphia's progressive image.[8]

In 1875, two years before Eakins completed the *William Rush,* Philadelphia's Commission of Engineers reported that the Schuylkill River had become, in its estimation, a natural "sewer." Also in 1875, the city's Water Department hired a prominent Philadelphia physician named Charles Cresson to conduct a special study based on numerous water samples taken at various

locations on the Schuylkill near central Philadelphia over three years. Cresson gave the following measured but decisive statement in his report:

> The pollution of the Schuylkill river has been increased to such an extent as occasionally to class the water as "unwholesome"; prompt measures should therefore be taken to relieve it of sewage containing faecal and decaying animal matter. The greatest proportion of these are now received from the streams draining into the pool of Fairmount dam. . . . That portion of the sewage which is most dangerous, and which would in the presence of an epidemic produce fatal results, is derived from the cess-pools and the drainage of slaughter houses. . . . The amount of sewage found in Fairmount forebay . . . has been steadily increasing . . . until the water is occasionally charged with an amount of sewage exceeding that carried by the river Thames at London (England), and is totally unfit for use.[9]

According to the standard modern history of Philadelphia, during the last quarter of the nineteenth century, "No respectable person would drink the city water, which came from the polluted Schuylkill, and everyone who could bought spring water from private companies. The typhoid fever death rate was the highest of the major cities, three times that of New York after the turn of the century."[10] In a recent study focusing on such conditions, historian Sam Alewitz has observed:

> The history of sanitation and public health in Philadelphia during the last quarter of the nineteenth century . . . is a saga of corrupt politics and a contaminated environment. . . . [B]y the 1870s the two rivers [the Schuylkill and the Delaware] had become cesspools for the city's sewage and the city had become an unhealthy place to live, threatening the welfare of its inhabitants. . . . It was not necessary to be an engineer, chemist, or a physician, a Councilman or a city bureaucrat to recognize the magnitude of the problem. It was only necessary to walk along the shore of the placid and picturesque Schuylkill River, particularly where the sewers drained into the river, to see the excreta, the offal, and industrial pollution lying along the shore.[11]

No wonder Eakins noted that the bittern had stopped "loving and much frequenting" the Schuylkill River. In addition to acknowledging that bird's dis-

appearance, he occasionally referred to unwholesome environmental conditions in other written statements. One example occurs in a letter from Paris in 1868, explaining his artistic philosophy using colloquial American boating language. There he praised the hypothetical "Big painter" who sails "parallel to Nature's sailing," while condemning "some Dutch painters" for their excessively literal realism, which he likened to "sailing up Pig's run among mud & slops & back houses." In concocting such folksy philosophical metaphors about the proper limits of realism, Eakins undoubtedly drew upon his personal experience around Philadelphia's waterways. For him, "Nature" apparently did not include "back houses" whose cesspools were then fouling the Schuylkill.[12]

Eakins also was personally affected by the dangerously unsanitary conditions of Philadelphia's waterways on at least two important occasions. In 1873 he contracted malaria while hunting in the city's outlying salt marshes, located south and downstream from the metropolitan center. According to Eakins, the bout with malaria left him "bedridden 8 weeks, senseless most of the time," such that "They believed that I would die." Nine years later, just a few days before Christmas in 1882, his beloved sister Margaret became a statistic in Philadelphia's mushrooming public health crisis when she died from typhoid, a disease caused by drinking water tainted with human waste.[13]

Far from confronting these realities, the art of Eakins looked the other way. *William Rush* and other works by him during these early, ambitious years of his career insistently upheld the positive, historic image of Philadelphia as a progressive, well-ordered city, regardless of the truth on the ground or in the water. In painting after painting, Eakins depicted bodies of water around the city as salubrious vehicles of human labor and leisure. Whether representing rowers on the Schuylkill near Fairmount Park, hunters in the marshes, fishermen along the Delaware River, or swimmers at a suburban pond, his basic message was the same: Philadelphia was a modern American city that retained its picturesque local color, natural harmony, and progressive tradition.

The Champion Single Sculls (fig. 25) typifies the artist's approach in this regard. It depicts Eakins's friend Max Schmitt gliding across the Schuylkill's glassy surface into the foreground in the latest-model scull. A successful Philadelphia lawyer and champion rower, Schmitt here exemplifies the heroic modern American man of leisure. In a recursive tribute to his friend, Eakins represented himself in the painting as a second rower in the middle distance, watching the champion from a scull cleverly inscribed with his own name.

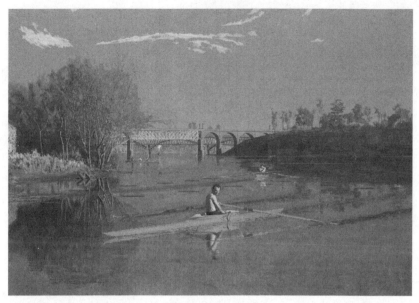

25. Thomas Eakins, *The Champion Single Sculls (Max Schmitt in a Single Scull)*, 1871. Oil on canvas, The Metropolitan Museum of Art, New York, Purchase, The Alfred N. Punnett Endowment Fund and George D. Pratt Gift, 1934.

Other background details, including ducks swimming along the river's edge at left and quaintly old-fashioned Quakers rowing near the horizon beyond, seem calculated to affirm a sense of natural integrity and historical continuity despite alarming contemporary evidence of water pollution. No signs of slaughterhouse offal or cesspool runoff here.[14]

Perhaps we should not fault Eakins for wanting to preserve, or invent, such a harmonious image of Philadelphia, but his selective approach teaches us an important lesson about the nature of his realism. Far from being strictly accurate or critical in representing the world around him, Eakins performed a kind of aesthetic filtration without sacrificing an illusion of reality. Art historians have made a similar point before, but rarely in connection with his images of outdoor life around Philadelphia. For many scholars and viewers, the Eakins reality effect remains particularly resilient here.

During Eakins's lifetime, a number of other artists had begun to direct attention to environmental pollution as a subject indicative of modernity. Works by those contemporaries provide a helpful reality check, revealing the different aesthetic limits governing his pictures. For example, James McNeill

Whistler's *Wapping* (1864), William Wyllie's *London from the Monument* (1870), and James Tissot's *On the Thames* (1876) all represented the stark realities of urban pollution, congestion, and development along London's signature river in a comparatively unflinching manner. Eakins also offered none of the gritty frankness seen, for example, in *The Ironworkers' Noontime* (1880), a painting by his own student Thomas Anshutz showing industrial laborers in the dingy, cindered precincts of a modern factory with plumes of black smoke belching into the air. In contrast to such works, Eakins's pictures constructed a far more affirmative vision of modern Philadelphia, using a civic realism rather than a critical or social realism.[15]

Nowhere is that affirmative vision more evident than in the images Eakins made depicting the Neck, an area located directly downstream from central Philadelphia on the peninsula where the Schuylkill and Delaware rivers converge. During the 1870s, the Neck was still largely a marshy, semi-rural space with muddy pastureland inhabited by a diverse population, including a growing number of working-class immigrants. As suggested by "Rail-Shooting" (fig. 26), it was also a place visited regularly by middle-class leisure hunters from the city. Such men liked to shoot rail and other marsh birds for sport with the help of hired laborers, known as pushers or pole-men. Yet, the pastures and tidal marshes of the Neck were gradually being displaced by factories, oil refineries, expanding neighborhoods along South Broad Street, and the massive League Island Navy Yard, none of which Eakins chose to depict. Today only a small vestige of the earlier wetlands survives at Franklin Delano Roosevelt Park, located adjacent to the Navy Yard.[16]

As the foremost artist of Philadelphia outdoor life, Eakins was invited by the editor of *Scribner's Monthly* to submit illustrations for an 1881 article by Maurice Egan titled "A Day in the Ma'sh," which describes the Neck as a picturesque getaway from the urban metropolis. The article portrays the area as both conveniently nearby and rustically exotic, a domestic developing country of sorts, easily accessible on weekends. According to Egan, the Neck is not frequented by "fashionable Philadelphians," but it does attract a heartier pleasure-seeker from the city: the "native Philadelphian." Egan notes that "many foreigners inhabit the Neck,—principally Irish" and that "in the fall . . . sportsmen, boatmen, and 'pushers'. . . swarm into the Neck." Eakins addresses this sporting phenomenon in "Rail-Shooting" and in a second illustration titled simply "A Pusher," showing a solitary black pole-man at rest, standing barefoot on his boat as he stares toward the viewer. We do not know whether this man lived in the Neck or came down from the city for work as

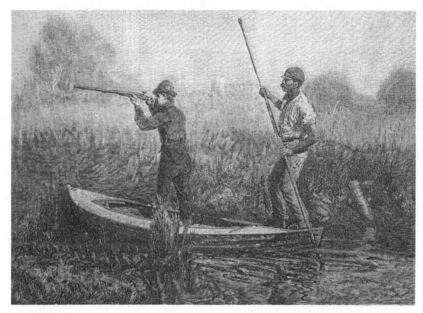

26. Thomas Eakins, "Rail-Shooting," engraving published in Maurice F. Egan, "A Day in the Ma'sh," *Scribner's Monthly*, vol. 22, July 1881, page 345. Courtesy, Connelly Library, LaSalle University, Philadelphia.

part of the "swarm" mentioned by the author. Eakins based this second illustration on a vignette from another oil painting titled *Pushing for Rail* (1874), showing various hunters and pole-men in the marsh. Although the painting indicates that pole-men could be black or white, Eakins chose to illustrate the *Scribner's* article with two images showing black laborers.[17]

With satirical humor, Egan repeatedly emphasizes the quaint but decrepit and polluted state of the Neck. In one passage, for example, the author describes the area as a "swamp" with "a weird and uncanny look." Elsewhere he observes that the area was "celebrated for its cabbages, its pigs, its dogs, its dikes, its reed-birds, its inhabitants, and, above all, for its smells." Other references are even more pointed, citing "stagnant water," "dirt," "odors," "manure," "iridescent coal-oil floats," "phosphates," "oozy green mire," and other "malarious" conditions. According to Egan, local boatmen "more than once, have also brought in a corpse floating out from the crowded city, in which there seemed to be no room for it." Such a description obviously was intended to amuse *Scribner's* urban, cosmopolitan readers by invoking stereotypes of rural poverty and foreign backwardness, but the article also tallied

with other nineteenth-century accounts, including those in the newspapers and official public health reports.[18]

Eakins's paintings and illustrations, however, do not explicitly represent industrial pollution, nor do they offer an obvious lampoon or critique of the environmental and economic conditions at the Neck. If anything, they present the area as a picturesque retreat largely untouched by modernity, where hunting opportunities and reliable labor remained abundant. Accepting this image as given, art historians generally have viewed Eakins's representation of the Neck and its social relations as truthful, affirmative, and even heroic. For visual evidence of the more unsavory aspects of modernity there, we must turn to other illustrations for the same article by two of Eakins's students, Joseph Pennell and Henry Poore. Pennell's "Oil-Refinery" (fig. 27) shows a large modern industrial structure towering over the marsh landscape, smokestacks pumping black soot into the sky—a nineteenth-century harbinger of the massive refinery complex that motorists see today along the I-76/Schuylkill Expressway leading into Philadelphia. By addressing such environmental realities, Pennell's illustration has more in common with the pictures by Anshutz and Tissot than with those by Eakins. It also echoes the following passage in Egan's article: "Oil-refineries are not unknown [in the Neck], and in many places whole plantations of the primeval Jamestown-weed have been destroyed by the loads of refuse from the soap-factories that have been cast upon them. But even the evidences of encroaching civilization assume a picturesque aspect in this mural yet rural territory. . . . The spatter-dock may disdain to show its spiky leaves in the rainbow-hued pools that surround the oil-refineries, but the scrub-willow grows in clumps and the Jamestown-weed, crushed to earth, raises its ribbed white bugle among heaps of rubbish."[19] Whereas Eakins ignored those conditions, Egan and Pennell confronted them directly. With similar frankness, Poore's "Outdoor Tenants" depicted an impoverished infant on the porch of a rundown shack, unaccompanied by other human beings but surrounded by dogs and chickens as he stares forlornly into space.[20]

Even if "Rail-Shooting" and other pictures by Eakins elided many of the modern social and environmental realities of the Neck, his image of the barefoot, baggy-clothed black laborer probably embodied those realities for many white middle-class readers of *Scribner's*. From their point of view, the Neck was an exotic locale where tourists expected to encounter differences of race, class, and environmental quality, so the black pole-man served as a convenient signifier of that locale. By acknowledging racial difference and

27. Joseph Pennell, "Oil-Refinery," engraving published in Maurice F. Egan, "A Day in the Ma'sh," *Scribner's Monthly*, vol. 22, July 1881, page 346. Courtesy, Connelly Library, LaSalle University, Philadelphia.

working-class labor in such a place, Eakins achieved persuasive effects of realism. At the same time, by avoiding any explicit reference to modern factories, oil refineries, pollution, and dire poverty, he constructed a purified image of the Neck, consistent with mainstream civic and aesthetic expectations in the fine arts.

A similarly selective strategy governed Eakins's pictures of rowers along the Schuylkill River upstream at Fairmount Park, a new urban public space that was Philadelphia's answer to Central Park in New York. Art historian Elizabeth Milroy has described *The Champion Single Sculls* (see fig. 25) as "an astute piece of civic boosterism" calculated to attract elite patrons at Philadelphia's Union League club, where it was exhibited in 1871. According to Milroy, the picture shows "a landscape in which nature, technology, and history coexist—a new kind of public space available only in the modern city—a setting Eakins's contemporaries would have recognized instantly as

a section of the Schuylkill River, lately incorporated into the massive and unique public works project that was Philadelphia's grand new Fairmount Park." As such, in Milroy's view, the work "fit in neatly" with the art exhibition program of the Union League, some of whose members belonged to the city commission then overseeing management and construction of the park.[21]

In 1867, just a few years before Eakins painted *The Champion Single Sculls,* the Pennsylvania legislature passed a law empowering Philadelphia to expropriate more than two thousand acres of city land for what it called "an open public place and park, for the health and enjoyment of the people of said city, and the preservation of the purity of the water supply." In 1872 the *Fourth Annual Report of the Commissioners of Fairmount Park* observed that "Whole blocks of buildings, including large hotels, have disappeared, railway tracks have been taken up; furnaces, foundries, and iron mills have been removed; huge ditches and broad canals have been obliterated; the adjacent banks of the Schuylkill have been relieved from contaminations." Such activity—carried out while Eakins worked on his painting—resembled the massive program of urban streamlining that the young artist had witnessed in Baron Haussmann's Paris during the 1860s. His painting of Schmitt thus served as a kind of American spatial model, envisioning the future results of a civic project undertaken by Philadelphia leaders. Such modeling had more to do with idealism than with accurate representation of the present, since Eakins and Schmitt would have had to walk through extensive demolition, construction, and the removal of "contaminations" in order to witness the site or launch their sculls there.[22]

Participating pictorially in that removal process, Eakins omitted the grittier details of contemporary reality, confirming an assessment by art historian Helen Cooper, who has described *The Champion Single Sculls* as "a wholly contrived studio production." Cooper adds that "all the rowing pictures" were studio works, "preconceived and invented; nothing was spontaneous or improvised." In another recent analysis of *The Champion Single Sculls,* Michael Leja notes the implausible regularity of wave patterns depicted on the river surface, among other details, further underscoring the fact that a combination of aesthetic, narrative, scientific, and social concerns here trumped strict empirical accuracy.[23]

Using *The Champion Single Sculls* as a key example, art historians also frequently have asserted the "democratic" and "egalitarian" character of American rowing—along with Eakins's paintings—citing the sport's accessibility

to some working-class men and middle-class women during the nineteenth century. For example, Elizabeth Johns has observed that rowing "appealed to the developing American advocacy of leisure that was instructive, elevating, and democratic." According to Cooper, rowing "was the ideal egalitarian and therefore American sport," and Eakins's pictures provided "symbols of a kind of democratic American morality." Referring to the distant crowd of onlookers and pedestrians in another rowing image by the artist, Milroy claims that "The landscape is expansive, public, and emphatically egalitarian." These interpretations appear to originate in nineteenth-century accounts, one of which, written in 1875 by a friend of Eakins's, trumpeted Fairmount Park as "foot-beaten, crowded, and democratic."[24]

In conferring such judgments about the democratic egalitarianism of Eakins's pictures and subjects, though, scholars have failed to contemplate an important historical fact: few sports in America have traditionally been *whiter* than rowing, especially in Philadelphia. With the notable exception of a successful African-American professional rower from Boston named Frenchy Johnson—an exception proving the rule—the sport was overwhelmingly dominated by white athletes across the nation during the late nineteenth century. Johnson competed in races in New York, Pittsburgh, and Canada during the 1870s and 1880s, but his activity in Philadelphia (if any) has not been documented. Neither he nor any other African-American rower apparently belonged to one of the "Schuylkill Navy" rowing clubs on Boathouse Row during the period. A reputation for exclusive whiteness even dogs Philadelphia rowing to this day, as demonstrated by numerous news stories heralding rather tentative steps to desegregate the sport only in recent years. As late as the 1990s, racial tensions continued to overshadow local political debates in Philadelphia about access to Boathouse Row. In a 1994 article in the *Philadelphia Tribune,* a local African-American newspaper, reporter Winslow Mason Jr. described meetings held by Mayor Ed Rendell, Councilman John Street, and the Fairmount Park Commission on "trying to figure out ways to make Blacks feel welcome to the [annual Regatta] celebration and to teach them the art of boating and rowing." In a 1998 piece in the *Philadelphia Weekly,* writer Solomon Jones summarized the contemporary culture of Philadelphia's Boathouse Row in these terms: "Their facades are carved from stone. Their membership is overwhelmingly white. Their traditions predate the Civil War."[25]

For another historical indicator of the racial politics in Philadelphia rowing during the late nineteenth century, let us briefly consider the case of

Benjamin Howard Rand, Eakins's former chemistry teacher at Central High School and the subject of an important early portrait by the artist in 1874. By the time he painted the portrait, Eakins had known Rand for more than ten years, very likely in multiple contexts. Since 1864, Rand had been professor of chemistry at Jefferson Medical College, where Eakins studied anatomy periodically. Rand also served as president of the Undine Barge Club, one of the private rowing clubs on Boathouse Row. Eakins, an avid rower himself, was informally associated with the clubs through his contacts with Rand, Max Schmitt, and others.[26]

In a minor public scandal of 1870, Rand refused to lecture at the Franklin Institute in Philadelphia when that organization admitted a new member named Octavius Catto, a prominent African-American educator. Covered in local newspapers, the controversy called attention to ongoing racial tension and segregation in Philadelphia. Many whites in the city supported Rand, believing that the Franklin Institute should remain segregated, but the institute refused to oust its new black member. Professor Rand's lecture was canceled. He had been unable to enforce segregation at the institute, but as president of a private rowing club he wielded more executive power. His racial views provide a barometer of the unspoken consensus about membership criteria on Boathouse Row at the time. Eakins and his rowing pictures thus belonged to, and implicitly affirmed, a world of white exclusivity and privilege. They do not embody a fully democratic egalitarianism in the sense that we now understand it. In constructing his affirmative vision of the city's showcase public waterway, Eakins filtered out all signs of pollution and construction while reinforcing the dominant complexion of rowing. Obviously, he did not intend his rowing pictures to be read as manifestos of racial segregation. Instead, they simply exemplify one of the common ways in which whites historically have maintained hegemony in America: through tacit assertions of social and spatial privilege amid outward claims about egalitarian democracy.[27]

In 1885 Eakins completed *Swimming* (fig. 28), the last of his outdoor water scenes set in the vicinity of Philadelphia. The painting shows a group of six naked men and a dog in various poses and actions, swimming and relaxing at a picturesque pond during the summertime around midday. The figures congregate at an abandoned stone pier, behind which appears a shady green forest. In the right background, the pond extends toward a brightly illuminated field bounded by more distant trees. In contrast to the vaguely defined foliage and landscape, the figures have been delineated with consider-

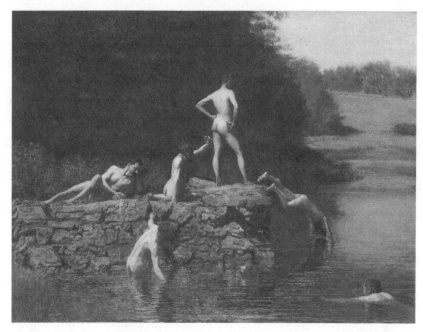

28. Thomas Eakins, *Swimming*, 1885. Oil on canvas. Amon Carter Museum, Fort Worth, Texas, Purchased by the Friends of Art, Fort Worth Art Association, 1925; acquired by the Amon Carter Museum, 1990, from the Modern Art Museum of Fort Worth through grants and donations from the Amon G. Carter Foundation, the Sid W. Richardson Foundation, the Anne Burnett and Charles Tandy Foundation, Capital Cities/ABC Foundation, Fort Worth Star-Telegram, The R. D. and Joan Dale Hubbard Foundation, and the people of Fort Worth.

able clarity, enabling art historians to identify the men as various friends or students of the artist. The figure in the right foreground is Eakins himself, partially submerged as he watches the group from a slight distance.[28]

The specific setting depicted in *Swimming* has been identified as an artificial reservoir called Dove Lake, located along Mill Creek about ten miles west of downtown Philadelphia, not far from the suburban villages of Gladwyne and Bryn Mawr. The artist and his friends traveled to Dove Lake by taking the Pennsylvania Railroad, or Main Line, from downtown Philadelphia to Bryn Mawr. Eakins produced *Swimming* on commission for his boss, Edward Hornor Coates, a successful Philadelphia financier and chairman of the Committee of Instruction at the Pennsylvania Academy. In October 1886, shortly after Eakins completed the picture for him, Coates purchased a large Main Line estate near the setting depicted. Coates's brother, George

Morrison Coates, already had made a similar land purchase in the area a few months before. Eakins may or may not have known of his patron's real estate plans, but he certainly would have been aware of burgeoning suburban development on the Main Line. He also knew of Coates's personal familiarity with the area. Coates had studied at nearby Haverford College as a young man, and he was acquainted with other members of the elite social set that owned property there, including Pennsylvania Academy president James L. Claghorn. Thus, the *Swimming* picture coincided with, and in effect modeled, the historical phenomenon of suburbanization, now known as "white flight," at an early phase in its development. By the middle 1880s, elite white Philadelphians were building homes in exclusive suburban real estate developments on the Main Line in order to escape urban congestion, pollution, crime, and racial difference.[29]

In an effort to appeal to his wealthy and well-educated patron, Eakins conceived *Swimming* with a calculated but unwieldy mix of aesthetic strategies. Specifically, he attempted to reconcile classicism and realism by naturalistically updating ancient Greek culture in the modern Philadelphian terms of "brotherly love," or *philadelphia* (from *philos* and *adelphos*). For a long time, scholars have noted various allusions to Greek classicism in *Swimming,* especially the pyramidal figure composition and the reclining "pediment"-like pose of one figure. In the words of art historian Kathleen Foster, "*Swimming* recovered the spirit of classical art in the beauty of contemporary life." Similarly, art historian Marc Simpson has observed that the picture portrayed a "local, idyllic substitute" for Arcadia, "modern in subject and execution but classical in intent." Such scholarly observations are confirmed by numerous other classicizing works by Eakins during the early 1880s, some of which explicitly quoted casts of ancient Greek sculptures by Phidias then owned by the Pennsylvania Academy. Unlike idealists of the period, Eakins used photographic studies to render his classical figural allusions in frankly naturalistic terms, believing, as he said in an 1879 interview, that "The Greeks did not study the antique. . . . [The] figures in the Parthenon pediment were modeled from life, undoubtedly. And nature is just as varied and just as beautiful in our day as she was in the time of Phidias."[30]

In addition to aesthetic concerns, a powerful personal motivation may have helped inspire Eakins to represent his contemporary Arcadia in suburban Philadelphia: the death of his sister Margaret from typhoid in 1882. Various scholars have suggested that the contemplative mood of *Swimming* and other classicizing works by Eakins shortly after Margaret's death consti-

tuted an artistic expression of mourning and cathartic purification, akin to the ancient reference to death in paradise or "et in Arcadia ego." Margaret often had accompanied Eakins on outdoor excursions around the city, though apparently not at the masculine outing pictured in *Swimming*. In the light of the personal impact of urban water pollution upon the Eakins family, it is no wonder that he envisioned a suburban Arcadia well outside downtown Philadelphia, on the relatively untainted waters of the Main Line.[31]

At that very moment, the Main Line was also becoming increasingly untainted by human difference. Until as late as 1880, Mill Creek had been a fairly diverse, sparsely populated area inhabited by farmers and manual laborers, including a number of immigrants and African Americans. By the end of the 1880s, however, hundreds of Philadelphia's wealthiest urban white citizens, including Edward Hornor Coates, had purchased expensive new estates along the Main Line and Mill Creek. These elite residential commuters often established fraternal organizations that helped create a sense of social cohesiveness in the suburbs. In the words of historian Margaret Marsh, "Many of the new social organizations that developed in the outer city during the late nineteenth century were nativist or otherwise exclusionary, demonstrating that a desire for cultural and ethnic homogeneity was a part of suburbanization from its inception." Marsh says that although "widespread ethnic and racial segregation was still some years in the future for the outer city, its groundwork was laid in this period."[32]

Swimming constructed a timely artistic vision of fraternal relations by situating Greco-Philadelphian "brotherly love" in a picturesque suburban retreat along the city's developing Main Line. The whiteness of its male figures modeled the increasingly exclusive complexion of the area, social vectors of which we already detected in *The Champion Single Sculls*. Not unlike that earlier picture painted for civic leaders at the Union League, *Swimming* projected the suburban sensibilities of another powerful Philadelphia patron, Edward Hornor Coates. Ironically, *Swimming* struck too close to home for Coates, who politely paid Eakins for the work and then refused to accept it. The painting too vividly evoked aspects of Eakins's academic teaching program at the Pennsylvania Academy that were already becoming controversial. Regardless of its failure to please Coates, though, *Swimming* echoed and arguably surpassed *The Champion Single Sculls* in offering an even more rarified, exclusively suburban retreat from the city's rivers and marshes downstream, which were increasingly marked by pollution, disease, and difference.

Let us conclude by returning to *William Rush Carving His Allegorical Figure of the Schuylkill River* (see fig. 24). Although set indoors, in the shadowy confines of a historic ship-carver's workshop, the painting addressed issues of pressing importance for Eakins and his generation in the 1870s. In explaining this painting and others, art historians have tended to focus their attention upon aesthetic concerns pertaining to Eakins and his struggle to establish academic realism in America. As I have tried to suggest, however, the painting also broached an environmental context fraught with tremendous personal and public concern for the artist and his Philadelphia contemporaries. Eakins knew that modernity was dramatically transforming the region around his beloved native city. He was willing to acknowledge a degree of racial diversity in his art within certain environmental and economic limits. Yet, he apparently could not—or would not—use his art to shine a critical light on Philadelphia's shortcomings, for Eakins was a civic realist, not a social realist. Even a later version of the *William Rush* (1908), featuring a black woman in the role of chaperone, kept traditional social structures largely intact. The model on the pedestal remained lily-white, embodying fine art and personifying the ideal purity of the Schuylkill, albeit rendered with realistic illusionism. By this time, the city of Philadelphia had embarked upon an ambitious project to construct a massive new water filtration plant north of the downtown at Torresdale, on the Delaware River, a project riddled with allegations of corruption but nevertheless expected to resolve the city's water crisis. Taking up the *William Rush* theme anew, perhaps Eakins hoped to purify the Schuylkill's image once and for all.[33]

Notes

1. On Eakins's *William Rush* see Darrel Sewell, ed., *Thomas Eakins* (Philadelphia: Philadelphia Museum of Art, 2002), 35–38, 59–68; Kathleen A. Foster, *Thomas Eakins Rediscovered: Charles Bregler's Thomas Eakins Collection at the Pennsylvania Academy of the Fine Arts* (New Haven: Yale University Press, 1997), 144–50; Elizabeth Johns, *Thomas Eakins: The Heroism of Modern Life* (Princeton: Princeton University Press, 1983), 82–114.

2. On racial ecology, see, for example, the description of a lecture by Sheila Foster titled "The Racial Ecology of a Natural Disaster," *Fla Law* (newsletter of the Levin College of Law, University of Florida) 9, no. 28 (2006): 1.

3. Thomas Eakins to Benjamin Eakins, Paris, March 6, 1868, Pennsylvania

Academy of the Fine Arts, quoted in Kathleen A. Foster and Cheryl Leibold, *Writing about Eakins: The Manuscripts in Charles Bregler's Thomas Eakins Collection* (Philadelphia: University of Pennsylvania Press, 1989), 207.

4. On Eakins viewing John Lewis Krimmel's painting *Fourth of July at Centre Square* (1812), for example, see Sewell, *Thomas Eakins,* 36; Johns, *Thomas Eakins,* 90. Regarding Latrobe and the waterworks see Michael McMahon, "Makeshift Technology: Water and Politics in 19th-Century Philadelphia," *Environmental Review* 12, no. 4 (1988): 21–37.

5. Johns, *Thomas Eakins,* 86; Costen Fitz-Gibbon, "Latrobe and the Centre Square Pump-House," *Architectural Record* 62, no. 1 (1927): 18–22; Caroline Auvergne, "Fairmount Water Works," *Early American Life* 20, no. 2 (1989): 42–47, 68; J. H. Powell, *Bring Out Your Dead: The Great Plague of Yellow Fever in Philadelphia in 1793* (Philadelphia: University of Pennsylvania Press, 1993). For the Fairmount Water Works Interpretive Center see http://www.fairmountwaterworks.org.

6. For comparisons to Courbet's *The Painter's Studio: A Real Allegory* (1855) and Velázquez's *Las Meninas* (1657) see Michael Fried, *Realism, Writing, Disfiguration: On Thomas Eakins and Stephen Crane* (Chicago: University of Chicago Press, 1987), 16–22, 74.

7. Thomas Eakins, unpublished exhibition label, Philadelphia Museum of Art, quoted in Sewell, *Thomas Eakins,* 35–36. For a contemporary discussion of "Birds Which Have Disappeared" from traditional habitats in the region see William P. Turnbull, *The Birds of East Pennsylvania and New Jersey* (Philadelphia: Lippincott, 1869), 60–62. Turnbull does not single out the bittern, but he observes: "Since the eastern provinces have become more densely populated, many of the larger and more wary species of birds have changed their course of migration" (60). For a recent discussion of how "American Bitterns have declined precipitously during the twentieth century," prompting the Pennsylvania Game Commission to change the bird's status from "Threatened" to "Endangered" in 1997, see Gerald M. McWilliams and Daniel W. Brauning, *The Birds of Pennsylvania* (Ithaca: Cornell University Press, 2000), 44–46.

8. For newspaper references to Schuylkill River pollution and questions of purity, see, for example, *Philadelphia Inquirer,* June 12, 1862, 3; February 6, 1865, 3; March 4, 1870, 2; November 16, 1871, 4; September 26, 1875, 2; February 2, 1877, 3; December 29, 1879, 2; January 23, 1880, 3; December 24, 1880, 8; December 28, 1881, 2; May 18, 1882, 3; June 9, 1882, 2; June 12, 1882, 2; June 14, 1882, 3; June 17, 1882, 3; July 6, 1882, 2; July 12, 1882, 4; January 13, 1883, 2; January 15, 1883, 2; January 16, 1883, 4; January 24, 1883, 3; February 1, 1883, 2; May 2, 1883, 2; July 24, 1884, 4; August 27, 1884, 2; October 5, 1884, 2. See also Sam Alewitz, *"Filthy Dirty": A Social History of Unsanitary Philadelphia in the Late Nineteenth Century* (New

York: Garland, 1989); John F. Watson, *Annals of Philadelphia and Pennsylvania, In the Olden Time* (Philadelphia: Carey and Hart, 1845), 1:257. On typhoid deaths see Michael P. McCarthy, *Typhoid and the Politics of Public Health in Nineteenth-Century Philadelphia* (Philadelphia: American Philosophical Society, 1989), 7.

9. Alewitz, *"Filthy Dirty,"* 1, 108, 183 n. 16, 187 n. 48; Charles M. Cresson, M.D., *Results of Examinations of Water from the Schuylkill River* (Philadelphia: Wm. Mann, 1875), 9–10, 15.

10. Nathaniel Burt and Wallace E. Davies, "The Iron Age 1876–1905," in *Philadelphia: A 300-Year History,* ed. Russell F. Weigley (New York: Norton, 1982), 496.

11. Alewitz, *"Filthy Dirty,"* 3, 6.

12. Thomas Eakins to Benjamin Eakins, Paris, March 6, 1868, quoted in Foster and Leibold, *Writing about Eakins,* 206–7.

13. Sewell, *Thomas Eakins,* xxviii, xxxi, 30.

14. For background on *The Champion Single Sculls* see Helen Cooper, *Thomas Eakins: The Rowing Pictures* (New Haven: Yale University Art Gallery, 1996).

15. For reproductions of the paintings by Whistler, Wyllie, Tissot, and Anshutz see John House, "Visions of the Thames," in *Monet's London: Artists' Reflections on the Thames, 1859–1914* (St. Petersburg, Fla.: Museum of Fine Arts, 2005), 22, 24, 99; Marc Simpson, *The Rockefeller Collection of American Art at the Fine Arts Museums of San Francisco* (San Francisco: The Museums and New York: H. N. Abrams, 1994), 203.

16. For discussion of Eakins, hunting, and the Neck see John Wilmerding, ed., *Thomas Eakins* (London: National Gallery, 1993), 100–101. On the Neck see Jeffrey M. Dorwart with Jean K. Wolf, *The Philadelphia Navy Yard* (Philadelphia: University of Pennsylvania Press, 2001).

17. Maurice F. Egan, "A Day in the Ma'sh," *Scribner's Monthly: An Illustrated Magazine for the People,* July 1881, 343–52. For a reproduction of Eakins's *Pushing for Rail* see Sewell, *Thomas Eakins,* 50.

18. Egan, "A Day in the Ma'sh," 343–51.

19. Ibid., 346.

20. For the Poore image see ibid., 347.

21. Elizabeth Milroy, "Images of Fairmount Park in Philadelphia," in Sewell, *Thomas Eakins,* 77.

22. Ibid., 77–79, 83.

23. Cooper, *Thomas Eakins,* 30, 50; Michael Leja, *Looking Askance: Skepticism and American Art from Eakins to Duchamp* (Berkeley: University of California Press, 2004), 59–92.

24. Johns, *Thomas Eakins,* 24; Cooper, *Thomas Eakins,* 25, 78; Milroy, "Images of Fairmount Park," 83; Earl Shinn, *A Century After: Picturesque Glimpses of Phila-*

delphia and Pennsylvania, including Fairmount, the Wissahickon, and Other Romantic Localities, with the Cities and Landscapes of the State, ed. Edward Strahan [pseud.] (Philadelphia: Allen, Lane and Scott and J. W. Lauderbach, 1875), quoted in Milroy, "Images of Fairmount Park," 84.

25. Winslow Mason Jr., "Row at Boathouse Continues," *Philadelphia Tribune,* April 26, 1994, A1; Solomon E. Jones, "River Blues: A New House Backed by John Street along Boathouse Row Still Has People Divided," *Philadelphia Weekly,* July 1, 1998, 13, 15. On recent desegregation of rowing elsewhere see, for example, Sara Rimer, "For Rowers, It's Getting There, First or Not," *New York Times,* October 20, 1997, A8. For references to Frenchy Johnson see "The Newburg Rowing Regatta," *New York Times,* August 13, 1877, 5; "The Silver Lake Regatta," *New York Times,* August 16, 1878, 5; "Racing on the Allegheny," *New York Times,* August 9, 1879, 5.

26. On Rand and the Undine Barge Club see Johns, *Thomas Eakins,* 24. For a reproduction of the *Rand* portrait see Wilmerding, *Thomas Eakins,* 76.

27. The Franklin Institute incident with Rand and Catto is discussed by Harry C. Silcox, "Nineteenth-Century Philadelphia Black Militant: Octavius V. Catto (1839–1871)," *Pennsylvania History* 44, no. 1 (1977): 72.

28. For detailed background on *Swimming* see Doreen Bolger and Sarah Cash, eds., *Thomas Eakins and the Swimming Picture* (Fort Worth: Amon Carter Museum, 1996).

29. Ibid., 36–38, 49–51.

30. On Eakins and classicism see Foster, *Thomas Eakins Rediscovered,* 178–87, quote on 178; Bolger and Cash, *Eakins and the Swimming Picture,* 16–18, 41–42, 73–74, 82–3, 87; Simpson in Sewell, *Thomas Eakins,* 113–15, quote on 114.

31. Foster, *Thomas Eakins Rediscovered,* 184, citing Simpson and other scholars.

32. Margaret Sammartino Marsh, "Suburbanization and the Search for Community: Residential Decentralization in Philadelphia, 1880–1900," *Pennsylvania History* 44, no. 2 (1977): 99–116.

33. For a reproduction of the 1908 *William Rush* see Sewell, *Thomas Eakins,* 346. On the Torresdale filtration plant see McCarthy, *Typhoid.*

7

Pastoral and Anti-Pastoral in Aaron Douglas's Aspects of Negro Life

Jeffrey Myers

One of the first places where the artwork of Aaron Douglas achieved wide visibility was in *The New Negro* (1925)—the "definitive text" of the Harlem Renaissance—to which the young artist contributed nine illustrations. Among these illustrations is one titled "The Poet" that precedes the book's poetry section, which features poems by Harlem Renaissance luminaries such as Countee Cullen, Claude McKay, Jean Toomer, and Langston Hughes. It is a highly stylized drawing of a human figure, executed in black and white with gray outlining, standing in front of a palm tree and surrounded by its foliage. The drawing displays features of a style that Douglas would eventually develop in later work, one of which is the rendering of the human figure with the face in profile and slits for eyes, characteristics that recall African Dan masks from the Ivory Coast. As Amy Helene Kirschke and other scholars have noted, Douglas was one of the first African-American artists to make significant use of Africanist themes in his work. Another feature, less often remarked upon, is the amount of vegetation in this picture and others. The human figure in "The Poet" is surrounded, almost engulfed, by the foliage of the landscape. Furthermore, he is positioned such that his body and the trunk of the tree are indistinguishable. This abundance of vegetation, framing and surrounding the mostly black human figures, is a motif that runs throughout Douglas's more mature illustrations for Paul Morand's *Black Magic* (1929), as well as paintings and murals such as *Harriet Tubman* (1930), *Into Bondage* (1936), and the series *Aspects of Negro Life* (1934, figs. 29–32).[1]

Such a profusion of nature imagery might at first seem counterintuitive: the Harlem Renaissance is, after all, an urban phenomenon, and twentieth-century African-American culture more typically (perhaps stereotypically)

has an urban inflection. Yet such sympathetic nature imagery is in keeping with what Melvin Dixon has identified as "the broad geographical metaphors for the search, discovery, and achievement of self" that permeate much African-American cultural production. Indeed, the poems by Hughes, Toomer, McKay and others that follow Douglas's illustration in *The New Negro* are replete with images of foliage and greenery: to quote the familiar story of a publisher's rejection of Norman Maclean's *A River Runs through It,* these works do indeed "have trees in them." Douglas joins other black artists such as Hale Woodruff and Richard Mayhew—and even nineteenth-century artists such as Robert Duncanson and Edward Bannister—who depict pastoral and wild landscapes. These correspond with major works of African-American literature, such as Jean Toomer's *Cane,* Zora Neale Hurston's *Their Eyes Were Watching God,* and Toni Morrison's *Song of Solomon,* that have an emphasis on the pastoral, however complicated that emphasis might be. Although such emphasis seems at odds with the reality of black urban experience, as bell hooks reminds us, "it has been easy for folks to forget that black people were first and foremost a people of the land."[2]

Of course, African Americans' relationship to that land has been deeply and perhaps permanently vexed by historical experience: the coerced labor of slavery, the sharecropping economy of the Jim Crow South, and the Great Migration to northern cities in the decades following World War I. As Michael Bennett has rightly pointed out, there is an "anti-pastoral African American literary tradition," originating in works such as *Narrative of the Life of Frederick Douglass* (1845), in which both the pastoral and the wild are sites of terror and incarceration, while cities have the usually pastoral characteristics of freedom and sustenance.[3] The liberating potential of urban space for African Americans is evident in the preponderance of works by Harlem Renaissance artists such as painter Archibald Motley and photographer James Van Der Zee. Aaron Douglas is no exception: many of his works celebrate the liberating potential of urban space, notably the fourth panel of *Aspects of Negro Life,* titled *Song of the Towers* (see fig. 32). And where his nature imagery is associated with North American rather than African settings, it is in fact often overlaid with the same potential for violence that pastoral landscapes often represent in African-American literature.

It is easy to read the four-panel mural series *Aspects of Negro Life* in the light of this anti-pastoral tradition. Painted in 1934 for the Countee Cullen Branch of the New York Public Library under the sponsorship of the federal Public Works Administration, it traces the African-American journey,

29. Aaron Douglas, *Aspects of Negro Life: The Negro in an African Setting,* 1934. Oil on canvas. Art and Artifacts Division, Schomburg Center for Research in Black Culture, The New York Public Library, Astor, Lenox and Tilden Foundations.

in time and space, from an African past, through the slavery and Jim Crow South, into the twentieth-century city. The first panel, *The Negro in an African Setting* (fig. 29), depicts African dance, music, and sculpture in the lush and brightly lit setting of an idealized African setting. The second and third panels, *From Slavery through Reconstruction* (fig. 30) and *An Idyll of the Deep South* (fig. 31), similarly depict aspects of African-American culture—music, dance, oratory—but here prevailing against the threats of forced labor, slave masters, and the Klan. Finally, in *Song of the Towers* (fig. 32), Douglas represents the recapturing of African-American cultural autonomy in the city, with a triumphant jazz saxophone player.

Douglas reminds the viewer that the scenes that white, nature-oriented American culture traditionally has held dear—the bucolic scenes of Winslow

30. Aaron Douglas, *Aspects of Negro Life: From Slavery to Reconstruction,* 1934. Oil on canvas. Art and Artifacts Division, Schomburg Center for Research in Black Culture, The New York Public Library, Astor, Lenox and Tilden Foundations.

31. Aaron Douglas, *Aspects of Negro Life: An Idyll of the Deep South,* 1934. Oil on canvas. Art and Artifacts Division, Schomburg Center for Research in Black Culture, The New York Public Library, Astor, Lenox and Tilden Foundations.

Homer, the romantic wilds of Thomas Cole or Albert Bierstadt—have a different meaning for a people for whom the pastoral landscape resonates with a history of forced labor and the wild conjures images of flight from men with guns and dogs.[4] Conversely, the urban scene often downplayed by that same white culture as a site of societal constraint and industrial pollution is, in *Song of the Towers,* a site of freedom and reintegration.

Such a reading is justified and in itself has important implications for environmental justice. But a close look at the panels reveals a more complicated picture, one that speaks to the tensions between African-American pastoral and anti-pastoral, country and city, Africa and North America,

32. Aaron Douglas, *Aspects of Negro Life: Song of the Towers,* 1934. Oil on canvas. Art and Artifacts Division, Schomburg Center for Research in Black Culture, The New York Public Library, Astor, Lenox and Tilden Foundations.

North and South. For while there is certainly a historical trend in African-American culture to privilege the city, it is only our habit of seeing urban space as somehow "not nature" that creates such a sharply dichotomous view. Douglas's combination of modernist and Africanist elements erases the artificially constructed boundaries between the urban and the natural. The trees and leaves of the earlier panels do not so much give way to the smoke and skyscrapers of the final panel as metamorphose into them—and as the term *metamorphosis* implies, they are two forms of the same thing. By linking the most joyously expressive figures in the series—the African dancers of

the first panel with the saxophonist of the final—Douglas creates a kind of urban pastoral that not only idealizes the Harlem Renaissance but also critiques the mainstream environmentalist valorization of rural and wilderness spaces over urban space.

At the same time, moreover, this urban pastoral is deeply grounded in the experience of southern blacks on the land, both in a remembered West Africa and the American South: a close look will show that *From Slavery through Reconstruction* and especially *An Idyll of the Deep South* are not thoroughly dystopian, nor is *Song of the Towers* simplistically utopian. In fact, in *Aspects of Negro Life* Douglas expands the dimensions of what we think of as place, layering the significance of cultural and spiritual geographies on top of one another and on top of physical geography itself, while maintaining the importance of the physical geography as intrinsically bound up with and part of what we mean by place. The implications for environmental justice are not only a revalorization of urban space as the subject of environmental concern on a par with non-urban space, but beyond that a sense of the seamlessness in ecological terms of rural, wild, and urban space as well as a continuum between human social ecology and the nonhuman world.

Alain Locke, the editor of *The New Negro* and a strong influence on Douglas, had expressed his hope that black artists would "receive from African art a profound and galvanizing influence"; the first panel in the series, *The Negro in an African Setting,* does so in both form and content. As Douglas explained, "The fetish, the drummer, the dancers, in the formal language of space and color, recreate the exhilaration, the ecstasy, the rhythmic pulsation of life in ancient Africa." Painted in the flat, silhouetted, African-derived style that Douglas had developed over a decade, the panel depicts dancers, drummers, and warriors in a lush and idealized African setting. It imagines this African setting as one of complete cultural and spiritual integration: the dancers and musicians are haloed in light; a religious statue, the "fetish," appears at the center of concentric rings of light, apparently suspended above the scene; the human figures are upright and look or incline their bodies upward. A dwelling, suggestive of home and homeland, is in the background. In short, the image is a wholly utopian one, with none of the dystopian elements that appear in later panels.[5]

Such utopianism of course opened Douglas to the criticism of engaging in a kind of "romanticized primitivism," in keeping with the charges that Harlem Renaissance artists and writers were manipulated by the patronizing expectations of white patrons such as Carl Van Vechten and others

to represent African and African-American cultures in ways that spoke to the biases of whites. African-American artist and critic James A. Porter, in the 1940s, criticized both the content and form of the murals and illustrations that Douglas executed in the Africanist style for their "stilted" and imitative qualities. But Douglas actively resisted the urgings of white patrons such as Charlotte Mason—the self-styled "godmother" of the Harlem Renaissance—to forego further training that might tarnish his "primitivism," and his use of African design elements was anything but naive. His knowledge of African art was far deeper than critics such as Porter acknowledged, stemming from his study of African art pieces during a yearlong fellowship at the Barnes Foundation in Philadelphia in 1928. European modernists such as Picasso and Paul Klee had already made use of African design elements, but Douglas was the first to recover them in a distinctly African-American context. Douglas looked to Africa as a source of cultural autonomy and integration that, as we will see, reemerges in complicated and unromanticized ways in the later panels.[6]

The place-based nature of this scene of cultural and spiritual integration, in *The Negro in an African Setting*, is unmistakable. Vegetation in the form of leaves and palm fronds surrounds and frames the human figures; the dancers themselves appear to be dancing on the greenery, suggesting an earth-based foundation for the "rhythmic arts" that Douglas depicts. The same dark green tones are used for human and plant life. Indeed, the drummer in the lower-right corner of the panel is overlaid by a plant that seems almost a part of his body; his knee and elbow have a similar shape, angle, and size as another plant to his immediate left—and both have a similar sense of movement. The religious statue that floats over the scene at the very center of the concentric rings of light marks the scene as unmistakably spiritual, and as Will Coleman explains, in traditional West African culture "the line of demarcation between animate and inanimate, human and non-human, spirit and human, is almost non-existent." In fact, in Dahomean folklore, he explains, human characters, trees, and spirits display remarkable metamorphic powers, such that "some can become human; others can become plants or animals."[7] This fluidity between the human world, the spirit world, and the nonhuman natural world is strongly expressed in *The Negro in an African Setting*. Douglas has clearly taken pains to show that African-American culture has its own "pastoral" tradition that preexists slavery and that is independent, in its origins, from the European pastoral tradition.

It is an idea that Douglas traces through the remaining three panels of *As-*

pects of Negro Life (and indeed in other paintings and illustrations) depicting life in North America through a series of motifs that first appear in the African setting and then reemerge throughout the series. The encircling, enfolding greenery and the trunks of trees reappear in the American South of the second and third panels, even appearing in attenuated form in the urban scene of the fourth, reminiscent of the line from *Cane* (1923), by Douglas's close associate Jean Toomer, that "the Dixie Pike has grown from a goat path in Africa."[8] The concentric rings of light in the later panels center on a succession of significant cultural icons—a banjo player, an orator and two written documents, a saxophone player—that link back to the earth-based spirituality of the African religious statue at the center of the ring in *The Negro in an African Setting,* implying that all manifestations of African-American culture have their roots in the place-based spirituality of Africa. Later panels pick up other elements of this cultural basis, as I will discuss—for example, the dwelling at the back of the scene echoes later in the rural dwellings of *An Idyll of the Deep South.* But here in *The Negro in an African Setting,* this sense of fluidity is at its most powerful, with the concentric rings of light in this panel encircling the entire scene, and drawing the people, the plant life, and the religious icon into the same circle.

The foliage that frames and encircles the first panel continues into the second panel, *From Slavery through Reconstruction,* although with significant changes that indicate life on a new continent and a different relationship to the land. For one thing, this panel (and the one that follows, *An Idyll of the Deep South*) is rectangular—much wider than it is tall—suggesting a passage through time. The first and final panels, representing Africa and the northern city, on the other hand, are square and in this context suggest a more stable and ongoing state of being. Douglas himself indicated that this second panel, unlike the first one, should be read in sequence from right to left in three sections: the first section depicts what appears to be a Union officer reading the Emancipation Proclamation as the freed slaves raise their arms in "exultation"; the center of the panel features an orator holding a document—perhaps a ballot—and pointing to a distant city on a hill, representing "the careers of outstanding Negro leaders" during Reconstruction; the leftmost section depicts the rise of the Klan and the betrayal of the promises of Reconstruction as Union soldiers depart into the distance. Palm fronds and other greenery similar to the preceding panel also appear here, and elsewhere there is a sense of carryover from the culture of *The Negro in an African Setting,* however attenuated. The upraised arms of the jubilant freed

slaves recall the dancers in Africa. While the officer is presumably white—he has his back to the viewer—the army bugler is black, hearkening back to the African drummers but also anticipating the jazz saxophonist of the fourth panel. The central figure is an African-American orator, picking up from the dancers and musicians of the African scene, since he is similarly ringed by the circles of light.

But the sense of fluidity and continuity between the human and non-human has been disrupted by the violence within the picture. The concentric rings of light that encircled the first scene in Africa are repeated here twice, although in a diminished form, and the focus is on the written word rather than the dancing and drumming. The Klan's arrival on the scene represents the southern landscape as a territory of fear. A row of cotton plants is now added to the wild greenery and runs underneath the human figures for almost the whole of the frame. This suggests the continuing enforced labor of African Americans in the cash-crop agriculture of the South throughout this period, as the institution of plantation slavery gave way to the debt peonage of sharecropping. Implied here also, by the ever-continuing row of cotton, is the failure of the Freedmen's Bureau to transfer over a million acres of restitution lands to freed slaves—the broken promise of "forty acres and a mule"—a failure with environmental, economic, and social justice repercussions that persist even to this day. Southern exploitation of African-American labor and exploitation of the land are linked: the post-Reconstruction South entered a period of massive large-scale agriculture, logging, and industry in which "forests and wild life were brutally used," as African Americans labored under sharecropping and even a convict-lease system, in which inmates, often convicted of no crime at all beyond "vagrancy," labored in virtual reenslavement. Thus, the Great Migration of African Americans during the twentieth century is already hinted at, as the orator in the center of the frame points to an idealized city on a hill, in anticipation of the urban scene in the fourth panel—although here they are represented without the gritty reality of smoke and machinery that occur in that final panel. Interestingly, in a small tempera study Douglas did that same year, *Study for Aspects of Negro Life: From Slavery through Reconstruction,* the smokestacks of the building are already emitting plumes of smoke, suggesting Douglas's attention to the consequences of industrial pollution.[9]

The third panel, *An Idyll of the Deep South,* is linked to the second, both in their southern setting and by their similar rectangular shape. However, rather than depicting a later time than the second panel, it represents a kind

of mirror image, a suggestion supported by the use of the word *aspects* in the title of the mural series, instead of, say, *phases* of "Negro life"—"aspects" implying differing perspectives on the same scene rather than a simply linear progression through time. Although the violence of the second panel is still present, the relationship of African Americans and nature is also represented in more salutary terms. The word *idyll* in the title is both earnest and ironic, depending on which part of the panel the focus is on: the right-hand and especially the center sections suggest pastoral harmony, which the leftmost section of the panel undercuts with terror. Douglas's own brief commentary, that the work "portrays Negroes toiling in the fields, singing and dancing in a lighter mood, and mourning as they prepare to take away a man who has been lynched," supports its essential timelessness as well as its portrayal of the complicated and ambivalent relationship between African Americans and the landscape of the American South. It is a conflicted view of the land that reappears throughout African-American culture of the Great Migration. Richard Wright's characterization, at the end of his autobiography *Black Boy* (1945), of the American South as "the culture from which I sprang [and] the terror from which I fled" states the conflict succinctly.[10] As does Toomer in *Cane*—which similarly moves from rural South to urban North—Douglas shows both positive and negative elements of the southern landscape. *An Idyll of the Deep South* is really no more dystopian, as we shall see, than the fourth panel, *Song of the Towers.*

One way Douglas approaches this conflicted view of the land is through a masterful reworking of an earlier, white American regionalist tradition. In doing so he both complicates and enriches the African-American relationship to landscape and recovers a connection to nature on more authentically African-American terms—just as he had done with the connection to Africa in the first panel. One regionalist work that particularly comes to mind is a painting by Eastman Johnson, popularly known as *Old Kentucky Home,* but the actual title of which, *Negro Life at the South* (1859), is echoed quite clearly by Douglas's title, *Aspects of Negro Life: An Idyll of the Deep South.* Indeed, the ubiquity of Johnson's painting, which one critic has called "probably the best known image of American slaves" from the time it was painted to the present, suggests that Douglas might have had the earlier work in mind, a probability reinforced by a number of compositional similarities such as the banjo player at the center of both works.[11] However much Johnson may have been seen as an artist sympathetic to African Americans in the context of his time, his *Negro Life at the South* clearly idealizes slavery and reinforces rac-

ist notions of rural black simplicity, anticipating the "plantation nostalgia" of late-nineteenth- and early-twentieth-century American culture. (Such nostalgia was undergoing a "renaissance" of its own when Douglas painted these murals: playwright Owen Davis's *Jezebel,* later a William Wyler film [1938], appeared on Broadway in January 1934; Margaret Mitchell's *Gone with the Wind* would appear in 1936, with its film version following three years later.) The scene in Johnson's painting is one of pastoral abundance and harmony with nature: the subjects play music, dance, and court; not one of the slaves is portrayed as performing any labor. It is a white fantasy about black rural life that romanticizes African-American attachment to the landscape even as it rationalizes African Americans' second-class economic and political status. Douglas's *An Idyll of the Deep South* retains the African-American connectedness to the landscape of Johnson's painting, but with significant differences: Douglas complicates the relationship with images of agricultural labor and a lynching; he deepens it by showing the roots of African-American attachment in their African heritage rather than in a faithfulness to plantation owners that the plantation nostalgia tradition spuriously attributes to blacks.

One of the most notable ways in which the third panel, *An Idyll of the Deep South,* differs from the second, *From Slavery through Reconstruction,* is in the absence of cotton which underlay all of the latter. The right side of the panel portrays African Americans laboring in the fields, but there are no cotton rows, no overseers, and the pace of the labor does not appear onerous—one man with a hoe rests on his knees as he listens to the musicians in the center play; another lounges on the ground to their left. As such, the panel suggests an alternative historical possibility from that of the sharecropping system indicated in the second panel—the lost possibility of a pastoral, agrarian life for blacks in the American South had the promises of restitution during Reconstruction been realized. Indeed, in places where they had the opportunity at least partly to determine their own agricultural practices, such as in the Sea Islands off the Carolina coast, slaves were able to plant subsistence crops, to hunt and fish, and even to buy small quantities of land. During Reconstruction, when blacks gained ownership of lands abandoned during the Civil War, they often struck a blow against the cash-crop economy of the plantation system by destroying the cotton gins and growing subsistence crops such as potatoes and corn.[12] In environmental terms, this represents a sustainable, bioregional way of life competing with the globalized and exploitative economy that much of the South undertook. In the

context of the 1930s, when Douglas painted this mural, the repercussions of that unsustainable cotton economy would have been visible in the dark clouds of the Dust Bowl and the migration of southern labor, blacks and poor whites alike, that would be poignantly documented in the photographs of Douglas's contemporaries Walker Evans and Dorothea Lange.

In many ways, this third panel recapitulates the composition of the first, *The Negro in an African Setting*, affirming Douglas's artistic claims of the degree to which West African religion, music, and culture underlay the development of African-American life in North America. As many recent scholars have pointed out, cultural traditions that have their origins in West Africa were transplanted onto American soil, where they developed into their own distinctly American forms—and with a strongly place-based nature. Coleman, for example, elucidates "the Afrocentric understanding of the relationship between the forces of nature and their own spirituality" in African Americans' religious life that he traces directly back to the cultures of West Africa. He notes, for example, the way that "the nature-related healing strategies . . . of their West African ancestors" had a new life in the "vast knowledge" that African-American healers had of roots and herbs in the antebellum South.[13] At the center of *An Idyll of the Deep South*—in a ring of light similar to that which shines on the drummers and dancers at the center of the first panel—is a banjo player (the banjo itself being an African-derived instrument) and a guitar player. Behind the musicians, two African-American figures dance with nearly the same posture and movement as the African dancers at the center of the first panel. The similar posture of the black human figures in the first and third panels is Douglas's way of creating a visual representation of this phenomenon of African culture finding new roots on American soil.

Black music had "both in Africa and America . . . served the dual purpose of not only preserving communal values and solidarity but also providing occasions for the individual to transcend, at least symbolically, the inevitable restrictions of . . . his society," as Lawrence Levine puts it.[14] And just as the West African context of that cultural practice had a distinctly place-based nature—envisioned by Douglas in the greenery that surrounds the dancers of the first panel—so does its manifestation in the third panel, where the scene is also set within a framework of the natural world, which Douglas represents by framing the musicians and dancers in the center of the panel between and under the trunks and foliage of the trees. And the importance of music in the place-based creation of African-American culture will of course continue into the fourth panel. Even the hoes of the figures in the

third panel echo the spears of the figures in the first panel. The repetition, in the upper-right background, of a row of dwellings similar in form to the dwelling at the back of the first panel symbolized the degree to which ideas of home and homeland are associated with both the African and African-American scenes. Douglas recovers a connection to nature here on African-American terms, rather than on the white terms of a regionalist painter such as Johnson.

That such a sense of place, home, and connection to nature is inevitably informed by white economic and political oppression of and violence toward African Americans is something that is painted out of the work of most white landscape painters. Douglas shows this with the inclusion, even in a seemingly bucolic scene, of a group of figures on the left of the third panel who are kneeling in mourning at the feet of a lynched victim hanging from a tree. Just at the time when newly freed African Americans were attempting to form a life as free citizens on American soil, the epidemic of violence against them in the form of lynching reached its zenith, part of a terror campaign on the part of white supremacists to reinstitute a racial caste system in the South in the aftermath of the Civil War that continued right up to Aaron Douglas's own time. Thus, in the two southern panels of *Aspects of Negro Life—From Slavery through Reconstruction* and *An Idyll of the Deep South*—Douglas creates a sense of place for African Americans in the American South that is deeply bound up with ideas of home and African-derived spirituality, but at the same time fraught with the socioeconomic oppression, environmental destruction, and potential for violence of the larger white society. Writer bell hooks has said of her childhood in Kentucky that "before I knew anything about the pain and exploitation of the southern system of sharecropping, I understood that grown up black folks loved the land."[15] Douglas here captures visually this same complex relationship of African Americans to the landscape of the rural South.

In an uncomplicatedly anti-pastoral reading of *Aspects of Negro Life,* the fourth panel, *Song of the Towers,* would be triumphant. The urban space at the end of the journey from the coercion and oppression of life in the Jim Crow South would give way to new possibilities for African-American political freedom, economic equality, and freedom of expression. Indeed, if the viewer's focus is drawn to the center and upper parts of the panel, this expectation is rewarded—and with good reason. In Douglas's own words, the jazz saxophonist at the panel's center "represents the will to self-expression, the spontaneous creativeness" of the Harlem Renaissance, as it expressed "the anxiety and yearning from the soul of the Negro people." There is obvious

significance in the positioning of the musician at the center of the rings of light, which in this context could be a spotlight as easily as sunlight: freed from the specter of white supremacist violence that hangs over the pastoral scene in the two southern panels, the jazz player seems to reenact the cultural autonomy of the African dancers and drummers in the first panel. His face and hands are lifted up, and the tall buildings of the cityscape soar above him, their pyramidal shape representative of the Egyptian influence on art deco design of the 1920s—indicative of the Egyptian aspect of African cultural influence on the American city that Douglas points out here and a reminder that not all urban civilization is modern and Western. Also at the center of the circle of light is a somewhat amorphous but recognizable Statue of Liberty, suspended between two of the skyscrapers in a fashion similar to the African religious statue of the first panel, further emphasizing the notion of the urban space as a landscape of freedom and cultural autonomy. Although lacking the clean lines of a cityscape by Charles Sheeler or Georgia O'Keeffe, the upper part of the panel captures a similar energy, as the tops of the buildings open outward as they rise. In terms of notions of place, the freedom that the white American pastoral tradition—expressed in visual art and literature—usually finds in wilderness or rural spaces, Douglas claims here for African Americans in the city. Even at this level, as anti-pastoral, the painting is a valuable antidote to the mainstream environmentalist valorization of rural and wilderness areas over urban environments and a reminder that such valorization has its own white cultural biases.[16]

The sense of freedom and elation that emanates from the jazz player, however, is counterposed if not actually undermined by the images of industrial degradation and other dystopian elements that appear in the bottom half of the scene. Anticipating a dominant image of Charlie Chaplin's film *Modern Times* (1936), the saxophonist himself stands on the immense cog of a gear wheel, whereas the dancers and drummers of the first panel had stood on a carpet of greenery. In his own commentary on the work, Douglas places the negative aspects of the panel in the context of a Depression-era sympathy with labor: "the confusion, the dejection, and frustration resulting from the Depression of the 1930s." But the ecocritical implications are strongly evident: the only greenery that remains from the lush landscape of Africa and the rural South in the first three panels is relegated to the far lower-right corner, where a few fronds and leaves appear to be both choked in flame and crushed by the industrial cog. Smoke spews from smokestacks and weaves throughout the scene in an ominous manner, at one point taking the form

of a skeletal hand that plucks menacingly at a distressed human figure at the bottom left of the frame. A wisp of smoke wraps around his trunk and neck in a manner evocative of the lynching in the third panel. Such imagery serves as a visual reminder of environmental racism, and "the growing body of evidence," as Robert D. Bullard puts it, "that people of color are subject to a disproportionately large number of health and environmental risks in their neighborhoods." The figure on the lower right may be escaping, in Douglas's words, "the clutching hand of serfdom" as manifested in the sharecropping economy of the Jim Crow South, but only to be subjected to the disproportionate siting of power plants, incinerators, and garbage transfer stations in poor, urban African-American neighborhoods.[17]

The jazz saxophonist at the center of *Song of the Towers* is a triumphant figure for African-American cultural autonomy and political freedom in the American city, but his is a triumph, Douglas shows us, that has come at a certain price. And yet, the panel also shows that such a price is not inevitable: it is only our habit of viewing urban space as "not nature" that has allowed for an American pastoralist tradition in art and literature that values the country over the city—as well as for mainstream environmentalist thought to emphasize wilderness preservation over environmental justice. By linking the jazz player of *Song of the Towers* back to the banjo and guitar players of *An Idyll of the Deep South,* to the orator of *From Slavery to Reconstruction,* and to the dancers and drummers of *The Negro in an African Setting,* Douglas shows that the relationships among the wild, the rural, and the urban are those of continuum rather than separation. The greenery that winds its way through the first three panels—even reaching tenaciously into the bottom right of the fourth panel—binds these geographies together. The dancers of the first panel and the saxophonist of the fourth panel are standing on the same earth, and the human cultural world of these murals is part of the larger ecological world. The murals of Aaron Douglas not only demonstrate the deep place-based roots of African-American culture but also reflect an environmental justice imperative that attends to issues of urban sustainability and social justice.

Notes

1. Arnold Rampersad, introduction to *The New Negro,* ed. Alain Locke (New York: Touchstone, 1997), ix. Amy Helene Kirschke's informative and valuable study *Aaron Douglas: Art, Race, and the Harlem Renaissance* (Jackson: University Press of

Mississippi, 1995), to which the present essay is much indebted, was the only book-length treatment of Douglas's life and work until Susan Earle, ed., *Aaron Douglas African American Modernist* (New Haven: Yale University Press, 2007). See Kirschke page 83 for Douglas's use of Dan sculpture and pages 25–26 for his use of African ideas in his work.

2. Melvin Dixon, *Ride Out the Wilderness: Geography and Identity in Afro-American Literature* (Urbana: University of Illinois Press, 1987), 5. Norman Maclean, *A River Runs through It, and Other Stories* (Chicago: University of Chicago Press, 1976), ix. bell hooks, "Touching the Earth," in *City Wilds: Essays and Stories about Urban Nature,* ed. Terrell F. Dixon (Athens: University of Georgia Press, 2002), 30.

3. Michael Bennett, "Anti-Pastoralism, Frederick Douglass, and the Nature of Slavery," in *Beyond Nature Writing: Expanding the Boundaries of Ecocriticism,* ed. Karla Armbruster and Kathleen R. Wallace (Charlottesville: University Press of Virginia, 2001), 195. For a similar treatment see also Robert Butler, "The City as Liberating Space," in *The City in African-American Literature,* ed. Yoshinobu Hakutani and Robert Butler (Rutherford, N.J.: Fairleigh Dickinson University Press, 1995), 21–36.

4. That the white tradition of pastoral writing is not an unproblematic one goes without saying; see, for example, William Empson, who, in *Some Versions of Pastoral,* memorably defines pastoral as the process of putting "the complex into the simple" (1935; New York: New Directions, 1974), 22.

5. Alain Locke, "The Legacy of the Ancestral Arts," in *The New Negro,* 256. Douglas's commentary on *Aspects of Negro Life,* here and throughout, is quoted in Romare Bearden and Harry Henderson, *A History of African-American Artists, from 1792 to the Present* (New York: Pantheon, 1993), 131–32.

6. See Kirschke, *Aaron Douglas,* 44–48, 78; David Driskell, "The Flowering of the Harlem Renaissance: The Art of Aaron Douglas, Meta Warrick Fuller, Palmer Hayden, and William H. Johnson," in *Harlem Renaissance: Art of Black America,* ed. Mary Schmidt Campbell (New York: Abrams, 1987), 111–12; and Campbell's introduction to *Harlem Renaissance,* 29–31, for information on these aspects of the art scene during the Harlem Renaissance and Douglas's relation to it. James A. Porter is quoted in Bearden and Henderson, *A History of African American Artists,* 133.

7. Will Coleman, *Tribal Talk: Black Theology, Hermeneutics, and African/American Ways of "Telling the Story"* (University Park: Pennsylvania State University Press, 2000), 25.

8. Jean Toomer, *Cane,* ed. Darwin T. Turner (New York: Norton, 1988), 12. For Toomer's strong influence on Douglas see Kirschke, *Aaron Douglas,* 52–54.

9. James C. Cobb, *Industrialization and Southern Society, 1877–1984* (Lexing-

ton: University Press of Kentucky, 1984), 68–69. Other sources for the historical background in this paragraph are John Boles, *The South through Time*, 2nd ed. (Upper Saddle River, N.J.: Prentice Hall, 1999), 372–73; Eric Foner, *Reconstruction: America's Unfinished Revolution, 1863–1877* (New York: Harper and Row, 1989), 157–66; and Albert E. Cowdrey, *This Land, This South: An Environmental History* (Lexington: University Press of Kentucky, 1983), 103. A reproduction of Douglas's *Study for Aspects of Negro Life: From Slavery through Reconstruction* can be found in Campbell, *Harlem Renaissance*, 20.

10. Richard Wright, *Black Boy* (New York: HarperPerennial, 1998), 257.

11. John Davis, "Eastman Johnson's *Negro Life at the South*," *Art Bulletin* 80, no. 1 (1998): 67. For the way in which nineteenth-century landscape painting reinforced the nationalist political agendas in the mid-nineteenth century see Angela Miller, "The Fate of Wilderness in American Landscape Art" (in this volume) and *The Empire of the Eye: Landscape Representation and American Culture Politics, 1825–1878* (Ithaca: Cornell University Press, 1993).

12. Foner, *Reconstruction*, 51.

13. Coleman, *Tribal Talk*, 111, 65–66.

14. Lawrence Levine, *Black Culture and Black Consciousness: Afro-American Folk Thought from Slavery to Freedom* (Oxford: Oxford University Press, 1977), 7–8.

15. hooks, "Touching the Earth," 29. For an examination of the history of lynching in the American South see Stewart E. Tolnay and E. M. Beck, *A Festival of Violence: An Analysis of Southern Lynchings, 1882–1930* (Urbana: University of Illinois Press, 1995).

16. See Kirschke, *Aaron Douglas*, 77–78, for Douglas's relationship to art deco and Egyptian art. See Campbell's introduction to *Harlem Renaissance*, 29, for a comparison of Douglas to precisionist painters Charles Sheeler and Charles Demuth. For the cultural biases implicit in the environmentalist valorization of wilderness, see, for example, Mei Mei Evans, "'Nature' and Environmental Justice," in *The Environmental Justice Reader: Politics, Poetics, and Pedagogy*, ed. Joni Adamson, Mei Mei Evans, and Rachel Stein (Tucson: University of Arizona Press, 2002), 182.

17. Robert D. Bullard, introduction to *Confronting Environmental Racism: Voices from the Grass Roots*, ed. Bullard (Boston: South End, 1993), 10.

8

Alexandre Hogue's Passion

Ecology and Agribusiness in *The Crucified Land*

Mark Andrew White

In 1939, Texas artist Alexandre Hogue completed *The Crucified Land* (fig. 33), a striking vision of water erosion on a Denton, Texas, wheat farm evoking the martyrdom of Jesus of Nazareth. *The Crucified Land* was originally intended as the final canvas of Hogue's *Erosion* series, which the artist began in 1932 as a condemnation of the careless agricultural practices that had devastated his home state. When Hogue exhibited *The Crucified Land* in 1939 at the Carnegie International in Pittsburgh, the painting's provocative religious overtones drew the notice of one critic, who referred to it as the latest in a "series of sermons on conservation." The anonymous critic correctly identified the artist's conflation of religious morality and ecological principles in the painting. Aside from this brief observation in 1939, there has been scant critical examination of Hogue's relationship to ecological thought or his application of religious ideals to the painting.[1]

This is not to say that *The Crucified Land* has been ignored by critics or historians, but the work has received less attention than other paintings by Hogue such as *Drouth Stricken Area* (1934) and *Erosion No. 2—Mother Earth Laid Bare* (1936). *The Crucified Land,* like its companions in the *Erosion* series, has been interpreted as Hogue's "condemnation of unwise farming practices" and his denigration of "man's ignorance of nature." This interpretation has been advanced repeatedly since the 1930s, beginning with *Life* magazine's 1937 profile characterizing the *Erosion* series as a "scathing denunciation of man's persistent mistakes."[2]

Although Hogue certainly blamed the extreme erosion and dust storms of the 1930s on indifference and negligent husbandry, the visual imagery of *The Crucified Land* indicates that a growing ecological sensibility led him to focus his criticism of agriculture upon the cultural or spiritual roots of

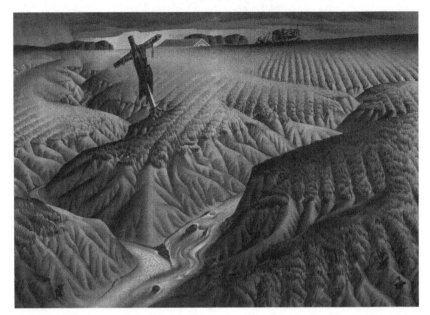

33. Alexandre Hogue, *The Crucified Land,* 1939. Oil on canvas. Gilcrease Museum, Tulsa, Oklahoma.

such abuse. Hogue developed a contrast in the painting between the verdant wheat grass, with its implication of abundant fecundity, and the looming disaster of water erosion that slinks in serpentine lines from the immediate foreground into the lush fields. The farmer has plowed downhill and across the contours of the land with a tractor, demonstrating apparent indifference to the environment in favor of industrial efficiency and profit. Reckless cultivation of the soil has produced the ideal terrain for water erosion, as departing rains at left take the ruddy topsoil of North Texas with them, leaving gullies that will expand with further erosion until the acreage's fertile potential literally washes away. The resulting wasteland, though lacking essential nutrients to sustain crops, will provide ample support for the needle grass that has already crept into the field in the lower-left and lower-right corners. As the gullies infiltrate the field, they threaten to undercut the cadaverous scarecrow whose tattered overalls barely disguise his cruciform support. Future storms will collapse the embankment and send him and his rock foundation into the rut.

Hogue's taut forms give the eroded terrain the appearance of jagged, flayed flesh, and his inclusion of the wasted, cruciform scarecrow reinforces

the implied comparison in the painting's title between the scourging of the land and the torture of the Passion. Salvation from this agricultural sin requires immediate action before the encroaching evil of erosion undermines the entire area. The sinuous gullies that snake back into the field create an additional biblical allusion to the devious serpent and a paradise lost to the encroaching wilderness. These pervasive violent overtones in *The Crucified Land,* when paired with the religious references, suggest both an ecological sympathy for the land as a sacred body and a moral attack on the aggressive practices of agribusiness as a form of blasphemy. *The Crucified Land* associates the loss of paradise with capitalist exploitation, suggesting a repudiation of the dominion over nature that God granted humanity in Genesis 1:28 as a justification for environmental plundering dangerous to both nature and humanity.[3]

As such, *The Crucified Land* indicates a reverence for nature as a sacred body while rebuking human dominion and calling for a new ecological covenant that emphasizes conservation. Hogue's approach, at once embodying and spiritualizing the land, shares much with Depression-era ecologists such as Frederic Clements, Aldo Leopold, and Paul Sears, who characterized nature as a delicately balanced organism that humanity must relate to symbiotically. The artist's work also compares closely to that of contemporary artist-commentators such as Pare Lorentz, John Steinbeck, and Archibald MacLeish, who not only attempted to raise public awareness of the abuses of industrial agriculture but also invoked religious metaphors to describe the environmental devastation of the 1930s.

Art historians have largely neglected Hogue's relationship to ecological thought and his strategic use of religious metaphors in *The Crucified Land.* In one cursory assessment, Lea Rossen DeLong has noted that "Hogue's work often suggests a 'cause-and-effect' relationship which illuminates the interconnections in nature, of which humanity is a part." Brad D. Lookingbill has discussed Hogue's use of religious rhetoric, associating the artist's work with the tradition of the American jeremiad described by literary historian Sacvan Bercovitch. According to Lookingbill, Hogue was among those "prophetic voices" who "cried out in bewilderment about the fate of civilization when observing disasters." The *Erosion* series not only attempted to alert Americans to the crisis but also offered a form of catharsis for those suffering through the environmental horrors. Hogue's interpretation of the environmental devastation as a moral failure certainly recalls the jeremiad, but

Lookingbill does not examine *The Crucified Land* or explain the artist's ecological use of Christian references. In some ways, Hogue's critique of agribusiness using religious symbolism anticipated an argument articulated three decades later in an important cultural essay for the journal *Science* by historian Lynn White, who questioned the "Christian axiom that nature has no reason for existence save to serve man."[4]

The issues posed by *The Crucified Land* invite consideration of biographical details in Hogue's religious upbringing that relate to the *Erosion* series. When Alexandre was only six weeks old, his father, Charles Lehman Hogue, accepted a Presbyterian pastorate in Denton, Texas. Christianity thus played a central role in the artist's childhood, undoubtedly providing an important lexicon of metaphors and moral lessons, even though he later distanced himself from the church out of disgust at its internal politics. Alexandre's profound respect for nature was shaped by his childhood affection for the Bishop Ranch, his sister's 50,000-acre sheep and cattle operation near Dalhart in the Texas panhandle, and by his time spent tending the family garden with his mother. On the Bishop Ranch, Hogue developed a deep affinity for what he called "the most luscious grassland in the world" and would later insist that the High Plains "never should have been plowed. Sad to relate, the grassland is gone forever." DeLong notes that it was in Dalhart "that Hogue began to recognize the human capacity to destroy nature's fragile balance. Reverence for the land, fascination with its expansive space, and a sense of loss at its destruction were attitudes which Hogue must have formed on the flat, windy plains of the Panhandle."[5]

Hogue's lament for the destruction of the grasslands surrounding Dalhart later informed one of his most notable paintings from the *Erosion* series, *Drouth Survivors* (1936) (fig. 34). Like *The Crucified Land, Drouth Survivors* depicts a landscape exhausted by overplowing, with the tractor identified once again as the means to this destructive end. Desertification has resulted from the absence of water and the erosive power of the wind, which conspire to engulf the tractor and the barbed-wire fence in the shifting dunes. Only prairie dogs and rattlesnakes can subsist in this dystopia of desiccated cows and denuded vegetation. The fate of the cattle recalls Hogue's lament for the Dalhart ranchlands, as DeLong has suggested. For the article illustrating his work, *Life* ran the headline "Artist Hogue Feels That Grazing Land Was Destroyed 'First by the Fence, Then by Overplowing, Now by Drouth.'" The West Texas Chamber of Commerce apparently took such of-

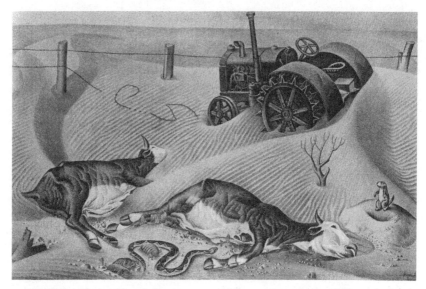

34. Alexandre Hogue, *Drouth Survivors,* 1933. Oil on canvas, destroyed (formerly Jeu de Paume, Paris). Reproduced in "The U.S. Dust Bowl," *Life,* June 21, 1936, 61.

fense at Hogue's *Erosion* series and *Drouth Survivors* that they sent a representative to Dallas to buy the painting for fifty dollars so that they might burn it in a public bonfire.[6]

If Hogue's love and lament for the vanished grasslands had a decisive influence on the *Erosion* series, his respect for nature may have been initially formed by his mother, Mattie Hoover Hogue. Alexandre often assisted her in the family garden, where she spoke of "mother earth," engendering in her child "visions of a great female figure under the ground everywhere, a figure which might be injured if one were not careful." His early sympathy for the land and his personification of it as a maternal figure later led him to paint *Erosion No. 2—Mother Earth Laid Bare,* depicting a large feminine form in the buff clay subsoil of the Dallas area with a lethal gash running through her neck (fig. 35). Nearby lies a plow, the perpetrator of this heinous murder and a symbol of "the power of the phallus." Mother Earth's nude form testifies to the destructive consequences of poor farming practices, which have stripped away the layer of protective topsoil, but the work also associates the destruction of land with sexual violence—the rape of nature.[7]

Although Hogue credited his notion of a feminine earth to his mother, *Mother Earth Laid Bare* relies on an inveterate paradigm of Western civili-

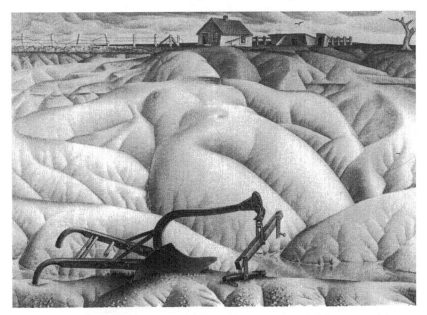

35. Alexandre Hogue, *Erosion No. 2—Mother Earth Laid Bare,* 1936. Oil on canvas. Museum purchase, 1946.4, © 2008 The Philbrook Museum of Art, Inc., Tulsa, Oklahoma.

zation that interpreted nature as both "a nurturing mother" and a disorderly consort. According to historian Carolyn Merchant, the paradigm in question required that "the female earth and virgin earth spirit were subdued by the machine." At the same time, however, Hogue offers what Merchant has called the environmentalist counternarrative, first formulated by the romantics and transcendentalists, which personified nature "as a powerful female to be revered, rather than a virgin land to be plowed and improved." This counternarrative has largely fused with aspects of modern feminism to construct a view of "nature as originally positive and pristine, but as desecrated and downgraded by commercial and industrial development."[8]

Hogue accentuated the visual impact of commercial destruction through a technique he referred to as "psycho-reality." Although this comment and his personification of nature as feminine would seem to suggest that he embraced surrealism, Hogue publicly distanced himself from that movement. Nevertheless, *Life* magazine used the following terms to assert that his formal technique intensified the psychological resonance of environmental devastation: "By placing symbols together in neat geometric patterns, he hopes to produce a 'superrealism' that will make the observer not only see the Dust

Bowl, but also feel its heat, its despair, its anguished death, the tragedy of its farmers." Whether intentionally surrealist or not, the tightly drawn geometric forms of *Mother Earth Laid Bare* suggest a maternal environment that had been fatally cleaved, chopped, and eroded to its naked essence.[9]

After completing *Mother Earth Laid Bare,* Hogue further stressed his indignation about a butchered, violated earth by suggesting an ethnic interpretation of the work. The artist had finished the painting in Taos, New Mexico, and subsequently discovered from either his fellow Taos artists or residents of the nearby Pueblo that an analogous belief in Mother Earth could be found in Native American cosmology. As he recounted in 1946, the Pueblo Indians' respect for Mother Earth had inspired a similarly intense concern about nature: "I learned about the Indian belief regarding the Earth Mother which runs through all animistic religions throughout the world as well as throughout all time. According to [Puebloan] beliefs the earth mother is pregnant just before the sprouting in spring and a quiescent period is declared in which time no iron wheels or other metal instruments may move over or pierce the ground. They even remove the shoes from horses."[10] Hogue also noted that the Pueblo people forbade the use of metal specifically "for fear of injury to the Earth Mother," suggesting a shared regard for nature as a fragile feminine body. The artist even discussed *Mother Earth Laid Bare* with an elder of Taos Pueblo, who "thought I had managed a look-see into the secrets of their beliefs."[11]

Hogue was unaware of Puebloan cosmology when he began *Mother Earth Laid Bare,* but he may have encountered the Taos elder by the time he began *The Crucified Land* in 1939. The artist clearly sympathized with Puebloan beliefs as further validation of his own animistic interpretation of nature and as a criticism of the mechanization of American agriculture. The lacerated furrows in *The Crucified Land* identify the tractor as the agent of violence against an animate, living nature, invoking both his mother's warnings and the Puebloans' prohibitions against metal implements. Both the plow and the tractor's steel wheels act as blades carving into the earth's flesh. The latter is a particularly significant detail, since rubber tires were readily available as a replacement for metal wheels on almost all tractors by 1935.[12]

Despite the influence of Mattie Hoover Hogue and Puebloan cosmology, *The Crucified Land* does not emphasize the gender of nature in the manner of *Mother Earth Laid Bare.* The Christian reference in the title and the male clothes of the scarecrow may imply a nontraditional interpretation of nature as masculine, but the eroded land refers less to a specifically femi-

nine or masculine body than to the flayed flesh of a generalized, animistic nature. Hogue thus seems to have downplayed gender in *The Crucified Land* in order to make the more fundamental argument that crimes against nature do not discriminate. Whereas *Mother Earth Laid Bare* seems to hold masculinity responsible for the rape of nature through the plow metaphor, *The Crucified Land* implies that all viewers are potentially culpable. The bloody soil that flows from the eroded farm to the lower edge of the canvas stains all hands.[13]

The issues raised by *Drouth Survivors, Mother Earth Laid Bare,* and *The Crucified Land* indicate Hogue's unwavering attack on agribusiness as a pernicious force largely responsible for converting prairie into farmland during the boom market of World War I. His lament for the grasslands, his animistic interpretation of nature, and his criticism of industrial agriculture together construct an ecological argument in favor of conservation. But, before Hogue's connections to Dust Bowl–era conservation can be examined, it is necessary first to discuss the spread of agriculture to North Texas grasslands, its environmental consequences, and its industrialization.

The North Texas prairies that once supported herds of grazing animals such as bison, antelope, and elk provided an ideal environment for cattle and sheep ranches in the nineteenth century. Rapid agricultural development of North Texas occurred during World War I, when President Woodrow Wilson attempted to remedy food shortages among European allies and U.S. troops by encouraging increased crop production on the Great Plains with an emphasis on wheat and corn. Agricultural conversion of the grasslands was considered instrumental to the war effort, as documented by Pare Lorentz in his 1936 film *The Plow That Broke the Plains,* which featured vintage footage of mechanized harvesting and narrated slogans such as "Wheat will win the war!" But the war effort also initiated a land boom that accelerated in the 1920s, causing a 69 percent increase in cultivation in North Texas between 1924 and 1929. Crop speculators were persuaded further by reports from the railroads that advertised an annual yield of wheat between thirty and thirty-five bushels. Agriculture was so lucrative in the late 1920s that "there was hardly an acre of arable land around Dalhart which did not pay for itself in its first year," according to one contemporary commentator.[14] This striking change to the grasslands around Dalhart certainly caught Hogue's attention and inspired his indignation toward modern agriculture.

The profitability of a cash crop like wheat encouraged monoculture planting, which often exhausted the soil within a few seasons. This kind of crop

speculation produced what historian Donald Worster has called a "trail of exploitation," creating a class of transient farmers who moved from plot to plot once the land could no longer sustain the crop and who had no real tie to the earth. According to Worster, these farms were often owned by an "agricultural entrepreneur [who] stood for the idea that the land's true and only end was to become a commodity—something to be used, bought, and sold for human gain." Inevitably, environmental disregard produced a "barren earth, marked by deep gullies, slashed timber, and thinning soils" culminating in the catastrophe of the Dust Bowl. Hogue's colleague Otis Dozier acknowledged such transience in Texas in a painting titled *The Annual Move* (1936), which depicted a family abandoning both the homestead and the exhausted land for the next field.[15]

The industrialization of agriculture through the tractor exacerbated the environmental consequences of monoculture planting, especially when some farmers hoped to gain greater efficiency by plowing the fields immediately after the harvest in order to save time before the next planting season. Winds and water in the intervening time period often eroded the topsoil, leaving a desolate wasteland and giving rise to the phrase "tractored out." The currency of that phrase prompted Dorothea Lange to use it as the title of her 1938 photograph showing an unproductive, fallow field in West Texas.

The Crucified Land depicts this "trail of exploitation" in both the monoculture of wheat, which will eventually sap the acreage of its fertile potential, and the downhill furrows, which hasten the erosion. Although the farm seems occupied, Hogue identified the site as "an abandoned field," suggesting the tenant may have moved on to an adjacent plot. The degraded, linear furrows clearly point to the tractor as the agent of erosion, but it is doubtful that Hogue limited the tractor's significance solely to environmental devastation, considering its tremendous impact on 1930s agriculture. He also certainly intended to highlight the impact on agricultural laborers in Texas who had been "tractored out" of their jobs and homes by the spread of mechanization. Indeed, his careful depiction of a particular model of tractor in *The Crucified Land* indicates that he was conscious of such consequences.[16]

The tractor in *The Crucified Land* appears to be a 1930s McCormick-Deering Farmall, probably an F-20 (or possibly an F-12).[17] Because it could perform multiple tasks using numerous attachments, such as plows, rakes, and harvesters, the Farmall was the most popular model of tractor. Such improvements in tractor technology enabled landowners to mechanize both planting and harvest, increasing efficiency and profitability. The number of

tractors in Texas increased from 37,000 in 1930 to 99,000 in 1938, resulting in drastic labor reductions and tenant evictions. According to one estimate, each tractor displaced three to five tenants or sharecroppers, such that by 1942 approximately 60,000 farm families had been evicted. A 1939 report from Fort Worth summarized the problem effectively: "Men with resources are buying or leasing large tracts of land. . . . They are displacing many small farmers—those who have been successful as well as marginal farmers. Most of the large operators are using tractors, thus throwing many farm laborers out of employment. . . . The worker has gradually degenerated from farm owner to tenant or sharecropper and finally to farm laborer."[18]

This economic degeneration of the farmworker through agricultural industrialization also left its mark in the physical and emotional decline of many displaced individuals. One Works Progress Administration (WPA) supervisor in Texas noted that "upon each visit to the office, we notice that the unassigned worker is thinner, his clothes more ragged, his facial expression more gaunt, his patience and endurance frayed." In short, the capitalist culture of crop speculation had produced a relatively sudden mechanization of the Texas farm, with erosive consequences for both the land and its inhabitants. Hogue's inclusion of the tractor in *The Crucified Land* thus alludes simultaneously to both the environmental damage and the social damage wrought by industrial agriculture. It is no accident that the scarecrow wears the overalls and chambray shirt of the typical Depression-era farmer, for its tattered, wasted form suggests a physical decay comparable to the WPA reports of unassigned workers. DeLong has argued that Hogue lacked "sympathy with the suffering of uprooted farmers" and that his "partisanship with the land" separated him ideologically from filmmaker Pare Lorentz and writer John Steinbeck. I contend, however, that *The Crucified Land,* Hogue's final meditation on the subject of environmental abuse, offers a critique not of the farmer but of the industrialization of contemporary agriculture and the capitalist ideology behind it. Hogue thus had more in common with Lorentz and Steinbeck than scholars have recognized.[19]

Lorentz's *The Plow That Broke the Plains,* commissioned by the Farm Security Administration, also depicted the tractor as a significant culprit in the Dust Bowl catastrophe. His juxtaposition of a fleet of tractors with a fleet of tanks during the World War I montage implies a kind of technological war to "break" the Great Plains soil. Lorentz specifically relates this agricultural aggression with the boom market of the 1920s by alternating images of ticker-tape machines and harvested wheat. This segment, which ends

with the market crash of 1929, suggests that Lorentz perceived the environmental devastation of the Dust Bowl to be the result of what historian Finis Dunaway calls "an entire culture of greed and overindulgence, a society that has lost its moral bearings." Dunaway argues that Lorentz blamed "the sins of unbridled capitalism" for the blowing dirt and eroded fields found in later sequences of the film.[20]

Lorentz was far less pointed than Hogue in associating the tractor with economic hardship, but the filmmaker did capture the extreme poverty in the Midwest and the migrancy it produced. John Steinbeck, by contrast, clearly acknowledged the tractor as the agent of both environmental devastation and economic destitution in his 1939 novel *The Grapes of Wrath*. Steinbeck portrayed the tractor as a violent implement that increased production in the short term only to have devastating long-term consequences for the environment. As he succinctly observed, "The land bore under iron, and under iron gradually died." But the machine was not solely to blame, for it was merely a tool of capitalist desire. The banks and finance companies, which held leases on the land and on the tractors that would soon farm it, demanded increasing profitability. This demand, in turn, promoted enhanced efficiency through mechanization. Tenant evictions seemed inevitable, since "one man on a tractor can take the place of twelve or fourteen families."[21]

As Steinbeck describes it, the dreaded tractor operator who took tenants' jobs and razed their houses functioned as an inhuman component in the capitalist machine, "a robot in the seat" who "loved the land no more than the bank loved the land." This automaton, seemingly fleshless in his concealing gloves, protective glasses, and rubber mask, lacked all empathy and sensory attachment with the land, because the bank had "goggled his mind, muzzled his speech, goggled his perception, muzzled his protest. . . . He could not see the land as it was, he could not smell the land as it smelled; his feet did not stamp the clods or feel the warmth and power of the earth." For Steinbeck, such detachment suggested an unwillingness to regard nature as a living entity. Capitalist greed, which discounted all aspects of nature except for its potential monetary value, prompted the death of the land through mechanistic efficiency. As an alternative, the author proposed the figure of Jim Casy, who articulates an ecological connection to nature in these simple terms: "There was the hills, an' there was me, an' we wasn't separate no more. We was one thing. An' that one thing was holy." By the end of the novel, Casy undergoes a Christ-like martyrdom akin to that of Hogue's desiccated terrain.[22]

Steinbeck's attack on agribusiness and his proposal of a different attitude to the land resonates strikingly with Hogue's pictorial argument in *The Crucified Land,* a work that condemns agricultural industrialization and envisions nature as animate. Not unlike both *The Plow That Broke the Plains* and *The Grapes of Wrath,* Hogue's painting asserts that agricultural industrialization transcended economics to become a moral issue concerning fair business practices and society's proper relationship to nature. In each work, profit functions as the dominant objective of agribusiness as well as the immoral, injurious cause of ruin, both economically and environmentally, in the Dust Bowl. For all three artists, the tractor provides an important focus of moral critique by epitomizing such ruin and the capitalist greed that prompted it. Like Lorentz and Steinbeck, Hogue intended not merely to condemn recent agribusiness practices but also to promote an ethical, symbiotic relationship with nature that emphasized conservation and preservation of resources such as the grasslands. As he later insisted, "I did not do the erosion series as social comment. . . . Social comment is negative, my interest in conservation is positive."[23]

Viewed in the light of his lament for the vanished grasslands and his ethical indictment of agribusiness, Hogue's reference to conservation relates him to other Depression-era ecological thinkers, particularly Frederic Clements of the Carnegie Institution. Clements characterized ecology as a concern for biological "wholeness" in which humans, animals, and plants act as "organs working in unison within a great organism." This theoretical model emphasizes a symbiosis or interdependence among nature's disparate parts that must be maintained in order to prevent ecological failure. Clements also identifies the introduction of monoculture agriculture into the relatively fragile grasslands ecosystem as the culprit behind the Dust Bowl, thereby placing the onus on humanity's disregard for ecological balance.[24]

Clements's theories were readily adopted by other ecologists in the 1930s who condemned the abuses of agricultural industrialization and encouraged contemporary Americans to redefine their relationship with nature in symbiotic terms. For example, Aldo Leopold urged Americans to reject the traditional definitions of the land as property, "entailing privileges but not obligations," and of progress as "the enslavement of a stable and constant earth." Like Clements, he characterized nature as "a state of mutual interdependent cooperation between human animals, other animals, plants, and the soils, which may be disrupted at any moment by the failure of any of them." The recognition that human beings were capable of disrupting an entire ecosystem

entailed a moral responsibility to the land, and Leopold proposed conserva-
tion as the new ethical paradigm. But this symbiotic relationship, as ecolo-
gist Paul Sears argues, was continually undermined by the "diabolical power
of modern technology." For Sears, that power "accelerate[d] the speed with
which [natural resources] are consumed" and created a culture of excess,
gratifying human desires but exacerbating the exhaustion of resources.[25]

We do not know whether Hogue read the work of these ecologists, but his
interest in conservation and his criticism of agricultural industrialization on
the Great Plains certainly demonstrate a similar perspective. Clements's char-
acterization of nature as a "great organism" would have been particularly at-
tractive to Hogue, given his enthusiasm for the archetype of Mother Earth
and his depiction of the land as body in *The Crucified Land*. The personifi-
cation of nature as an organism also implied that reckless action on the part
of humanity could promote failure of an ecosystem, resulting potentially in
its death. *The Crucified Land* not only depicts just such an outcome but also
equates such disregard with the sin of murder. Hogue specifically situated
the farm in the North Texas redlands "to symbolize the fact that water is cut-
ting into the very flesh of the earth, draining it of its life-blood, crucifying
the land."[26]

By portraying such environmental destruction as a form of execution or
murder, Hogue invoked a metaphor popular among the ecologically minded
commentators of the period, notably Archibald MacLeish, whose important
1935 exposé for *Fortune* magazine titled "Grasslands" similarly critiqued
agribusiness. Hogue probably had read MacLeish's essay, which discusses
Dalhart and depicted dust storms battering the town in two of the accom-
panying photographs. The essay pointed to the agricultural boom following
World War I as the primary cause of the Dust Bowl and criticized agricul-
tural industrialization on the Great Plains as a form of capitalist exploita-
tion. To underscore his argument, MacLeish detailed the true story of Tom
Campbell, a symbol "of the American passion for power, speed, and the pre-
dictable machine." During World War I, Campbell had received a ten-year
lease on the Shoshone Reservation in Wyoming and the Crow, Blackfoot, and
Fort Peck reservations in Montana at significantly reduced rental payments.
After securing financing on the 100,000-acre venture from James J. Hill of
the Great Northern Railway and J. P. Morgan, Campbell used this capital to
mechanize his farming enterprise with heavy, medium, and light tractors.
Machinery allowed Campbell to break sod at an astounding rate, thereby
dramatically decreasing expenses and increasing profit. By continually modi-

fying his tractors for greater efficiency, Campbell further reduced his labor force from two hundred employees to fifty and his operating costs from $7.50 to $4.80 an acre. MacLeish acknowledged that Campbell's innovations had generally improved agricultural efficiency by encouraging increased use of tractors on the Great Plains: "Without Tom Campbell the tractor would have been a different and an inferior thing."[27]

For MacLeish, however, Campbell's faith in technology and his desire for increasing profit through efficiency also typified the environmental disregard that produced the Dust Bowl. Like Hogue, the author viewed such attitudes as both destructive and violent while encouraging his readers to cultivate a more symbiotic relationship with nature. He even personified the land in a similar manner by defining erosion as a "Cancer of the Earth" and "an ill resulting from injury to the vegetative cover." MacLeish illustrated this point with a photograph of erosion that compares closely to the foreground of *The Crucified Land* (fig. 36). In order to prevent the "murder" of the land through wind and water erosion, he prescribed "the healing humbleness of grass" as a physical and moral antidote to the greed and indifference of Campbell and his tractors.[28]

MacLeish's appeal portrays grass as a vital link within the Great Plains ecosystem, one whose restoration could repair the significant damage caused by agribusiness. His association of the loss of prairie grasses with environmental collapse was echoed by Steinbeck's Tom Joad, who blamed the failure of their Oklahoma farm on the loss of such grasses: "Ever' year I can remember, we had a good crop comin', an' it never come. Grampa says she was good the first five plowin's, while the wild grass was still in her." In Steinbeck's novel, the eradication of prairie grass causes the Joad farm to fail, emphasizing both the precarious balance of the Great Plains environment and the symbiotic relationship between prairie grass and contemporary Americans.[29]

MacLeish went even further to suggest that human lives were spiritually connected to the fate of the flora. At the beginning of his essay, he confronted readers with a passage from Isaiah 40:6: "All flesh is grass."[30] Consulting the Bible, we find that the verse in question continues, "and its loveliness is like the flower of the field. The grass withers, the flower fades, when the breath of the Lord blows upon it; surely the people are grass. The grass withers, the flower fades, but the word of our God stands forever." Although MacLeish did not maintain the biblical metaphor throughout his essay, his use of Isaiah adds a prophetic tone, warning Americans of the potential consequences of their disregard for the grass.

CANCER OF THE EARTH

Without water the high Plains perish. With water they perish too unless the grass holds it. How they perish is convincingly told in the three photographs above. At the top runnels of water from one of the pelting storms characteristic of the area have scratched into the siltlike soil of an overgrazed New Mexican range. Next below a gully head has begun to eat back into a fertile valley. Such gullies will move 200 feet in a year. At the bottom the disease has run its course. What is left is the rutted skeleton of earth.

36. "Cancer of the Earth," published in Archibald MacLeish, "Grasslands," *Fortune,* November 1935, 62.

The passage from Isaiah emphasizes not only the eternal power of the divine but also the transitory nature of earthly existence. According to historian Brad D. Lookingbill, biblical admonitions such as this were given frequently during the Dust Bowl, and journalists often characterized the calamity as a form of divine judgment against human hubris. After the black blizzard on April 14, 1935, for example, the *Topeka Daily State Journal* ran the headline "The Garden of Eden Destroyed When Man Turned the Sod on the Prairies of Kansas." Numerous other commentators, particularly religious leaders, interpreted the Dust Bowl as a sign that Americans were facing expulsion from paradise. As Lookingbill has demonstrated, however, most saw the hardships of the period as divine judgment on their sinful lives, not necessarily as punishment for their treatment of the environment.[31]

The Crucified Land warns of the destruction of the American Eden through visual details such as the serpentine gullies that slither back into the farmland, corrupting its fertile potential like the proverbial snake in the grass. Yet, Hogue's evocation of Eden does more than simply portray the North American land as a threatened paradise: it offers a moral lesson on the consequences of human greed. In alluding to Genesis, Hogue clearly drew an analogy between the greedy disobedience of Adam and Eve and the modern pursuit of profit that drove the plowing of the grasslands. Humanity fell from grace, in effect, by attempting to exercise complete dominion over nature. As Hogue suggests, Americans run the risk of losing paradise all over again due to what he considered "the evil effects of erosion" prompted by an equally destructive drive for profit.[32]

Hogue's reference to the expulsion from an American Eden and his juxtaposition of nature with the Christian symbolism of the cross recall aspects of nineteenth-century landscape painting by the Hudson River school, particularly the works of Thomas Cole and Frederic Edwin Church. According to art historian Tim Barringer, Cole's *Expulsion from the Garden of Eden* (1827–28) constitutes "an allegory of America's fall from grace, as the wilderness was increasingly destroyed by westward expansion and industrialisation." Church repeatedly addressed the theme of the cross in the wilderness as a way of reinforcing nature's sacred value in works such as *To the Memory of Cole* (1848), *Cross in the Wilderness* (1857), and *Heart of the Andes* (1859).[33]

A more immediate prototype for *The Crucified Land* was William Lester's *The Three Crosses* (1935–36), which the Dallas Museum of Art (the current owner) displayed alongside Hogue's *Erosion No. 1—Permian Red Beds*

(1932) in the Eighth Allied Arts Exhibition in 1937. Lester gave traditional Christian iconography a decidedly southwestern flavor by using fenceposts as instruments of martyrdom. Although Christ and the two thieves do not appear, the skull of Adam awaits the Savior's redeeming blood. The centurions have already gambled for Christ's clothing, but the winner must have decided that this prize was of little worth, for it rests unclaimed nearby. Rick Stewart has suggested that Lester's somewhat ambiguous crosses may refer not only to Christ and the thieves but also to settlers' graves, "where the bones have been exposed by the restless elements." According to Stewart, Lester's darkened sky "suggesting a dust pall over the bleak landscape" insinuated that inept pioneers, ill suited to handle the tenuous ecological balance of the prairie grasslands, had brought about the Dust Bowl.[34]

Lester's implication of human activity in environmental disaster, filtered through the lens of Christian symbolism, certainly resonates with *The Crucified Land*. Yet, Hogue's ecological sermon is far more confrontational in its visual association between the engine of human greed and the wasted landscape. As depicted by Hogue, the application of industrial efficiency to agriculture has left the land bloody and broken. The instrument of flagellation and martyrdom, the tractor, stands menacingly close. By using the Christian metaphors of the Fall and the Crucifixion to condemn the sin of avarice, Hogue also perhaps hints that a form of salvation from this ecological disaster is possible. His previous comments and the evidence within the painting suggest that redemption can come only through a revision of thought, namely, the embrace of an ecological sensibility that regards nature as a delicately balanced organism within which humanity is only a part. Hogue would have agreed with historian Lynn White's charge that Christianity had isolated humanity from nature and fostered environmental abuse: "Our science and technology have grown out of Christian attitudes towards man's relation to nature, which are almost universally held not only by Christians and neo-Christians but also by those who fondly regard themselves as post-Christians. Despite Copernicus, all the cosmos rotates around our little globe. Despite Darwin, we are *not,* in our hearts, part of the natural process. We are superior to nature, contemptuous of it, willing to use it for our slightest whim."[35]

White proposes stewardship as an alternative and advocates St. Francis as a model for Christian interaction with nature. *The Crucified Land,* viewed in the light of White's condemnation of dominion, acts as an ecological appeal in art for a complete revision of human attitudes toward nature and the agri-

cultural practices those notions produced in the 1930s. Hogue's scathing pictorial condemnation of agribusiness as murderous, avaricious, and destructive questions the unbridled application of capitalist efficiency to agriculture and links him ideologically to the ecological thought of contemporaries such as Steinbeck, Clements, and MacLeish. His image of the flayed, bloodied land is not simply an indictment of agribusiness abuses but also an appeal for conservation as a moral relationship with nature. By implying that mistreatment of nature is a crime against both God and humanity, Hogue offers a visual sermon of sorts, critiquing Americans' faith in a boundless, inexhaustible nature as a dangerous ideology that resulted in the tragedy of the Dust Bowl. As such, *The Crucified Land* represents more than an artistic artifact of 1930s America; its passionate assertion of ecological principles still resonates today.

Notes

1. On the *Erosion* series see Lea Rossen DeLong, *Nature's Forms/Nature's Forces: The Art of Alexandre Hogue* (Norman: University of Oklahoma Press, 1984). According to DeLong, "Each *Erosion* painting presented a different aspect of the blind, continual exploitation of the land for which humans are clearly culpable" (20). *The Crucified Land* was the last work Hogue painted in response to contemporary environmental conditions in Texas. In 1944 the *Encyclopedia Britannica* approached him through the Associated American Artists to paint two additional images of erosion, resulting in *Avalanche by Wind* (1944) and *Soil and Subsoil* (1946). In the information sheet he prepared for *Britannica,* Hogue noted that the images depicted environmental conditions around 1932–34 (DeLong, *Nature's Forms,* 140). See "Paintings in International Art Show Reflect World Turmoil," *Pittsburgh Post-Gazette,* October 19, 1939, quoted in DeLong, *Nature's Forms,* 130.

2. DeLong, *Nature's Forms,* 130; Rick Stewart, *Lone Star Regionalism: The Dallas Nine and Their Circle, 1928–45* (Austin: Texas Monthly Press, 1985), 108; "The U.S. Dust Bowl: Its Artist Is a Texan Portraying 'Man's Mistakes,'" *Life,* June 21, 1937, 61. The Dust Bowl, so named because of the dust storms that plagued the region in the early 1930s, encompassed the Oklahoma and Texas panhandles, southwestern Kansas, southeastern Colorado, and northeastern New Mexico. Brad Lookingbill has suggested that Hogue may have been one of the first to use the term *Dust Bowl* when he selected it as the title for a 1933 painting. Brad D. Lookingbill, *Dust Bowl, USA: Depression America and the Ecological Imagination, 1929–1941* (Athens: Ohio University Press, 2001), 136 n. 2.

3. Although "agribusiness" is a term of recent origin (the *OED* dates its emer-

gence to 1955 in the United States), it effectively describes a dominant trend in farming since World War I. Agribusiness may be defined as the application of capitalist business practices to agriculture through the embrace of industrial production. Mechanization and technological innovation are considered keys to the increase of agricultural efficiency, which results in greater profitability. As such, the term captures the relationships among economics, technology, and agriculture.

4. DeLong, *Nature's Forms,* 7; Lookingbill, *Dust Bowl,* 25; Lynn White, "The Historical Roots of Our Ecologic Crisis," *Science,* March 10, 1967, 1203.

5. Hogue to Matthew Baigell, June 14, 1967, Hogue Papers, McFarlin Library, University of Tulsa, box 2, folder 1; DeLong, *Nature's Forms,* 7. While Hogue blamed agriculture for much of the erosion that spawned the Dust Bowl, he ignored the equally important issue of overgrazing and its role in erosion. His bias originated most likely in his attachment to his sister's ranch.

6. "The U.S. Dust Bowl," 60; Elisabeth Crocker, "Hogue Ignites Bomb from the Southwest," *Dallas Morning News,* May 15, 1938, quoted in DeLong, *Nature's Forms,* 24. Hogue sold *Drouth Survivors* to the Jeu de Paume Museum, Paris; ironically, the painting was destroyed in a fire in 1948.

7. Alexandre Hogue to Frederic Allen Whiting, late 1939, Hogue Papers, box 3, folder 8; Lookingbill, *Dust Bowl,* 40. *Mother Earth Laid Bare* is Hogue's most recognizable image and has been discussed extensively in critical literature. For further discussion see both DeLong, *Nature's Forms,* 120, and Joni L. Kinsey, *Plain Pictures* (Washington D.C.: Smithsonian Institution Press, 1996).

8. Carolyn Merchant, *The Death of Nature: Women, Ecology, and the Scientific Revolution* (New York: Harper and Row, 1983), 2, as well as her *Inventing Eden: The Fate of Nature in Western Culture* (New York: Routledge, 2003), 118.

9. DeLong has argued that "Hogue was willing to admit there was a surrealistic tone in some of his works, but he did not wish to be considered a surrealist" (*Nature's Forms,* 25). She finds his work closer to magic realism, which Jeffrey Wechsler defined as "an art of the implausible, not the impossible, of the imaginative, not the imaginary." See Wechsler, *Surrealism and American Art* (New Brunswick, N.J.: Rutgers University Art Gallery, 1977), 38. DeLong maintains, however, that Hogue's term "psycho-reality" most closely describes his style.

10. Hogue to Thomas Beggs, February 8, 1946, Hogue Papers, box 1, folder 10.

11. Hogue to Tom Kelley, May 5, 1946, Hogue Papers, box 1, folder 10, and Hogue to Alfred Frankenstein, May 28, 1944, Hogue Papers, box 2, folder 2.

12. Hogue first visited Taos in 1926, and he returned nearly every year until the beginning of World War II. When he visited Taos in 1938, he showed *Mother Earth Laid Bare* to a group of his Taos colleagues that included Kenneth Adams, Emil Bisttram, Howard and Barbara Cook, Lady Dorothy Brett, Andrew Dasburg, and Ernest, Mary, and Helen Blumenschein. Hogue remembered that Dasburg was the

first to associate Hogue's image of a feminine nature with Puebloan beliefs, and it seems likely that Dasburg fostered in some way Hogue's meeting with the Taos elder. Hogue to Alfred Frankenstein, May 28, 1944, Hogue Papers, box 2, folder 2. For Hogue's experiences in Taos see DeLong, *Nature's Forms,* 10–16, and Randy Leffingwell, *The American Farm Tractor* (Osceola, Wisc.: Motorbooks International, 1991), 103.

13. This interpretation is supported by Hogue's *Grim Reaper* (1932), which depicts "a wheat-haired human face" symbolizing "a death in nature itself, brought about by greedy, voracious plows of profit-conscious farmer." There Hogue fused a personification of the land with that of the wheat farmer to suggest both human negligence and nature's wrath (see DeLong, *Nature's Forms,* 100). Hogue never transferred the drawing to paint, because he decided to work with "a less surrealistic attitude"; see Hogue to Alfred Frankenstein, April 19, 1973, Hogue Papers, box 2, folder 4.

14. Archibald MacLeish, "Grasslands," *Fortune,* November 1935, 187–88.

15. Donald Worster, "The Dirty Thirties: A Study in Agricultural Capitalism," in *Americans View Their Dust Bowl Experience,* ed. John R. Wunder, Frances W. Kaye, and Vernon Carstensen (Boulder: University Press of Colorado, 1999), 359 (originally published in *Great Plains Quarterly* 6 [Spring 1986]: 107–16); Donald Worster, *Dust Bowl: The Southern Plains in the 1930s* (Oxford: Oxford University Press, 1979), 59. Rick Stewart has interpreted Dozier's *The Annual Move* as a "reassuring survival of tradition and continuity in such an uprooting" (*Lone Star Regionalism,* 63). The image seems far more complex, however, and deserves further attention.

16. Hogue to Thomas Beggs, February 8, 1946, Hogue Papers, box 1, folder 10.

17. The identification of the tractor as an F-20, which was produced between 1932 and 1940, is based primarily on the position of the engine and wheel configuration.

18. Carey McWilliams, *Ill Fares the Land* (Boston: Little, Brown, 1942), 218, 220, 222.

19. WPA supervisor quoted in McWilliams, *Ill Fares the Land,* 226; DeLong, *Nature's Forms,* 19.

20. Finis Dunaway, *Natural Visions: The Power of Images in American Environmental Reform* (Chicago: University of Chicago Press, 2005), 49.

21. John Steinbeck, *The Grapes of Wrath* (1939; New York: Penguin, 1992), 49, 44.

22. Ibid., 48, 110.

23. Hogue to Matthew Baigell, June 14, 1967, Hogue Papers, box 2, folder 1.

24. Frederic E. Clements and Ralph Chaney, *Environment and Life in the Great Plains,* rev. ed. (Washington D.C.: Carnegie Institution, 1937), 51.

25. Aldo Leopold, "The Conservation Ethic," *Journal of Forestry* 31 (October

1933): 635; Paul Sears, *This Is Our World* (Norman: University of Oklahoma Press, 1937), 278.

26. Hogue to John O'Connor Jr., August 29, 1938, Hogue Papers, box 2, folder 2.

27. MacLeish, "Grasslands," 186–88.

28. Ibid., 62, 67, 203. MacLeish would revisit the theme of an injured earth in his celebrated book *Land of the Free*. This "book of photographs illustrated by a poem" used documentary photographs from organizations such as the Farm Securities Administration Historical Section in order to question American notions of progress. On page 42 he included a photograph from the Tennessee Valley Authority titled "'A Bleeding Hillside'—Newly Plowed Land in a Virginia Valley after One Hour of Rain." The image of extreme erosion echoed many of the photographs included in "Grasslands."

29. Steinbeck, *Grapes of Wrath,* 37.

30. MacLeish, "Grasslands," 60.

31. Lookingbill, *Dust Bowl,* 31.

32. Hogue to Beggs, February 8, 1946, Hogue Papers, box 1, folder 10.

33. Andrew Wilton and Tim Barringer, *American Sublime: Landscape Painting in the United States, 1820–1880* (Princeton, N.J.: Princeton University Press, 2002), 93. Also see William H. Truettner and Alan Wallach, eds., *Thomas Cole: Landscape into History* (New Haven: Yale University Press and Washington, D.C.: National Museum of American Art, Smithsonian Institution, 1994); J. Gray Sweeney, "'Endued with Rare Genius': Frederic Edwin Church's *To the Memory of Cole,*" *American Art* 2, no. 1 (1988): 44–71.

34. Stewart, *Lone Star Regionalism,* 69. Like Dozier's *The Annual Move,* Lester's *The Three Crosses* clearly deserves further attention. James C. Malin was the first to argue that pioneers were responsible for the Dust Bowl and that a knowledge of progressive agriculture and the specific environmental conditions of the prairies would help remedy the damage caused by this earlier agricultural generation. See Malin, *The Grasslands of North America: A Prolegomena to Its History with Addenda* (Lawrence, Kans.: Privately published, 1947). It is possible, however, that Lester beat him to the punch.

35. White, "Historical Roots," 1206.

9

The Sumptuary Ecology of Buckminster Fuller's Designs

Jonathan Massey

Sustainable design—the art of designing buildings, cities, and other artifacts so that they meet current needs without jeopardizing the ability of future generations to meet their needs—is one of the fastest growing areas of design practice and education. By increasing the efficiency of human resource use, more and more designers are working to reshape contemporary society along economically, socially, and ecologically sustainable lines.

There is no more important precursor to today's sustainable design movement than R. Buckminster Fuller (1895–1983), the designer, philosopher, and educator best known for developing the geodesic dome. Though not an architect, Fuller concentrated his energies on the design of shelter, beginning in the 1920s with proposals for industrially manufactured housing, and continuing in 1950 through his invention of geodesic construction, extending to visionary proposals for the reorganization of entire cities. More than any other twentieth-century figure, Fuller approached modern architecture as an ecological technology. Keenly aware of both the vast resources in the earth's ecosystem and the limits to human population growth and prosperity posed by inefficient mechanisms for extracting and using those resources, he strove to rationalize resource use for maximum human benefit. By treating buildings as "environmental valves" efficiently regulating transmissions of energy, light, air, moisture, and information between their occupants and the external environment, he sought to optimize the quality of human life for as many people as possible.[1]

Fuller's practice of ecological design emerged from his lifelong confrontation with dilemmas of economic organization and political representation posed by industrialization—in particular, his belief that the ecological limits to human population growth necessitated technological, social, and political

changes on a global scale. Preoccupied with the Malthusian principle that population grew faster than did supplies of food and other necessities, Fuller traced antagonisms of all kinds to the struggle for access to scant resources. In his analysis, virtually all social ills—from deprivation and disease to class division and war—were caused by Darwinian competition. Yet nature was bountiful, Fuller felt, and human intellect was a resource of infinite potential. If technological innovation could increase productivity exponentially by "doing more with less," outputs could outstrip population growth. By intensifying the industrialization of production, technological innovation could create an economy of sufficient abundance to diminish, or even to eliminate, the sources of strife.[2]

Fuller situated human society within a universe constituted by dynamic energy flows, treating science as the identification of natural principles and industry as the application of those principles for human purposes. His view of industry was shaped by the ideas of friends and contemporaries in the technocracy movement, an intellectual and political movement that sought to place engineers and other technical experts in charge of production and consumption decisions. While new industrial methods yielded productive capacity sufficient to create an economy of universal abundance, technocrats argued, this potential was withheld by outdated and inefficient political, financial, and managerial practices. Technocrats aspired to eliminate the social unrest arising from scarcity and resource competition by establishing a centralized command economy to coordinate production and consumption. They believed that top-down rationalization would yield social harmony through what one leading technocrat called "the organization of human affairs in harmony with natural laws."[3]

Like the technocrats, Fuller believed there was one optimal solution for economic and social organization at any given time—"one best way" to do things, in the evocative phrase of efficiency engineer Frederick Winslow Taylor, who had helped Henry Ford develop the automated assembly lines that produced the Model T. Echoing the analyses of Thorstein Veblen and other technocrats, Fuller argued that the rationalization of industrial production along optimal lines was thwarted by "vested interests": managers, financiers, and politicians who benefited from systemic inefficiencies. Scarcity-driven strife—which for Fuller encompassed not only war and class conflict but also the tensions between husbands and wives and parents and children—could be eliminated only by liquidating these "feudal" obstacles. Industrial

production required centralized decision making if it were to realize fully the efficiencies promised by mass production.[4]

Yet, while Fuller shared the technocratic conviction that there existed only "one best way" to organize society for maximum production, he was too much of a libertarian to accept the autocratic solution technocrats proposed. Convinced of the ethical and practical superiority of democratic governance and market economies to autocracy and Soviet-style command economy, Fuller insisted on seeking solutions that preserved, and even enhanced, individual autonomy.

To resolve this dilemma, Fuller conceptualized design as the art of reconciling systemic rationalization with individual initiative. He pursued a strategy of market-based social reform by designing standardized solutions to problems of housing, transportation, and resource use—solutions that would rationalize society incrementally as individuals voluntarily purchased these superior products. Fuller's slogan was "new forms rather than reforms." Rather than try "to reform man," he later recalled, "what I would do was try to modify the environment"—the realm of built artifacts that mediated the relation of individuals to one another and to the natural world—"in such a way as to get man moving in preferred directions."[5]

In accordance with this principle, Fuller set out to create "a whole new world industry concerned only with man's unavoidable needs and implementation of his inherent freedoms." Through design, he aspired to reorganize the "mechanical arrangement" of society so that individual selfishness would make the individual "inadvertently selfish for everyone,—for interactive life in toto" in a kind of "universal selfishness." By leveraging resources more efficiently and by reshaping patterns of human resource use through noncoercive means, Fuller sought to rebalance production and consumption in sustainable terms.[6]

The first stage of Fuller's "new world industry" was a manuscript and house design he developed in 1928. The *Model of the Dymaxion House* and the *4D Time Lock* manuscript that accompanied it established many of the principles that would characterize Fuller's subsequent work. They were essential precursors to many of his later projects, including not only his geodesic domes but also a series of "Geoscopes," large terrestrial globes furnished with layers of economic, demographic, and sociological data designed to help guide policy decisions at the individual and social scales. The project of using design to reconcile conflicting imperatives and rebalance the in-

dustrial economy that originated in the Dymaxion House and continued in the geoscopes culminated in Fuller's most prominent built work: the United States Pavilion at Expo 67 in Montreal, Canada. In the process, Fuller developed a full ecological analysis of industrial society and its architecture. The U.S. Pavilion, which combined geodesic construction with innovative automatic climate-control systems, was the first full-fledged attempt to build a large-scale ecologically sustainable building, and it continues to serve as a reference point for sustainable design.

From the beginning of his career, Fuller took nature as both a source of efficient solutions and a desirable environment for family life. As he refined his ideas and designs from the 1930s through the 1960s, he increasingly turned to ecology for a model of symbiotic mutuality that promised an alternative to competition and conflict. Because they aligned abundance and social harmony with cooperative rather than competitive practices, ecological ideas were rhetorically effective in Fuller's promotion of new design solutions. Ecological rhetoric furnished his agenda with a sumptuary discourse—a discourse distinguishing luxuries from necessities in order to regulate individual consumption—that legitimized radical changes in social organization.[7]

The novelty of geodesic construction, combined with Fuller's practice of patenting his designs, initially led many architects and members of the general public to see his work primarily as a series of structural innovations and mechanical inventions. The rise of sustainable design during the late twentieth century, however, has stimulated revisionist accounts reconstructing the full extent of Fuller's social and ecological vision. This reassessment has gained momentum from the acquisition of the voluminous Fuller archive by Stanford University, which has cataloged the collection and made it more broadly available to researchers.

These archival materials shed new light on the extent of Fuller's struggle to reconcile technocratic principles with practices of democratic governance and market economies. They also reveal that his work had highly personal motivations. Though it addressed matters of broad public concern, Fuller's work was stimulated by private dilemmas, in particular his struggle in the 1920s to live up to his ideals as a son, husband, and father. By drawing on archival materials to examine the genesis of Fuller's first major project, the Dymaxion House, this essay helps to clarify the interaction between personal and political motivations in Fuller's turn to ecological principles to frame his ideas and designs. It highlights the unrecognized sumptuary dimension of Fuller's work—his use of design to regulate consumption in the service of

particular social and political goals. Reconstructing the modernist ecology of the Dymaxion House and the later projects that stemmed from it, in turn, reveals the sumptuary premise of today's sustainable design movement.

Natural House

Over the course of several months in 1928, Fuller outlined a system of industrialized housing that promised to transform human society by systematically reducing waste. In May of that year he privately published these ideas in a manuscript called *4D Time Lock,* which combined attributes of philosophical treatise, mystical statement, reform manifesto, and business prospectus. *4D Time Lock* outlined Fuller's vision of a world integrated by increasingly efficient manufacturing and transportation systems that would free up time, energy, and material so that families could enjoy lives of nomadic leisure. The manuscript invited readers to invest in a company, called the 4D Control Syndicate, dedicated to manufacturing and renting prefabricated houses.

While writing *4D Time Lock,* Fuller developed designs for lightweight metal dwellings suitable for mass production. Many of his sketches featured multistory apartment towers in which hexagonal floors hung from cables affixed to a tall central mast. Others showed a single-family version consisting of just one of the floors suspended above an open carport or patio, its roof serving as an elevated deck (fig. 37). These designs were inspired by many sources, including pagodas, nineteenth-century octagon houses, lighthouses, transmission towers, and the recent residential designs of Swiss architect Le Corbusier, whose houses were sometimes raised on columns, topped by roof-decks, and equipped with horizontal window bands. They owed as much to the design and technology of ships, automobiles, and airplanes, however, as to architectural precedents. Fuller's central masts and tension cables were modeled on the masts and rigging of sailboats, while his lightweight aluminum frames and enclosures were based on airplane construction. The promotion of a standardized solution, in turn, was inspired by the Model T. As Fuller asserted in a Taylorist flourish, "the house and all its functions," like the Model T, were "material and therefore solvable in but one best way."[8]

Fuller called this family of industrially mass-produced designs "4D housing," after the fourth dimension, because they applied to production, distribution, and use of the house Taylor's principle that time management was the

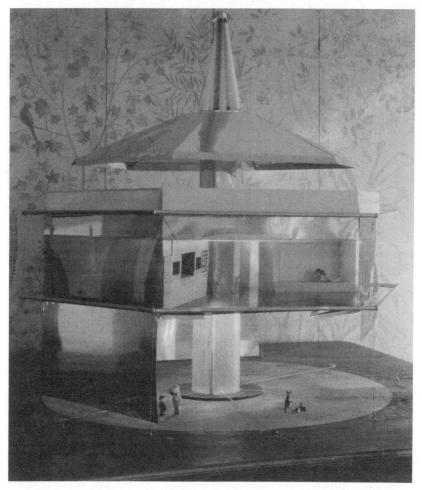

37. R. Buckminster Fuller, *Model of the Dymaxion House,* ca. 1929. Courtesy, The Estate of R. Buckminster Fuller.

key to efficiency increases. A 4D house could be manufactured with unprecedented rapidity and transported easily from factory to dwelling site. The compact radial plan was supposed to reduce the time it took occupants to move about the house, as well as to clean it. Like refrigerators and cars, the house was to be a consumer product with a limited lifespan, frequently replaced as innovation rendered it obsolete.[9]

Unlike Henry Ford's automobiles, Fuller's houses never went into production. But, like the Model T, the 4D house would have exploited mass-

production economies of scale to give middle-class consumers a new degree of mobility and independence from local bonds and associations. Airlifted from factory to building site by dirigible, its mast anchored in a bomb-crater excavation, this "autonomous dwelling unit" would be installed wherever its nomadic family found the best opportunities for work and leisure. Air deliverability was essential to Fuller's plan because his goal was to liberate families from dependence on electrical and gas networks, water supplies, sewer systems, and roads, as well as the financial systems, such as mortgage loans, that bound individuals in a modern form of serfdom. In Fuller's imagination, mobile dwellings would stabilize the economy and eliminate neofeudal bonds by creating a self-regulating labor market in which workers followed jobs. The state would dissolve into a self-optimizing industrial economy in which consumers dealt directly with transnational corporations.

Concerned about protecting his ideas pending word on the patent application he had recently filed, Fuller omitted from printed copies of *4D Time Lock* the drawings he had made of his house designs. But the full-page frontispiece of the original manuscript (fig. 38) thematized the global mobilization that 4D housing would engender, along with the easing of social tensions that Fuller thought would result. This full-page drawing is filled by the globe, shown from a high angle that places the North Pole at upper center. Airplanes and blimps buzz around the planet, scattering dwelling towers across its surface at such remote locations as Greenland, Alaska, the Sahara, and the Amazon basin. A spindle and flange at the pole evoke the spindle of a desk-mounted globe and Fuller's housing towers, as well as the combination lock dial that floats directly above. Handwritten lines at bottom left note: "The whole of the human family could stand on Bermuda[.] All crowded into England they would have 750 sq. feet each[.] 'United we stand, divided we fall' is correct mentally and spiritually but fallacious physically or materially. 2,000,000,000 new homes will be required in next 80 years." The message is clear: 4D housing is the key to unlocking the earth's bounty by rapidly dispersing the world's population across the full extent of its land surface. A companion drawing that served as title page bore the following legend: "4D TIME LOCK, in which the great combination is revealed if thoughtfully followed in the order set down; awaiting the click at each turn."[10]

Though these and other drawings emphasize multistory apartment towers, Fuller concentrated on developing his one-story version so that it could compete in the large market for single-family houses. He divided its floor plan into four equally sized triangular rooms (two bedrooms, each equipped

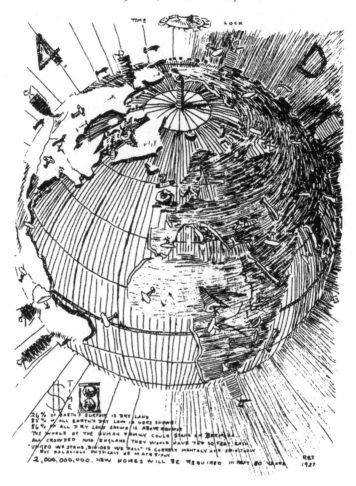

38. R. Buckminster Fuller, frontispiece drawing for *4D Time Lock*, 1927. Ink on paper. Courtesy, The Estate of R. Buckminster Fuller.

with its own tiny bathroom; a kitchen and utility room; and a library) and a large rhomboidal living room, and he added secondary features such as exterior louvers and built-in furnishings and appliances. Fuller called the library the "go-ahead-with-life room" because it included a desk outfitted with drawing board, filing cabinet, safe, map and globe storage, and revolving bookshelves, along with typewriter, phonograph, motion picture machine, dictaphone, and a telephone receiver and transmitter. By updating the Victorian library with this range of modern media, Fuller turned it into some-

thing combining the attributes of classroom and theater with those of the bridge and plotting room of a ship. The media-intensive "go-ahead-with-life room" would both compensate for the isolation of the house's globe-trotting occupants and help them plot their course in both space and time.

In 1929, with the help of an advertising consultant, Fuller renamed his product the Dymaxion House, employing a contraction of "dynamic" and "maximum" to evoke the Taylorist principle of continual productivity increases. To better promote the product, he built large-scale models for display in department stores, restaurants, and other sites of consumption. Figure 37, a photograph of one of these models, not only shows the form, construction, and furnishing of the Dymaxion House but also stages a striking vision of the family life the house was intended to foster. The model is set on a drop-leaf table before a wall papered in a botanical print, the jambs and hinges of a closet or service door visible but unobtrusive, washed by daylight from an unseen window. This domestic setting—most likely the Long Island dining room of Fuller's in-laws—is quite different from the domestic interior presented in the model, but the contrast reduces the strangeness of the Dymaxion House, reassuringly domesticating its novel form, material, and construction. Tiny figurines occupy the model, a toddler and an older boy standing together on the patio below the house not far from a group of sitting and lying dogs. The grasses, ferns, branches, leaves, and flowers of the wall behind suggest a temperate environment of plants and young trees, while a single wild bird perched just above and behind the roof terrace complements the human occupants of the house and their domesticated animals. The industrialized house, the photograph suggests, promises to realize the suburban dream of the middle-class family living in harmony with nature. Only one thing disturbs this idyll: upstairs in the living room, mother lies naked on the built-in couch. Propped on her elbows, one leg crossed over the other to accentuate her curves, hair flowing back from her raised head, she looks out at the camera's lens. Father is nowhere to be seen.

Pastoral yet eerie, this scene combines the gender segregation of middle-class Victorian society (father at work downtown, mother and children at home in the suburbs) with an un-Victorian sexual suggestiveness. Of course, the naked woman in the living room evokes Fuller's emphasis in *4D Time Lock* on the comfortable pneumatic furniture and perfectly tempered climate provided by his house, her leisurely posture suggesting that the labor-saving features of the mechanized house have freed her from drudgery for more stimulating pursuits. Yet, the directness of her gaze and the displace-

ment of her nakedness from bedroom to living room also suggest a disruption of conventional libidinal boundaries. Alone in the woods, she wantonly exhibits herself to the viewer through the giant horizontal window, perhaps in the hope of attracting a replacement for her absent husband.

The tension between containment and liberation, domesticity and desire, evoked by this photograph recurs in other photographs Fuller staged during the same period, such as one that features three naked female figurines in the living room facing a standing man in a business suit. These uncanny scenarios remind us that their creator had an unconventional and fraught family life of his own. In fact, though it expressed the ambition of improving the quality of life for all people, Fuller's development of the Dymaxion House project was spurred by the tensions in his own personality between appetite and duty.

Fuller married Anne Hewlett, daughter of prominent New York architect James Monroe Hewlett, in 1917, and their daughter Alexandra was born the following year. In 1922, Fuller and his father-in-law co-founded Stockade Building System, a company that built houses using a patented construction system. Fuller idealized his wife and daughter, but he spent much of his time living apart from them in hotel rooms, working by day yet drinking, gambling, and carousing by night. Alexandra died of polio in 1922 during one of her father's absences. Though Anne gave birth to a second daughter, Allegra, five years later, Alexandra's death haunted her father.

Fuller's writings confirm that his personal experience of marriage, fatherhood, and domesticity was integral to his architectural work. An early version of *4D Time Lock* contains an extended self-examination (cut from the printed version) in which Fuller berates himself for his failure to live up to the noteworthy ancestors in his distinguished New England family, honor his wife, and care for his first child. In subsequent autobiographical accounts, Fuller explained that his invention of the Dymaxion House was spurred by a personal crisis. In late 1927, not long after Allegra's birth, Fuller was fired from Stockade when his father-in-law was forced to sell off part of his controlling stock share. Late one night, as he contemplated suicide because of his shortcomings as a son, husband, and father, Fuller experienced an out-of-body revelation. A voice proclaimed it Fuller's duty to devote his knowledge and ability not merely to gratifying his own desires or feeding his family but to serving "the highest advantage of others." Fuller followed this oracular command by embarking on his campaign to industrialize the housing field.

While Fuller simplified and distorted the details of this narrative over many retellings, his letters and other documents of the 1920s and early 1930s show that these were years during which the pleasures of drinking, carousing, and an extramarital affair caused him great anxiety and emotional turmoil. Channeling his frustration and self-hatred into an intense productivity, Fuller devoted himself to reforming society by eliminating the "chaos" caused by waste, scarcity, and war, which denied men, women, and—most painfully—children the benefits of the scientific and industrial revolutions.[11]

This context suggests an explanation for the strange scenarios Fuller envisioned for his Dymaxion House. What if a house could reconcile home with travel, domesticity with worldliness, and constancy with variety? Fuller created the Dymaxion House in order to transcend the conflicts he and others like him experienced between the requirements of work and family, between duty and desire. Projecting his commitment to personal reform outward onto the society around him, Fuller set out to redeem himself by saving children and families through better house designs.[12]

In this project, nature represented the source of bounty, the paradigm of efficiency, and the model of harmonious estate. Fuller held a transcendentalist view of nature derived from the ideas of Ralph Waldo Emerson and the example of his great-aunt Margaret Fuller Ossoli, a friend of Emerson's who had collaborated with him to publish *The Dial* magazine. Like these predecessors, Fuller invested nature with religious feeling. While John Ruskin, William Morris, and other nineteenth-century thinkers had seen industrial society as an unnatural system that alienated its members from communion with nature, Fuller saw no such conflict. "Man is the arch machine," Emerson had written in 1860. "He helps himself on each emergency by copying or duplicating his own structure, just so far as the need is." Fuller brought a similar conviction to his own work. "Nature, or the material world of God," he explained, "has in the course of time solved every mechanical problem" by segregating and solving functions. "Slowly nature has centralized production through industry, and taken the one best mechanical way of doing something . . . and made it available to all who will." In designing the Dymaxion House, Fuller translated some of nature's ideal solutions into architectural terms. He compared the central mast and underground foundation of the house to the trunk and roots of a tree; associated its radial structure and plan with radial patterns in nature, such as the ripples created by the impact of a stone in water; and likened its pneumatic furniture and floors

to "the life cell . . . , a globule in which elements in their liquid and gaseous states are compressively enclosed by elements in their solid and tensed state." Industrializing the house, Fuller believed, would bring it closer to nature.[13]

Disciplining desires—his own and those of others—was a major preoccupation for Fuller, who characterized his entire career as a series of "self-disciplines" of broadening scope. In Fuller's representations of the house, as we have seen, nature served as a positive inducement to buyers to embrace this industrial product. But nature also played a regulatory function. Like Henry Ford, who famously said that the customer could have any color Model T as long as it was black, Fuller took a restrictive approach to variety in housing design. In his view, the greater human freedom permitted by technological improvement more than offset the limits to individual choice entailed in the standardization of housing. Freed from the necessity of working by increasingly efficient industry, and freed from the burdens of housekeeping by the rationalized house, women and men would find themselves with copious time for creative pursuits. The 4D House, Fuller predicted, would become "a place in which to live free from worry, free to explore, free to devise, include, refine, free to compose and synchronize."[14]

This sumptuary trade-off extended to other areas of consumption, too. Fuller anticipated that his house design would change its occupants' purchasing patterns in other economic sectors as well. In *4D Time Lock* he recounted his visit to the opening of a new Woolworth store in Chicago. The eagerness with which customers purchased frivolous items at the five-and-dime, Fuller explained, was "a result of a starved and 'don'ted' childhood in too close living quarters, with no other outlet for activity, amongst people whose minds have been purged of creative thought, as children." 4D housing would rationalize consumption by eliminating purchases Fuller considered wasteful and viewed as sublimated expression of creative energies stunted by childhood deprivation. "All the junk and temptation with which our store windows are crammed, furniture dealers, picture dealers, bird cage dealers, etc., etc.," he asserted, "will vanish with 4D housing established." Instead of these "time wasting" objects, people would purchase the instruments of creativity: "Photographic supplies, sports equipment, tools, laboratory equipment, musical instruments, art supplies and any adjunct of creative or rhythmical activity will ever increase in sale." Fuller's industrial shelter service was a project of sumptuary regulation designed to change behavior not only in housekeeping and child rearing but also in home decorating, furnishing, and consumption more generally. It is not accidental that the unique triangular

module of the 4D House, like its extensive array of built-in furnishings, left little room for occupants to add home furnishings and decorative accessories expressing their personal taste. Fuller's design redefined personalized decoration as wasteful consumption.[15]

The intrusive nature of Fuller's sumptuary vision emerges with particular force in a passage on "Fuller's Law of Economics" in an early draft of *4D Time Lock*. This section suggests that individuals should receive monetary credit to the extent that their work saves time for others, but that, conversely, they should be charged for any indulgence of personal appetite lacking a socially redeeming purpose. Fuller called such self-indulgence "bestial" and associated it with the stomach. He envisioned his 4D world operating according to a "specific economy" of moral behavior that punished selfishness but rewarded the practice of working toward "acquisition of harmony." Through a complex reward structure akin to the tax code, Fuller hoped to reshape the time use and consumption patterns of a whole society. "When we have learned complete mastery of our selves to the extent of complete unselfconsciousness and unprocrastination in fulfillment of true duties as revealed," he explained, "then we can control all other matter." It was just a matter of "licking the bestial self."[16]

Political Ecology

Fuller's idea that redesigning the home could reform the lives and familial relations of its inhabitants had roots in Enlightenment social and architectural theory, but it was closer still to Victorian environmentalism—the conviction that redesigned houses and cities could morally reform their inhabitants. In the years following his development of the Dymaxion House, Fuller's attention to the ways the physical environment shapes the relations among people developed into a full-blown vision of how industrialized housing could reorder human society along ecologically sustainable lines. In this evolution, the globe, previously a figure of liberation, began to serve as the figure of limitation as well—as when Fuller coined the term "spaceship earth" to emphasize the precariousness and small scale of the environment capable of sustaining human life. The globe came to symbolize the promise of better living through the acceptance of limits to consumption—one of the axioms of sustainable design.

Ecology furnished Fuller with a way of reconciling his commitments to both optimization and self-determination by suggesting that the pursuit of

self-interest could lead not to a Hobbesian war of all against all, but to synergies that benefited the whole society. (He would later develop a philosophy he called "synergetics," another contraction of keywords, combining "synergy" with "energetics.") In 1942, while working for the Industrial Engineering Division of the U.S. Board of Economic Warfare, Fuller envisioned the transcendent potential of global human collaboration in a treatise outlining ways to achieve "a workable system of mutual survival" among individuals and societies once World War II had ended. His manuscript, titled "Motion Economics and Contact Economies," envisioned a technocratic science of "Dymaxion economics" progressively optimizing energy and resource use to achieve unprecedented efficiency, as well as a series of rationalized local "contact economies" growing into a World Energy Commonwealth that would supersede national sovereignties.[17]

The "contact economies" Fuller outlined in "Motion Economics" reflected an organicist social vision in which ecological concepts justified the elimination of individual property ownership. Fuller characterized all wealth as ultimately solar, since fossil fuels and other natural resources were "storable increments" of converted solar energy. On this basis, he argued that all energy sources were the common property of humanity and should be socialized for technocratic use. Rather than seize property through nationalization, however, contact economies would progressively increase their regulation of all stored energy resources, whether in the form of fossil fuels, minerals, metals, or biological resources. Limitations on private enterprise would gradually eliminate "inorganic proprietorship" in favor of "advancing socialization."

Industrialization, Fuller argued, unleashed energies too intense for private harness. Comparing the individual to a fuse or filament, Fuller warned that the energy current of industrial society was so intense that it would "burn up the individual" or any other "minor group" that tried to claim "title to articulation, transmission, or confinement of its organic potential." Consequently, industrialization dictated ecological social integration. "As man harvests principles of energy control and induces them into his survival system, calling the result industry," Fuller wrote, "he himself becomes a part of that new interdependent microcosmic energy gestating system within the greater universe of totally interdependent systems." Society would come to resemble "the floral kingdom," he explained, "not an aggregate of a myriad of individually struggling species, but an interactive supporting team or community of species whose distribution, conversion, and relay of original sun energy by

action mechanics and reaction chemistry [is] totalized to advance the survival probability of the whole." Fuller mobilized ecology to describe nature as a pastoral system of symbiotic mutuality.

Much as Fuller saw industry as the exploitation of natural principles, he characterized democracy as "a dynamic principle of nature" analogous to gravity. In an essay titled "Democracy Is a Principle" (1948), Fuller called democracy the "synchronous coordination of dynamic complexities" and "an effective means of satisfactory coexistence of the many." He asserted that humanity had recently exceeded the planet's "environmental limits," necessitating the global solution of "world, or total, democracy." Fuller developed a global ecological perspective in order to persuade potential customers to choose standard solutions that optimized planetary resource use.[18]

In order to globalize democracy while rationalizing human resource use on a planetary scale, Fuller sought ways to scale up the advantages of the Dymaxion House. His continuing experimentation with triangulated construction, for instance, resulted in 1950 in the first of his many designs for geodesic domes, lightweight semi-spherical shells that could enclose large volumes of space with minimal material, cost, and time. The go-ahead-with-life room, meanwhile, served as prototype for a series of navigational facilities designed to steer larger entities. In 1932, Fuller and some associates published a design for a "Conning Tower for industrial navigation," a media-intensive situation room designed to furnish the leaders of a corporation or other large organization with a panorama of up-to-the-minute data on the basis of which to chart the most rational course through the rough seas of the disorganized global economy. Throughout the 1930s, Fuller compiled clippings and facts to serve as the basis for economic and demographic analysis and prediction, drawing on this growing database to develop a set of "Dymaxion charts for economic navigation" that distilled long-term trends and patterns. He highlighted the value of such information not only to individuals and corporations but also to whole societies in making decisions about how to allocate resources in the complex industrial era. Evoking the plotting room of a battleship, where both the ship's navigational course and the trajectory of its missiles were plotted, Fuller called such anticipatory planning "shot-calling." During World War II he argued that Dymaxion data could help corporations and government agencies plot a course capable of preserving democracy from the assault of "social progress enemies," including not only market fluctuations but also the military assault of the Axis powers.[19]

In 1943, at the height of the war, Fuller published the first version of a

new method for mapping the globe as a cartographic basis for "shot-calling" both literal and figurative. By projecting the globe onto an icosahedron, then unfolding the twenty triangular facets of this Platonic solid, the Dymaxion Airocean Map minimized the visual distortion that plagued maps made using other projection techniques. More importantly, it created a decentered, reconfigurable map that could be used to study trajectories that were hard to plot on the conventional Mercator projection, such as bomber trajectories across the North Pole. By publishing a cutout version in *Life* magazine, Fuller put this new navigational tool at the disposal not only of the military forces but also of everyday consumers who might use it to start calling the shots in their own lives.

While the go-ahead-with-life room had been designed for use by a single family, and the Conning Tower for perhaps a dozen people, Fuller sought ways to make crucial data available to the large populations of democratic societies. In "Democracy Is a Principle" he asserted that industrial North America needed "first and foremost a means of direct daily expression of its will." He proposed "electronic hookup of democracy by wire and walkie talkies" or high-frequency transmitters so that the public will could be continually assessed on questions not only of governance but also of investment allocations and production decisions. By providing feedback on current policies, the Dymaxion charts and map would furnish such an "electronically operative democracy" with comprehensive and accurate information sources on the basis of which to plot a collective course.[20]

In the 1950s and 1960s, Fuller prototyped larger-scale, more ambitious feedback systems derived from the Dymaxion House and the Conning Tower. In collaboration with artist and futurist John McHale, as well as with students at American and British architecture schools, Fuller designed a series of geoscopes, large occupiable globes displaying geographical, climatological, and sociological data. Presented on triangular acetate sheets based on his Dymaxion Airocean Map, these data formed a comprehensive panorama of global distributions of people, resources, and needs. Updated periodically, these displays could not only show present conditions but also track backward or forward in time to analyze historical events or project the scenarios that would result from present-day policy decisions. By demonstrating the interconnection of phenomena at a planetary scale over long time spans, the geoscopes challenged citizens to find better ways of matching resources with needs. Fuller's geoscopes were elaborate, public-access versions of the earlier go-ahead-with-life room and Conning Tower, outfitted with updated

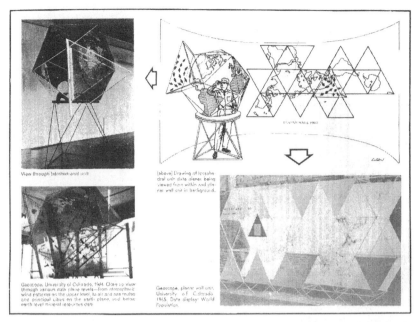

39. Drawing and photographs of a small icosahedral geoscope built by University of Colorado students working under the direction of John McHale in 1964. Published in John McHale, *World Design Science Decade 1965–1975 Phase I (1965) Document 4: The Ten Year Program* (Carbondale: World Resources Inventory, Southern Illinois University, 1965). Courtesy, The Estate of R. Buckminster Fuller.

charting techniques so that democratic populations could deliberatively engage in collective "shot-calling."

Most of the geoscopes that Fuller, McHale, and their associates built were stationary geodesic spheres around twenty feet in diameter, anchored to footings on the ground or on rooftops. An unusually small, portable version that McHale built with students at the University of Colorado in 1964 (fig. 39) better represents the concept, though, because, unlike its larger cousins, it received its full data skin. The Colorado Geoscope was an icosahedral frame of slender metal struts joined by circular hubs, each of its triangular faces clad with layered acetate sheets bearing different types of data. Since they were clipped to the frame between layers of clear Plexiglas, these transparencies could be added, removed, or recombined at will to highlight different relationships among data sets. Extension struts allowed users to add still more layers should they desire to focus on a particular area of the globe, and

the whole data panorama could be removed from the globe and clipped to a vertical surface should they desire to see the planetary surface unfolded as a flat Dymaxion map.

In drawing the Colorado Geoscope for publication, McHale and his students highlighted not only its capacity for transformation from globe to map but also the unique view afforded from the interior of the icosahedral construction, suggested by a man shown adjusting his eyewear while standing inside the device. Fuller frequently emphasized the "quick comprehensive survey" and sense of "cosmic orientation" provided by looking out through the Geoscope skin, suggesting that the experience would lead the observer to see "the whole pattern" of the planet and grasp the significance of that pattern for his or her conduct of life. In this way, as Fuller explained in 1955, these devices would help humans understand "the unprecedented, emergent, integrating, synergetic patterns" of global society and initiate "the comprehensive new strategies appropriate to forwarding human welfaring processes." In one proposal, Fuller called for a Minni-Earth Geoscope (*sic*) to be erected above Blackwell's Island in New York's East River, across from the United Nations headquarters. By confronting UN delegates with comprehensive representations of global demographic scenarios, he hoped to change the voting patterns of this international governing body. The Geoscopes promised to reshape individual and collective decisions about resource consumption in socially constructive ways by helping their users develop a keener perception of their involvement in planetary ecologies.[21]

Technocratic Planet

Fuller's geoscope work culminated in a proposal to the United States Information Agency (USIA), the State Department division responsible for international public relations, for the construction of a giant geoscope to represent the United States at the world's fair planned for Montreal in 1967. Invited by USIA to develop a vision for American representation at Expo 67, Fuller teamed with McHale and architect Shoji Sadao to propose a giant geoscope alerting the world public to long-term trends that threatened its survival, such as patterns of inequality in access to key resources. In the initial design, a rectangular space-frame resting on four giant piers was to shelter a large unfolded geoscope instrumented with computer-controlled display capabilities. Visitors would use computer consoles on a perimeter balcony to play the World Game, a multiplayer strategy game that used the Dymaxion Airocean Map to dramatize long-term planning of resource use

patterns. Players would develop their own theories of "how to make the to-
tal world work successfully for all of humanity"—how to achieve the kind
of symbiotic coexistence Fuller had envisioned in "Motion Economics." The
computer would answer questions and test proposals against computerized
versions of the Dymaxion files and charts, scoring them based on its data
and projections. "The objective of the game," Fuller and his colleagues ex-
plained, "would be to explore ways to make it possible for anybody and every-
body in the human family to enjoy the total Earth without any human in-
terfering with any other human and without any human gaining advantage
at the expense of another." In another version of the proposal, a giant icosa-
hedral geoscope would be housed within a geodesic sphere four hundred
feet in diameter. Wired with 100,000 tiny lightbulbs controlled by a com-
puter in the dome's basement, and constructed so as to unfold mechanically
into a flat map, the geoscope would display datascapes and animated sce-
narios to Expo visitors using it to play the World Game from a circumferen-
tial balcony.[22]

USIA rejected the geoscope proposal, commissioning another firm to de-
sign a series of exhibitions that promoted American popular and consumer
culture, but it did hire Fuller and Sadao to design a geodesic dome similar
to the one they had proposed. The resulting pavilion, a geodesic hemisphere
atop ten horizontal rings, translated the organicist social vision of "electroni-
cally operative democracy" into formal and technological terms. By furnish-
ing the dome with automatic and partially cybernetic climate-control de-
vices, Fuller and Sadao created a simultaneously functional and allegorical
representation of how ecological design could help sustain human life.

The dome structure, 250 feet in diameter and 200 feet tall, was made up
of open tetrahedral cells averaging about a meter in depth, and it was clad
with transparent acrylic panels. Motorized triangular roller shades attached
to roughly one third of the interior surface allowed parts of the dome to
be shaded as needed. Controlled automatically by light sensors, the shades
adapted to changing sun conditions, shielding occupants from direct expo-
sure while otherwise maintaining the greatest possible degree of openness.
By combining automated shades with thermostat-controlled conventional air-
handling equipment, the U.S. Pavilion exploited automatic and cybernetic
systems to maintain a consistent temperature while minimizing fossil fuel
use. (Fuller had envisioned the shades linked by central computer control so
that they could all be reset six times per day to track the movement of the
sun, but this more ambitious system was not implemented.) Though its au-
tomated sun-shading system never worked properly, the pavilion was an am-

bitious attempt to replicate the homeostatic mechanisms through which our bodies maintain the stable internal temperature our cells require to survive. In developing the design, Fuller had envisioned an even more ambitious enclosure system, predicting that just as some skin cells are specialized to sense light, sound, or heat, so future geodesic domes would have markedly differentiated cells or "pores." "One could be a screen, others breathing air, others letting light in," he explained, "and the whole thing could articulate just as sensitively as a human being's skin."[23]

The U.S. Pavilion was the first major attempt to construct a systematically rationalized ecologically sustainable building. Its functional organicism made it a compelling prototype for more comprehensive "environmental valves." Fuller envisioned such enclosures allowing "whole future communities" to live in environments hostile to human life, such as the polar regions or the lunar surface. Given the cold war tensions that pervaded Expo 67, it hardly needed underlining that the temperate zones of the planet would be just as hostile to life in the aftermath of a nuclear war. In this context, the form and visual appearance of the pavilion endowed it with a powerful allegorical significance. The partial sphere evoked a satellite or spaceship, a resemblance highlighted by the display of actual spacecraft inside. Its moving triangular shades, meanwhile, produced a range of cloud conditions, as though it were a planet encased in a technological atmosphere. Photographers captured the building at sunrise and moonrise, and they frequently created images that highlighted its resemblance to these celestial bodies. In one such image from the magazine *Paris Match* (fig. 40), the pavilion is shown from below with the Expo monorail—which passed right through the building—emerging at lower left. Its interior platforms and space program exhibits are silhouetted against the triangular facets of the geodesic structure by the rising sun. Whether interpreted as a microcosmic rationalized earth or an interplanetary lifeboat for escaping a dying planet, the pavilion suggested that cybernetic systems could sustain humanity in the face of its possible extinction. It was a vastly expanded version of the Dymaxion House, scaling up the strategies Fuller had developed in 1928 to protect families from the domestic catastrophes of unemployment, infidelity, and bad parenting.[24]

Sustainable Design

Fuller's passion for disciplining his own appetites and redeeming his family life carried over into his work as a lifelong campaign to regulate the consumption of others by reorganizing society's "mechanical arrangement" so

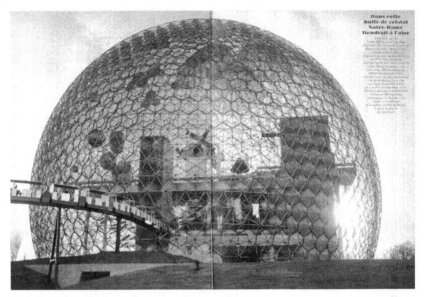

40. Magazine layout featuring the United States Pavilion at Expo 67, 1967. *Paris Match,* May 20, 1967. Courtesy, The Estate of R. Buckminster Fuller.

that individual selfishness would make the individual "inadvertently selfish for everyone." From the start of this campaign, Fuller took nature as a model for architecture and society alike. From World War II forward, ecological thinking gave his sumptuary agenda a powerful new rhetoric.

The sumptuary logic that structured Fuller's work also underlies contemporary sustainable design practice. The U.S. Pavilion that rose over Expo 67 preceded "Earthrise" and "Whole Earth," the photographs of the planet seen from space that have served as icons of the ecology movement from the Fuller-inspired *Whole Earth Catalog* to Al Gore's film *An Inconvenient Truth.* Yet the pavilion's planetary imagery, derived from the Dymaxion House and *4D Time Lock* via the Geoscopes and other projects, helped to establish the strategy of using global ecology to justify changes in individual consumption patterns. As Christine Macy and Sarah Bonnemaison have shown, Fuller's work inspired key figures in younger generations to develop core ideas and practices of the 1970s ecology movement.[25]

The same is true of sustainable design theory and practice. The best illustration is Norman Foster, the leading designer of sustainable buildings, who began collaborating with Fuller in 1968 and has built on Fuller's legacy in numerous high-profile commissions. None of his many buildings has commanded as much attention as the office tower Foster recently designed for

the reinsurance firm Swiss Re in central London. Completed in 2003, the Swiss Re tower is a sophisticated reinterpretation of Fuller's exposition dome, stretched vertically to accommodate the narrow floorplates that command high rents from office tenants. Its double-skin glass enclosure and natural ventilation system have helped to lower the building's energy consumption below even low-energy performance standards.[26] The building deliberately evokes the U.S. Pavilion in its tapering, torpedo-like profile and in the triangular pattern of its exposed structure, which employs geodesic construction principles. Visually striking and formally self-contained, the Swiss Re tower offers a repeatable, potentially generic solution to the type of the sustainable tall office building, drawing on Fuller to make an aesthetically compelling argument for the ecological and social value of technocratic solutions.

Notes

1. For an overview of Fuller's work and a selection of his writings see Joachim Krausse and Claude Lichtenstein, *Your Private Sky*, 2 vols. (Baden: Lars Müller, 1999, 2001). Fuller's discussion of "environmental valves" is in R. Buckminster Fuller, John McHale, Shoji Sadao, Fuller & Sadao Inc., and Geometrics, Inc., *World Resources Expo 67 Exhibit Proposal* (1964), R. Buckminster Fuller Papers M1090, series 18, box 28, folder 10, Department of Special Collections and University Archives, Green Library, Stanford University.

2. Fuller, "The World Game," *Ekistics*, October 1969, 287.

3. Henry L. Gantt, *Organizing for Work* (New York: Harcourt, Brace and Howe, 1919): 17, quoted in William E. Akin, *Technocracy and the American Dream: The Technocrat Movement, 1900–1941* (Berkeley: University of California Press, 1977), 10.

4. For an overview of Fuller's design philosophy see his *Ideas and Integrities: A Spontaneous Autobiographical Disclosure,* ed. Robert W. Marks (New York: Collier, 1963), 9–34. Regarding Taylor see Robert Kanigel, *One Best Way: Frederick Winslow Taylor and the Enigma of Efficiency* (New York: Viking, 1997). Fuller's relation to technocracy is discussed in Karl Markley Conrad, "Buckminster Fuller and the Technocratic Persuasion" (Ph.D. diss., University of Texas at Austin, 1973).

5. Fuller, *Nine Chains to the Moon,* rev. ed. (Garden City, N.Y.: Anchor, 1971), 195. For a longer discussion of the "new forms rather than reforms" principle see Fuller, *Ideas and Integrities,* 9–34; and Fuller and John McHale, *World Design Science Decade—1965–1975. Phase I (1963) Document 1: Inventory of World Resources Human Trends and Needs* (Carbondale: World Resources Inventory, Southern Illinois University, 1963), appendix A, 51ff.

6. Fuller, "Motion Economics and Contact Economies," unpublished typescript (1942), Fuller Papers, Stanford University, M1090, series 8, box 5, folder 5.

7. For a survey of Western sumptuary regulation see Alan Hunt, *Governance of the Consuming Passions: A History of Sumptuary Law* (New York: St. Martin's Press, 1996). Regarding the role of sumptuary regulation in modern architecture see Jonathan Massey, "New Necessities: Modernist Aesthetic Discipline," *Perspecta: The Yale Architectural Journal* 35 (2004): 112–33.

8. Fuller, *4D Time Lock* (1928), 51. Privately published in a mimeographed edition of approximately two hundred copies, the treatise was reissued, with the addition of drawings Fuller made during 1927 and 1928, as *4D Time Lock* (Albuquerque: Lamas Foundation, 1972). Parts of the *4D Time Lock* first appeared in a manuscript titled "Lightful 4D Homes and Housing Projects" (1928), Fuller Papers, Stanford University, M1090, series 8, box 1, folder 5.

9. For a more extensive analysis of the Dymaxion House and the distinctive concept of the fourth dimension that informed its design see Jonathan Massey, "Necessary Beauty: Fuller's Sumptuary Aesthetic," in *New Views on R. Buckminster Fuller*, ed. Roberto Trujillo and Hsaio-Yun Chu (Palo Alto, Calif.: Stanford University Press, 2009).

10. Fuller, *4D Time Lock* (1972), title page.

11. Fuller's autobiographical narrative is related in R. Buckminster Fuller, *Ideas and Integrities: A Spontaneous Autobiographical Disclosure,* ed. Robert W. Marks (New York: Collier, 1963), 30; and Fuller, *Autobiographical Monologue/Scenario,* ed. Robert Snyder (New York; St. Martin's Press, 1980), 35; see also Lloyd Steven Sieden, *Buckminster Fuller's Universe* (New York: Plenum, 1989), chap. 4, "Years of Deterioration." For revised accounts of Fuller's personal history, see Massey, "Necessary Beauty," and the other essays in *New Views on R. Buckminster Fuller* (see n. 9).

12. On Fuller as a "redemptive mechanic" see Conrad, "Buckminster Fuller and the Technocratic Persuasion," esp. 168.

13. Ralph Waldo Emerson, *Essays and Lectures,* ed. Joel Porte (New York: Library of America, 1983), 950; Fuller, *4D Time Lock* (1972), 36; Fuller, *Nine Chains,* 175. Fuller quoted Emerson in many of his writings and included Emerson's "Essays" in a handwritten list of references appended to the *4D Time Lock* manuscript.

14. Fuller with Kiyoshi Kuromiya, *Critical Path* (New York: St. Martin's Press, 1981), ch. 4, "Self-Disciplines of Buckminster Fuller"; Fuller, *Nine Chains,* 17.

15. Fuller to George N. Buffington, August 31, 1928, incorporated into the *4D Time Lock* (1972), 120–48.

16. Fuller, "Lightful 4D Homes," 56–58. Using Henry Ford as an example, Fuller outlined how his system might operate in practice. Assuming that Ford was worth a million dollars a day to the world, he should be compensated at that rate for all time

spent sleeping, eating, exercising, and cleaning himself. Every minute Ford spent "in self indulgence" such as gossip, however, would be debited from his compensation.

17. Fuller, "Motion Economics and Contact Economies."

18. Fuller, "Democracy Is a Principle" (1948), unpublished typescript, Fuller Papers, Stanford University, M1090, series 8, box 8, folder 2.

19. Fuller, "Ballistics of Civilization" (1938–39), unpublished typescript, Fuller Papers, Stanford University, M1090, series 8, box 4, folder 1. The Conning Tower design was published in *Shelter* 2, no. 5 (1932): 64–65.

20. Fuller, "Democracy Is a Principle"; Fuller with Kuromiya, *Critical Path*, 197.

21. Fuller to Brigadier General Harold E. Watson, April 19, 1955, Fuller Papers, Stanford University, M1090, series 18, box 38, folder 4. In this letter, as in other documents promoting his ideas, Fuller combined such global and humanitarian appeals with arguments about the strategic value of his invention to American cold warring. See Jonathan Massey, "Buckminster Fuller's Cybernetic Pastoral: The United States Pavilion at Expo 67," *Journal of Architecture* 11, no. 4 (2006): 463–83. Regarding the Geoscopes more generally see Fuller with Kuromiya, *Critical Path*, ch. 5, "The Geoscope"; John McHale, "The Geoscope," *Architectural Design* 34 (December 1964): 632–35; and McHale, ed., *World Design Science Decade, 1965–1975. Phase I (1963) Document 4: The Ten Year Program* (Carbondale: World Resources Inventory, Southern Illinois University, 1965), appendix A; and Mark Wigley, "Planetary Homeboy," *ANY* 17 (1997): 14–23.

22. Fuller et al., *World Resources Expo 67 Exhibit Proposal*; and Fuller with Kuromiya, *Critical Path*, 169.

23. Fuller in *Domebook* 2 (1971), quoted in Krausse and Lichtenstein, *Your Private Sky*, vol. 1, *R. Buckminster Fuller: The Art of Design Science,* trans. Steven Lindberg and Julia Thorson, 428. *Domebook* was the manual for dome builders edited by Fuller disciple Lloyd Kahn. For analyses of the U.S. Pavilion see Massey, "Buckminster Fuller's Cybernetic Pastoral"; Timothy M. Rohan, "From Microcosm to Macrocosm: The Surface of Fuller and Sadao's US Pavilion at Montreal Expo 67," *Architectural Design* 73, no. 2 (2003): 50–56; and Christine Macy and Sarah Bonnemaison, *Architecture and Nature: Creating the American Landscape* (London: Routledge, 2003), esp. ch. 5, "Closing the Circle: The Geodesic Domes and a New Ecological Consciousness, 1967."

24. Fuller et al., *World Resources Expo 67 Exhibit Proposal.*

25. Regarding "Earthrise" and "Whole Earth," see Neil Maher, "Shooting the Moon," *Environmental History* 9, no. 3 (2004): 526–32. On Fuller's environmental legacy see Macy and Bonnemaison, *Architecture and Nature,* ch. 5.

26. Regarding the Swiss Re tower see Kenneth Powell, *30 St Mary Axe: A Tower for London* (London: Merrell, 2006).

10

"Every Corner Is Alive"

Eliot Porter as an Environmentalist and Artist

Rebecca Solnit

Behind the Eyes

"As I became interested in photography in the realm of nature, I began to appreciate the complexity of the relationships that drew my attention," wrote Eliot Porter in 1987, on the occasion of a major retrospective exhibition of his work organized by the Amon Carter Museum in Fort Worth, Texas.[1] Complexity is a good foundational word for this artist, whose work synthesized many sources and quietly broke many rules, and whose greatest influence has been felt outside the art world. Porter was one of the major environmentalists of the twentieth century, not because of his years on the board of the Sierra Club, but because of his role in raising the public awareness about the environment and shaping it in the popular imagination.

When Porter's first book, *"In Wildness Is the Preservation of the World": Selections and Photographs by Eliot Porter,* appeared in November 1962, it came as a revelation. Nothing like it had been seen before, and while the subject was ancient, the technology to represent it so dazzlingly was new. Porter was one of the pioneers of color photography, and his editor, Sierra Club executive director David Brower, enlisted new printing technology to attain unprecedented sharpness and color fidelity. Essayist Guy Davenport wrote that the book "cannot be categorized: it is so distinguished among books of photography, among anthologies, among art books, that its transcendence is superlative." A later reviewer recalled, "A kind of revolution was underway, for with the publication of this supremely well-crafted book, conservation ceased to be a boring chapter on agriculture in fifth grade textbooks, or the province of such as bird watchers." Despite its twenty-five-dollar cover price, it became a best seller in the San Francisco Bay Area and did well across the country.

When a less expensive version was published in 1967, it became the best-selling trade paperback of the year. Porter's 1963 book, *The Place No One Knew: Glen Canyon on the Colorado,* a counterpoint to his first, was similarly well received. Precisely because his photographs were so successful, it is impossible now to see what they looked like when they first appeared.[2]

There are two kinds of artistic success. One makes an artist's work distinctly recognizable to a large public in his or her time and afterward—Picasso might be a case in point. The greater success is paradoxical: this work is so compelling that it eventually becomes *how* we see and imagine, rather than *what* we look at. Invisible most of the time, such art may look obvious or even hackneyed when we catch sight of it. Such success generates imitations not only by other artists but throughout the culture. The ubiquitous Porter imitations in advertisements, calendars, and posters are testimony to his success and fundamental effect on our perception.

Color demanded a new approach to composition and called attention to different aspects of nature than did black-and-white photography. Porter's aesthetic, born out of an individual talent, grew into a genre—"nature photography"—in which thousands of professionals and amateurs now toil. His photographs have come to embody what many people look for and value in the outdoors. That Porter's pictures look "natural" today testifies to their great cultural success. We now live in a world he helped to invent. Because his pictures exist behind our eyes, it is sometimes hard to see the Porters in front of our eyes for what they were and are. Understanding his photographs means understanding the world in which they first appeared and the aesthetic and environmental impact they have had since.

Silence and Wildness

David Brower chose to publish *"In Wildness"* in the centennial year of Henry David Thoreau's death, a historical move that prompted Porter to pair his photographs with passages from the nineteenth-century writer. But 1962 made plenty of history of its own. In September of that year, Rachel Carson's *Silent Spring* was published, and this indictment of the pesticide industry quickly became a controversial best seller. In October, President Kennedy announced that the Soviet Union had deployed nuclear missiles in Cuba and that the United States would attack unless they were removed: the world came closer to an all-out nuclear war than at any time before or since. "The very existence of mankind is in the balance," declared the secretary-general

of the United Nations. The revelations of the atomic bomb and the concentration camps at the end of World War II had begun to erode faith in leaders, scientists, and the rhetoric of progress, and that faith continued to crumble as the 1950s wore on. *Silent Spring* and the Cuban Missile Crisis were crescendos of events that had been long building, and *"In Wildness Is the Preservation of the World"* may have succeeded in part as a response to these circumstances.[3]

In the late 1950s and early 1960s, fear of a possible nuclear war was coupled with fear of what preparing for one entailed. The 1959 discovery that in many parts of the country milk, both bovine and human, was contaminated by atomic-testing fallout prompted a national outcry. The appearance of man-made carcinogens in what was perceived to be the most natural and nurturing substance in the world meant that nature was no longer invulnerable to science and politics; the government generated biological contamination in the name of national security. Pesticide-spray campaigns in the nation's forests already had provoked uproar by the late 1950s (Porter was among those decrying the abuse of pesticides in letters to his local newspaper), but now even the intimate realm of human biological reproduction was threatened. As Carson wrote of pesticides, "Their presence casts a shadow that is no less ominous because it is formless and obscure, no less frightening because it is simply impossible to predict the effects of lifetime exposure." The world faced a new kind of fear—of nature itself altered, of mutations, extinctions, contaminations without precedent. Porter declared in 1961, "Conservation has rather suddenly become a major issue in the country—that is, more people in higher and more influential places are aware of its importance and willing to do something about it."[4]

Pesticides and radiation were only part of the strange cocktail that fueled what gets called "the sixties." In November 1961, Women Strike for Peace, the most effective of the early antinuclear groups, launched a nationwide protest that in many ways prefigured the feminist revolution. In 1962 the civil rights movement was at its height, the United Farm Workers was founded, and Students for a Democratic Society held its first national convention. The voiceless were acquiring voices and using them to question the legitimacy of those in power and the worldview they promulgated. Some were speaking up for nature and wilderness with an urgency never heard before. During the late 1950s and early 1960s, the epochal Wilderness Act of 1964 was being debated alongside pesticide and radiation issues; the remotest reaches of the environment were at stake. In this context, the small American conserva-

tion movement became a broad-based environmental movement, with Porter playing a central role.

What *"In Wildness"* depicts as a beatific vision, *Silent Spring* tells as a nightmare: our chemical sins will follow us down the decades and the waterways. Carson's book addressed a very specific history, that of the development of new toxins during World War II, their later application to civilian uses, and their effects on birds, roadside foliage, the human body, and the vast ecosystems within which these entities exist. "The world of systemic insecticides is a weird world," she wrote, "where the enchanted forest of the fairy tales has become the poisonous forest in which an insect that chews a leaf or sucks the sap of a plant is doomed."[5]

Porter's book showed the forest still enchanted, outside of historical time and within the cyclical time of the seasons (fig. 41). His photographs, which had appeared earlier in an exhibition titled The Seasons, followed a sequence depicting spring, summer, fall, and winter. Only one image—of a mud swallow's nest built against raw planks—showed traces of human presence, rendered as slight and benign. Whereas politics tends to be about what we fear, environmentalism concerns things worth protecting; *"In Wildness"* spoke directly of the latter. Nevertheless, despite its lyrical celebration of the nonhuman world, Porter's first book was widely recognized as a political book.

In a review of the 1967 edition, *Sports Illustrated* proclaimed: "Hundreds of books and articles have been written urging private citizens to do something ('Write your Congressman, now!') about the destruction of the nation's natural beauties, but the most persuasive volume of all contained not a word of impassioned argument, not a single polemic." In fact, it did contain a few words of impassioned argument. At the end of his introduction to *"In Wildness,"* Joseph Wood Krutch stated: "If those who believe in progress and define it as they do continue to have their way, it will soon be impossible either to test his [Thoreau's] theory that Nature is the only proper context of human life or that in such a context we may ultimately learn the 'higher laws.' One important function of a book like this will have been performed if it persuades those who open it that some remnant of the beauties it calls to our attention is worth preserving."[6] Out of these two delicate sentences tumbles an avalanche of assertions: that progress, as conventionally imagined, was devastating the natural world, perhaps irreversibly; that nature is a necessary but imperiled moral authority; that Porter portrays not only nature but its moral authority; that the purpose of Porter's book may be to help rally citizens to

41. Eliot Porter, *Skunk Cabbage, Near Peekskill, New York, April 12, 1957.* 1957. Dye transfer photograph. © 1990 Amon Carter Museum, Fort Worth, Texas, Bequest of the artist.

preserve this nature; that photographs of blackberries, birds, and streams can be politically and philosophically persuasive because a love of nature can be inculcated through beauty; and that such love can lead to political action on its behalf. Modernity had placed its faith in science, culture, and progress; the Rousseauian antimodernism that would be central to both the counter-culture and the environmental movement put its faith in nature, usually nature as the embodiment of an ideal of the way things were before various interventions—before human contact, before the Industrial Revolution, before the arrival of the Europeans, before chemical contamination. Krutch, who had had a distinguished career as a literary critic before he left the East Coast intelligentsia for Arizona and nature writing, embodies this shift. A

major ally of Porter's, he supplied Americans with a visual definition of the nature worth preserving. Of course, this definition was made possible by a technologically advanced and aesthetically sophisticated art.[7]

In his next book, *The Place No One Knew: Glen Canyon on the Colorado,* Porter depicted a place that had been at least as pristine as anything shown in *"In Wildness"* but which, by the time of publication, was irrevocably lost: the labyrinthine canyon lands drowned by Glen Canyon Dam. The book was an argument for preventing further dams in the Colorado River canyons, a struggle that continues today despite the loss of Glen Canyon. Porter portrayed the site as a gallery of stone walls in reds, browns, and grays with gravel-and-mud floors through which water flowed, occasionally interspersed with images of foliage and, much more rarely, the sky (fig. 42). Some found the book claustrophobic and longed for more conventional distant views. Compared to *"In Wildness,"* the new book was challenging in several respects: formally, in its compositions; politically, in the directness of its advocacy; and conceptually, in its depiction of an imminent catastrophe that would have been unimaginable only a century before. Beautiful landscape images traditionally functioned as invitations of a sort, but Porter's photographs surveyed a place no longer available; they were portraits of the condemned before the execution. The beauty of the images was inflected by information from outside the frame; all this was being drowned. As environmental writer and photographer Stephen Trimble wrote, "The message was clear: go out into the land, stand up for it, fight its destruction—you lose forever when you fail to know the land well enough to speak for it."[8]

Flow and Convergence

Among the factors feeding Porter's vision were a socially conscious family whose influence contributed to his lifelong support of human rights and environmental causes; a boyhood passion for the natural world; an involvement with photography from late childhood onward; a medical and scientific education that gave him the skills to develop color-photography technology; the inherited funds to stand apart from fashions and pressures; and a sense of himself as an artist dating from Alfred Stieglitz's recognition of his work at the end of the 1930s. His training as a doctor and biomedical researcher refined his understanding of biology, chemistry, and laboratory work, which would stand him in good stead as a nature photographer, environmentalist, and innovator of color-photography processes. "I did not consider those years

42. Eliot Porter, *Near Balanced Rock Canyon, Glen Canyon, Utah, September 6, 1962.* 1962. Dye transfer photograph. © 1990 Amon Carter Museum, Fort Worth, Texas, Bequest of the artist.

wasted," he once said. "Without those experiences it would be impossible to predict what course my life would have taken, least of all that it would be in photography. In retrospect, from my experience it appears highly desirable to order one's life in accord with inner yearnings no matter how impractical."[9]

As a child, "all living things were a source of delight to me," Porter wrote.

I still remember clearly some of the small things—objects of nature— I found outdoors. Tiny potato-like tubers that I dug out of the ground in the woods behind the house where I lived, orange and black spiders sitting on silken ladders in their webs, sticky hickory buds in the spring, and yellow filamentous witch hazel flowers blooming improbably in

November are a few that I recall. I did not think of them as beautiful, I am sure, or as wondrous phenomena of nature, although this second reaction would come closest to the effect they produced on me. As children do, I took it all for granted, but I believe it is not an exaggeration to say, judging from the feeling of satisfaction they gave me when I rediscovered them each year, that I loved them.[10]

The items he names in this brief account—insects, buds, branches—are easily imaginable as subjects of his camera, and many of his photographs can be seen as childhood epiphanies of the minutiae of nature.

During his career as a photographer, Porter discovered that "color was essential to my pursuit of beauty in nature. I believe that when photographers reject the significance of color, they are denying one of our most precious biological attributes—color vision—that we share with relatively few other animal species."[11] This statement moves from aesthetics to science as though it were the most natural transition in the world, and for Porter it evidently was, though few others could or would deploy biology in explaining their art. This mix made him something of a maverick and a misfit in photography circles—even the landscapists did not ground their work in science as he did. As a photographer, he engaged with evidence of natural processes, biodiversity, the meeting of multiple systems, with growth, decay and entropy.

In 1924, while hopping freight trains in the West, Porter joined the International Workers of the World, better known as the Wobblies—an expression of solidarity with radicals not common among Harvard students from wealthy families. His tax records portray him as a staunch supporter of human rights and progressive causes. The American Civil Liberties Union was the one organization to which he donated year after year throughout his life. In the 1930s he gave small sums to support the Republican side of the Spanish Civil War as well as the National Committee for the Defense of Political Prisoners. By 1946, the National Association for the Advancement of Colored People was on his list. In 1948 he began giving to the Emergency Conservation Committee—a small, radical environmental organization.

Documents in Porter's archives show he was concerned about pesticides long before *Silent Spring* appeared, along with logging, grazing on public lands, and other subjects that environmental activists have since taken up. He often wrote letters to newspapers and politicians. In 1959, for example, he wrote the *Santa Fe New Mexican,* his local newspaper, to call attention to the centennial of abolitionist John Brown's execution. After quoting Thoreau

on Brown, he wrote, "Not only are the bonds of the slaves he gave his life to free still not struck off, but we have since forged new bonds for ourselves. Is not this a fitting anniversary for us to rededicate ourselves to the cause of freedom, freedom from bigotry, freedom from prejudice, freedom from discrimination and freedom to stand up and be heard?"[12] Later, he would write politicians and newspapers repeatedly about the war in Vietnam and the Watergate crisis, both of which outraged him; he also took an interest in Native American issues long before most of the non-Native public was aware there were any. Though his principles involved him with many issues, his passion and his talent were dedicated to environmental causes, particularly the protection of wildlife and wilderness.

Early in his photographic career, Porter made modernist photographs in the tradition of Paul Strand and Stieglitz, but he also pursued ornithological photography. The latter genre tapped a tradition that went back to the nineteenth-century paintings by John James Audubon, whom Porter cited in two successful applications to the Guggenheim Foundation for funding to support such photography. Though he wanted to document birds for scientific-environmental purposes, he was committed to doing so aesthetically (as were, of course, Audubon and many others in that tradition). With Stieglitz's encouragement, Porter quit his day job as a biomedical researcher to devote himself full-time to photography. In 1939 he showed his bird photographs to Rachel Carson's editor, Paul Brooks, then the editor-in-chief of Houghton Mifflin. Brooks shared Porter's enthusiasm for the environment but not for the bird photographs. He told the artist that they would be far more valuable if they were in color. This prodding led Porter to become a pioneer of color photography. Eleven years later he approached Brooks again, only to be told that his jewel-like bird images would be too expensive to publish in color and would have a limited audience anyway. Fortunately, Porter found supporters elsewhere, including David McAlpin of the Museum of Modern Art, Ansel and Virginia Adams, and Beaumont and Nancy Newhall. Even so, he toiled with little public recognition for more than twenty years.

By the time *"In Wildness"* appeared in 1962, Porter had met David Brower and had begun to use photography and aesthetics as political tools on behalf of the Sierra Club. The book merged a childlike sense of wonder, modernist artistic sensibility, innovative color photographic technology, scientific acumen, and political awareness—a convergence that would last and evolve through the subsequent books and years. "Photography is a strong tool, a propaganda device," he wrote, "and a weapon for the defense of the environ-

ment . . . and therefore for the fostering of a healthy human race and even very likely for its survival."[13]

Dr. Porter and Mr. Brower

In David Brower and the Sierra Club, Porter met a man and an organization that had long put the aesthetic to political use in a way no other environmental group had. In 1938, well before Brower had become the club's executive director, photographer Ansel Adams had published *Sierra Nevada: The John Muir Trail* and sent it to Secretary of the Interior Harold Ickes to lobby— successfully—for the creation of King's Canyon National Park and expansion of Sequoia National Park. A Californian who spent much time in the Sierra Nevada and a board member of the club from 1934 to 1971, Adams was far more deeply tied to the club than the easterner Porter would ever be, and it was another of his books that opened the door for Porter. Brower had published the club's first exhibit-format book, *This Is the American Earth,* in 1960; its black-and-white photographs were mostly by Adams, and its Whitmanesque text was by Nancy Newhall. More rhapsody than documentary survey, it was a respectable financial success. Edgar Wayburn, who served his first term as the club's president from 1961 to 1964, recalled that *This Is the American Earth* "changed Dave's whole way of looking at the conservation movement. He saw what a book could do." As an exhibit-format book, it introduced many Americans to their public lands through fine art photography. Whereas a few subsequent books in the series lobbied for the protection of specific threatened places, most—including *This Is the American Earth* and *"In Wildness"*—were more general in their political aims.[14]

Brower himself came out of publishing and publicity, and he naturally gravitated toward books—and later, newspaper ads and films—as a means of educating the public and advocating on issues. A brilliant mountain climber and mercurial personality, he, more than anyone else, changed the club from its postwar role as a small, regional outdoor society that did a little lobbying to the preeminent environmental organization of the 1960s. His book projects sometimes made money for the Sierra Club; more reliably, they brought in members and raised awareness. The club had 7,000 members in 1952, 16,500 in 1961, 24,000 by 1964, and 55,000 by 1967. (In mid-2000, membership stood at 636,302.) By the mid-1960s, however, the publications program had begun to lose money—from 1964 onward, an average of $60,000 a year, according to historian Stephen Fox. Brower and the club published various

other books by Porter, including the lavishly illustrated *Galápagos: The Flow of Wildness* (1968). The latter's high production costs helped fuel a controversy swirling around Brower in the late 1960s, by which time Porter was a member of the board of directors.[15]

Porter had been elected in 1965 and served two terms during the great years of transition in the Sierra Club. In the 1950s the club had been fairly active in organizing outings and expeditions, less so in fighting environmental battles, and little involved in such battles outside California, but by the 1960s the club was beginning to oppose many kinds of pesticide and herbicide use, and by the 1970s, nuclear power and other major technologies were called into question; it had moved from preserving isolated places to protecting pervasive systems. As an outsider in the club, Porter brought with him an independence from its traditional ties and limitations. The club's directors were then mostly Californians, longtime members of the organization, and, more often than not, participants in its outings. Several had been great mountaineers in the days when the Sierra Club was a major force in American mountaineering, and many had ties within more powerful institutions in California—there were engineers, chemists, physicists, and executives involved with enterprises the club would later target. "The idea of playing hardball with big corporations—Standard Oil or PG&E [Pacific Gas and Electric] and what have you—was a jarring thing to them," recalled board member Phil Berry.[16]

With Diablo Canyon Nuclear Power Plant, the drama of Dinosaur and Glen Canyon essentially replayed itself. The builder was PG&E, the same company that benefits from hydropower from Hetch-Hetchy Dam inside Yosemite National Park, the early-twentieth-century dam John Muir strove so hard to prevent and that first made the club into a forceful political organization. In 1963, members of the club discovered that PG&E was planning to build a plant at Nipomo Dunes on the central California coast, a site that had often been recommended for park status. After the club's executive committee voted to try to preserve the dunes, board president Will Siri privately negotiated to have the plant moved to Diablo Canyon. Once again, too late, Sierra Club activists discovered that Diablo Canyon was too important to trade off. Many board members, including Ansel Adams, argued that if the club had agreed to support the Diablo site, then they had an obligation to stick by the agreement. Porter thought differently. As Berry puts it, the uncompromising stand advocated by board member Martin Litton "was most eloquently stated, really, by Eliot Porter. Eliot said at that infamous Septem-

ber '68 board meeting that the Sierra Club should never be a party to a convention that lessens wilderness. That's the truth. We shouldn't be. I think we gained strength from the mess of Diablo."[17]

At least since the battle over Hetch-Hetchy early in the twentieth century, the Sierra Club had had a lot of internal dissent about tactics and mission, but the battles of the 1960s were far more heated than their predecessors. Like the controversy over Diablo Canyon, the controversy over the publications program threatened to tear the club apart in the late 1960s. Porter was later accused by conservative board member Alex Hildebrand of conflict of interest for voting to support the lavish publications program, a charge Porter vehemently denied. Brower, Porter, and some of the others on the board saw the publications as having far-reaching, if indirect, effects in promoting environmental awareness and raising the club's profile. Others considered the program—particularly the picture books—a drain of time and money and felt that publications should be far more closely tied to specific campaigns and endangered American places. Adams—who had mixed feelings about color photography anyway—was opposed to the lavishness and political indirectness of the publications program and to Brower's direction in those years. Porter's *Galápagos* book, which he had been thinking about since the early 1960s, joined Diablo as one of the conflicts that came to a head in 1968. "There was a great deal of opposition to the proposal within the board of directors," recalled Porter of the Galápagos project, "on the grounds that the islands were outside the continental United States, which, it was felt, put them outside the legitimate conservation concerns of the club; so the idea was rejected." Newly reelected president Edgar Wayburn argued that "other projects have higher conservation priority; for example a Mount McKinley book could make or break a great national park." Porter shared Brower's sense that the club and the American conservation movement should expand to begin working globally, and he was passionate about the threats to the islands' unique species and ecosystem.[18]

Brower was voted off the club's board in 1969. He subsequently founded Friends of the Earth and continued working to protect wilderness, nationally and globally. Porter served out his second term but, to his combined relief and chagrin, was not nominated to a third. He continued to support the club's objectives and served on the New Mexico Nature Conservancy board and on the Chairman's Council of the Natural Resources Defense Council, gave images as donations and for reproduction to environmental organizations (and Planned Parenthood), and continued to donate money to a wide

variety of causes. His books continued to be published, primarily by E. P. Dutton, which, in 1972, finally put out the bird book that had prompted Eliot to take up color photography more than thirty years earlier.[19]

Porter himself roamed farther afield, completing books on Antarctica, Iceland, Egypt, Greece, Africa, and China as well as continuing to photograph North American places and phenomena. Many of the images made abroad incorporated evidence of human culture and portrayed human beings, as the American work generally did not. The books on Africa and Antarctica were particularly concerned with environmental issues, though questions of extinction and habitat were present in most. From a modest initial definition of nature as birds and details of the New England landscape, Porter's photography grew into a global picture of natural systems and human participation—often benign—in those systems. His work evolved as the environmental movement did, from protecting particular species and places to rethinking the human place in the world, a world reimagined as an entity of interconnected systems rather than one of discrete objects.[20]

An Ecological Aesthetic

Perhaps the central question about Porter's work concerns the relationships among science, aesthetics, and environmental politics—about what an environmental aesthetic might be and to what extent Porter succeeded in creating one. His brother Fairfield Porter, a painter and critic, wrote in a 1960 review of the color photographs, "There is no subject and background, every corner is alive," suggesting what an ecological aesthetic might look like. The description prefigures Barry Commoner's 1971 declaration of the first principle of ecology, "Everything is connected to everything else," which ecofeminist Carolyn Merchant revised in 1981 to "All parts of a system have equal value." Porter's most distinctive compositions are the close-ups in which the frame is filled with life and with stuff. Rather than portraits that isolate a single phenomenon, they are samples from the web of interrelated phenomena.[21]

This close-up scale emphasizes the ordinary over the extraordinary, as indicated by a plate in *The Place No One Knew* titled *Near Balanced Rock Canyon* (see fig. 42). Balanced Rock is a landmark, an outstanding and unusual feature of the landscape visible from a distance, but Porter's medium close-up shows large, river-rounded stones on a rock surface—a quotidian scene near the unseen, exceptional one. Of course, Porter meant the picture to be viewed in the context of other, more spectacular images of Glen Canyon. The re-

sulting serial approach affected the expectations for each photograph: not all needed to be prima ballerinas straining for the spectacular, for together they formed a corps de ballet. But *Near Balanced Rock Canyon* also suggests that ordinary rocks are important enough—that we can love a place for its black-berries or its stream ripples, not just for its peaks, waterfalls, or charismatic macrofauna. All parts have equal value. Such images demonstrate why Porter was willing to fight for Diablo Canyon, a beautiful, pristine, but unexceptional landscape.

"Every corner is alive" suggests another important aspect of Porter's characteristic close-ups. Landscape photography generally depicts open space, usually defined by a horizon line, with the camera looking forward, much as a standing or striding human being might. It depicts, most often, an anthropomorphic space—anthropomorphic because its central subject is space, space that can be entered, at least in imagination. Moreover, it often shows things at such a distance that the entities themselves—the grass or trees or rocks—cannot be subjects, only compositional elements. The implication of many classic landscape photographs (and the paintings from which they derive) is that such space is essentially empty, waiting to be inhabited. This approach follows the evolution of landscape painting itself out of anthropocentric painting: the human protagonists got smaller, and the landscape behind the drama grew more complex, until eventually the actors left the stage. But the landscape was still composed as scenery, a backdrop, a description of habitable space.

Porter, by contrast, often photographed flat surfaces up close—the surface of the earth, a stone, or a tree trunk—and subtle tonal ranges. He looked directly at his subject rather than across or through it to space. There is very little empty space in his images, and thus little or no room in which to place oneself imaginatively. The scale is not theatrical, or at least not anthropocentrically so. He once remarked, "Don't include the sky in the picture unless the sky has something to say," which seems to propose that the sky constitutes a subject in its own right, not simply a provider of orienting horizon lines and habitable space above the surface of the earth.[22] His extensive series of cloud photographs bear out this notion, for the clouds should be seen as autonomous scientific and aesthetic phenomena rather than as part of a landscape scene. In fact, Porter produced very few "scenes." When not capturing a close-up, his camera tilted down or up to show things on their own terms, rather than as background to habitable space. Whereas landscape photography generally has an empty center, Porter's work fills that center, whether

with leaves, stones, creatures, or clouds. This is not landscape photography, but nature photography—a new genre Porter founded. If it has an ancestor, that ancestor is still-life painting and photography, though before Adams and Porter still-life subject matter was nearly always limited to domestic items indoors that could be set up for the studio easel or camera—fruit, flowers, household objects, instruments, food—not wild stuff in its own place.

When Fairfield Porter wrote that "there is no foreground and background," he was probably less interested in ecological issues than in compositional ones. Fairfield was a painter, as was Eliot Porter's wife, Aline, whose close friend Betty Parsons was an important Manhattan gallery owner and doyenne of the New York school of painting. In the absence of a color photographic tradition, Porter likely drew some inspiration from contemporary abstract expressionist painting, which Parsons championed. Some of Porter's flat-to-the-picture-plane images bring to mind such painting and even may have been influenced by it (fig. 43). Abstract expressionism famously emphasized the formal process of painting itself, or what in Jackson Pollock's work was sometimes called "all-overness." Porter's photographs exhibit a similar compositional approach as well as a passion for process in ecological, rather than purely aesthetic, terms. Porter appreciated lichen a great deal, for example, not only because it had wonderful color range and texture but because it embodied a process of unique symbiosis between fungus and mold, making its home on the seemingly inhospitable faces of rocks. Painter Valerie Cohen has suggested to me that Porter's closest ties are to painters of the early twentieth century: "Porter's close-ups, and especially his flattening of space, follow developments in European and American painting (Milton Avery, Pierre Bonnard, Arthur Dove, Henri Matisse)."[23] Elsewhere, Porter's compositions show the strong influence of the great modernist photographers, though he adapted what he learned from them to his own medium, color photography, and transformed their lessons through a very different kind of involvement with his subject. Porter rejected much of high modernism's philosophy in the way he tied his work to science, politics, and literature, but he never quarreled with its strategies or aesthetics.

Though childlike wonder had a role in Porter's work, dispassionate scientific observation was important, too. The clarity and convincing color of many of his images convey a coolly objective view—perhaps not objective in the true sense, but with objectivity as an aesthetic and an ideal. Porter's personality—reserved, attentive, principled—comes across more in this withholding of drama and the personal than in any other aspect of his work

43. Eliot Porter, *Lichens on Beech at Hemlock Hill, Blue Mountain Lake, Adirondack Mountains, New York, May 17, 1964.* 1964. Dye transfer photograph. © 1990 Amon Carter Museum, Fort Worth, Texas, Bequest of the artist.

save, perhaps, his choice of subjects and his deployment of those subjects for political purposes.

Wilderness and Strategy

The golden age of the Sierra Club publication program can be seen to parallel the golden age of American landscape painting in the second half of the nineteenth century, when the American West was celebrated in paintings by Albert Bierstadt, Frederic Church, and Thomas Moran and in photographs by Carleton Watkins, Eadweard Muybridge, William Henry Jackson, and others. In that time it was the West that was terra incognita to the majority;

in the 1960s it was the remaining remote places, east and west. Both were eras in which the American public discovered their terrain through artistic representation, and in both cases American landscape was seen as the stage onto which no actors had yet entered, virgin wilderness before the first taint of civilization. As Thomas Cole had written, "the most distinctive and perhaps the most impressive characteristic of American scenery is its wildness. It is the most distinctive, because in civilized Europe, the primitive features of scenery have long since been destroyed or modified."[24]

For Cole, the American landscape was a stage on which the principal acts had yet to take place, and this idea of wilderness as a place as yet affected by nothing but natural forces has been powerful ever since. Wilderness, as Wallace Stegner wrote of it in 1960 in the letter that coined the term "the geography of hope," meant a place apart from civilization, a place where humans had not yet and should not arrive onstage.[25] Since that era, much has been written to revise this idea, most significantly by acknowledging that Native Americans spent millennia in places Euro-Americans dubbed "virginal" and that the supposed pristine quality of those places had been much affected by the Native presence—and sometimes damaged by their absence. Out of the imagination of wilderness and the ignorance of indigenous presences came a false dichotomy: a wholly nonhuman nature and a wholly unnatural humanity. The latter was seen as a threat, meaning the former had to be protected as a place apart. Historian William Cronon writes, "The critique of modernity that is one of environmentalism's most important contributions to the moral and political discourse of our time more often than not appeals, explicitly or implicitly, to wilderness as the standard against which to measure the failings of our human world. Wilderness is the natural, unfallen antithesis of an unnatural civilization that has lost its soul."[26] Now that the critique of modernity is accomplished, we have entered upon the critique of wilderness—not of places themselves, but of the way they are imagined, described, and administered.

One of the ironies of Porter's career is that although he did much to give "the wilderness idea" a face, that face exists not so much in the images he made as in the way people perceive them. *"In Wildness"* was seen—and successfully deployed—as a defense of wilderness. In their thank-you notes for the book, most of the congressmen and senators to whom Brower had sent it called it "In Wilderness." In fact, most of the phenomena it portrays might readily be seen on the fringes of civilization—by a small-town New England schoolchild taking a detour through the woods on the way home, for ex-

ample, or by Thoreau on the outskirts of long-settled Concord. The creatures are small—caterpillars, moths, songbirds; the bodies of water are brooks, not rivers; the trees are maples, not bristlecones. The photographs could equally have been used to justify development, in that the flora and fauna they show could and do survive on the fringes of developed areas.

There are no human traces in *The Place No One Knew,* though the region abounds in petroglyphs and ruins and is partially within the huge Navajo reservation. Rainbow Ridge, which the Sierra Club defended as a great natural phenomenon whose setting would be damaged by Glen Canyon, has more recently been fought for as a sacred site by five Native tribes in the area. But the book seems to postulate Glen Canyon (see fig. 42) as an untouched place and the dam as the first, devastating human trace that would be left on it. Now, wilderness can be seen as a useful fiction, a fiction constructed by John Muir and his heirs and deployed to keep places from being destroyed by resource extraction and wholesale development. In more recent years, it has become equally valuable to understand the things that human presences can do other than destroy, the way wild places can be a homeland rather than an exotic other.

The work of Ansel Adams and Eliot Porter generates instructive comparisons on many grounds: the two were nearly the same age, crossed paths both as artists and as activists, and became perhaps the most famous American photographers of the second half of the twentieth century (though Adams's reputation has not faded as Porter's has). The differences are obvious: Adams was a successful, confident artist in an established medium while Porter was still experimenting in relative isolation; Adams was ensconced in both artistic and environmental communities as Porter was not; Adams's work, with its taste for grandeur and spectacle, has ties to the great western landscape photography of the nineteenth century, while Porter was exploring the new medium of dye transfer color photography as both a technical medium and a compositional challenge, echoing new developments in painting. Like Porter, Adams has suffered from becoming famous for a portion of his work now thought of as the whole: as the former is to pristine close-ups, so the latter is to majestic views, though both made many close-up photographs of flora and other natural details.

Whereas Adams produced the majority of his pictures in the classic landscape-photographic tradition, emphasizing deep space, strong contrast, dramatic light, and crisp delineation (the near-sculptural qualities that black-and-white was suited to portray), Porter often flattened out a subject and

sought a painterly subtlety of color range. Adams's pictures often depend on the drama of a revelatory light that appears almost divine, while Porter preferred cloudy days to make images that speak of slow, careful attention. Adams usually photographed prominent geological features, such as the balancing rock of Balanced Rock Canyon, but Porter tended to ignore such natural monuments. Adams focused on major landmarks—Half Dome (fig. 44) or the Grand Tetons—but Porter dealt with smaller, representative specimens, such as the sandstone of the Southwest, the warblers of the Midwest, the maple leaves of New England.

Another way to describe the difference between Adams and Porter would be to distinguish conservationist from environmentalist. As a conservationist, Adams prized the most spectacular and unique aspects of a place; as an environmentalist, Porter valued the quotidian aspects of even the most exotic places he went. With Adams's monumental scenes, viewers at least felt they were remote from civilization (though cropping out the people and infrastructure in Yosemite Valley must have been a challenge at times); with Porter they could be a few feet from it—his close-ups might speak of an intact natural order, but not necessarily of an inviolate wilderness space. It could be said that whereas Porter photographed cyclical time, Adams strived for an almost biblical sense of revelatory time-suspension. Porter once argued that photography "almost always unintentionally softens rather than exaggerates the unpleasant aspects of the conditions it attempts to dramatize most forcefully. The same is true when photography is used to show the devastations produced by man's works."[27] Such an assertion helps explain Porter's strategy of showing what can be saved and what remains intact rather than what has been ravaged, of photographing nature as existing in cyclical time rather than in history (though looming catastrophe had been the unseen subject of *The Place No One Knew*).

Legacy

Today's respected landscape photographers are producing very different work, and few of them have the role within environmental organizations or the broad popular success Porter enjoyed. The terrain has changed. Almost two decades after *"In Wildness Is the Preservation of the World,"* landscape photographer Robert Adams wrote: "More people currently know the appearance of Yosemite Valley and the Grand Canyon from having looked at

44. Ansel Adams, *Monolith: The Face of Half Dome, Yosemite National Park, California,* 1927. Gelatin silver print. © The Ansel Adams Publishing Rights Trust, Collection Center for Creative Photography, University of Arizona, Tucson.

photographic books than from having been to the places themselves; conservation publishing has defined for most of us the outstanding features of the American wilderness. Unfortunately, by perhaps an inevitable extension, the same spectacular pictures have also been widely accepted as a definition of nature, and the implication has been circulated that what is not wild is not natural." He argues here that the same images mean different things at different points in history. By this time, the popular imagination had reached a point where such imagery had achieved what success it could; a new generation of photographers ought instead to "teach us to love even vacant lots out of the same sense of wholeness that has inspired the wilderness photographers of the past twenty-five years."[28]

Of course it can be argued that Porter photographed backyards, if not vacant lots, along with people, ruins, and signs of rural life from Maine to Mexico, but Adams has a point. Whatever images Porter made, the ones that proved most memorable and influential were of a pristine nature, a place apart. Though his pictures may have been primarily of the timeless seasonal world of natural phenomena, they were subject to the passage of historical time, and their influence, even their appearance, has changed over the decades. Later in his career, Porter came to believe that his photographs were as likely to send hordes of tourists to an area as to send hordes of letters to Congress in defense of that area, countering Adams's argument that the books could substitute for visits to wilderness. Far more Americans had become familiar with the remote parts of the country, and recreational overuse as well as resource extraction and development threatened to disturb the pristine places. It may be precisely because of Porter's spectacular success in promoting American awareness and appreciation for remote and pristine places that a different message may now be called for.

This invisible success is counterbalanced by a very visible one: thousands of professionals and countless amateurs now produce color nature photography more or less in the genre first delineated by Porter. Their work is not quite like his. For the most part, Porter seemed to value truth more and beauty—at least showy, bright beauty—less. He was concerned more with representing processes, systems, and connections than are many of his followers. He often made photographs of reduced tonal range, and some of his images of bare trees in snow are not immediately recognizable as being in color. "Much is missed if we have eyes only for the bright colors," he wrote.[29] The contemporary nature photography seen in calendars and advertisements tends to pump up the colors and portray a nature far more flawless and untouched than anything Porter found decades earlier (though the best defense for such images is that some of them continue to raise money for environmental causes). Their work tends to crop out anything flawed and to isolate a perfect bloom, a perfect bird, a perfect icicle, in compositions usually simpler than Porter's. Looking at these images, one has the sense that the genre Porter founded has become narrower rather than broader. A kind of inflationary process has raised the level of purity, of brightness, of showiness each image must have. Some of this may be about the continued evolution of technologies; with improvements in film and cameras and innovations like Photoshop, a greater degree of technical perfection is possible now than was in Porter's time. And images that were relatively original in his work have now become staples, even clichés.

The thing least like an original is an imitation; the two look alike, but they are not akin at all in their function in the world. Porter's work was innovative, responding imaginatively to a new medium and the new way of representing the world that this medium made possible. Imitating Porter is not responding to the world but to a now-established definition of it. The photographers who follow Porter most closely in their compositional innovations and their definitions of nature, the human place in it, and the role of photography in the preservation of the world may be those whose work looks least like his. They make work that responds to their time and their outdoor encounters with the same imaginative integrity as Porter did to his. Porter's primary legacy may not be photographic, but something far more pervasive: a transformation of what we see and what we pay attention to.

Notes

1. Eliot Porter, *Eliot Porter* (Boston: New York Graphic Society, 1987), 83.

2. Eliot Porter, *"In Wildness Is the Preservation of the World": From Henry David Thoreau. Selections and Photographs by Eliot Porter* (San Francisco: Sierra Club, 1962); Eliot Porter, *The Place No One Knew: Glen Canyon on the Colorado* (San Francisco: Sierra Club, 1963); Guy Davenport, *National Review,* December 18, 1962, Eliot Porter Archives, Amon Carter Museum, Fort Worth, Texas; Stephen Fox, *John Muir and His Legacy: The American Conservation Movement* (Boston: Little, Brown, 1981), 317, quoting *Smithsonian* magazine, October 1974.

3. Spencer R. Weart, *Nuclear Fear* (Cambridge, Mass.: Harvard University Press, 1988), 258; Rachel Carson, *Silent Spring* (New York: Houghton Mifflin, 1962).

4. Carson, *Silent Spring,* 188; Porter to Aline Porter, April 11, 1961, Porter Archives.

5. Carson, *Silent Spring,* 32.

6. *Sports Illustrated,* November 22, 1967; Joseph Wood Krutch, introduction to Porter, *"In Wildness,"* 13.

7. On Krutch see Paul N. Pavich, *Joseph Wood Krutch* (Boise: Boise State University Press, 1989).

8. Stephen Trimble, "Reinventing the West: Private Choices and Consequences in Photography," *Buzzworm,* November/December 1991, 46–54.

9. Porter, *Eliot Porter,* 29.

10. Porter, "An Explanation," *Harvard Alumni Bulletin,* 2–3, n.d., Porter Archives.

11. Porter, *Eliot Porter,* 83.

12. Porter to the *Santa Fe New Mexican,* December 2, 1959, Porter Archives.

13. Porter, "Photography and Conservation," manuscript in "Notes on Conservation" file, pp. 5–6, Porter Archives.

14. Ansel Adams and William A. Turnage, *Sierra Nevada: The John Muir Trail* (Berkeley, Calif.: Archetype, 1938); Ansel Adams and Nancy Newhall, *This Is the American Earth* (San Francisco: Sierra Club, 1960); Edward Steichen, *The Family of Man* (New York: The Museum of Modern Art, 1955); Wayburn quoted in Michael P. Cohen, *The History of the Sierra Club, 1892–1970* (San Francisco: Sierra Club Books, 1988), 293.

15. Fox, *John Muir and His Legacy,* 318–19; Cohen, *History of the Sierra Club,* 424–26; Eliot Porter and Kenneth Brower, *Galápagos: The Flow of Wildness* (San Francisco: Sierra Club, 1968).

16. Philip S. Berry, "A Broadened Agenda, a Bold Approach: Oral History Transcript," interview conducted by Ann Lage, 1981, 1984, Regional Oral History Office, Bancroft Library, University of California, Berkeley, 1988, 21. The club was used to cordial relations with the sources of power: *"In Wildness"* was underwritten by a philanthropic arm of the giant Bechtel Corporation, which built Hoover Dam, countless oil pipelines around the world, and Glen Canyon Dam, and now manages the nuclear bomb testing program at the Nevada Test Site.

17. Berry, interview, 27.

18. Alexander Hildebrand, in "Sierra Club Leaders: Oral History Transcript/ 1980–1982," interviews conducted by Ann Lage, 1980–81, Regional Oral History Office, Bancroft Library, University of California, Berkeley, 20–21. For more on debate within the club over publication of Porter's *Galápagos,* see Cohen, *History of the Sierra Club,* 421; Porter, *Eliot Porter,* 56.

19. Eliot Porter, *Birds of North America: A Personal Selection* (New York: Dutton, 1972).

20. Eliot Porter, *Antarctica* (New York: Dutton, 1978); *The Greek World* (New York: Dutton, 1980); *Under All Heaven: The Chinese World* (New York: Pantheon, 1983); *Iceland* (Boston: Bulfinch, 1989); *Monuments of Egypt* (Albuquerque: University of New Mexico Press, 1990). See also Peter Matthiessen and Eliot Porter, *The Tree Where Man Was Born: The African Experience* (New York: Dutton, 1972).

21. Fairfield Porter, *The Nation,* January 1960, 39; Carolyn Merchant, "Appendix B: Feminism and Ecology," in Bill Devall and George Sessions, *Deep Ecology: Living as If Nature Mattered* (Layton, Utah: Gibbs Smith, 1985), 229.

22. David Brower quoting Porter in a letter to John Rohrbach, September 16, 1999, Porter Archives.

23. Valerie Cohen, e-mail communication to the author.

24. Thomas Cole, "Essay on American Scenery," in *American Art, 1700–1960:*

Sources and Documents in the History of Art, ed. John McCoubrey (Englewood Cliffs, N.J.: Prentice-Hall, 1965), 92.

25. For "the geography of hope" see David Brower, ed., *Wilderness: America's Living Heritage* (San Francisco: Sierra Club Books, 1961), 102; and Wallace Stegner, *The Sound of Mountain Water* (New York: Dutton, 1980), 245–53.

26. William Cronon, "The Trouble with Wilderness," in *Uncommon Ground: Rethinking the Human Place in Nature,* ed. Cronon (New York: Norton, 1995), 69–90. See also Rebecca Solnit, *Savage Dreams: A Journey into the Landscape Wars of the American West* (San Francisco: Sierra Club Books, 1994); Alston Chase, *Playing God in Yellowstone: The Destruction of America's First National Park* (Boston: Atlantic Monthly Press, 1986).

27. Eliot Porter, "Address to Los Alamos Honor Students," 1971, Porter Archives.

28. Robert Adams, "C. A. Hickman," in *Beauty in Photography: Essays in Defense of Traditional Values* (New York: Aperture, 1981), 103.

29. Porter, *Eliot Porter,* 44.

II

Alberta Thomas, Navajo Pictorial Arts, and Ecocrisis in Dinétah

Janet Catherine Berlo

In 1981, Alberta Thomas wove an intricate cosmogram within a ground made of light brown sheep's wool (fig. 45). The cosmogram contains a scene, recognizable to any Navajo, in which the Hero Twins of sacred history stand girded for war against the Monsters that plague the world. Their weapons include flint armor, bolts of lightning, painted shields, and sacred tobacco pouches. The center of the image holds four sacred mountains, above which, at each cardinal direction, the twins Monster Slayer and Child of the Water (in a double set) hover. The sustaining plants of life spring from between the mountains. This world is surrounded by a protective rainbow, with an opening to the east. The moon at the north and the sun at the south guard the opening to the sacred enclosure that is the Navajo homeland, Dinétah, where this dazzling spectacle takes place.[1]

Alberta Thomas (1933–93) wove her first rug at the age of ten and sold it at the Shiprock Trading Post for five dollars. Later she proudly recalled buying her first pickup truck with rug money. In her adulthood the patronage of Troy and Edith Kennedy, owners of the Red Rock Trading Post, and an unrelated collector named Edwin Kennedy provided her with a steady income. Her rug money and the income of her husband, Carl, as a miner made the Thomases more prosperous than many other unschooled Navajos of their generation. As I will demonstrate, the narrative of her work and her husband's forms a weave nearly as complex as the one in her textiles, wherein strands of entrepreneurship, creativity, patronage, philosophy, ecology, and corporate greed intertwine.[2]

Many other interlocutors have played roles in this narrative as well, from anthropologists and traders to philanthropists and art patrons, even executives of global energy companies. Looking through the dual lenses of eco-

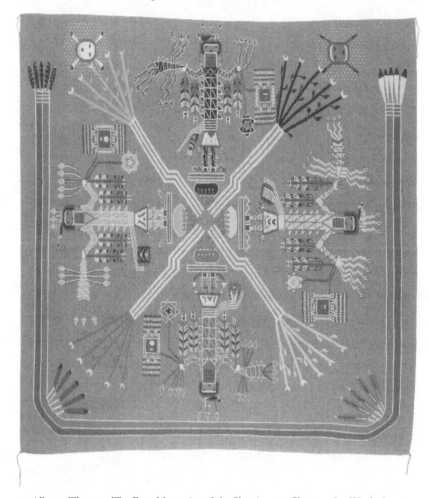

45. Alberta Thomas, *The Four Mountains of the Shootingway Chant,* 1981. Wool. Courtesy Kennedy Museum, Ohio University, Athens, no. 91.023.1.10.

criticism and dialogics, one can examine these interwoven strands and learn much about how Navajos negotiated modern life and ancient tradition during the twentieth century. As in other contexts of Native American art history, the long-term patronage here by a small number of white collectors, traders, and dealers produced certain creative constraints even as it allowed for the development of a multi-layered oeuvre. While the story I present here is in part one of victimization, more upbeat inflections inform the narrative as well. In this context, as elsewhere, we can detect strategies by which Native people

have negotiated modernity as active, entrepreneurial participants, not simply hapless victims.[3]

An Ecocritical Model of Navajo Aesthetics and Epistemology

The Navajo are among the best-known and most thoroughly studied Native American tribes. Their land encompasses some twenty-five thousand square miles of the Four Corners region, where Arizona, New Mexico, Colorado, and Utah meet. More than two hundred thousand Navajos live on the reservation today, with more residing beyond its borders. Over centuries, they have developed an elaborate philosophical and cosmological system, often articulated in ceremonies that include pictorial narratives in the medium of sandpainting.[4]

Sandpainting is an ephemeral art made of the crushed minerals and pollens found on, or extracted from, the southwestern environment. Its artists are the *hataali,* ritual specialists who develop their expertise over many years of apprenticeship and study with the help of assistants (fig. 46). On a bed of packed earth, they painstakingly drop ground substances of different colors, drawing anthropomorphic images of supernatural figures known as Holy People engaged in activities of creation at the beginning of time in specific sacred locales. As part of a longer ritual involving singing, praying, and the use of herbal medicine, a person who seeks physical and/or psychological healing sits within such an image. To occupy the healing force field of a sandpainting is to embody and actualize the central ideal of Navajo culture: *hózhó* (harmony, goodness, wellness, beauty).[5]

Anthropologists and art historians have painstakingly studied the metaphysics and aesthetics of sandpainting since the late nineteenth century. Less appreciated, however, is the way in which such works present a cogent ecological worldview concerning the spiritual and material relationships between human beings and their environment, keyed to a specific sense of place. In the act of constructing a sandpainting, the ritual practitioner seeks to create an ideal diagram of interactions among the Diyin Dine'é (the Holy People), Dinétah (the Navajo land), and the Dine'é (the Navajo or Earth Surface People). Sandpaintings thus provide an artistic model of Navajo cosmology, according to which people, spirits, and the environment are inextricably tied together.[6]

Fundamental to that cosmology is a profound regard for Dinétah, the ancestral homeland of the Navajo. Attachment and rootedness to that specific

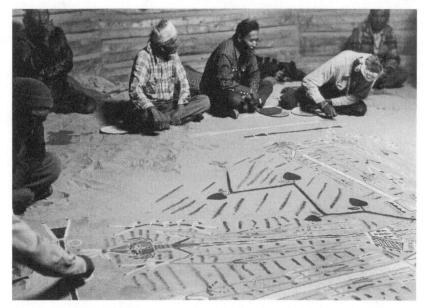

46. Laura Gilpin, *Untitled (Yeibichai, Sandpainting, Near Shiprock, New Mexico),* 1951. Gelatin silver print. © 1979 Amon Carter Museum, Fort Worth, Texas, Bequest of the artist.

place thus underlies all Navajo spirituality, philosophy, and aesthetics. Navajo art, whether abstract or representational, refers to the land both in its materials and iconography. As illustrated in fig. 45, the ancient acts of the Holy People—beginning with creation—unfolded in Dinétah. Since the beginning, the Navajo worldview has asserted the primacy of place, a broadly environmental approach to art that insists upon landscape and geography as the ultimate ground of all creation and creativity.

In the Navajo philosophy of place, the universe is conceptualized as a *hogan,* the traditional tribal house with doorway facing east toward the rising sun. This universe, in turn, contains many subsets of and metaphorical references to home. For example, the Navajo conceptualize Dinétah itself as a *hogan.* Geographically, the area is circumscribed by four sacred mountains: Mount Blanca in Colorado (the east), Mount Taylor west of Albuquerque (the south), the San Francisco Peaks near Flagstaff (the west), and Mount Hesperus in Colorado (the north), forming a parallelogram. While much of the Navajo landscape might strike outsiders as a tough and dramatic wilderness, European concepts such as "wilderness" and "landscape" make no sense in a system in which, at every level, one is within the safety of home.

Many traditional Navajo homes are made of wood, but Carl and Alberta Thomas built theirs out of rocks blasted from the mine where Carl worked. On both a large and a small scale, then, the couple lived within the mountains of Dinétah. Alberta's weaving *The Four Mountains of the Shootingway Chant* (see fig. 45) envisions the universe on a grand scale, with the sacred mountains as the central, pivotal point. In Navajo thought, humans and mountains are kin, intimately bound to one another, such that what happens to the mountains also happens to human beings. We might call this the Navajo version of much more recent Western notions about "deep ecology" and the related Gaia hypothesis, which merge scientific and ethical points of view in representing the world as a living, biological system.[7]

A sense of place is fundamental in the Navajo creation story as expressed in the Shootingway, a ceremony recounting the exploits of the Sun and his sons, the Hero Twins (an episode of this ceremony is pictured in fig. 45). After the Sun taught his boys the art of making sandpaintings representing the skies and his own house, he took them to a mountaintop "and showed them the whole universe, pointing out every important spot and drilling them on the names of the places he mentioned," as one scholar has summarized the story.[8] This may be one of the few creation stories in which a geography quiz figures as part of the narrative.

In Shootingway sandpaintings, the Hero Twins embark upon a perilous journey to rid the world of "monsters," a term referring not only to mythic enemies but to ills that plague the world. The twins failed to conquer Old Age, Poverty, and Hunger, however. For that reason, according to the Navajo, such ailments plague people still.

More than a dozen scenes from the Shootingway are among some five dozen pictorial textiles known as "chant weaves" made by Alberta Thomas, her older sister Anna Mae Tanner (1929–93), and their mother, Despah Tutt Nez (1903–2002) since the 1950s.[9] These works testify not only to the extraordinary skill of this family but also to the complex web of relationships forged during the twentieth century that conjoin the specialized knowledge of weavers and ritual practitioners with the diverse interests of numerous outside constituencies. To weave such textiles, these women referred to books given to them by the Red Rock Trading Post owners, as I will discuss more fully below. Thus encouraged by local traders to work on commission for a patron with the help of books illustrating traditional designs, the weavers and their textiles embodied the profoundly dialogic nature of this Navajo art form.

The Dialogics of Sandpainting and Weaving

Anthropologists Dennis Tedlock and Bruce Mannheim have observed that "the shared worlds that emerge from dialogues are in a continuous state of creation and recreation, negotiation and renegotiation." This certainly holds true for Navajo artistic practices. The dialogic method of cultural interpretation stems from the work of Mikhail Bakhtin (1895–1975), who theorized it in 1934/1935 in a now classic study of the novel as a literary form capable of encompassing diversity in the modern age. Tedlock, a cultural anthropologist specializing in Native American performance and oral narratives, has borrowed Bakhtin's ideas in developing an understanding of the transcultural collaborations between ethnographers and indigenous peoples. Among the more useful Bakhtinian insights for Tedlock was the notion that language unfolds dialogically, constructing meaning not through individual utterances but through the context of communicative acts between and among people. Tedlock applied this not only to culture-making but to the cross-cultural making of meaning. Such a position recognizes the inescapability of *heteroglossia* (another of Bakhtin's terms), whereby "culture" develops not as an authoritative monologue but with a multiplicity of voices, including that of the outside field-worker (or, for our purposes, the trader or patron), who affects meaning even as he or she records it. Following Bakhtin, Mannheim and Tedlock have proposed that "all present discourse is already replete with echoes, allusions, paraphrases, and outright quotations of prior discourse." These ideas are relevant for my discussion in terms of the practice of art-making, the interventions in such practices by outsiders, and the reciprocal spiral of those interventions.[10]

Navajo epistemology of the sacred is inherently dialogic. Unlike the Old Testament, for example, the Navajo story of creation is less fixed and codified, despite having been written down in several versions during the modern era. Indeed, it can change with each ritual practitioner's knowledge and as a result of his or her manner of expression, both orally and visually. Moreover, the recording of Navajo sandpainting ceremonies and images has been a dialogic practice for over a century, involving a range of interlocutors including doctors, anthropologists, Catholic priests, and traders as well as artist-practitioners both Native and non-Native. Ritual practitioners and artists today even regard such recorded sandpainting ceremonies as legitimate sources of information about Navajo culture for use in future ceremonies.

In the 1880s, when U.S. Army surgeon Washington Matthews "discovered" sandpaintings, he worked closely with *hataali,* but he, rather than they, made the drawings. Matthews noted that some of the ceremonialists later would bring their apprentices to see and discuss his drawings. By the 1930s, a number of scholars and students of Navajo religion were publishing their own drawings (made with permission of sacred practitioners) as well as drawings made by *hataali* themselves.[11]

Well-respected *hataali,* including Miguelito and Hosteen Klah, collaborated with outsiders, including a number of white women. Franc Newcomb (a trader's wife and avocational student of Navajo culture), Gladys Reichard (an anthropologist), and Mary Cabot Wheelwright (a philanthropist), among others, produced drawings or watercolors for publication. The full range of such collaborations is extensive; it has been estimated that more than sixteen hundred such drawings exist in archives and museums as a result of cross-cultural collaboration. These dialogic encounters have continued in successive generations. Many of the sandpainting images that Alberta Thomas and other weavers at Red Rock have been replicating in their textiles since the middle of the twentieth century were copied from the publications resulting from the collaborations just noted. This was a new collaborative venture (one geared to the art market rather than the market for intellectual knowledge), in which Red Rock Trading Post proprietors Edith and Troy Kennedy distributed these publications to weavers and commissioned sets of images from different chants. Thus, the dissemination of knowledge about sandpaintings has been one of the key loci for dialogic interactions between Navajo intellectuals and a diverse group of interlocutors.[12]

This dialogic practice has fostered the modern understanding, preservation, and spread of Navajo religious and artistic knowledge within and beyond the Navajo Nation. In recent years, the repatriation of objects and the protection of indigenous knowledge systems have become important issues for many Native Americans. In raising such issues, some Native people have adopted an essentialist position regarding who has the right to know, own, or publish certain things, while often characterizing the work of anthropologists as a form of colonialism.[13]

Anthropology certainly has a checkered history as an intellectual project not far removed from more aggressive aspects of colonial power. Yet, it is simplistic to condemn that discipline out of hand, especially in the light of the productive dialogic exchanges between anthropologists and Native cere-

monialists. While imbalances of power have tended to color relationships between anthropologists and indigenous peoples, for many decades Navajo ceremonialists have willingly collaborated with non-Natives—not just those among the latter group who paid for such knowledge but also those who showed a persistent and sincere interest in Navajo ways, including some who have received ceremonial blessings themselves. Despite the many conflicts, animosities, and betrayals they have endured over time, the Navajo have managed to preserve a significant amount of tribal knowledge through dialogic, transcultural collaboration with Euro-Americans.

Of "Monsters" and Mining: Navajo Aesthetics and Environmental Realities

Long- and deeply held Navajo beliefs about the importance of environmental harmony emerge not only in sandpaintings and weavings but also in the work of tribal ecological activists. In a book about such activism, John Sherry has written:

> Scattered across the homeland, a large number of sacred places provide a living reminder of the past struggles, tying these sacred stories concretely to the physical environment. *Tsoodzil*—Mount Taylor—the sacred mountain of the south, marks the place where Monster Slayer and Child Born of Water killed *Yé'iitsoh,* the Big Giant. Shiprock, the giant basalt formation in northwestern New Mexico, is the place where Monster Slayer finally subdued the Monster Eagle. The land is covered with such sacred sites.
>
> Now the landscape is dotted with a new class of Alien Monsters: oil rigs, coal drag lines, power plants, logging trucks, and uranium mines, to name but a few. They are a different breed. For one thing, they are only the contact points, the obvious evidence of monsters that are actually far more intractable, vast, and diffuse. Every mine and power line indexes a whole system, a complex infrastructure that includes not only mechanical, chemical, and electronic components but social ones as well, including systems of labor, finance, and even ways of thinking.[14]

Sherry's observations reveal a disturbing truth about the immediate historical context and environmental conditions faced by Alberta Thomas, her hus-

band, and other Navajos at Dinétah during the late twentieth century: new ecological "monsters" associated with industrial resource extraction, including devastating pollution caused by nearly four decades of uranium mining. That radioactive substance was mined in several locations around Dinétah: in the south, near sacred Mount Taylor; in the west, on the way to the San Francisco peaks; and, most of all, in the north in the Carrizo and Lukachukai mountains en route to Mount Hesperus. In the west, near Tuba City, Arizona, and in the east, near Shiprock, New Mexico, the permanent legacy of the cold war nuclear age can be seen in the huge mountains of tailings (radioactive waste from the process of uranium extraction), some reaching heights of seventy feet and lengths approaching a mile. The sacred geography of Dinétah has been literally irradiated, such that land within the four mountains contains some of the gravest environmental pollution in North America.[15]

Uranium was first mined on the reservation in the 1940s to feed the Manhattan Project at the Los Alamos Laboratory in New Mexico. The Kerr-McGee Company mined uranium on Navajo lands from 1948 to 1985, an extremely lucrative business. According to one recent study,

> There were no taxes at the time, and labor was cheap. There were no health, safety, or pollution regulations, and few other jobs for the many Navajos recently home from service in World War II. The first uranium miners in the area, almost all of them Navajos, remember being sent into shallow tunnels within minutes after blasting. They loaded the radioactive ore into wheelbarrows and emerged from the mines spitting black mucus from the dust, and coughing. . . . Such mining practices exposed the Navajos who worked for Kerr-McGee to between one hundred and one thousand times the limit later considered safe for exposure to radon gas.[16]

Many former miners and their family members have testified about the conditions in the mines. One anonymous Navajo worker offered the following recollections during a 1999 radio interview: "When I was on the job, only white men dressed for safety and went down into the tunnel. They never told us. They never asked us to wear these things. . . . We'd go home with our clothes stained yellow with uranium. To us it looked like the corn pollen we used in our ceremonies. We used to drink the water from the mines. It was

cool."[17] Some older Navajos speak metaphorically about uranium as a monster, using terminology borrowed from tribal history and cosmology. For example, in 1997 Anna Rondon observed the following:

> In our Navajo creation story we have always learned that uranium—the Navajo call it "cledge" from the underworld in our creation stories—was to be left in the ground. It is a yellow substance. We knew that from our legends. We were told from the gods in our songs and our creation stories that we had a choice, a choice between uranium and yellow corn pollen that we pray with every morning and carry in our medicine bags. The yellow corn pollen possesses the positive elements of life in our belief. We chose that way, which is the beauty way of life. Uranium was to remain in the ground. . . . It will bring you evil, death, and destruction, and we are at that brink today.[18]

Another Navajo, George Tutt, remembered this: "Down in the mine where I worked, ore extended out in yellow rock formations. The ore looked like a huge snake. When you blasted a whole wall, you could see the heads, bodies, and tails of big snakes. They may have been alive in the beginning of time. They were very yellow. We were told that this ore was high grade uranium. We were completely unafraid to handle it, because we did not know the danger from its radiation. We only worked to get food for our families." In the past five decades, high levels of death, cancer, miscarriage, and birth defects (in both humans and animals) have been widely recorded on the reservation. The word for cancer in Navajo is *chlodonatzeeyee,* which translates as "no medicine will ever cure it."[19]

As discussed above, the Navajo home is a miniaturized version of the cosmos, within which dwells *hózhó,* harmony and goodness. Homes are built from the material of Mother Earth. Alberta Thomas's husband, Carl, worked in the uranium mines from 1947 to 1967. The couple lived nearby, in the home they built of discarded rocks from the mines. When Harold Tso, the director of the Environmental Protection Commission of the Navajo Nation, was testing with a Geiger counter in 1979, he stopped to visit with the Thomases: "I was standing beside a home talking to people, holding my instrument casually," said Tso. "Suddenly I noticed the needle went crazy. It was registering the uranium count of the family home." He testified at a congressional hearing the following year that on that day his instrument recorded more than 100 rems of gamma-emitting radioactivity. Five

rems per year is the maximum permissible exposure level. The rocks used in the construction were waste ore from the mines. In the same hearing, Carl Thomas testified: "In 1969 I became very ill. I have a problem with my throat, with my lungs. My breathing became very difficult. I was told by the doctor that I was sick and this was a result of working in the mines. This is what I know. . . . Most of us, I would say all of us, didn't smoke. We never did use cigarettes at that time. Most of those workers I was with at the time have passed away. I worked in this certain mine and I am the only one that still exists." Of his house, he said only: "I built this house and I didn't know that it contained high radiation, uranium. I still live in that house. I was told that it is very dangerous to live in this stone house. I don't have any money. I don't work. There is no way that I could get money to build me a house that does not contain radiation from uranium."[20]

Carl Thomas had a steady job until 1967; subsequently, Alberta supported their household by weaving on commission to Edwin Kennedy. Kennedy began this collection in 1954 when, as a financial adviser to Kerr-McGee, he traveled to the Red Rock area to inspect mining operations. He was on Kerr-McGee's board of directors from 1949 to 1990, a major shareholder, and a member of its executive committee.[21]

Alberta Thomas wove for fifty years. Of her patron Edwin Kennedy, she said, "He bought most of my rugs from Red Rock Trading Post; he pays me a good price and then he would send me a bonus if the rug was extra good." As the Navajos say, and as an ecocritical perspective reminds us, everything *is* related. One of the great instances of patronage of indigenous arts in the American Southwest in the second half of the twentieth century was predicated on money that Kerr-McGee earned at the expense of the lives of Navajo miners.[22]

In the sandpainting ceremony, the individual seeking harmony and well-being sits in the ritually diagrammed landscape made from the crushed rocks and pollens that are the fabric of the earth. The aim is to seek unification of human and natural worlds in such a way that "landscape" cannot possibly be a separate construct. In the words of a well-known Navajo prayer, "Earth's feet have become my feet; by means of these I shall live on. Earth's body has become my body; by means of this I shall live on." The sad reality is that it is the Monster *leetso,* uranium, that shall live on, for the half-life of uranium is 4.5 billion years. Nonetheless, Navajo philosophy requires that one think positive thoughts. One must think the world into beauty, and weave the world into beauty, for that is the Navajo way. Ceremonial special-

ists make it clear that chant weaves are not ritually activated the way sand-paintings themselves are; they are reproductions.[23] But to weave is to create *hózhó*. In an irradiated home, or a despoiled world, a weaver's act of resistance builds beauty, harmony, and goodness, one weft at a time.

Postscript

In April 2005 the Navajo Nation enacted the Diné Natural Resources Protection Act, banning all uranium mining and processing on the reservation, with Nation president Joe Shirley Jr. declaring, "I believe we reinforced our sovereignty today." In August 2006, Kerr-McGee, a Fortune 500 Company in operation since 1929, with a market value of $11.3 billion, ceased to exist when it was acquired by Anadarko Petroleum. In November 2006 the *Los Angeles Times* published a four-part series on uranium pollution and the Navajo Nation that was the most in-depth examination of the issue in the national media in the last twenty-five years. In December 2006 more than three hundred participants from nine countries convened the Indigenous World Uranium Summit in Window Rock, Arizona, the capital of the Navajo Nation. They unanimously endorsed a declaration opening with the following statement:

> We, the Peoples gathered at the Indigenous World Uranium Summit, at this critical time of intensifying nuclear threats to Mother Earth and all life, demand a worldwide ban on uranium mining, processing, enrichment, fuel use, and weapons testing and deployment, and nuclear waste dumping on Native Lands.
>
> Past, present and future generations of Indigenous Peoples have been disproportionately affected by the international nuclear weapons and power industry. The nuclear fuel chain poisons our people, land, air and waters and threatens our very existence and our future generations.[24]

Notes

I am grateful to Alan Braddock for the invitation to take part in this landmark venture down a new avenue for the investigation of visual culture. He and Christoph Irmscher improved my essay immeasurably through their deft editorial suggestions. Critical readings of the essay by Bill Anthes, Norman Vorano, Aldona Jonaitis, Ruth Phillips, and Emily Neff helped to sharpen my ideas. I am particularly grateful to

my valued friend and colleague Jennifer McLerran, former curator of the Kennedy Collection at Ohio University, for critiquing this essay, sharing her vast knowledge with me, facilitating my examination of the textiles in that collection, and sharing her files on uranium poisoning as it affected the weavers of Red Rock and their families. As a longtime admirer of the natural history writings of Barry Lopez and Terry Tempest Williams, I thank these creative writers whose wise ethical voices have shaped my knowledge of the landscape, ecology, and soul of this continent.

1. For a fuller explanation of the iconography of this image see Gladys Amanda Reichard, *Navajo Medicine Man Sandpaintings* (1939; New York: Dover, 1977), 64–66.

2. The anecdote about Alberta Thomas appears in Frederick Dockstader, *Song of the Loom: New Traditions in Navajo Weaving* (New York: Hudson Hills Press, 1987), 130. The full story of the Red Rock weavers is recounted in Jennifer McLerran, "Woven Chantways: The Red Rock Revival," *American Indian Art Magazine* 26 (Winter 2002): 64–73.

3. For another study of long-term patronage of a Native artist see Marvin Cohodas, *Basket Weavers for the California Curio Trade* (Tucson: University of Arizona Press, 1997). For many years, Elizabeth Hickox (1872–1947) of the Lower Klamath River area of northern California wove baskets on an exclusive contract to Pasadena collector and dealer Grace Nicholson. Having a patron who bought everything allowed Hickox to make original, unique baskets with more than eight hundred stitches per square inch at a time when nothing in her local culture rewarded such painstaking artistry. For a study of Navajo entrepreneurship as a negotiation of modernity see Colleen O'Neill, *Working the Navajo Way: Labor and Culture in the Twentieth Century* (Lawrence: University Press of Kansas, 2005).

4. Elucidation of Navajo philosophy and aesthetics can be found in works by both non-Native scholars and Native intellectuals. See, for example, Klara Kelley and Harris Francis, *Navajo Sacred Places* (Bloomington: Indiana University Press, 1994); Leland Wyman, *Blessingway* (Tucson: University of Arizona Press, 1970); Gary Witherspoon, *Language and Art in the Navajo Universe* (Ann Arbor: University of Michigan Press, 1977); Paul Zolbrod, *Diné Bahane': The Navajo Creation Story* (Albuquerque: University of New Mexico Press, 1984). Recent literary treatments include Irvin Morris's novel *From the Glittering World* (Norman: University of Oklahoma Press, 1997) and Luci Tapahonso's collection of poems *Blue Horses Rush In* (Tucson: University of Arizona Press, 1997).

5. Excellent studies of Navajo ritual specialists include Franc Newcomb, *Hosteen Klah: Navajo Medicine Man and Sandpainter* (Norman: University of Oklahoma Press, 1964); and *Navajo Blessingway Singer: The Autobiography of Frank Mitchell,* ed. Charlotte Frisbie and David McAllester (Tucson: University of Arizona Press, 1978). The term *hózhó,* which is key to Navajo aesthetics and ritual, is difficult to render

succinctly in English; anthropologist Clyde Kluckhohn once suggested that this difficulty is a reflection of the poverty of the English language, which lacks terms that simultaneously connote morality and aesthetics. In the Navajo language and worldview, in contrast, aesthetics and morals are inseparable. See Kluckhohn, "The Philosophy of the Navaho Indians," in *Readings in Anthropology,* ed. Morton M. Fried, 2nd ed. (New York: Thomas Y. Crowell, 1968), 2:674–99.

6. The first outsider to record sandpaintings was Washington Matthews, "The Mountain Chant: A Navajo Ceremony," in *Fifth Annual Report of the Bureau of American Ethnology for the Years 1883–1884* (Washington, D.C.: Government Printing Office, 1885), 379–467. The literature on this topic is now vast. Gary Witherspoon notes that *Diyin* may be translated as "immune," for the Holy People "are immune to danger, destruction, and death as a reflection of their inherent knowledge." Ritual allows the Earth Surface People to partake in such knowledge. See Witherspoon, "Language and Reality in Navajo World View," in *Handbook of North American Indians,* vol. 10, *Southwest,* ed. Alfonso Ortiz (Washington, D.C.: Smithsonian Institution, 1983), 575. *Dine'é* is the proper word to characterize Navajo people collectively, yet it is more commonly seen as the singular *Diné.*

7. "Deep ecology" concerns itself with issues that are not merely human centered (for example, how ecological problems affect human health) but go beyond the anthropocentric to the ecocentric. In an ecocentric view, other species and natural processes have intrinsic value rather than simply instrumental value for humans. Such beliefs are akin to those expressed by many Native Americans. The term "deep ecology" was coined by Norwegian philosopher Arne Naess in 1973 and published in "The Shallow and the Deep, Long Range Ecology Movement: A Summary," *Inquiry* 16 (1973): 95–100. See also Bill Devall and George Sessions, *Deep Ecology: Living as If Nature Mattered* (Salt Lake City: Peregrine Smith, 1985).

8. The quote is from Reichard, *Navajo Medicine Man Sandpaintings,* 44. The Shootingway is the most complex and frequently performed ceremony, associated with more sandpaintings than any other chant. It is used for troubles caused by thunder, lightning, snakes, and arrows, as well as numerous physical ailments. Leland Wyman, "Navajo Ceremonial System," in *Handbook of North American Indians,* 10:545.

9. See Laura Banish, "Threads of Culture and Love," *Albuquerque Journal,* August 16, 2002.

10. Dennis Tedlock and Bruce Mannheim, eds., *The Dialogic Emergence of Culture* (Urbana: University of Illinois Press, 1995), quotes on 2 and 7. See Mikhail Bakhtin, *The Dialogic Imagination,* ed. Michael Holquist, trans. Caryl Emerson and Michael Holquist (Austin: University of Texas Press, 2004); and Tzvetan Todorov, *Mikhail Bakhtin: The Dialogical Principle* (Minneapolis: University of Minne-

sota Press, 1984). See Dennis Tedlock, "The Analogical Tradition and the Emergence of a Dialogical Anthropology," *Journal of Anthropological Research* 35 (1979): 387–400.

11. On Matthews see Nancy Parezo, "Matthews and the Discovery of Navajo Drypainting," in *Washington Matthews: Studies of Navajo Culture 1880–1894,* ed. Katherine Halpern and Susan McGreevy (Albuquerque: University of New Mexico Press, 1997), 65. In 1920 the respected medicine man Miguelito made drawings for John Huckel, one of the owners of the Fred Harvey Company. Miguelito later allowed Franc Newcomb both to aid him in laying down the sandpaintings in ceremony and to record his sandpaintings in her notebooks. Newcomb relates that she learned to memorize the sandpaintings as they were being constructed, only later drawing them in her notebook. Moreover, her teacher took great pride in her memorization skills. See Franc Newcomb and Gladys Reichard, *Sandpaintings of the Navajo Shooting Chant* (1937; New York: Dover, 1975), 3–4.

12. Parezo, "Matthews and the Discovery of Navajo Drypainting," 70, estimated the number of sandpainting drawings in museums. For examples of collaboration see Hosteen Klah and Mary C. Wheelwright, *Navajo Creation Myth* (Santa Fe: Museum of Navajo Ceremonial Art, 1942); and Newcomb and Reichard, *Sandpaintings of the Navajo Shooting Chant.* On the extraordinary Catholic priest Berard Haile, who became a prominent scholar of Navajo language and culture, see William Lyon, "Ednishodi Yazhe: The Little Priest and the Understanding of Navajo Culture," *American Indian Culture and Research Journal* 11, no. 1 (1987): 1–41. The work of Red Rock weavers has been well documented by Jennifer McLerran, who points out that although many of these weavers were the relatives of *hataali,* their designs came from books rather than from the ritual practitioners who were their relatives ("Woven Chantways," 66–70). Many of the resultant textiles, the books distributed to weavers, and the notes recorded by Edith Kennedy are housed in the Kennedy Museum at the University of Ohio.

13. For an introduction to such debates see Michael Brown, *Who Owns Native Culture?* (Cambridge, Mass.: Harvard University Press, 2003); and Kathleen Fine-Dare, *Grave Injustice: The American Indian Repatriation Movement and NAGPRA* (Lincoln: University of Nebraska Press, 2002).

14. John Sherry, *Land, Wind, and Hard Words: A Story of Navajo Activism* (Albuquerque: University of New Mexico Press, 2002), 9.

15. In 1978 the United States' biggest spill of radioactive materials—one hundred million gallons of radioactive water—burst from a dam on the reservation and contaminated the Rio Puerco River near Mount Taylor. Donald Grinde and Bruce Johansen, *Ecocide of Native America: Environmental Destruction of Indian Lands* (Santa Fe: Clear Light Press, 1995), 211.

16. Ibid., 208.

17. Miner quoted from an archived transcript of a radio broadcast, "Navajo Uranium Miners," by Sandy Tolan, December 31, 1999, *Living On Earth,* World Media Foundation/Harvard University. See also "Occupational Health Hazards of Older Workers in New Mexico: A Hearing Before the Special Committee on Aging," Grants, New Mexico, August 30, 1979, *United States Senate, 96th Congress, First Session* (Washington, D.C.: Government Printing Office, 1980). For substantive oral histories with former uranium miners see Doug Brugge, Timothy Benally, and Esther Yazzie-Lewis, *The Navajo People and Uranium Mining* (Albuquerque: University of New Mexico Press, 2006).

18. Anna Rondon, "Uranium, the Pentagon, and the Navajo People," in *Metal of Dishonor, Depleted Uranium: How the Pentagon Radiates Soldiers and Civilians with DU Weapons,* comp. and ed. by the Depleted Uranium Education Project, 2nd ed. (New York: International Action Center, 1997), 94.

19. The interview with George Tutt from Oak Springs, Arizona, appears in Navajo Uranium Miner Oral History and Photography Project, *Memories Come to Us in the Rain and the Wind* (Jamaica Plain, Mass.: Red Sun Press for the Environmental Health Policy Information Project, Tufts School of Medicine, 1997), 16. A full accounting of the epidemiological evidence is beyond the scope of this essay; the evidence of one doctor's experience with the inhabitants of Red Rock, Arizona, who were stricken with lung cancer will suffice: "From January 1970 to June 1973, eight former uranium miners saw LaVerne Husen, then a newly arrived young doctor. . . . Two of them were over 60, the others were 45, 43, 39, 33, and 31 years of age. They all died within a year of diagnosis." See Molly Ivins's report in "Uranium Mines in the West Leave Deadly Legacy," *New York Times,* May 20, 1979, 1, 44. The translation of the Navajo word for cancer is from Tolan, "Navajo Uranium Miners."

20. Tso quoted in Kathie Saltzstein, "Red Valley Residents Fear Silicosis, Leukemia, Defects," *Gallup Independent,* April 3, 1980. Other data are from "Occupational Health Hazards of Older Workers in New Mexico," 32, 40.

21. See "Edwin Kennedy, Kerr-McGee, and Uranium Mining," on the Web site of the Kennedy Museum of Art, University of Ohio, http://www.ohiou.edu/museum/hoskerr.htm.

22. Alberta Thomas quoted in Dockstader, *Song of the Loom,* 120. Edwin Kennedy gave Ohio University six hundred Navajo textiles and a substantial collection of southwestern jewelry. Of some one hundred chant weaves, sixty-three are by Despah Nez and her two daughters; others were given to the Maxwell Museum at the University of New Mexico, and some went to other collections (Jennifer McLerran, personal communication, January 2007). Kerr-McGee's other international industries

have included oil drilling and refining, coal mining, natural gas operations, and, as some may remember from the 1983 film *Silkwood,* nuclear power plants.

23. The prayer is from David P. McAllester, ed., *The Myth and Prayers of the Great Star Chant and the Myth of the Coyote Chant* (1956; Tsaile, Ariz.: Navajo Community College Press, 1988), viii. The perspective on chant weaves was a personal communication from ceremonial practitioner Ronald Largo to Jennifer McLerran during consultations held at the Kennedy Museum in 2001.

24. For the declaration see http://www.grandcanyontrust.org/whatsnew/ documents/UraniumNavajoresolutionFeb_08.pdf. For Kerr-McGee financial data see http://money.cnn.com/magazines/fortune/fortune500/snapshots/737.html. Also see Judy Pasternak, "Blighted Homeland," *Los Angeles Times,* November 19–22, 2006; and "Summit Declaration Demands Worldwide Ban on Uranium," *Indian Country Today,* December 22, 2006.

12

Reframing the Last Frontier

Subhankar Banerjee and the Visual Politics of the Arctic National Wildlife Refuge

Finis Dunaway

"Cast your eyes on this," implored Senator Barbara Boxer, a Democrat from California, as she stood on the Senate floor and showed her colleagues a picture of a polar bear (fig. 47). A clear blue sky delineates the top of the image, while below, a polar bear lumbers across the ice, its large white figure strikingly reflected in the water. Taken by Subhankar Banerjee in the Arctic National Wildlife Refuge (ANWR), the photograph, according to Boxer, offered compelling visual evidence as to why drilling should not take place in this remote Alaskan landscape. President George W. Bush and leading Republicans hoped to open the region to oil development, but Boxer maintained that such actions would threaten the habitat of the polar bear and other Arctic creatures. So on March 19, 2003, in the midst of a heated debate, she continued to display Banerjee's photographs and to urge her fellow senators to vote in favor of an amendment to prevent drilling. Just before the vote was taken, Boxer held up a copy of the photographer's book, *Arctic National Wildlife Refuge: Seasons of Life and Land,* and recommended that everyone visit an exhibition of Banerjee's "breathtaking" photographs, soon to open at the Smithsonian Institution's National Museum of Natural History. The Senate, much to the dismay of the Bush administration, approved Boxer's amendment by a vote of 52–48, thus forestalling, at least temporarily, plans to drill in ANWR.[1]

Yet strange reports began to surface a few blocks away, as officials at the Smithsonian decided, only a few weeks before the show's debut, to eviscerate the captions and relegate the exhibit to an obscure location. Their actions, clearly made in response to Boxer's speech, triggered an unexpected controversy. Before it subsided, a relatively unknown nature photographer would

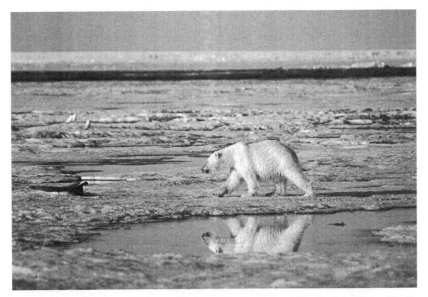

47. Subhankar Banerjee, *Polar Bear on Bernard Harbor (Oil and The Caribou, Barter Island)*, 2001. Ultrachrome print. Courtesy of the artist.

find himself embroiled in the culture wars that often erupt on the National Mall, a debate over visual politics that intersected with a range of issues of interest to scholars in American studies, environmental studies, and visual culture. Banerjee's photographs raise important questions about environmental aesthetics and the idea of wilderness, about the relationship between texts and images in visual culture, and about the ongoing contest over how to define the Arctic in the nation's spatial imagination. For Bush and other drilling proponents, ANWR represents a frontier of economic possibility, a terrain filled with valuable oil reserves; for most environmentalists who oppose drilling, the wildlife refuge signifies pristine nature, a sacred space far removed from the problems of contemporary life. Banerjee's images, paired with selected nature writings and other environmental texts, clearly draw on the latter tradition. Yet they also gesture toward an alternative way of viewing the region: not as separate and remote, a faraway land disconnected from the rest of the United States, but rather a space vitally connected to national and even global ecosystems, a landscape valued not only for its special and unique qualities but also because of its crucial links to places closer to home. From this perspective, which often exists uneasily with other ideas presented

in the Banerjee exhibition and the companion catalog, the Alaskan Arctic should not be considered the last frontier but rather a place intimately tied to the history and ecology of the modern world.[2] *How will this be argued*

Banerjee's photography glorifies the Arctic and makes the refuge appear as a hallowed place deserving protection. This approach would seem to follow that of other American artists who venerated wild landscapes in the hopes of arousing powerful emotional responses in their audiences. Using the camera to visualize their faith in nature, photographers like Ansel Adams filtered their emotions through the machine, creating iconic images that shaped modern perceptions of the natural world. Banerjee indeed locates himself within this tradition and often describes the Arctic in spiritual and emotional terms. Yet even as his photographs portray the refuge as sacred, Banerjee also reimagines the wilderness as part of larger ecological systems, not an enclave set apart from modern life. This idea of connectedness, one shared by a growing number of ecologists and environmental activists, respects the distinctive qualities of the refuge while also reincorporating it into a broader vision of global ecology. Viewers of the Smithsonian show probably found it difficult, if not impossible, to glean this idea from the photographs, as the museum's deletion of the captions effectively silenced this theme. Yet the full exhibit, revived by the California Academy of Sciences in the fall of 2003, matched texts with images in an innovative manner to reveal Banerjee's ecological emphasis, thus marking an important departure from the traditional way of looking at the American wilderness.[3]

For Subhankar Banerjee, the Arctic exhibit signaled the beginning of a new career. Born to a middle-class family in Calcutta in 1967, Banerjee completed a bachelor's degree in electrical engineering and then moved to the United States in 1990 to attend New Mexico State University, where he earned master's degrees in both physics and computer science. While he was in New Mexico, a backpacking trip through the Gila National Forest stirred his interest in the environment of the region. "In India I was a city boy," Banerjee writes. "In the American Southwest I was drawn irresistibly to the wide-open spaces. I joined the Sierra Club and soon found myself hiking frequently in New Mexico's mountains." Banerjee began to take photography courses and to bring a camera along on his hikes. "Nature was now my classroom," he explains, "and my new path was capturing images of wild things on film."[4]

This new path remained a hobby for many years as Banerjee concentrated

Interdisciplinary = different background = interdisciplinary work

on pursuing his scientific career, first at the Los Alamos National Laboratory in New Mexico and later at the Boeing Company in Seattle. In the meantime he traveled frequently across much of North America, hoping to experience different wilderness settings and to improve his photographic skills. Banerjee cites one moment in particular as representing the epiphany that would lead him to quit his lucrative job and journey for more than a year through the Arctic National Wildlife Refuge. In the fall of 2000 he visited Churchill, in northern Manitoba, Canada, to take pictures of polar bears. It was, he recalled, "an arresting moment. But I also saw too many people, each scrambling for pictures. My entire being became galvanized with the desire to witness polar bears in a wild landscape untrammeled by tourism or industry."[5]

Banerjee's displeasure at the crowds gazing at polar bears echoed a familiar complaint made by American nature writers and environmental advocates, who have often worried that tourism would render wild places inauthentic. Like Banerjee, they coupled this anxiety about the loss of wildness with a desire to find a new frontier where they could feel a sense of solitude, of being set apart from the masses and experiencing nature in its most authentic state. After he heard about the Arctic National Wildlife Refuge, Banerjee began to turn his eyes northward, to imagine polar bears crossing the ice and to envision himself standing alone in nature, far from the crowds.[6]

Banerjee's view of ANWR was undoubtedly shaped by his involvement with the Sierra Club and other environmental organizations, which have promoted a vision of the Arctic as a sacred domain not yet corrupted by civilization. Indeed, many commentators have described ANWR as a remnant of the original frontier, the only remaining outpost of untrammeled nature in the United States. *National Wildlife* magazine, in a pair of articles published in the 1990s, defined the region as both a "fragile frontier" and the "last frontier." In a similar fashion, the U.S. Fish and Wildlife Service, the government agency responsible for managing the refuge, emphasizes the frontier myth in its ANWR pamphlet. Distributed at the entrance to the Banerjee show at the Burke Museum of Natural History and Culture in Seattle, where I saw the exhibit, the pamphlet celebrates the refuge as "a frontier—perhaps America's last—like those that helped shape America's distinct cultural heritage. Here conditions exist like those that once surrounded and shaped us—as individuals and as a Nation." In these examples, ANWR appears as a landscape of frontier nostalgia, removed not only in space but also in time from the con-

So then how is it connected?

temporary United States, a place—like the frontier described by the historian Frederick Jackson Turner in 1893—that remains essential to the maintenance of American national identity.[7]

Less than six months after his epiphany in Manitoba, Banerjee quit his job, liquidated his retirement account, and headed for the Alaskan Arctic, hoping to produce a comprehensive photographic record of the wildlife refuge during all four seasons. Meanwhile, a newly inaugurated George W. Bush tried to fulfill his campaign promise to make drilling in ANWR a centerpiece of his national energy policy. Banerjee's decision to travel through the Arctic thus coincided with a renewed effort, spearheaded by Bush and other Republicans, to clear the way for oil production in the region.

The ongoing debate over ANWR centers on its northernmost section, the coastal plain along the Beaufort Sea. Established in 1960, the Arctic National Wildlife Refuge doubled in size twenty years later, with much of its area at that time designated as permanent wilderness. Yet the coastal plain did not receive this added protection and instead remained in legislative limbo, its eventual fate to be decided when Congress could either extend wilderness status or allow oil development there. Presidents Reagan and Bush père both pushed for drilling, but the infamous *Exxon Valdez* disaster in 1989, in which ten million gallons of oil spilled into southern Alaska's Prince William Sound, made this position politically untenable. The issue lay relatively dormant for a few years, cropping up again in 1995 when Congress approved a pro-drilling measure, roundly vetoed by President Clinton. The ascendancy of George W. Bush, together with a Republican majority in both houses of Congress, reactivated the debate and reenergized the hopes of drilling proponents.[8]

Banerjee claims that he did not consider his journey to the Arctic, at least initially, to be a "political quest." No doubt aware of the raging debate in Washington, D.C., he nevertheless viewed his photographic excursion primarily in personal terms, an opportunity, he says, to find "a place that would inspire me." Still, his effort to photograph the wildlife refuge was inherently political, for he hoped to convey the beauty of this remote land to a wider public. His goal, he explains in the exhibition catalog, was "to capture images that evoke emotion and inspire the audience to care." Banerjee, who until that time had spent much of his adult life studying and working in scientific fields, frequently stresses the feelings and emotions that enliven his photography. "Science definitely helped me immensely to deal with the equipment, the weather and the conditions," he explains, "but I feel science creates a very

rational mind, and I just wanted my passion to take over. When you look at the work, it's very much from the soul."[9]

Banerjee's emphasis on the emotions evoked by ANWR stands in sharp contrast to the view of drilling proponents, who disparage any claims made by environmentalists regarding the coastal plain's scenic beauty. Gale Norton, Bush's secretary of the interior, described the area as a "flat, white nothingness." Standing before his Senate colleagues, Frank Murkowski, a Republican from Alaska, held up a blank white poster and argued that it gave them an accurate and complete glimpse of the coastal plain, a place devoid of any aesthetic value.[10] *is that part of the aesthetic value?*

Banerjee saw it as his mission to challenge this view of the Arctic landscape. If drilling proponents claimed it was a frozen wasteland of nothingness, especially during the long winter months, then he would spend all four seasons in ANWR, using his camera to reveal the vibrant presence of life throughout the year. His effort to record seasonal change linked his project to an established tradition in environmental art and literature. Throughout American cultural history, a number of nature writers, including Henry David Thoreau and Joseph Wood Krutch, along with influential artists such as Sierra Club photographer Eliot Porter, all tried to understand the passage of time in particular landscapes. For these individuals, the four seasons offered the opportunity to appreciate the subtle biological changes that characterize the ecology of a place. Likewise, by photographing seasonal change in the Arctic, Banerjee hoped to immerse viewers in not only the aesthetics of the landscape but also its community of life. He wanted them to recognize that the wildlife refuge, even in the depths of winter, sustained vast numbers of creatures. Using the motif of the four seasons, he wanted them to consider the difference between the temporality of nature, governed by ongoing cycles, and the temporality of modern society, marked by restless, linear change.[11] *show that it is not a vast nothingness or devoid wasteland*

After spending fourteen months in the Arctic and producing a huge collection of photographs, Banerjee lined up an impressive roster of nature writers, scientists, and environmental activists to contribute essays to an exhibition catalog, for which he secured a contract from the Seattle-based Mountaineers Books. His work also piqued the interest of a program official at the Smithsonian's National Museum of Natural History, who decided to plan a major exhibition of Banerjee's photographs to open in May 2003. Banerjee was promised a coveted spot, Hall 10, just off the main rotunda where the massive elephant killed by Teddy Roosevelt welcomes visitors to the museum.

The show would feature approximately fifty of his photographs, along with lengthy descriptive and interpretive captions situating the images within their ecological and historical contexts.[12]

[margin handwriting: Political Spite?]

But these plans changed dramatically following Senator Boxer's remarks on March 19. Two weeks later, Banerjee learned that the show would be moved from its prime spot on the main floor to a narrow corridor downstairs behind an escalator. Once it opened, many visitors would find it difficult even to locate the exhibition space. As one museum volunteer explained to a reviewer, "unless you get lost, you'll never find it." In addition to changing the venue, the museum informed Banerjee that the captions would be al-

[margin handwriting: Why? Reason?]

most entirely eliminated. Rather than providing viewers with any meaningful context, they would offer only the most basic information. Captions that originally contained several sentences would be scaled back to one or two phrases that merely identified the scenes, such as "McCall Glacier: Brooks Range." Smithsonian attorneys then wrote letters to Banerjee and his publisher demanding that future editions of the exhibition catalog remove "any and all references to the Smithsonian Institution or a Smithsonian-sponsored exhibition."[13] *[margin handwriting: Wouldn't the Institution want to protect wild?]*

These developments stunned Banerjee as well as a number of politicians who believed the Smithsonian's decision smacked of censorship and replicated other recent museum controversies on the National Mall. Senator Richard Durbin, a Democrat from Illinois, issued a press release in which he recounted the extensive planning that lay behind the show and then lambasted the museum for the sudden changes. "Just a few days after Senator Boxer mentioned Banerjee's book during a policy debate on the Senate floor," Durbin charged, "the artist was informed the exhibit was being moved to the basement and all the explanatory material was being deleted. You don't have to have a degree in museum studies to figure out something fishy happened." Museum officials claimed that no political pressure was exerted upon them, but nevertheless they felt that Boxer's speech had "politicized" the photographs and, for that reason, decided to strip away any material they deemed too political.[14]

A wide range of newspapers across the United States soon expressed support for Banerjee and outrage at the Smithsonian. The *Los Angeles Times,* responding to the museum's disavowal of outside pressure, sarcastically opined: "Whatever." An editorial in the *St. Petersburg Times* compared the issue with the 1995 *Enola Gay* controversy, which resulted in the National Air and Space Museum caving in to political pressure by displaying, without any

How can one have an informative apolitical museum?

contextual framework, the plane that dropped the atomic bomb on Hiroshima. "When history is rewritten or distorted to make us feel better," the paper argued, "we are collectively diminished." Other commentators connected the controversy to what they viewed as the decline of free expression and open debate during the Bush presidency. Timothy Cahill, writing for the *Times Union* in Albany, New York, argued that "the incident" was "part of a relentless assault on free speech, free thought and dissent that has spread like a cancer since the 2000 election. There is a terror at large that wants to control what we see, think and know. Truth lies bleeding." In a letter to the editor, one reader offered "kudos" to Cahill for revealing "the chilling effect of politics on the venerable Smithsonian Institution." The reader continued, "I hope this assault on free speech will not be tolerated, and that other galleries not beholden to the Bush administration will exhibit his work. It is ironic that we send troops to Iraq in the name of democracy, but seem to have trouble accepting free speech at home. A mature democracy can tolerate dissent."[15]

Angered by the Smithsonian's treatment of Banerjee, officials at the California Academy of Sciences in San Francisco offered to sponsor the exhibit with the original captions intact. The revived show opened to rave reviews in September 2003, generating even more media exposure for Banerjee. For the next three years, the full exhibition of forty-nine photographs, along with a smaller version featuring thirty images, traveled around the United States, appearing in prominent natural history and science museums as well as a number of art galleries and museums. These various sites suggest that Banerjee's photography straddles the line between art and science, that it manages to capture the ecology of the Arctic while also offering audiences an aesthetic vision of the natural world.

Banerjee himself uses both of these discourses to describe his work. Although he often comments on the limits of scientific rationality and emphasizes the spiritual content of his images, he also places his work in the documentary tradition, describing it as an effort to provide "the first-ever documentation of this place." Referencing the popular myth of photographic truth, he claims that he wanted to make distant Arctic scenes accessible to American audiences, to use the camera as a device to register reality and depict the natural world in an accurate and objective manner. Yet he also hoped to elicit an emotional response in viewers. "In essence," he explains, "my Arctic study is both documentary, because it documents the important ecological and cultural aspects of the refuge, and at the same time it is art, be-

cause it is a meditative study of the fragility and vulnerability of a remote and harsh landscape." Blending scientific knowledge with spiritual sentiment, Banerjee hoped his photography could convey both the ecological reality of ANWR as well as the intense emotion he experienced there.[16]

Banerjee's captions, restored to the show by the California Academy of Sciences, revealed a similar fusion of science and passion and provided a broader context within which to view the photographs. Together, the images and texts moved beyond competing frontier visions of ANWR—a battle over whether to preserve therapeutic wilderness or exploit economic resources—to frame the landscape instead as a place that is connected to everyday life in the rest of the United States and beyond. The controversy triggered by the Smithsonian show would probably lead one to assume that Banerjee's captions directly commented upon the ANWR debate, but that was simply not the case. Indeed, I was quite surprised to find that the issue of oil drilling was never explicitly mentioned in the show. Moreover, the arguments often advanced by environmentalists against drilling—the relative paucity of oil available there (according to many estimates, about a six-month supply for the United States); the declining fuel economy of the nation's automobiles, particularly in the age of the SUV, which has dramatically increased the demand for oil; and their belief that energy independence could more readily be gained from conservation than from drilling in Alaska—were not even hinted at by the captions. (These issues were addressed, however, by the catalog.) But if the show did not dwell on the political and economic context of ANWR, a topic that would certainly have raised even more hackles in Washington, D.C., it instead outlined a context too often missing from the debate: the broader ecology of the landscape, including its surprising links to faraway ecosystems.

From the beginning, the exhibition introduced this ecological perspective through captions that described how global warming has altered the region. These effects would not be immediately apparent to the viewer of Banerjee's photographs, so the texts provided a counterpoint to the images, blending science with aesthetics in unexpected ways. In museum exhibits, wall captions usually expand upon the content of images or objects, providing details that reinforce, rather than contradict, the meanings suggested by the items on display. Banerjee's treatment of global warming used captions in a completely different manner, often challenging and undercutting the aesthetic presuppositions embedded in the images. In these juxtapositions of text and image, beauty and ecology collided, producing rich dialectics of meaning.

A perfect illustration of this strategy appeared in the autumn section of

the exhibit. A photograph of *Fleeting Autumn* in the Chandalar River Valley portrays trees ablaze in colors of red, orange, and yellow, set off against a placid blue lake. While the photograph on its own would appear as a snapshot of autumnal beauty, a moment of seasonal change captured by the camera, the text forced viewers to question this obvious reading. The caption suggested that these species—the dwarf birch and golden willow—were new arrivals to this part of the Arctic, moving northward because of the effects of global warming. Rather than offering a transparent image of natural beauty, the photograph, in conjunction with the text, prompted viewers to ask whether the presence of these trees should be considered an emblem of pure wilderness or a product of human history. While Banerjee's work contemplates the cyclical time of nature, this image carries other meanings, reflecting not just seasonal change but also the environmental history of the modern world, a history that has produced global warming and led the dwarf birch and golden willow to migrate further north.

Banerjee has described his aesthetic style as a cross between Ansel Adams and Eliot Porter, two Sierra Club artists who, like him, used photography to galvanize concern for wilderness preservation. To a certain extent, this comparison works, not necessarily for each individual image, but rather for the 2003 show as a whole, which displayed a mix of the wide, panoramic views so often employed by Adams and the close, detailed studies of nature emphasized by Porter. Banerjee's photographs, like Adams's, often feature the sky, an approach eschewed by Porter. Banerjee follows Porter, though, in choosing the medium of color photography as a way to record seasonal change, in contrast to Adams's preference for black and white. His use of color helps counter the notion of ANWR as a lifeless, barren landscape, a vast white nothingness. In Banerjee's photographs, the Arctic appears not as an empty monochrome but as pulsing with life, a diverse environment marked by subtle gradations of color and tone throughout the year. Even the much-maligned whiteness of the landscape yields a variety of shades and hues, along with occasional pockets of color that expand Banerjee's palette.[17]

Banerjee took a number of photographs while flying in an airplane, looking down upon the land. In one of these pictures, a shot of caribou migrating across a frozen river, the aerial perspective reveals vast expanses of ice and snow that stretch beyond the boundaries of the frame (fig. 48). While whiteness dominates the scene, broad patches of blue ice offer unexpected swirls of color glistening amid the frozen surround. The panoramic view from above conveys a sense of openness, suggesting the wide spaces of the Arctic and the

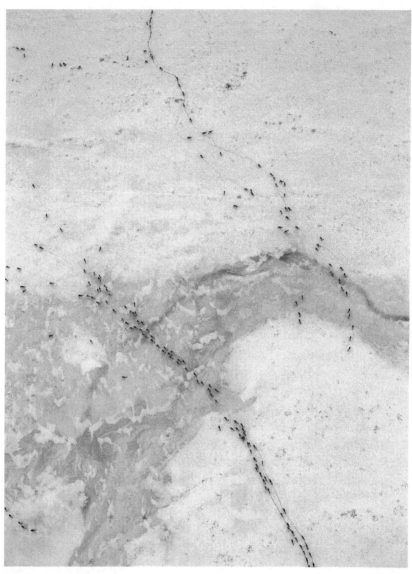

48. Subhankar Banerjee, *Caribou Migration I (Oil and The Caribou, Coleen River Valley)*, 2002. Ultrachrome print. Courtesy of the artist.

long distances traveled by the caribou. Although the animals are large deer distinguished by their enormous antlers, they appear tiny and almost antlike in the photograph, with few of their features detectable to the viewer. Like Banerjee, many wildlife photographers and filmmakers have used aerial vision to situate animals within their larger ecological fabric. Rather than isolating individual creatures, this perspective provides a glimpse of the web of life that encompasses different species and their environments. In this case, as the catalog explains, the pregnant caribou "move with a sense of purpose and determination to reach the coastal plain in time to calve." The text and image suggest the caribou's dependence upon the coastal plain, the key area targeted for drilling, and imply that radical alteration of the habitat could threaten the survival of a tremendous herd of animals. By viewing the caribou from such a distance, a perspective that makes the individual creatures seem minuscule, the photograph emphasizes the vast numbers that populate the ecosystem, long lines of caribou extending into the space beyond. The image does not call for sympathy for individual caribou, does not, unlike much popular nature photography, present animals as cute and cuddly, but instead triggers a different kind of emotive response, one that encourages viewers to feel that tampering with an environment that sustains this many creatures would be an unconscionable act.[18]

Banerjee's ecological perspective also incorporates human beings into the picture, portraying the Arctic not as an untouched wilderness but as a space where people have developed complex relationships with their environment. The exhibit and catalog both emphasize the importance of the caribou herb to the Gwich'in people, who live in an area just south of the refuge and also to the east in the Canadian Arctic. The disruption of the caribou habitat from drilling would spell potential disaster for the animals and thereby threaten a crucial food source and cultural tradition of the Gwich'in. While some readers might criticize Banerjee for romanticizing Native communities and engaging in the familiar fantasy of the Ecological Indian, he recognizes that indigenous groups are active agents in their environment. Instead of portraying them as passive beings capable only of genuflecting before nature, Banerjee captures scenes of death and violence to illustrate how hunting rituals are woven into the fabric of community life. In one series of photographs he leaves behind the sentimental portrayal of animals, a common feature in much environmentalist imagery, to record the butchering of a moose, with vivid shots of its red flesh being cut up and transported back to a Gwich'in village. In these ways his ecological vision enables audiences to discern the

[handwritten marginalia:] Sees that humans are a part of the ecosystem whether through disruptive drilling or indigenous living harmonious

interrelationships among humans, animals, and the environment, to see the Arctic as a landscape where people are not excluded, but instead form bonds of exchange and interdependence with the nonhuman world.

Banerjee's focus on human communities in the region extends as well to the Inupiat people, who live on the northern coast of Alaska. Although many environmentalists have condemned Native peoples' continued practice of whale hunting, Banerjee presents this Inupiat tradition in sympathetic terms, recording a communal prayer and other rituals that follow a successful hunt. He also photographed a cemetery containing several crosses and a pair of bowhead whale jawbones rising out of the snow (fig. 49). The jawbones seem to converge, forming an arc that marks an entrance to the grave areas. The sharp verticality of one jawbone reaches toward the top of the frame, overpowering the crosses and mimicking their geometric forms that stretch toward the horizon. In his caption, Banerjee emphasized the spirituality of the space and the symbolism of the jawbones, encouraging viewers to consider the links between religious feeling and attitudes toward nature. "The cemetery," he observed, "is marked by a pair of bowhead whale jawbones; the scene is silent. This is a sign of reverence, I think—a sign of the relationship the Inupiats have with the whale."

Banerjee thus emphasized the significance of whale hunting to Inupiat culture and also has portrayed, in other images, how human actions constitute vital components of the ecological system. Even the polar bear photograph displayed by Barbara Boxer, a portrait of a single bear walking across the ice, reveals these linkages and interrelationships (see fig. 47). Rather than depicting pure wilderness unaffected by people, the photograph, as the caption explained, shows the bear moving toward whale bones left from the Inupiat hunt the previous autumn. Their remains, "consumed by polar and grizzly bears, Arctic foxes and gulls," thus convey the interdependence of humans and nature, turning this image of a lone animal roaming the landscape into a broader vision of the regional ecology.

Banerjee's effort to offer a holistic picture of the Arctic environment, one that encompasses people and the wider natural world, sometimes ran counter to other themes in the 2003 show, especially the idea of wilderness as a pristine space apart from human society. This concept, long employed by mainstream conservation groups, draws on the frontier myth to imagine nature as a therapeutic retreat from industrial civilization, an anomalous zone of freedom that can alleviate the problems and tensions of modern life. A number of captions, including quotations by Margaret Murie and George B.

49. Subhankar Banerjee, *Inupiat Cemetery (Inupiat and The Whales, Barter Island)*, 2001. Ultrachrome print. Courtesy of the artist.

Schaller, who both played crucial roles in the creation of ANWR, evoked the wilderness ideal, describing the refuge as "untouched," a place where "one can recapture the rhythm of life and the feeling of belonging to the natural world." The catalog furthered these sentiments, with former president Jimmy Carter celebrating ANWR as "a remnant of frontier America that our first settlers once called wilderness."[19]

This appeal to purity, to a narrative of untouched nature, provides an attractive frame for many environmental groups. It offers a simple, bifurcated vision of unspoiled landscapes that need to be preserved in contrast to the polluted places where most people live and work. It encourages Americans to yearn for pristine wilderness, to imagine real, essential nature cordoned off from the modern world, protected from the corruptions and contradictions of history. Yet this view also distances people from nature by denying the links between humans and their environment. In the case of ANWR, this perspective obscures how much this landscape is tied to the rest of United States and, indeed, to much of the world.[20]

Even though some of the texts in the 2003 show and catalog reinforced the notion of ANWR as remote and disconnected, Banerjee ultimately transcended the dualism that isolates Arctic nature from contemporary culture.

Just as he revealed the effects of global warming on the region and portrayed the human communities that inhabit the landscape, two subjects that undermine the idea of pure wilderness, Banerjee also emphasized the importance of the refuge, especially its coastal plain, to more than 180 species of migratory birds. Traveling from almost every American state and from points much farther afield—Antarctica and South America, as well as parts of Europe, Asia, and Africa—the birds use the coastal plain either as their breeding ground or as a place of sustenance during part of the year. These migratory patterns exemplify the links among distant ecosystems, suggesting that the Arctic is not so remote after all. "The tundra may seem like a world apart," ornithologist David Allen Sibley observed in the catalog, "but to the birds, . . . every place is connected."[21]

To portray migratory birds, Banerjee relies on two different representational strategies: aerial shots of large flocks and close studies of individual creatures. As he did with the caribou, Banerjee uses the view from above to suggest the tremendous numbers of birds that depend upon the coastal plain for their survival. Photographs of snow geese present the birds as tiny white flecks grouped together in random patterns. The geese float, as far as the eye can see, above the Jago River and the coastal plain, their whiteness a sharp contrast to the colors below—barren shades of gray and dark brown in one, radiant vistas of blue and orange in the other.

In the 2003 exhibition, Banerjee interspersed panoramic photographs with detailed portraits of individual birds. Like Eliot Porter, who became widely renowned for his bird photography in the mid-twentieth century, Banerjee uses color to enable audiences to appreciate the distinct characteristics of different species and also tries to provide a sense of closeness and intimacy, making viewers feel part of the scene, as if the bird were right before their eyes. A photograph of a buff-breasted sandpiper shows the creature engaged in courtship display—standing erect, with wings outstretched to reveal its orange-yellow breast (fig. 50). Although Porter sought to record both birds and their surroundings in full focus, a technique Banerjee uses in many of his photographs, this image instead concentrates more on the bird itself. The features of the foreground appear relatively clear, but the background becomes soft and fuzzy. The sandpiper's pose looks even more determined when placed against this blurry landscape.[22]

Although the image does not fully capture the bird's setting, the exhibition caption situated it within a much broader context: its global migration pattern. "This species," the text explained, "a long-distance traveler that mi-

50. Subhankar Banerjee, *Buff-breasted Sandpiper (Oil and The Caribou, Coastal Plain of the Jago River)*, 2002. Ultrachrome print. Courtesy of the artist.

grates each year from Argentina to the Arctic Refuge coastal plain to nest and rear its young, is one of the top five bird species at greatest risk if its habitat is disturbed." The caption encouraged audiences to view the sandpiper within the different geographies that define its life course, to consider how Argentina and the Arctic are connected by its flight, and to feel concerned about its fate, particularly if drilling were to take place in the coastal plain. When Senator Durbin found out that this caption would be removed from the Smithsonian show, he was outraged, announcing to the *New York Times* and other papers: "I want the world to see the caption of the little bird that the Smithsonian says is too controversial for the public."[23]

seems like pure censorship

In many ways, this image and its accompanying text encapsulate Banerjee's quietly subversive achievement. As *Vanity Fair* art critic Ingrid Sischy observed in a feature story on the photographer, "Banerjee is certainly not the first artist to produce an exhibition that scared a museum, but what is unusual is that, on the surface, his pictures are tame and sweet." Indeed, the buff-breasted sandpiper photograph seems like the kind of innocent image that appears routinely in calendars and other such media as a sign of pure nature. Yet the exhibition caption urged audiences to see the bird as a creature that does not exist in some separate domain, apart from their own lives. Ac-

cording to Banerjee, the sandpiper offers a small glimpse of the interconnections that define the global environment. From this vantage point, the significance of ANWR extends far beyond its symbolic value as the last frontier of American wilderness. Rather than providing a retreat from modernity, a sequestered realm that operates in a different time and space, the refuge forms a vital link in a chain of relationships stretching from the Arctic to places around the globe.[24]

From 2003 to 2006, as Banerjee's show was extended and traveled across the United States, the mainstream media devoted increasing attention to global warming, representing the Arctic as a new type of frontier—not a landscape of therapeutic escape, but rather, as the *New York Times* explained, a "frontier of climate change." As this coverage demonstrates, the effects of global warming are clearly visible in the contemporary Arctic and therefore cannot be consigned to some vague, imaginary future. "Be Worried. Be *Very* Worried," *Time* magazine announced in a 2006 cover story that featured a photograph of a lone polar bear surrounded by melting sea ice. Al Gore's *An Inconvenient Truth* (2006) likewise described the Arctic and Antarctica as representing "canaries in the coal mine"; the tremendous success of both the book and documentary film brought images of shrinking ice caps and vanishing glaciers to surprisingly large audiences.[25]

Despite the mounting evidence of global warming, the Bush administration tried to deny the reality of climate change and dismissed energy conservation as a matter of personal virtue rather than national policy. Equally disturbing, government scientists and museum officials described concerted efforts to restrict their speech, suppress research, and limit what they could communicate to the public. In the spring of 2004, just before the release of Roland Emmerich's *The Day After Tomorrow,* a Hollywood blockbuster about global warming, NASA scientists received a directive not "to do interviews or otherwise comment on anything having to do" with the movie. A copy of the message was leaked to the *New York Times* by "a senior NASA scientist who said he resented attempts to muzzle climate researchers." Two years later, the Smithsonian's National Museum of Natural History, where Banerjee's work had generated so much controversy, opened an exhibition entitled "Arctic: A Friend Acting Strangely." Although the show included photographs of permafrost melting and other signs of climate change, an official later revealed that the museum "toned down" the exhibit "for fear of angering Congress and the Bush administration." In particular, "the script . . .

51. Subhankar Banerjee, *Exposed Coffin (Oil and The Caribou, Barter Island)*, 2006. Ultrachrome print. Courtesy of the artist.

was rewritten to minimize and inject more uncertainty into the relationship between global warming and humans."[26]

As for Banerjee, he returned to the Arctic in 2006 to launch a new project. His focus now extends beyond the potential threat to ANWR to encompass the "joy and sorrow" he finds throughout the region. He describes the Arctic "as the most connected land on the planet" and intends to examine a wide range of issues: from the Gwich'in community's relationship to the porcupine caribou herd to the accumulation of toxins—persistent organic pollutants that migrate from around the world—in alarmingly high concentrations among the region's wildlife and people. In these more recent travels, Banerjee saw things he had not seen before, signs of the ongoing impact of global warming. On Barter Island, about two miles from where he took the photograph of the Inupiat cemetery (see fig. 49), he encountered a ghastly scene: an exposed coffin, with human bones strewn across the land (fig. 51). While the earlier photograph of the cemetery reveals a sense of continuity, with the jawbones and crosses embodying a kind of material permanence in the land,

this more recent photograph instead conveys profound disruption. The term "permafrost" literally means permanent frost, but throughout the Arctic the permafrost is melting and, in some cases, gravesites are opening up. In this image, the coastline of the Beaufort Sea seems tranquil, the water still and serene, but the exposed coffin appears menacing, perhaps a portent of things to come.[27]

In 2001, Banerjee began his photographic excursion in a manner that followed other seekers of solitude, hoping, in his case, to see polar bears uncorrupted by the presence of crowds, to experience nature in its purest and most authentic state. By the time Senator Boxer displayed one of his polar bear pictures, Banerjee had moved beyond the dueling frontier visions that have tended to frame the debate over oil drilling. Perhaps he had realized as well that these visions ultimately reinforce one another, as they both portray ANWR as a remote place, disconnected from everyday life. Banerjee's striking aesthetic compositions, together with his attention to ecological context, reframe the Arctic landscape and question some of the reigning assumptions about the relationship between nature and culture in modern America. His work makes viewers feel closer to the Arctic, not only by offering memorable portrayals of the region, but also by repeatedly reminding them of the ties that bind this distant land to their own lives.

Notes

1. First quotation from "Smithsonian Defends Move on ANWR Photos," *All Things Considered,* National Public Radio, May 20, 2003, http://www.npr.org/templates/story/story.php?storyId=1269389; second quotation from Elizabeth Shogren, "Heat Turned Up on Arctic Exhibit?" *Los Angeles Times,* April 29, 2003.

2. The exhibition, titled Arctic National Wildlife Refuge: Seasons of Life and Land, opened at the National Museum of Natural History in May 2003. For background on the Smithsonian controversy see also Ingrid Sischy, "The Smithsonian's Big Chill," *Vanity Fair,* December 2003, 242–56; and Timothy W. Luke, exhibit review of Arctic National Wildlife Refuge: Seasons of Life and Land, *Public Historian* 26 (February 2004): 193–201. For a perceptive analysis of the prevalence of frontier discourse in American literary responses to Alaska see Susan Kollin, *Nature's State: Imagining Alaska as the Last Frontier* (Chapel Hill: University of North Carolina Press, 2001).

3. On the importance of the emotions and spirituality to environmental image making see Finis Dunaway, *Natural Visions: The Power of Images in American En-*

vironmental Reform (Chicago: University of Chicago Press, 2005). For a succinct discussion of the impact of ecological thought on contemporary nature writing see Daniel J. Philippon, *Conserving Words: How American Nature Writers Shaped the Environmental Movement* (Athens: University of Georgia Press, 2004), 266–77. Philippon focuses here on the metaphor of the island, a term not used by Banerjee, but one that aptly expresses his ecological view of ANWR.

4. Subhankar Banerjee, introduction to *Arctic National Wildlife Refuge: Seasons of Life and Land* (Seattle: Mountaineers Books, 2003), 16.

5. Ibid., 17.

6. On antitourist rhetoric in environmental writing see Kollin, *Nature's State,* chap. 1.

7. Lisa Drew, "Caring About Alaska: Who Does? And Why?" *National Wildlife,* April/May 1996, 30; Bert Gildart, "Hunting for Their Future," *National Wildlife,* October/November 1997, 21; and U.S. Fish and Wildlife Service, "Arctic National Wildlife Refuge," October 2002, n.p.

8. For background information on ANWR and the current debate see, e.g., Peter Matthiessen, "In the Great Country," in *Arctic National Wildlife Refuge,* 40–57.

9. Brandon Griggs, "From Arctic Refuge to Utah Deserts, a Focus on Fragile Lands," *Salt Lake Tribune,* October 31, 2004; Subhankar Banerjee, "Photographer's Notes," in *Arctic National Wildlife Refuge,* 172; and Natasha Gural, "Fuel for Debate," *Tulsa World,* September 16, 2004.

10. Norton quoted in Liz Ruskin, "ANWR Exhibit Opens Quietly at Smithsonian," *Anchorage Daily News,* May 3, 2003. Murkowski's use of the poster can be seen in a documentary film: *Oil on Ice,* DVD, directed by Dale Djerassi and Bo Boudart (2004; Burbank, Calif.: Warner Home Video, 2005).

11. On the seasons as an organizing device in environmental literature see Lawrence Buell, *The Environmental Imagination: Thoreau, Nature Writing, and the Formation of American Culture* (Cambridge, Mass.: Belknap Press, 1995), chap. 7. For a broad study of the four seasons in American cultural history see Michael Kammen, *A Time to Every Purpose: The Four Seasons in American Culture* (Chapel Hill: University of North Carolina Press, 2004). On Eliot Porter's photography of the seasons see Dunaway, *Natural Visions,* chap. 6.

12. Sischy, "The Smithsonian's Big Chill"; and Luke, exhibit review.

13. Volunteer quoted in Luke, exhibit review, 197. Letter quoted in Sischy, "The Smithsonian's Big Chill," 254.

14. Durbin press release quoted in Luke, exhibit review, 195–96. Second quotation from Ruskin, "ANWR Exhibit Opens Quietly."

15. "Some Scary Pictures," *Los Angeles Times,* May 2, 2003; "Tampering with Treasures," *St. Petersburg Times,* May 24, 2003; Timothy Cahill, "Politics Storms

the Smithsonian," *Albany Times Union,* May 18, 2003; and Terry Rodrigues, letter to editor, *Albany Times Union,* May 24, 2003.

16. Shogren, "Heat Turned Up on Arctic Exhibit?"; "A Conversation with Subhankar Banerjee," in Subhankar Banerjee, *The Last Wilderness: Photographs of the Arctic National Wildlife Refuge* (New York: Gerald Peters Gallery, 2004), n.p.

17. For more on the careers of Adams and Porter, including their involvement with the Sierra Club, see Dunaway, *Natural Visions,* chaps. 5–7. See also the insightful essays in John B. Rohrbach, Rebecca Solnit, and Jonathan Porter, *Eliot Porter: The Color of Wildness* (New York: Aperture, in association with the Amon Carter Museum, 2001). Solnit's essay on Porter appears, in revised form, in this volume.

18. Banerjee, *Arctic National Wildlife Refuge,* 37. On the use of panoramic vision in wildlife films see Gregg Mitman, *Reel Nature: America's Romance with Wildlife on Film* (Cambridge, Mass.: Harvard University Press, 1999), esp. chap. 4.

19. Jimmy Carter, foreword to *Arctic National Wildlife Refuge,* 13.

20. For an important critique of the wilderness ideal see William Cronon, "The Trouble with Wilderness; or, Getting Back to the Wrong Nature," in *Uncommon Ground: Toward Reinventing Nature,* ed. Cronon (New York: Norton, 1995), 69–90.

21. David Allen Sibley, "Visiting the Birds at Their Summer Home," in *Arctic National Wildlife Refuge,* 106.

22. For a discussion of Porter's bird photography, including his efforts to capture the surroundings of birds in full focus, see John B. Rohrbach, *A Passion for Birds: Eliot Porter's Photography* (Fort Worth: Amon Carter Museum, 1997).

23. Durbin quoted in Timothy Egan, "Smithsonian Is No Safe Haven for Exhibit on Arctic Wildlife Refuge," *New York Times,* May 2, 2003.

24. Sischy, "The Smithsonian's Big Chill," 242.

25. William Yardley, "Engulfed by Climate Change, Town Seeks Lifeline," *New York Times,* May 27, 2007; *Time,* April 3, 2006, cover; and Al Gore, *An Inconvenient Truth: The Planetary Emergency of Global Warming and What We Can Do About It* (Emmaus, Penn.: Rodale Press, 2006), 126.

26. Andrew C. Revkin, "NASA Curbs Comments on Ice Age Disaster Movie," *New York Times,* April 25, 2004; and Brett Zongker, "Smithsonian Toned Down Exhibit on Arctic," *Houston Chronicle,* May 21, 2007.

27. Quotations from Liam Moriarty, "Arctic Photographer Interview," radio interview with Banerjee, KPLU-Seattle, December 8, 2006, http://www.publicbroadcasting .net/kplu/news.newsmain?action=article&ARTICLE_ID=1008809.

Contributors

Janet Catherine Berlo is Professor of Art History and Visual and Cultural Studies at the University of Rochester. She holds a Ph.D. in history of art from Yale University and is a scholar of Native American art history and women's textile arts. Her books include *Spirit Beings and Sun Dancers: Black Hawk's Vision of a Lakota World* (2000), *Native North American Art* (1997), and the exhibition catalog *Plains Indian Drawings, 1865–1935: Pages from a Visual History* (1996). Her most recent coauthored book is the textbook *American Encounters: Art, History and Cultural Identity* (2008).

Alan C. Braddock is Assistant Professor of Art History at Temple University, where he teaches courses in American art from the colonial era to the present. He is the author of *Thomas Eakins and the Cultures of Modernity* (2009) and articles on various topics in *American Art, American Quarterly, Nineteenth-Century Art Worldwide,* and *Winterthur Portfolio*. His current book project, titled *Gun Vision: The Ballistic Imagination in American Art from Homer to O'Keeffe* examines the relationship between art and arms, seeing and shooting, in the United States between the Civil War and World War I. He has also taught at Syracuse University and the University of Delaware, where he received his Ph.D. in 2002.

Lawrence Buell is Powell M. Cabot Professor of American Literature at Harvard University. His books include *The Environmental Imagination* (1995), *Writing for an Endangered World* (2001), and *The Future of Environmental Criticism* (2005). In 2007 he won the Modern Language Association's Jay Hubbell Award for lifetime contributions to American literature studies.

Finis Dunaway is Associate Professor of History at Trent University, where he teaches courses in modern U.S. history, visual culture, and environmental studies. He is the author of *Natural Visions: The Power of Images in American*

Environmental Reform (2005) as well as essays in *American Quarterly, Environmental History, Raritan,* and other journals. He is currently working on a book about visual culture and the environmental crisis.

Thomas Hallock is the author of *From the Fallen Tree: Frontier Narratives, Environmental Politics, and the Roots of a National Pastoral* (2003) and co-editor of *William Bartram's Manuscripts* (forthcoming). He is Assistant Professor of English at the University of South Florida St. Petersburg.

Elizabeth Hutchinson is Assistant Professor of Art History at Barnard College and Columbia University, where she teaches courses on the visual cultures of North America's diverse populations and their encounters. She has published numerous articles on American painting, photography and decorative arts in such journals as *American Art, The Art Bulletin,* and *October.* Her first book, *The Indian Craze: Primitivism, Modernism and Transculturation in American Art* (2009), identifies the passion for collecting, displaying, and emulating Native American art between the late nineteenth century until World War I as a transcultural "contact zone." Her current book project, on Eadweard Muybridge's photographs of American frontiers from Alaska to Guatemala, takes a similar transcultural approach while building on the kind of object-centered analysis that is shown in the essay published in *A Keener Perception.*

Christoph Irmscher is Professor of English and Adjunct Professor in The History and Philosophy of Science and American Studies at Indiana University Bloomington. His books include *Masken der Moderne* (1992), *The Poetics of Natural History* (1999), *Longfellow Redux* (2006, revised paperback edition, 2008), *Public Poet, Private Man: Henry Wadsworth Longfellow at 200* (2009), and he edited the Library of America edition of *John James Audubon: Writings and Drawings* (1999). In recent years he has been working with the National Park Service, the National Endowment for the Humanities, and the Field Museum to increase public interest in nineteenth-century writing and art. He is currently finishing a cultural biography of the scientist Louis Agassiz.

Jonathan Massey is Associate Professor and Undergraduate Program Chair in the School of Architecture at Syracuse University. He received a Ph.D. in Architecture from Princeton University in 2001. At Syracuse he has organized the architecture lecture series, chaired departmental and university committees, and worked with colleagues in other academic divisions to establish a new interdisciplinary program in Lesbian, Gay, Bisexual, and Transgender Studies. His research—published in the *Journal of Architecture,*

Perspecta, the *Journal of the Society of Architectural Historians,* and other journals and books—examines the ways architecture mediates power by giving form to civil society, shaping social relationships, and regulating consumption. His essays have analyzed topics ranging from Buckminster Fuller and organicism in modern architecture to mortgage finance and sumptuary regulation. Massey's forthcoming book, *Crystal and Arabesque,* reconstructs the techniques through which American modernists engaged the new media, audiences, and problems of mass society.

Angela L. Miller is Professor of Art History at Washington University in St. Louis, where her areas of specialization include the cultural history of nineteenth- and twentieth-century American arts, nineteenth- and twentieth-century visual culture, early American modernism, and the cultural histories of the arts between the world wars. She has published *The Empire of the Eye: Landscape Representation and American Cultural Politics, 1825–1875* (1993) as well as numerous articles in journals such as *American Art, Art in America, American Quarterly, New England Quarterly,* and *Winterthur Portfolio.* Her work appears in anthologies such as *American Iconology* (1993), *Art in Bourgeois Society, 1790–1850* (1998), *Caught by Politics: Hitler Exiles and American Visual Culture* (2007), and *Walt Whitman: Where the Future Becomes Present* (2008). She is the lead author of *American Encounters: The Arts and Cultural Identity, from the Beginning to the Present* (2007).

Jeffrey Myers is Associate Professor of English at Manhattan College, where he teaches nineteenth-century and multiethnic American literature as well as environmental literature. He is the author of *Converging Stories: Race, Ecology, and Environmental Justice in American Literature* (2005) as well as articles in *African American Review* and *Interdisciplinary Studies in Literature and Environment.* His work focuses on the intersection of race and the environment as they are represented in literature and culture, with particular attention to the implications for environmental justice. He has an essay on teaching African-American literature as environmental literature appearing in the new edition of *Approaches to Teaching North American Environmental Literature* (forthcoming), and he is at work on a long-term project on the environment in African-American literature, art, and music.

Rebecca Solnit is an activist, historian, and writer who lives in San Francisco. Her work deals in particular with landscape, cityscapes, cultural geographies, the environment, place, time, speed, memory, photography, metaphor, counternarratives, and the uses of story. She is currently working on her

twelfth book; the first eleven include *Storming the Gates of Paradise* (2007), *A Field Guide to Getting Lost* (2005), *Hope in the Dark: Untold Histories, Wild Possibilities* (2004), *As Eve Said to the Serpent: On Landscape, Gender, and Art* (2001), and *Wanderlust: A History of Walking* (2000). For *River of Shadows: Eadweard Muybridge and the Technological Wild West* (2003) she received a Guggenheim, the National Book Critics Circle Award in criticism, and the Lannan Literary Award. A contributing editor of *Harper's* and a columnist for *Orion,* she frequently writes for the political site Tomdispatch.com. She has worked on antinuclear, antiwar, environmental, indigenous land rights, and human rights campaigns and movements over the years.

Timothy Sweet is Professor of English at West Virginia University. His publications include *Traces of War: Poetry, Photography, and the Crisis of the Union* (1990), *American Georgics: Economy and Environment in Early American Literature* (2002), and articles on early, antebellum, and Native American literature.

Mark Andrew White serves as the Eugene B. Adkins Curator at the Fred Jones Jr. Museum of Art at the University of Oklahoma. He is a historian of American art with specializations in modernism, the American West, and Native American art. He received his Ph.D. from the Kress Foundation Department of Art History at the University of Kansas in 1999. His research interests, though restricted to the twentieth century, are diverse, and he has published on George Bellows, Peter Blume, Alexandre Hogue, Oscar Howe, and Olinka Hrdy. In 2003–2004 he received a fellowship at the Georgia O'Keeffe Museum and Research Center in Santa Fe, New Mexico, where he began research on a forthcoming book examining American abstractionists of the 1930s and their efforts to infuse their modernist experiments with social significance.

Index

A Keener Perception

A Keener Perception

Ecocritical Studies in American Art History

EDITED BY
ALAN C. BRADDOCK
AND CHRISTOPH IRMSCHER

FOREWORD BY LAWRENCE BUELL

THE UNIVERSITY OF ALABAMA PRESS
Tuscaloosa

Typeface: Granjon

∞

The paper on which this book is printed meets the minimum requirements of American
National Standard for Information Sciences-Permanence of Paper for Printed Library
Materials, ANSI Z39.48–1984.

**green
press**
INITIATIVE

University of Alabama Press is committed to preserving
ancient forests and natural resources. We elected to print this
title on 30% postconsumer recycled paper, processed chlorine-
free. As a result, for this printing, we have saved:

10 Trees (40' tall and 6-8" diameter)
1,533 Gallons of Wastewater
3 million BTUs of Total Energy
197 Pounds of Solid Waste
369 Pounds of Greenhouse Gases

Red Empire Press made this paper choice because our printer,
Thomson-Shore, Inc., is a member of Green Press Initiative,
a nonprofit program dedicated to supporting authors, publish-
ers, and suppliers in their efforts to reduce their use of fiber
obtained from endangered forests.

For more information, visit www.greenpressinitiative.org

Environmental impact estimates were made using the Environmental Defense
Paper Calculator. For more information visit: www.edf.org/papercalculator

Library of Congress Cataloging-in-Publication Data

A keener perception : ecocritical studies in American art history / edited by Alan C.
Braddock and Christoph Irmscher ; foreword by Lawrence Buell.
p. cm.
Includes bibliographical references and index.
ISBN 978-0-8173-1668-6 (cloth : alk. paper) — ISBN 978-0-8173-5551-7 (pbk. : alk. paper)
1. Art, American—Historiography. 2. Ecocriticism—United States. I. Braddock, Alan C., 1961–
II. Irmscher, Christoph. III. Title: Ecocritical studies in American art history.
N7480.K44 2009
709.73—dc22

2009010162

Five of the essays included here have previously appeared elsewhere and are here republished in slightly different or revised form. Angela L. Miller, "The Fate of Wilderness in American Landscape Art: The Dilemmas of 'Nature's Nation,'" in *American Wilderness: A New History,* ed. Michael Lewis (New York: Oxford, 2007), 91–113; Elizabeth Hutchinson, "They Might Be Giants: Carleton Watkins, Galen Clark, and the Big Tree," *October* 109 (Summer 2004): 46–63; Mark Andrew White, "Alexandre Hogue's Passion: Ecology and Agribusiness in *The Crucified Land,*" *Great Plains Quarterly* 26, no. 2 (2006): 67–83; Rebecca Solnit, "Every Corner Is Alive: Eliot Porter as an Environmentalist and an Artist," in John Rohrbach, Rebecca Solnit, and Jonathan Porter, *Eliot Porter: The Color of Wildness* (New York: Aperture, in association with the Amon Carter Museum, 2001), 113–31; Finis Dunaway, "Reframing the Last Frontier: Subhankar Banerjee and the Visual Politics of the Arctic National Wildlife Refuge," *American Quarterly* 58, no. 1 (2006): 159–80. The publisher and the editors thank the copyright holders for allowing us to reuse this material for our anthology.

Contents

Illustrations

Foreword

Lawrence Buell

This excellent collection deserves careful scrutiny by all environmental humanists, particularly those concerned with literature and the arts. Its diversity of accomplishment confirms my long-standing conviction that ecocriticism, which has burgeoned in less than fifteen years from a small vanguard of the Western Literature Association to a worldwide movement, should have started with engagement of literary texts rather than, say, theater, music, dance, or visual studies.

To be sure, this inception makes a certain kind of sense insofar as the medium of language predisposes literary genres to philosophical and ethical reflection, and the point of geographical origin also makes sense—as this volume's emphasis on the legacies of America's moving frontier attests—insofar as environmental history, the first of the environmental humanities to mature into a recognized subdiscipline, began as and still remains for Americanists at least a sort of offshoot of western history. But given that visual art in whatever medium has always already been at least implicitly conceptual, and given that visual media have always been deeply invested in environmentality whether or not consciously recognized as such, it should come as no surprise to find ecocriticism catching on quickly in visual culture studies, and at a high level of sophistication.

A Keener Perception showcases no less than three major trend lines simultaneously. First, the increasing cross-border synergies between literary studies and art history, several of this volume's contributors being in fact literary scholars in the first instance. Second, the opening up of ecocriticism from what now looks like a parochial back-to-nature-ism focused on a very few genres in post-romantic Anglo-American literary history to a far more inclusive pluriverse of multigeographic, multiethnic approaches that find for ex-

ample the environmentality of urban and futuristic landscapes at least as profound and consequential as the backcountry. And third, the opening up of what counts as "art history" itself, in part because of the internal momentum of the discipline but also—this book suggests—because of the provocation and promise of ecocriticism. Those for whom art history still means painting and sculpture featured by traditional museums will be surprised, maybe at first jolted, but increasingly excited by the range of visual discourses encompassed here, from botanical illustration to Navajo rugs, and by the fresh reconceptions of canonical art and artists undertaken here.

Rarely has a miscellaneous collection of critical essays so consistently engaged me from start to finish—and with good reason. Most of its contributors are early to mid-career scholars on rising trajectories. *A Keener Perception* promises to add luster to their standing as individual scholars even as it makes clear the emergence of a mature, eloquent ecocritical presence within art history that is sure to command much wider notice and emulation, not least because it refuses to reduce the phenomenon of environmentality to any one methodological persuasion or doctrinal party line.

Acknowledgments

Editing this volume was an extraordinary privilege. Loren Eiseley, at the beginning of *The Firmament of Time,* said that he was given much more than he gave, and that was quite literally our experience, too. We were immeasurably enriched and inspired by the insights the contributors to our volume have shared with us, and we feel honored that they entrusted us with their work. We hope that they will like the final product.

Alan Braddock wishes to thank, first and foremost, Christoph Irmscher for his intellectual rigor, scholarly maturity, and patient commitment in undertaking this project, which would not have been possible without his generous collaboration. And Christoph Irmscher, in turn, would like to thank Alan Braddock for asking him to come along for the ride and for the exhilaration, entertainment, and enlightenment he provided en route. We exchanged countless e-mails, became more skilled than we ever imagined possible in using that wonderfully addictive tool in Microsoft Word unglamorously called "Track Changes," and held high-level strategy meetings at Burdick's Chocolate Café and John Harvard's Brewhouse in Harvard Square. Interdisciplinary sparks flew at various points during the project's realization; they helped us discover new things not only about each other and our own fields but also about ourselves. We began our work as collaborators and ended up as friends.

The staff at The University of Alabama Press believed in the importance of this book from the beginning. Two anonymous readers for the press offered strong support for the manuscript we had submitted; their suggestions for revision helped us clarify our goals. The American Studies Association (ASA) also deserves credit for assisting in the germination of the project by sponsoring Alan Braddock's session on "The Environmental Imagination:

Toward a Green History of American Art" at the 2005 ASA conference in Washington, D.C. Elizabeth L. Johns (Indiana University Bloomington) began the difficult task of gathering the illustrations for the volume, and the Office of the Vice Provost for Research at Indiana University awarded us a generous grant-in-aid that paid for that bane of a writer's life known as permission fees. Another grant-in-aid was awarded by Temple University.

Finally, the present volume owes a considerable debt to Lawrence Buell, whose extraordinary body of environmental criticism stands as an enduring inspiration and benchmark, shining a path across disciplines that we, in *A Keener Perception*, have only begun to explore. We hope many of our readers will accept our invitation to travel with us.

Alan C. Braddock and Christoph Irmscher